FRANCIS BACON

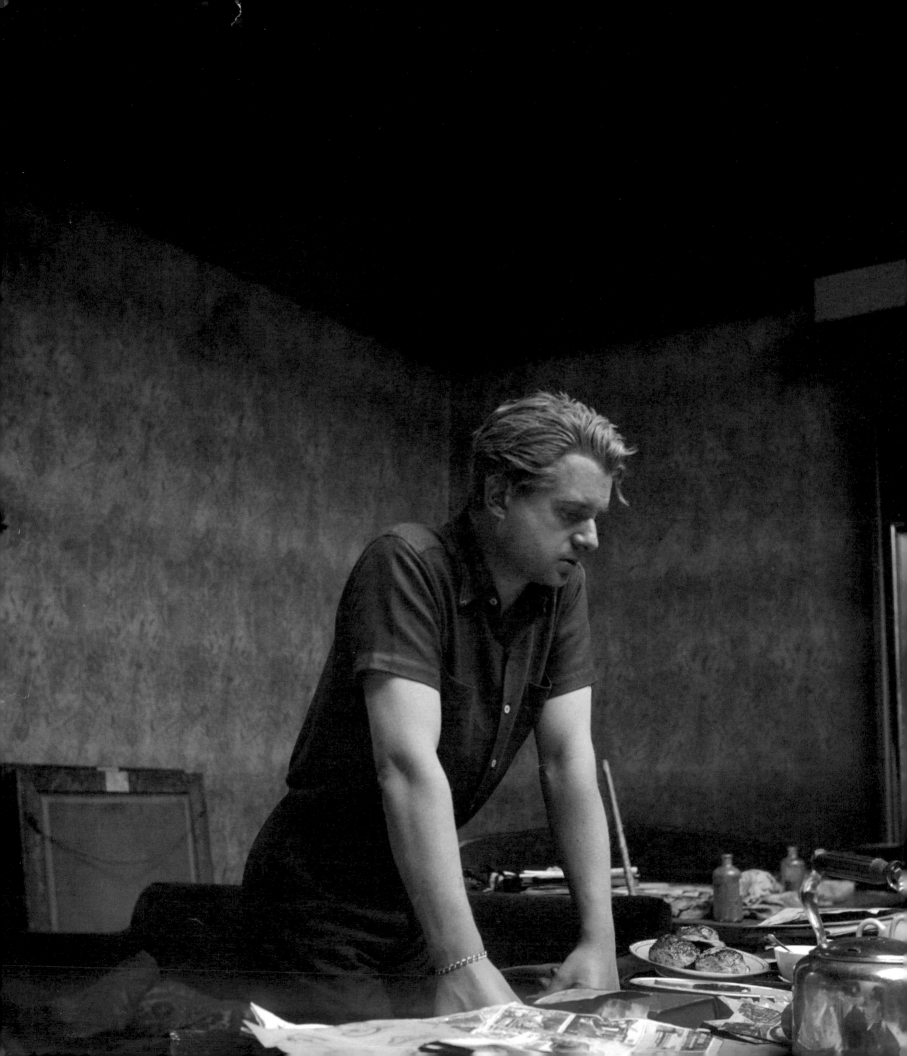

FRANCIS BACON

Edited by Matthew Gale and Chris Stephens

Essays by
Martin Harrison
David Alan Mellor
Simon Ofield
Gary Tinterow
Victoria Walsh

TATE PUBLISHING

First published 2008 by order
of the Tate Trustees
by Tate Publishing, a division of
Tate Enterprises Ltd,
Millbank, London SW1P 4RG
www.tate.org.uk/publishing

on the occasion of the exhibition
FRANCIS BACON

Sponsored by

Bank of America

Tate Britain, London
11 September 2008 – 4 January 2009

Museo Nacional del Prado, Madrid
3 February – 19 April 2009

The Metropolitan Museum of Art, New York
18 May – 16 August 2009

© Tate 2008

British Library Cataloguing in Publication Data
A catalogue record for this book is available
from the British Library

ISBN 978-1-85437-738-8 (paperback)
ISBN 978-1-85437-824-8 (hardback)

Designed by Peter Willberg
assisted by Rory McCartney at
Clarendon Road Studio, London
Printed in Great Britain
by Westerham Press Limited

Front cover: *Head VI* 1949 (detail, p.104)
Back cover: *Francis Bacon* 1950
Photograph by Sam Hunter
Frontispiece: *Francis Bacon* 1950
Photograph by Sam Hunter

Measurements of artworks are given in
centimetres, height before width

CONTENTS

7 **Sponsor's Foreword**

8 **Directors' Foreword**

11 **Curators' Acknowledgements**

14 **On the Margin of the Impossible**
Matthew Gale and Chris Stephens

28 **Bacon and his Critics**
Gary Tinterow, assisted by Ian Alteveer

40 **Bacon's Paintings**
Martin Harrison

50 **Film, Fantasy, History**
David Alan Mellor

64 **Comparative Strangers**
Simon Ofield

74 **'Real imagination is technical imagination'**
Victoria Walsh

Catalogue

90 **Animal**

106 **Zone**

120 **Apprehension**

136 **Crucifixion**

152 **Crisis**

164 **Archive**

180 **Portrait**

200 **Memorial**

212 **Epic**

232 **Late**

252 **Chronology**

267 **Selected Reading**

268 **Notes**

280 **List of Works**

283 **List of Lenders**

284 **Index**

SPONSOR'S FOREWORD

Bank of America is delighted to partner with Tate Britain in organising this major retrospective of Francis Bacon's work in anticipation of the artist's centenary in 2009.

As a painter, Bacon was entirely self-taught; his success is testament to an enterprising nature, passion and pursuit of excellence in his artistic practice. These are qualities which we strive to promote for our clients, our employees, and the communities in which we live and work.

Bank of America understands the beneficial role art plays within our communities and has emerged as a leading corporate supporter of arts and culture in the United States. Our programme includes grants and sponsorships across the full range of arts, as well as loans from our own art collection to museums throughout the world. We are now extending this model of arts support to Europe.

We are honoured to join with one of the world's leading art institutions in bringing together the works of such a fascinating, provocative and groundbreaking artist. We hope that you will find this exhibition both enjoyable and thought-provoking.

Jonathan Moulds
President, Bank of America, EMEA & Asia

DIRECTORS' FOREWORD

No artist knows in his own lifetime whether what he does will be the slightest good, because I think it takes at least seventy-five to a hundred years before the thing begins to sort itself out from the theories that have formed about it.[1]

Francis Bacon is internationally acknowledged as the most powerful painter of the figure in the second half of the twentieth century. His images of straining bodies that leave 'a trail of the human presence' (as he expressed it in 1955) are replete with a physical and psychological tension.[2] Over the last fifty years a negative critical response to the horrors of the paintings has given way to recognition of Bacon's extraordinary ability to expose humanity's frailties and drives. Bacon's concentration on the figure in a period of the ascendancy of abstraction seemed to mark him out even though he was far from isolated in this endeavour. However, it was from this engagement with the visceral body in twentieth-century life that Bacon derived the energy for his work.

This major project, marking the centenary of his birth on 28 October 1909, brings together many of the most important works from across Bacon's career in three cities of particular significance to him. It is the third retrospective in London, both of the others having been at the Tate Gallery: the career-defining show of 1962 and the major survey of 1985. New York echoes that pattern with exhibitions at the Solomon R. Guggenheim Museum in 1963, The Metropolitan Museum of Art in 1975, and The Museum of Modern Art in 1989. It is thirty years since the last major exhibition in Madrid, the city where he died on 28 April 1992. To be shown in the new galleries of the Prado, whose collection fascinated him, seems especially appropriate.

This exhibition provides an opportunity to survey Bacon's achievement afresh, unfettered by the artist's personal preferences or by those, however inspired, of his long-time champion David Sylvester who died in 2001. We hope that a new generation will focus on some of the primary issues that Bacon's works raise: the continuing power of painting, the extent to which degrees of realism can carry meaning, the paramount importance of the engagement between the individual viewer and the painting. The last decade has seen the state of Bacon studies transformed by John Edwards' extraordinary gift of the Reece Mews studio to Dublin City Gallery The Hugh Lane. This development and a series of focused exhibitions and publications have opened new ways of thinking about this most remarkable of artists.

These new developments are reflected in the selection of the exhibition and in the accompanying catalogue, which has brought together a variety of different voices. The project took as a starting point the two fundamentals of Bacon's philosophy: the challenge to painting in a photographic age, and his personal sense of existing in a godless world. Different bodies of works and periods allow the examination of the relationship between the human and the animal, the transformation of portraits of friends, the treatment of epic subjects, and the final expressions of a sense of imminent death. Tate curators Chris Stephens and Matthew Gale have developed these themes in close consultation with Gary Tinterow at the Metropolitan Museum and in discussion with Manuela

1 Bacon to David Sylvester, May 1966, in *Interviews with Francis Bacon*, London 1993, p.60.

2 *The New Decade: 22 European Painters and Sculptors*, exh. cat., The Museum of Modern Art, New York, 1955, pp.60–1.

Mena Marquéz at the Museo del Prado, seeking to recapture some of the complexity with which the painter invested his work, by gathering the most extraordinary of his paintings and exposing their unity and variety. While Bacon was renowned for using Velázquez's *Portrait of Pope Innocent X* as a point of departure, he simultaneously made and showed paintings of apes that cast light on how he viewed life, from the exercise of power to the abjection of physical existence. Along with the violence, threat and pathos, nothing is more consistently present than this sense of mortality.

We are tremendously grateful to the owners, both private and public, who have recognised the importance of this project and generously agreed to lend their precious works in order to bring them to a wider public. It is only because of this extraordinary generosity that this exhibition can be achieved, and it is a mark of the long-standing commitment of collectors, museum directors, and curators alike to Bacon and his work that this has been forthcoming. From the outset, four years ago, we have also benefited enormously from the enthusiasm, knowledge and support of Brian Clarke, the Executor of the Francis Bacon Estate, and that of his colleagues associated with the Estate and with the ongoing project to produce a new catalogue raisonné: Elizabeth Beatty, Christophe Dejean, Peter Hunt, John Eastman and Martin Harrison. The generosity of the Estate has helped us to extend research on a scale and with a scope that would otherwise have been impossible. In London the exhibition benefits from the generous sponsorship of Bank of America. Their support for the project has been very considerable and we thank them for such commitment to our work. In New York, the exhibition is made possible in part by The Daniel and Estrellita Brodsky Foundation, whose support is most warmly appreciated.

With an artist as powerful as Francis Bacon, the challenge of a retrospective is to gather major works that communicate most directly, unswervingly, with the nervous system of the viewer, as the painter often remarked. We believe that they will still prove to be piercing, revelatory even, and confirm that Bacon remains a masterful and uniquely haunting painter.

Nicholas Serota
Director
Tate

Philippe de Montebello
Director
The Metropolitan Museum of Art

CURATORS' ACKNOWLEDGEMENTS

Encountering Francis Bacon's paintings is a notoriously robust experience, as they demand the highest standards of concentration and easily resist temporary impositions. To work with them over a sustained period is, therefore, a test as well as an honour. Add to this the celebration of the centenary of Bacon's birth (a reason, one suspects, of which he may have been dismissive) and the third Tate exhibition of his work (an acknowledgement that one hopes would have touched him), and the project assumes an even greater significance. We have continually borne in mind the power and importance of the paintings at the centre of this endeavour, picturing their ability to lock-in shock and transfix emotion viscerally. The work must be allowed to speak for itself and this remains the exhibition's primary contention. With the passage of time, of course, there is already a necessity to unravel some of the accumulations, to scrutinise assumptions, habits and interpretations, to allow space for new insights and contexts, and to ask new questions of paintings that still hold a contemporary audience in thrall.

It has been a pleasure to share the excitement of these demands with colleagues on both sides of the Atlantic, who have brought their own dedication and contribution to the project, making it a truly international collaboration. A long-held ambition, the project has received crucial impetus and unquantifiable support (and memorable espresso) from the Francis Bacon Estate, guided by Brian Clarke and supported by Elizabeth Beatty and Christophe Dejean. Their dedication, knowledge and help have lent energy and insight at many turns. Gérard Faggionato, who represents that Estate in London, has helped at critical moments, with support from Anna Pryer at Faggionato Fine Art. We are also most grateful to the rich fount of Bacon scholarship marshalled by Martin Harrison (while masterminding the catalogue raisonné) assisted by Rebecca Daniel, as well as the encouragement offered by his colleagues on the Bacon Authentication Committee: Richard Calvocoressi, Hugh Davies, Sarah Whitfield and Norma Johnson. The Bacon Estate has also lent generously, not least a substantial number of archive items, and we are grateful for the loan and the work involved. We should also single out Barbara Dawson, Director of Dublin City Gallery The Hugh Lane, and her staff for the important loan of archival material originally donated by John Edwards.

However substantial the enthusiasm, an exhibition cannot come together without the willingness of collectors, both private individuals and public institutions, to make their works available for sustained periods. The deep conviction of Bacon collectors has been repeatedly demonstrated in the generous offer of support on the announcement of the project and the request for loans, ensuring that almost every painting from our ideal list is present in the exhibition. We are enormously grateful to all of those private collectors who have so willingly endorsed our adventure in bringing these paintings to a new audience: The Estate of Francis Bacon, London (courtesy Faggionato Fine Art, London and Tony Shafrazi Gallery, New York); Peter and Nejma Beard, New York; Steven and Alexandra Cohen; Hess Art Collection, Berne; Samuel and Ronnie Heyman; Mr and Mrs J. Tomilson Hill; the Michael Hoppen Gallery, London; Murderme, London; Denise and Andrew Saul; and other private collectors who have preferred to remain anonymous.

We would also like to acknowledge the generosity of the following colleagues and public institutions that have relinquished crucial paintings: Jennifer Melville, Curator, and Christine Rew at Aberdeen Art Gallery and Museum Collections; Dr Jim McGreevy, Director, and Anne Stewart, Curator, at Ulster Museum, Belfast; Dr Peter-Klaus Schuster, Director, Neue Nationalgalerie, Staatliche Museen zu Berlin; Rita McLean, Director, Birmingham Museum and Art Gallery; Louis Grachos, Director, and Douglas Dreishpoon, Chief Curator, at Albright-Knox Art Gallery, Buffalo; Susan Lubowsky Talbott, Director, Des Moines Art Center; Graham W. J. Beal, Director, Detroit Institute of Arts; Barbara Dawson, Director, Jessica O'Donnell and Patrick Casey at Dublin City Gallery The Hugh Lane; Dr Julian Heynan, Director, Dr Anette Kruszynski and Dr Maria Müller, Curators, at Kunstsammlung Nordrhein-Westfalen, Düsseldorf; Richard Calvocoressi, former Director, his successor Simon Groom, and Patrick Elliott, Curator, Scottish National Gallery of Modern Art, Edinburgh; Max Hollein, Director, Städelsches Kunstinstitut, Frankfurt am Main; Wim van Krimpen, Director, and Frans Peterse at the Gemeentemuseum, The Hague; Prof. Dr Hubertus Gaßner, Director, Hamburger Kunsthalle; Robert Hall, Director, Huddersfield Art Gallery; Caroline Douglas, Head of the Arts Council Collection, London, and Jill Constantine, Senior Curator; Guillermo Solana, Chief Curator, at Museo Thyssen-Bornemisza, Madrid; Frances Lindsay, Acting Director, National Gallery of Victoria, Melbourne; Dr Reinhold Baumstark, Director, Sammlung Moderne Kunst, Bayerische Staatsgemäldesammlungen, and Dr Carla Schulz-Hoffmann, Director, Staatsgalerie Moderne Kunst, Munich; Thomas Krens, Director, Marc Steglitz, Interim Director, and Susan Davidson, Senior Curator, Solomon R. Guggenheim Museum, New York; Glenn D. Lowry, Director, The Museum of Modern Art, New York, and John Elderfield, The Marie-Josée and Henry Kravis Chief Curator (retired), Department of Painting and Sculpture; Nichola Johnson, Director, the Sainsbury Centre for Visual Arts, University of East Anglia, Norwich; Gunnar Kvaran, Director, Grete Årbu, Curator, and Bjørn Ronneberg at The Astrup Fearnley Collection, Oslo; Alfred Pacquement, Director of Centre Pompidou, Paris, and his colleagues; Ernst Beyeler and Sam Keller at Fondation Beyeler, Riehen/Basel; Sean Rainbird, Director, Staatsgalerie, Stuttgart; Riitta Valorinta, Director, and Päivi Loimaala, Curator, at Sara Hildén Art Museum, Tampere; Prof. Edelbert Köb, Director, and Dr Wolfgang Drechsler, Head of Collections, at Museum Moderner Kunst Stiftung Ludwig, Vienna; Beverley Lang Pierce, Director, and Kerry Brougher, Deputy Director and Chief Curator, at Hirshhorn Museum and Sculpture Garden, Smithsonian Institution, Washington, D.C.; Dr Dorothy Kosinski, Director and Eliza Rathbone, Chief Curator, at The Phillips Collection, Washington, D.C.; Dr Christoph Becker, Director, Kunsthaus, Zürich.

A project on this scale and so long in germination necessarily benefits from advice, both specific and general, from many quarters and at many times. We are most grateful for a variety of contacts, suggestions and observations offered by the following: Dawn Ades, Bill Acquavella, Kate Austen (Marlborough Fine Art), Oliver Barker (Sotheby's), Ivor Braka, Dr Paul Brass, Richard Calvocoressi, Margarita Cappock, Melanie Clore, Hugh Davies,

John Erle Drax (Marlborough Fine Art), John Eastman, Gérard Faggionato, Martin Hammer, Martin and Amanda Harrison, Sandy Heller, Sam and Maia Hunter, Gilbert Lloyd, Massimo Martino, David Alan Mellor, Jean-Yves Mock, Richard Nagy, Simon Ofield, Pilar Ordovás (Christie's), Michael Peppiatt, Adam Prideaux, Piers Secunda, Victoria Walsh, Sarah Whitfield, Aroldo Zevi.

Holding the outstanding concentration of Bacon's paintings, Tate's collection has been a constant measure and, fittingly, a rich source of works for the exhibition. Nicholas Serota and Stephen Deuchar, Director of Tate Britain, have consistently made crucial contributions throughout the project. Those within the Tate project team have been remarkable in their calm, good humour and efficiency: Rachel Tant (until adding to her family) and Bettina Kaufmann, who has picked up the thread seamlessly, ably supported by Sandra Adler and Greg Vamvakas, together with Sionaigh Durrant, Exhibition Registrar, and Cathy Putz, Exhibition Co-Ordinator. Early contributions were made by Gair Boase and Sophie Shaw. The transformation of ideals into reality has been further aided by the exhibition designers: Andy Altmann and Geoff Williamson of Why Not Associates. At particular moments we have also been helped by colleagues including: Tara Feshitan, Ann Gallagher, Jacqueline Hill, Judith Nesbitt, John Nixon, Kate Parsons, Sarah Robinson, Vicente Todolí and Rebecca Williams. Colleagues in our Tate Learning who have developed parallel programmes of interpretation material, film and lecture programmes include Jennifer Batchelor, Jane Burton, Madeleine Keep, Doris Pearce, Minnie Scott and Victoria Walsh. We would also like to take this opportunity to thank all those across the institution whose support makes everything run smoothly in London. This includes, in particular, those in Archive and Library, Art Handling, Communications, Conservation, Tate Britain and Modern Curatorial departments, Development, Front of House, Legal, Press Office, Special Events and Registrars. Tate is an extraordinary place because of those colleagues too numerous to name.

The opportunity to show Bacon in Madrid came through the vision of Miguel Zugaza, Director at the Museo del Prado, and has been made possible through the hard work of Manuela Mena Marquéz and her colleagues.

The exhibition has been a collaborative adventure between Tate and The Metropolitan Museum of Art, New York, where it culminates. Director Philippe de Montebello has been continually supportive of the project, and was pleased to contribute the loan of two important works from the Museum's collection to the show. The team in New York has been made up of Anne Strauss, Associate Curator; Ian Alteveer, Research Associate; and Nykia Omphroy, Associate for Administration, all from the Department of Nineteenth-Century, Modern, and Contemporary Art. We would also like to thank all those within the institution whose work has made the exhibition possible, particularly Mahrukh Tarapor, Associate Director for Exhibitions; Linda Sylling, Manager for Special Exhibitions; Martha Deese, Senior Assistant for Exhibitions and International Affairs; Herb Moskowitz, Chief Registrar; Kirstie Howard, Assistant Counsel; Nina Mc.N. Diefenbach, Vice President for Development

and Membership; Emily Rafferty, President of The Metropolitan Museum of Art, and Andrea Kann, Deputy Chief Development Officer. We owe additional thanks to David Nash, whose expertise was greatly valued.

* * *

The legacy of the exhibition will be this accompanying volume. We are thrilled that the pieces written for the catalogue all represent new opinions and research, and acknowledge the efforts and dedication of the authors. At different times we have debated issues, broad or esoteric, with each of them and never found them wanting in imagination. Martin Harrison, the author of the forthcoming catalogue raisonné, has brought a forensic eye to the relationship that the painter maintained with his source material and his understanding of the Old Master tradition in which he sought to place himself. Taking the pre-eminent new art form of the twentieth century – the cinema – David Alan Mellor explores Bacon's contrasting enthusiasm for the complexity of film and how this may impinge upon his vision of making art in our time. Other perspectives are provided by the socio-artistic context of the period in which Bacon first came to prominence in London. As homosexuality remained illegal in Britain until 1967 , his growing public acclaim was achieved alongside a personal life that was continually in jeopardy from the law. Simon Ofield looks at the tensions and the consequences of the illegal imagery of desire. Although never formally a teacher, Bacon also occupied a position of increasing authority in the London art world that Victoria Walsh explores in her essay.

For these insights and contributions we would like to thank all of the authors, as well as Rachel Tant, who has written for the catalogue section; and those who gathered key information: Bettina Kaufmann, Sandra Adler, Greg Vamvakas and Sophie Shaw. The catalogue has been marshalled with characteristic good humour by Mary Richards as Project Editor, with support from Sarah Tucker, Production Manager. We would particularly like to thank Peter Willberg and his team for their elegant design, as well as Mary Scott, Anna Ridley, Deborah Metherell and Beth Thomas; Celia Clear, Roger Thorp and James Attlee have all been very supportive.

Though they are too numerous to name, a project on this scale and across three countries cannot function without the wealth of support that many colleagues have given so freely. Nor would it be possible without the support of our families, who have tolerated its penetration into our home lives with good-humoured forbearance.

Matthew Gale
Chris Stephens
Gary Tinterow

ON THE MARGIN OF THE IMPOSSIBLE[1] *Matthew Gale and Chris Stephens*

The level of Francis Bacon's ambition set him apart. While some artists may have been content to be considered among the greatest in their country or of their time, he was said to gamble that his 'pictures were to deserve either the National Gallery or the dustbin, with nothing in between'.[2] As early as 1946, Kenneth Clark commented to Graham Sutherland: 'You and I may be in a minority of two, but we may still be right in thinking Francis Bacon has genius.'[3] Bacon himself looked to the truly great historical figures for comparators: Michelangelo, Rembrandt, Velázquez. When a young artist in St Ives announced that he was a sculptor, Bacon retorted: 'there are only three sculptors: Michelangelo, Rodin and Brancusi.'[4] These exacting standards and uncompromising ambitions underpin Bacon's status as the greatest figurative painter of his time. To achieve that position he took as his bases two fundamental states. First, as an atheist, he sought to express what it was to live in a world without God, a state of existence that was merely transitory, without reason or afterlife. Second, as a painter, he addressed the defining problem of how to express that state of existence once photography had taken over representation of the perceived world.

It is not unusual for artists' reputations to wane after their death, as late maturity can overshadow groundbreaking early work. Though he expected to be forgotten, the fascination Bacon holds for other artists and collectors, art historians, critics and their readers has continued unabated.[5] As John Russell recorded, Bacon's (apparently) sudden emergence on the London art scene in April 1945 almost immediately secured for him a reputation as Britain's most challenging painter.[6] Within four years, Wyndham Lewis extended this in recognising him as 'one of the most powerful artists in Europe today and … perfectly in tune with his time'.[7] Though his reputation was not unwavering, he remained a dominating figure through the 1960s and 1970s until, at the head of the 'School of London', he was associated with the perceived revival of painting in the 1980s.[8] Bacon has been described as the greatest British painter since J.M.W. Turner and, at the time of the Tate Gallery retrospective in 1985, Alan Bowness's assertion that he was 'surely the greatest living painter'

did not reflect simply the excitement of the moment.[9]

Despite the accolades accorded him, Bacon has not fitted comfortably into dominant histories of modern art. His distortion of the human figure, with its necessary fusion of a process of abstraction and dogged insistence on a degree of representation (what J.-F. Lyotard dubbed 'figural'),[10] was anathema to the narrative of a modernist progression described by critics like Clement Greenberg after the 1940s.[11] The Greenbergian teleology essentially extended Alfred H. Barr Jr.'s chart of 'The Development of Abstract Art' and, although The Museum of Modern Art was the first major public collection to acquire a Bacon,[12] the artist has remained difficult to set within a wider context.[13] In the 1950s in New York, before Abstract Expressionism came to overshadow most historical accounts, Bacon was repeatedly presented as part of a new figuration, mostly but not exclusively European.[14] In the last twenty years, retrospective studies of the post-war moment have gone further in identifying such parallels. With the immediate experience of war as part of the common ground, Bacon's work has been associated with sculpture – the work of Alberto Giacometti and Germaine Richier in France, for example, and Reg Butler, Lynn Chadwick and Eduardo Paolozzi in Britain – and such painters as Giacometti, Sutherland, Jean Fautrier and Jean Dubuffet.[15] His age and distortion of the human form have led to frequent associations with Henry Moore also. Such broader studies have recaptured something of the diversity of contemporary surveys like *Art Since 1945*,[16] but it is surprising, perhaps, that non-formalist accounts of Abstract Expressionism have not allowed a greater accommodation of such artists outside that, for some, hegemonic group.[17]

The corollary of Bacon's problematic relationship to larger historical structures has been a tendency to treat him as an individual genius. In this he follows a persistent trope in treatments of British art: William Blake, Stanley Spencer, Lucian Freud are all artists whose singularity but undeniable importance has necessitated them to be treated as special cases outside historical and stylistic patterns. In Bacon's case this is reinforced by the insistent reiteration of a bohemian

fig.1 Daniel Farson
Francis Bacon 1950s
Archive of Modern Conflict

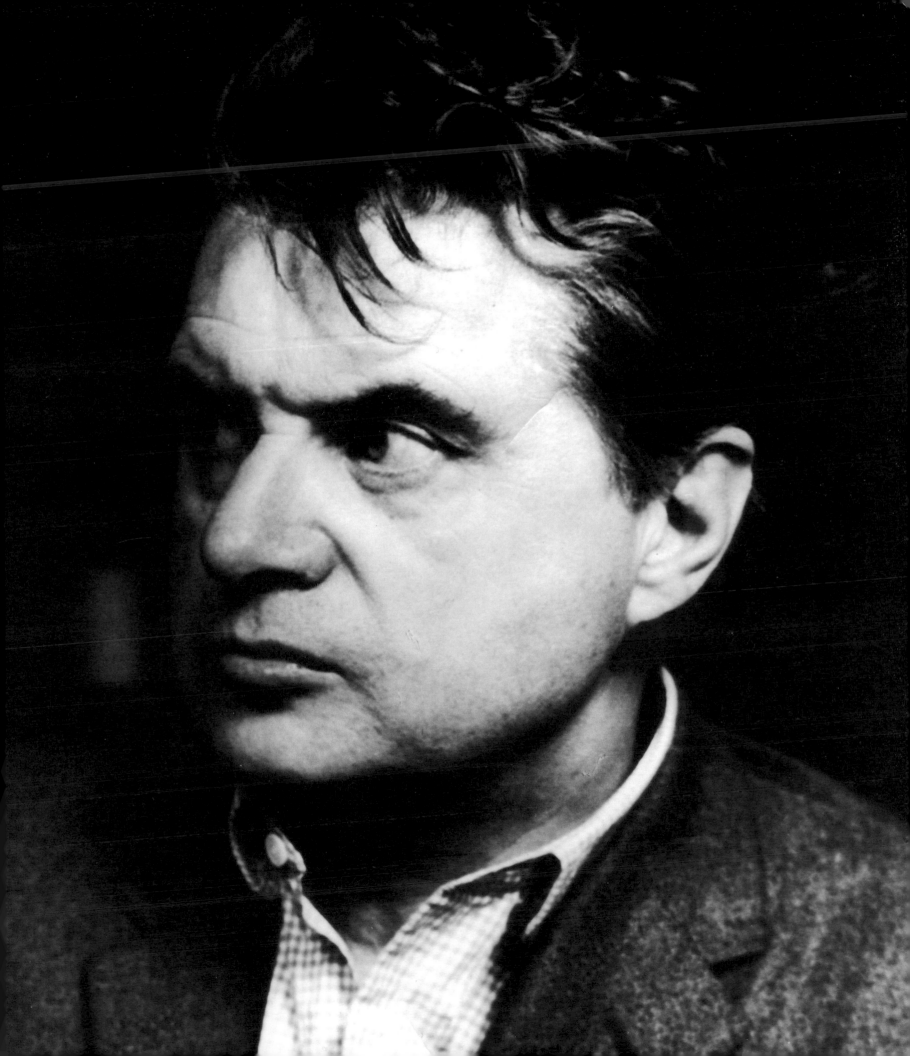

identity associated with London's Soho and closely bound up with his, initially illicit (because illegal), homosexuality. Daniel Farson's *The Gilded Gutter Life of Francis Bacon* (the first of three posthumous biographies) epitomised this by building on a well-established, romanticising literature of the social clique denoted by 'Soho' as a licentious and libidinous *demi-monde* gathered for illicit (hetero- and homo-) sexual encounters and the consumption of copious volumes of alcohol.[18] We know the names of its characters – Bacon, Freud, Dylan Thomas, Isabel Rawsthorne, the photographer John Deakin, the Bernard brothers (Bruce, Jeffrey and Oliver); and its primary settings – the Colony Room, the Gargoyle Club, the French House.

The dominance, and distortion, of this firm identification of Bacon with the urban and bohemian experience of London was established by the time of Sam Hunter's 1950 visit, (reported two years later, fig.2).[19] In fact, the artist kept separate the South Kensington of his studios from the Soho of his entertainments and, furthermore, spent much of the period abroad. Following the publication of *Horizon*'s 'News Out of France' issue in May 1945, he was among the first post-war

wave returning to the Continent.[20] While regularly visiting Paris, he made extended visits to Monte Carlo where the casino was a major source of funds. Bacon also travelled to see his family in southern Africa in 1950–1 (returning through Egypt), and again in 1953 and 1957.[21] He considered new surroundings where 'nobody … is at all interested in ART' (as he described Monaco) as 'a comfort'.[22] This became more evident when, following the death of his nanny Jessie Lightfoot in 1951, he relinquished his Cromwell Place studio and only established a permanent base in London on securing Reece Mews in autumn 1961. In the intervening decade he borrowed friends' studios (notably occupying a space in Battersea between 1955 and 1961) and, in the wake of his new lover Peter Lacy, spent time at Henley-on-Thames and nearby Hurst, and then in Tangier, where Lacy had settled himself in 1955 and would die in 1962.

Given Bacon's need to paint that degenerated into desperation at times, it is striking that the myth should grow that he could not work anywhere but London. This may reflect upon a judgement in hindsight, as his letters indicate that he painted prodigiously while away. In December 1946 he told Sutherland that Monte Carlo was 'very good for pictures falling ready made into the mind. I paint dozens every week there.'[23] During his stay in Rome and Ostia in 1954 he reassured his first dealer, Erica Brausen (who gave him advances against future sales), that he was producing a considerable body of works.[24] In Tangier four years later, despite the intervening lament that he had 'not been able to finish anything here',[25] he assured Brausen of his plan to complete 'at least 20' paintings, an ambition that, perhaps inevitably, reduced as the moment drew nearer.[26] The fact that, in October that year, he suddenly quit Brausen's gallery for Marlborough Fine Art, seemingly because the latter could afford to pay off his debts, may encourage one to read these claims with scepticism.[27] The credibility of his aim to produce twenty works is further undermined by his uncertain production in St Ives the following year: over four months he shipped five paintings to London and, when he left, had a further three heads (one unfinished), one unfinished nude, a pile of untouched canvases

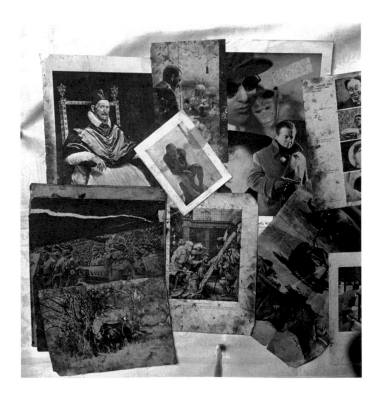

fig.2 Sam Hunter
Montage of material from Bacon's
Cromwell Place studio, c.1950
(previously unpublished)

and twelve stretchers from which the canvas had been cut.[28] That only six works survived from that trip – and their alteration after Cecil Beaton photographed them – suggests that a rigorous editing process was enacted in London.[29]

The paintings that Bacon made in these years and various locations caught his audience by the throat. They appeared to transcend the geographic specificity of the places in which they were conceived and, instead, to distil the violence and apprehension of the times. The ambiguous hybridity of the two paintings that he showed in April 1945, *Three Studies for Figures at the Base of a Crucifixion* (pp.146–7) and *Figure in a Landscape* (p.97), reflected his productive friendship with Sutherland. At the same time, they were part of a tight group of works that chimed with contemporary concerns with the 'hidden presence of animal trends in the unconscious'.[30]

Bacon's early reputation rests on these astonishing works, the small number of which reflects his ruthless culling of failures. This seems to have resulted from conflicting tendencies: an uncontrollable drive that could lead to overworking, and a

self-criticism that was severe and, perhaps, despairing. The oil paint overlaid with pastel that characterised these breakthrough works was overtaken by the extraordinary density of the 1949 Heads, through which he sought to secure (as he said of Matthew Smith) 'a complete interlocking of image and paint, so that the image is the paint and vice versa'.[31] He cited *Head II* 1949 (p.103), a canvas that groans under the weight of impasto, as a rare success in integrating image and surface, but this ambition risked a 'clogging' of the material and the consequent danger of applying 'illustrational paint'.[32] In common with Giacometti's portraits (fig.3), Fautrier's *Otages* (fig.69) and Dubuffet's *Corps de dame* series (fig.4), and as a manifestation of what David Sylvester called 'the end of the streamlined era', the medium became an equivalent to flesh.[33] In 'interlocking' the image and the *matière* of his paint in a mutual identification, Bacon's heads appear to suffocate in the unctuous surface, setting up a sense of existential isolation and abjection in their explicitly bestial transformation of the human figure.[34]

fig.3 Alberto Giacometti
Jean Genet 1954–5
Oil on canvas, 65.3 × 54.3
Tate. Accepted by H.M. Government
in lieu of tax and allocated to the
Tate Gallery 1987

fig.4 Jean Dubuffet
The Tree of Fluids / L'Arbre de fluids 1950
Oil on canvas, 116.1 × 89
Tate. Accepted by H.M. Government
in lieu of tax and allocated to the
Tate Gallery 1996

In their encounter with, and exposure of, reality, Bacon's paintings of the 1950s explored a more nuanced interaction between subject and ground. He drew back from the laden paintwork of the late 1940s without losing the intensity of the imagery. In 1952 he would call this a process of 'opening up areas of feeling rather than merely an illustration of an object'.[35] In *Head VI* (p.104) he maintained an identity of flesh and paint but more through suggestion than application. It is just this enfleshment that Bacon would achieve in the break-through to the facility of the *Man in Blue* series (pp.132–3), in which the veiled surface is hardly disturbed by the traces of features. The canvas was now only stained with dilutions of paint that closed out perspectives and established the limited chambers evocative of the intense theatre of the absurd. His achievement in this new phase was to work with suggestion in order to secure the impact that had previously been explicit.

At their most effective, the results were a combination of extreme concision and extreme impact. The face and hand of a businessman laid-down on a penumbral ground could suggest the pretensions and duplicities of an era struggling between the legacy of the dangerous life of wartime and the re-imposition of pre-war conventions. The wider realm of Cold War politics – that appeared to move towards melt-down in the coincidence of the 1956 Hungarian uprising and the Suez debacle – could also be implied in Bacon's exposure of superficial certainties and, oddly but effectively, in his notori-ous reworking of Velázquez's image of power and corruption: *Portrait of Pope Innocent X* c.1650.

Rather like the spaces of his paintings, the spaces of Bacon's studios have attracted a mystique as observers have sought in their chaos explanations, both in detail and in broad concep-tion, for the works that emerged from them. The veil of myth

fig.5 Douglas Glass
Francis Bacon in his studio,
Battersea 1957

fig.6 M. Hardy for the *Daily Telegraph*
Francis Bacon's Reece Mews living room
(date unknown)
Tate Gallery Archives

has become attached to the discarded photographs, loose leaves and books, boxes and scraps of clothing. This composting of detritus, which echoed that of Walter Sickert's studio, fascinated contemporaries and was regularly recorded, not least by the photographs of Douglas Glass and Beaton in his 1950s Battersea studio (fig.5). In the autumn of 1961, Bacon moved into a modest three-room space at 7 Reece Mews, close to the Victoria and Albert Museum, the Natural History Museum and the Royal College of Art.[36] Though he acquired other properties in London, in the countryside and in Paris, he remained at Reece Mews for the rest of his life. While the living room was austere (fig.6) and the sink jostled for space with the bathtub in the kitchen, the painting studio became the epitome of his creative chaos. Its final enshrinement was secured when Bacon's heir, John Edwards, donated it to the Hugh Lane Gallery in Dublin, instigating an archaeological reassembling.[37]

Inevitably, the investigation of unknown paintings and so-called 'working documents' excavated in the studio has dominated research on Bacon since 1992. The unfinished, abandoned or forgotten canvases covered a considerable range: from an exhibited work of 1950 that was thought to have been destroyed (and which Sylvester had imagined, from a black-and-white photograph, to be 'his finest "Pope" ever', p.112),[38] to the barest beginnings of a new painting left on the easel. A significant number seemed, however, to have been abandoned and are all the more fascinating for revealing false starts, as Bacon moved beyond his habitual single-figure subjects, exploring groups as well as entirely unpopulated compositions, the results of which proved intractable or irresolvable.

In addition to that major cache of archival material removed from Reece Mews, a number of smaller collections of Bacon's supporting material have come to light since he died.[39] This stock of (largely) photographic imagery was a kind of visual dictionary and it is evident that he marked-out particular figures to help to isolate the frozen action. Margarita Cappock's investigation of the studio contents has offered an empirical survey of the range of material and uses to which it

was put.[40] Martin Harrison has examined it more thoroughly within a chronological account of Bacon's life and work, tracing the original sources and exposing possible relations to the paintings. A key revelation has been his proposal that the folding, crumpling and juxtaposing reflected deliberate strategies through which Bacon envisaged distortions in the final painting.[41]

Bacon turned to photographs as a visual source from the earliest moments, reputedly using an x-ray of the skull of the collector Michael Sadler for *The Crucifixion* 1933 (fig.74), and a 'snapshot' of Eric Hall for *Figure in a Landscape* 1945 (p.97).[42] Harrison's research, in particular, is progressing knowledge of what were the subsequent sources on which Bacon was drawing. The most important, however, has been known for many years: Eadweard Muybridge's sequential photographs that Bacon called 'a record of human motion – a dictionary, in a sense' (fig.7).[43] The derivation of numerous details from particular Muybridge frames is well documented: the wrestlers whose entwined bodies appear to embrace, the turning woman, the low-slung mastiff dog, the paralytic child and so on. Although these have justifiably been described as

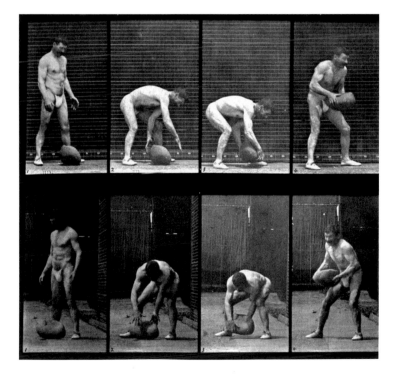

fig.7 Eadweard Muybridge
Plate 317, *Athlete Heaving 75-Pound Rock* (detail), from *The Human Figure in Motion* (1887, 1901 ed.)
Collections of the University of Pennsylvania Archives

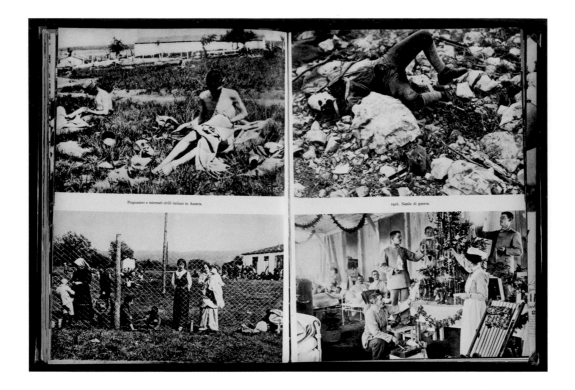

Bacon's 'life class',[44] the painter's use of the groundbreaking photographs was more complex. He himself described their blending with Michelangelo, Muybridge's positions gaining 'ampleness' and 'grandeur of form' from their association with his figures: 'it would be very difficult for me to disentangle the influence of Muybridge and the influence of Michelangelo.'[45] In Bacon's mind Muybridge was projected on to a history of representation of the human figure – particularly the male nude in sculpture – from Ancient Egypt through to Auguste Rodin. Highlighting the snatched view and partial body, Bacon also wondered whether the Elgin Marbles would have been as important to him if they had not been fragmentary.[46]

Although hardly unique, Bacon's use of photographs is central to his achievement.[47] In appropriating, transforming and translating Muybridge's figures to canvas, he carried over and enhanced the innate poignancy derived from the body isolated in motion. The fleeting moment that is captured by the camera is (in Barthesian terms) laden with pathos as, in freezing the transient, it reveals a sense of mortality.[48] This seems especially marked in Muybridge's work, where the figures are literally laid bare and lifted outside time. The lack of context and of a rational explanation for their actions focuses the viewer on their physical nature and, by implication, on their inevitable transience, degeneration and death. With typical sangfroid Bacon admired Jean Cocteau's dictum, 'Each day in the mirror I watch death at work',[49] and the attention to fragile physicality is echoed in many of the painter's compositions.[50]

Interleaving, conceptually at least, with the photographs of the body's vulnerability are the masses of images emphasising political violence, its perpetrators and victims: Nazi leaders, massacres in revolutionary Russia and the wars of independence and decolonisation. Sitting somewhere between these two categories are sites of social violence, epitomised by the crime scenes of Weegee's *Naked City*,[51] that can also be associated with an ambition to capture 'The History of Europe in My Lifetime' that Russell believed 'presides over everything that Bacon has done: portraits, figure subjects, landscapes

fig.8 Double-page-spread from Leo Longanesi, *Il Mondo Cambia. Storia di cinquant'anni / The world is changing. History of Fifty Years* 1900–1950 (1949)

even'.[52] The painter later claimed that he had been pushed into coining the phrase,[53] but his correspondence with Sonia Orwell reveals that this grand subject matter was indeed part of his thinking. A letter from the end of 1954 reveals that Bacon had been in discussions over a publication reflecting his views on art, but had made a counter-proposal 'of very personal history of what has happened since I can remember anything'. He elaborated:

> If I did the history I would like to do it with photographs and paintings, that is the only possibility I think, as it would be intimately bound up with the painting. – There is a wonderful book of photographs of the last 50 years called *Il Mondo Cambia* compiled and a for[e]word by Longanesi it is published by Rizzoli in Milan [fig.8] – They are nearly all photographs which I have already got through collecting them over years, but I think a sort of life story which sees underneath the events of the last 40 years, so that you would not know whether it was imagination or fact, is what I could do, as the photographs themselves of events could be distorted into a personal private meaning or, in part, it could be a book about the history of the last 40 years.[54]

For all its circumlocution, this is an important statement of Bacon's thinking at a seminal moment and on a project wider than painting, though 'paintings' – his own and, perhaps, those of others – play a part in his proposal. It is particularly notable how he connects the idea of a personal vision of history to the role of photography, as a means for enlarging upon that experience of reality; as if, by viewing photographs, one inevitably reviewed reality more intensely. He noted that through the interlocking of the imagined and the recorded 'we could make something nearer to facts – truer – and more exciting, as though one was seeing the story of one's time for the first time'.[55] In imagining this filtering through photography, Bacon was also implicitly describing the process that he hoped to achieve through making paintings derived from these images.

Despite the thousands of items in Bacon's studio at his death, it is striking how much was already familiar since his work has regularly been discussed in light of his sources. In his important 1949 essay on Bacon, Robert Melville cited the Odessa Steps sequence of Sergei Eisenstein's *Battleship Potemkin* (and specifically, the still of the blinded nurse), and Salvador Dalí's and Luis Buñuel's *Un Chien andalou* (fig.9).[56] Three years later Hunter published two selections of photographic material from 7 Cromwell Place (figs.2, 88–9) that relate to paintings made across the previous decade.[57] Sylvester also listed the material in several texts, culminating in his introduction to Bacon's first show in Paris in 1957:

> Topical photographs in newspapers and newsmagazines; the Velasquez portrait of Innocent X; the still of the screaming nurse from *Potemkin*; covers of *Time*; Rembrandt's self-portraits; the life-mask of Blake; Muybridge's *Human Locomotion* and *Animal Locomotion*; coloured picture-postcards of Monte Carlo; etc., etc.[58]

So strong had this referential thread become that Russell asserted the primacy of painting over photography as a means of visual expression. Citing, for example, how Bacon's space frames anticipated the glass cage in which the Nazi Adolf Eichmann sat for his trial in Jerusalem in 1961 (fig.132), he added that the paintings in the Tate exhibition the following year, worked

fig.9 Luis Buñuel and Salvador Dalí
Film still from *Un Chien andalou* (1929)
Courtesy of Contemporary Films

on a completely different wavelength from that on which they operated when first shown. People who in 1952 or 1957 had picked away at source-material, identifying a Victorian photograph here, a news-clipping there, an echo of Picasso or Grünewald somewhere else, were confronted with something that spoke above all for the continuing validity of the painted image: or, to put it another way, for the capacity of paint to go on ahead of the conscious mind.[59]

Thus, by the time of the 1962 retrospective – a watershed in his career – the visual sources were established as a key point of reference, which Bacon, through the interviews with Sylvester (that started shortly after), was complicit in reinforcing.

Interviews were the primary means through which Bacon managed the ways in which he and his work were communicated. In an era when interviewing gained the currency of authenticity, he was not the first to combine obfuscation with apparent candour and revelation in order to set the terms in which his art was interpreted.[60] He was, however, surely one of the most successful. Few have strayed far from the basic co-ordinates that he determined in conversation with Sylvester: his Nietzschean, atheistic view of life and the inevitability of death; his debt to particular works of art (by Cimabue, Velázquez, Rembrandt, Nicolas Poussin, Vincent van Gogh, Picasso) and disdain for abstraction; his fascination with film and photography; his profound debt to literature and, specifically, to Aeschylus and T.S. Eliot; his belief in chance. Like Eliot's notes to *The Waste Land* (1922), these explanations can be as multivalent as the works themselves, and Bacon's accounts have proved partial or misleading. Thus, his insistence that he never drew, as his compositions were intuitive, was undermined by the posthumous revelation of figure studies from the 1950s.[61] Similarly, despite denying any narrative aspects to his work, he could list privately for Michel Leiris precisely the books that were informing a 1976 triptych.[62] As well as countenancing such partiality, the Sylvester interviews have reinforced a tendency to ignore the historical dimension of Bacon's work in favour of continuity. Although the book collected interviews that spanned nearly twenty-five years, the statements inevitably read as the views of one man at a single moment, often obscuring the knowledge acquired over a third of a lifetime. Slippage between discussions of single works and broader conversations about personal philosophies serve to divorce these statements from the historical specificity of the works' forms, let alone the physical and intellectual processes that originally shaped them.

While there does appear to be a remarkable consistency in the philosophical underpinning of Bacon's art addressed through the motif of the human figure, this was made manifest in quite different ways as the paintings developed over time. In structure, the paintings that he made after the 1962 retrospective can be broken down into some basic elements through which it is possible to trace their individual developments and the means by which they were made. A habitual structure was established in the early 1960s, which rarely changed thereafter, as Bacon limited his supports to a portrait-head format and the grand canvas, either of which could stand alone or become part of a triptych. The elements from which the large paintings were constructed – the figure, the zone of its setting, and the plane – were also broadly established. This was the arena in which the painter acted, in which variety, invention and chance were under his command.[63] Having established this basis he could construct images without having to reinvent his process.

By and large, Bacon started a painting by committing a figure to the naked canvas. In 1962 he claimed that their genesis came through visualisation while daydreaming: 'I see rooms full of paintings.'[64] The works on paper and lists of images that have emerged since his death appear to be notations of those ideas with the studio detritus as points of reference. One such example is his own *Study for Crouching Nude* 1952 (p.118), the composition of which Bacon thought to reuse in January 1959, suggesting that his own coalescence of the image liberated him from returning to the original source.[65] Rare indications suggest that a mapping-out practice followed that was fairly orthodox: the general pose and position fixed in dry, black oil paint applied almost like drawing. The figure would be painted first and then its surround-

ings brought-in around and up to it, with extensive additions and adjustments. The size of Bacon's figures rarely varied. If the portraits often seem pressed-up against the confines of the canvas,[66] the figure in the bigger compositions is habitually more withdrawn, inviting an engagement (which is also denied) with their fictive space. Despite his admiration for Edgar Degas, Bacon only rarely mimicked the snapshot imagery of bodies cut by the edge of the canvas; his figures do not pass through his compositions but rather act within the space that Deleuze has identified as a field or zone.[67]

The structures that accumulate around the figures are dependent upon them. This was already seen in the daises for Popes or space frames for businessmen in the 1950s, but was more marked with the sofas and rails of the following decade. This structural sense is one way in which Bacon's painting is not (just as he claimed) illustrational, as the acting out of the figure determines the setting created around it in tune with a broader phenomenological understanding of the body in space determined by its physical presence. The figures in the side panels of *Triptych – August 1972* (pp.208–9), for instance, appear to have been eaten away, but close inspection reveals that they were conceived as fragmentary from the outset. That such an erosion of the body was preconceived confirms that the execution was an enactment with little revision.[68] In this particular case the process is also bound up with a psychological understanding of the subject as the object of a memorialising image.[69] Such grand tragic statements as this posthumous portrait of George Dyer were marked by an unusual degree of simplification, but elsewhere the setting is elaborate and distinct. Thus the complexity within the side panels of *Triptych – Inspired by T.S. Eliot's Poem 'Sweeney Agonistes'* 1967 (pp.220–1) all but overwhelms the background and, in their tense interrelationship with the bloody central scene, invites that reading of the painting in narrative form in just the way that Bacon sought to avoid.

Between these two extremes of grand austerity and complex theatricality lie most of Bacon's paintings in which the structured setting and then the background accumulate around the figures. While this necessarily dictates that the

details were resolved in the void of the raw canvas, it also shows how the laying-in of the ground plane served as a uniting action. In the complex *Painting* 1978 (p.227) the extreme pose, teetering to one side, relies upon the complementary figure to the left to establish the compositional balance. However, the white also served to unify the whole by providing weight (in its thickness and opacity) to the area above which the main figure is poised; it serves as a physical and, in a barely perceptible way, visual support for this partial and active body.

That the sequence of figure, setting and background often left Bacon with problems is evident in the rare areas in which changes can be detected. The complexity of *Painting* 1978 demanded alterations, for instance, although much more radical were the few paintings, including *Reclining Woman* 1961 (Tate), for which Bacon salvaged a figure from an unsuccessful composition and pasted it on a new canvas.[70] More than a

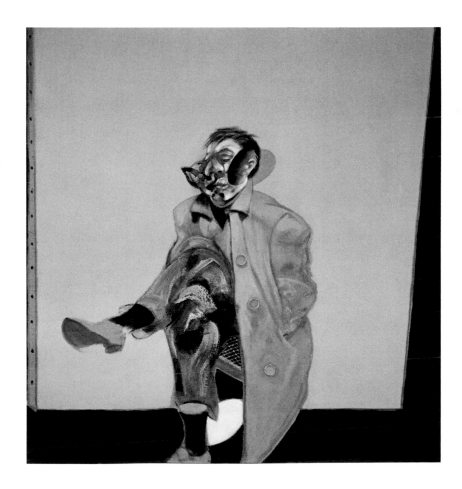

fig.10 *Self-Portrait* 1970
Oil on canvas, 152 × 147.5
Marlborough Fine Art, London

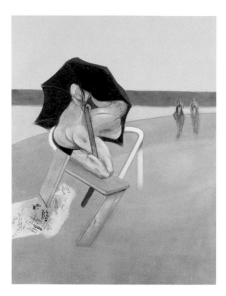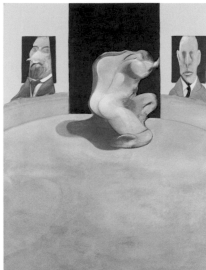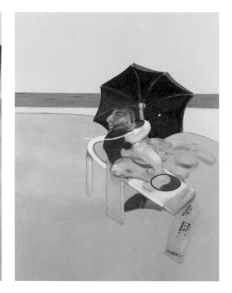

decade later the alteration of the *Triptych 1974–7* (figs.11, 12) shows how he made major revisions (painting out a foreground figure) even after the work left the studio. Indeed, he remained a habitual destroyer of canvases,[71] concerned, as he had remarked in 1962, that over-working was also a form of destruction, of clogging.[72]

At that earlier stage the clogging of paintings was the price to be paid – the failed bet, as it were – of Bacon's supposed harnessing of chance gestures. His discussion with Sylvester of this as part of his practice was extensive and repeated. It is as if, with spontaneity a key watchword in the post-Surrealist, *Tachiste* and Abstract Expressionist context, it was important for Bacon to *lay claim* to it. However, he makes clear that, for him, chance is not simply an artistic strategy but a fundamental part of an attitude to life. A common love of gambling was one of the things that he shared with Sylvester, and the embracing of chance injected a certain Mallarméan vitality into existence.

It is clear from close inspection that Bacon's chance actions were, paradoxically, very controlled. A splotch of white paint trailing out of the figure on the right-hand panel in *Triptych – August 1972* appears entirely unpremeditated. However, the

painter made plain to Davies that, while in theory anyone could do it, habit allowed him to place such actions precisely.[73] So the splotch of white serves certain composition purposes. Like a *Tachiste* mark, it asserts the picture surface against the spatial illusion while, as signifier, its ejaculatory action alludes to the sexual coupling in the central canvas. It is, as such, an acutely circumscribed spontaneous action and, whatever the chaos of the studio may have suggested, this is part of a much more controlled pictorial activity than Bacon himself acknowledged. Perhaps the most telling evidence lies in the sequence of paintings of the bullfight, made at the end of the 1960s,

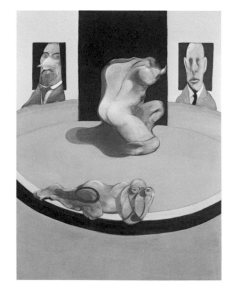

where the bull and the toreador are conjoined in a concentration of fatal energy. A fleck of foamy white – suggestive of the animal's spit or sweat – flying across the bull's neck was achieved by hurling paint at the canvas; being oil paint, it held its form to embody the energy of the gesture. This was enacted for each version, and this serial repetition of spontaneity suggests a different understanding of Bacon's use of chance (figs.13, 14). Here chance is a tool, like the sportsman's muscle memory evoked by Sylvester,[74] and not a release from conscious control.

In the formulation of these studio practices Bacon was driven by the belief that painting had to address, and draw strength from, the crisis precipitated by the advent of photography. He talked repeatedly of 'the complicated situation in which painting is now', tacitly acknowledging that this had contributed to the development of non-representational art.[75] Bacon, however, rejected abstraction as banal in its decorativeness and because 'the obsession with something in life … gives a much greater tension'.[76] Taking Velázquez as a yardstick, he set out an ambition to achieve an image that communicated the effect and apprehension of the subject more deeply than visual reality. 'One wants to do this thing of just walking along the edge of the precipice,' he said in 1962, noting Velázquez's ability 'to keep it so near to what we call

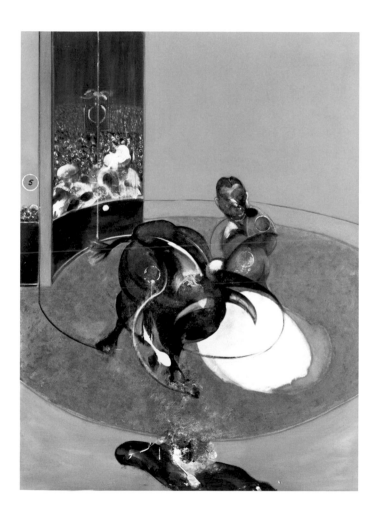

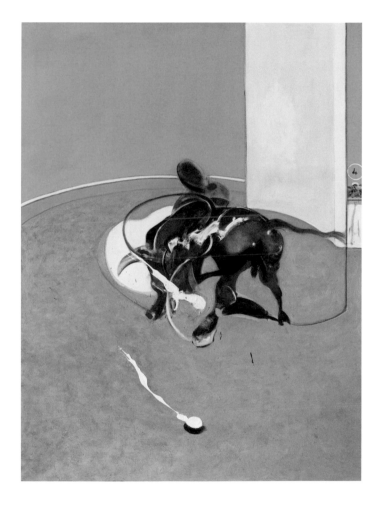

fig.13 *Study for Bullfight No.2* 1969
Oil on canvas, 198 × 147.5
Musée des Beaux-Arts, Lyon

fig.14 *Study for Bullfight No.2*
2nd Version 1969
Oil on canvas, 198 × 147.5
Viktor and Marianne Langen Collection

illustration and at the same time so deeply unlock the greatest and deepest things that man can feel'.[77] Four years later he used the same language of release: 'one wants a thing to be as factual as possible and at the same time as deeply suggestive or deeply unlocking of areas of sensation other than simple illustration of the object that you set out to do. Isn't that what it's all about?'[78]

Bacon recognised that, in a way that remains inexplicable, the inherent qualities of oil paint could aid this communication through sensation rather than through narrative. He famously claimed that 'Some paint comes across directly onto the nervous system, other paint tells you the story in a long diatribe through the brain'.[79] In this he invoked the painterly tradition of late Titian, Velázquez and Rembrandt, which he had described as the bringing together of 'paint and image'.[80] In this concept the medium was not employed to describe but was ineluctably interlocked with the subject. It was, he told Sylvester nine years later, 'a tightrope walk between what is called figurative painting and abstraction … an attempt to bring the figurative thing up onto the nervous system more violently and more poignantly'.[81] This was a concept to which he often returned as, for Bacon, the 'nervous system' took the place of the unconscious of much contemporary discourse and referred to an instinctive, atavistic reaction. As well as the interlocking of image and paint, 'the only way' one can bring 'the sensation and the feeling of life over [is] at the most acute point one can'.[82]

It is in this sense that Bacon's approach to painting may be illuminated more by poetry than among the works of fellow painters. Bacon's appreciation of poetry is well documented and he acknowledged mining images from Aeschylus, W.B. Yeats, Federico García Lorca, Ezra Pound, William Shakespeare and, especially, Eliot. From Aeschylus Bacon is reputed to have regularly quoted an image from the *Oresteia* ripe with possibilities: 'the reek of human blood smiles out at me.' This was one of the few translations in W.B. Stanford's study of the ancient playwright that had inspired the painter since first encountering it in the 1940s.[83] Bacon also overtly associated specific paintings with Eliot,[84] and admired the

poet's recasting of sanguine Greek tragedy for the repressed settings and mores of modern Britain.[85] Furthermore, the painter seems to have been particularly drawn to Eliot's concerns with mortality, the pathetic futility and solitude of life, and the locating of those existential conditions within a specific set of modern circumstances.

Poetry offered a conceptual model, as poets tread exactly that tightrope between abstraction and representation that Bacon described. The condensation of language in *The Waste Land* epitomises poetry's ability to be affective, to bring the 'thing up onto the nervous system', as Eliot stimulates responses in the reader that precede conscious and coherent understanding. In this sense it captured what Bacon described in 1982–4 as 'the intensity of … sophisticated simplicity', adding: 'You have to abbreviate into intensity.'[86]

The irony of the almost paternal position that Eliot came to take in relation to Bacon is that the poet's Christianity is directly opposed to the dogged atheism that underpins the painter's philosophical position and his work. Bacon summarised the essence of his position in his first interview with Sylvester: 'I think that man now realizes that he is an accident, that he is a completely futile being, that he has to play out the game without reason'.[87] Bacon was no nihilist however. His conclusion was that there is no life other than the present and that one had to make sense of it whilst here. 'You can be optimistic and totally without hope,' he claimed, adding later: 'I think of life as meaningless; but we give it meaning during our existence.'[88]

Painting was one way in which Bacon strove to give life that meaning. In the 1950s he wrote:

I would like my pictures to look as if a human being had passed between them, like a snail, leaving a trail of the human presence and memory trace of past events, as the snail leaves its slime.[89]

It is most common for this abject imagery to be understood in relation to Bacon's subjects, that he was seeking to make a representation of a human as a record of their being in the world. However, it can be argued that the process of producing

objects, which would themselves eventually serve as a record of Bacon's own passing through this world, is equally akin to the snail's slimy trail.

Tested by Sylvester, Bacon insisted that his optimistic nature was not incompatible with a constant awareness of death. In a world without God, humans are no different to any other animal, subject to the same innate urges; transient and alone, they are victims and perpetrators of meaningless acts. This is the theoretical context for his creation in the 1940s of animalistic humanoid figures and his superimposition of animal features on to the human form. In this way, too, Bacon's collecting of photographs of wild animals fits alongside his obsession with images of violence and of hieratic figures. These images and his painted appropriations of them – dogs, apes or even an elephant crossing a river – generally show the beasts as solitary, abject and pathetic. The belief in an inherent vulnerability and potential for cruelty in all living creatures was projected on to Bacon's sexuality. The erotic attraction for him of physical pain is well documented and it would seem it extended beyond the violent sex of the bedroom to violence plain and simple. One may speculate on the relationship between this and his insistence on his homosexuality as 'an affliction'. Deleuze wrote of masochism in terms of the animal in man:

> Masochistic characters do not imitate the animals; they enter zones of indetermination or proximity in which woman and animal, animal and man, have become indiscernible.[90]

It is just that zone of indiscernibility that Deleuze himself identified in Bacon's paintings.

Man or animal, devoid of a spiritual dimension, all that exists is the physical body and all that will remain after are the 'memory traces'. Even Bacon's insistence that he had scooped dust from the studio floor to use in *Figure in a Landscape* 1945 (p.97),[91] is heavy with the symbolism of death; as Eliot appropriated John Donne:

> And I will show you something different from either
> Your shadow at morning striding behind you
> Or your shadow at evening rising to meet you:
> I will show you fear in a handful of dust.[92]

There is a dramatic disjuncture between Bacon's deeper theme and his apparent subject matter. The simple descriptions of his titles can be extremely banal: a figure on a folding bed, a figure in an interior. Yet it is in the very banality that he explores the larger themes of the abiding presence of mortality, the ultimate hopelessness of life in a world without God and with no prescribed meaning, the passions shared by humankind with other animals, not least the ridiculous, violent excitement of the sexual drive. These are the great themes of an optimist without hope, simple and profound, testing the possibility of fixing experience. The present exhibition follows this legacy, exploring the belief that Bacon was not only one of the great painters of the human form but one of the great articulators of the human condition and, from the perspective of the new century, one of the greatest artists of the last.

BACON AND HIS CRITICS *Gary Tinterow, assisted by Ian Alteveer*

'If I took any notice of what critics said I'd never work at all.'[1]

'Of course, it is true, there are very, very few people who could help me by their criticism.'[2]

FRANCIS BACON

John Russell, an active enthusiast of Francis Bacon's work from his first view in April 1945, accurately summed up the state of writing on Bacon forty years later: 'It may strike us that whereas in England Francis Bacon's work has prompted some of the best art writing of the last 30 and more years, it has never had a comparable impact among Americans.'[3] Perhaps unknowingly, he hinted at the underlying reason for this disparity:

> In April 1945 the war in Europe was about to end. No one knew what peace would be like, but there was a general reluctance in England to believe that there was in human nature an element that was irreducibly evil … Bacon's 'Three Studies' put forward a less comfortable point of view. They suggested that people would always go on doing dreadful things to one another, and that other people would always come by to gloat … As a view of humankind, this was thought to be as pessimistic as it was untimely.[4]

Bacon always insisted on his 'exhilarated despair':[5] mankind was 'nothing but meat'.[6] For Bacon, life was essentially meaningless: 'We are born and we die and that's it. There is nothing else.'[7] (Although he often professed his love of life, saying that since we fabricate meaning out of daily existence therefore he was not a pessimist, rather he was 'an optimist … [but] an optimist about nothing!')[8] As Adam Gopnik observed on the occasion of the 1989–90 retrospective at the Hirshhorn Museum and Sculpture Garden, Washington, D.C. (fig.21), Bacon had 'maintained an obstinate allegiance to the body and the primacy of its appetite'.[9] 'What he most strongly denied,' wrote David Plante,

> was that his paintings portrayed the horrors of the post-war world. He denied, that is, the validity of what most people went to his paintings to see, in the screaming popes, the violently mauled bodies, the figures isolated in vast spaces, images of the age in which they lived. To portray the horror of the world was to him to be illustrational, and he insisted his work was not illustrational.[10]

Bacon wanted to address the viewer's nervous system directly, 'to unlock the valves of feeling'[11] through the use of distorted forms derived from chance and accident. Yet despite Bacon's assertions to the contrary, his work *was* premonitory: his paintings anticipated the photographs of walking skeletons at Auschwitz; Adolf Eichmann's glass witness-booth in Jerusalem (fig.132); the silent, futile scream of mankind stripped of its illusions, of mankind left alone with its delusions.[12] Reflecting or resembling distasteful aspects of modern life, Bacon's images did not conform to the boundless optimism of much post-war American painting.

For American critics, Bacon's art was too figurative, too narrative, too concerned with Christian imagery yet dangerously unpious in its view of religion. His art, like, say, Alberto Giacometti's, was profoundly European, reflecting an experience of the war and a philosophy that was unaccommodating to America's view of the world and its art. As Gopnik saw it, 'The pessimism of Bacon's vision leaves it disengaged from any modernist context of "progress" or advance'.[13] Because of this disengagement with progressive modernism, because of his rejection of abstraction ('I don't believe in abstract art because you must have a starting point in reality')[14] Bacon was sidelined in American art criticism for most of his career. And it is now finally becoming evident that this marginalisation should be partly attributed to Bacon's homosexuality. Although, since the 1960s, he has been one of the best-known British artists in America, sharing that distinction over time with Henry Moore, David Hockney and, later, Lucian Freud, Bacon's overt homosexuality was incompatible with the disguised Puritan and overtly macho ethos of many of his American contemporaries – artists, critics and writers – at least until the 1980s, when the advent of feminist art history, gender studies and queer theory created a newly receptive environment for art made by non-heterosexuals.

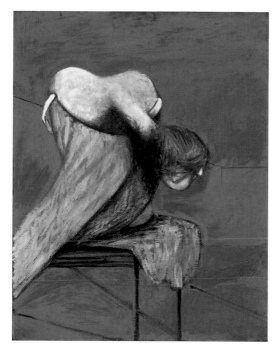 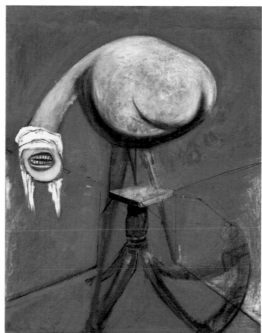 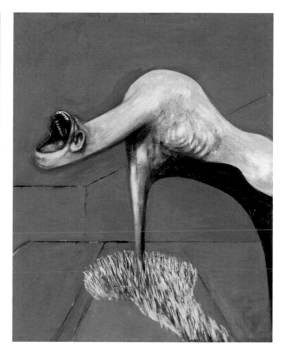

fig.15 *Three Studies for Figures
at the Base of a Crucifixion* c.1944
Oil on board, each 94 × 73.7
Tate. Presented by Eric Hall, 1953

Although Alfred Barr's purchase of *Painting* 1946 (p.101) for The Museum of Modern Art in 1948 was the first museum acquisition of Bacon's work, and the museum's curator James Thrall Soby reproduced a similar painting by Bacon, *Study for Man with Microphones* (also 1946, fig.126), at the end of his 1948 volume *Contemporary Painters*, there is nonetheless a striking absence of comments from important American critics during Bacon's early maturity. [15] For example, Thomas Hess, the eloquent advocate of Willem de Kooning and the post-war New York School, never wrote about Bacon. Clement Greenberg, perhaps the most influential American critic of the 1950s and 1960s, mentioned him in print only very late, and then only to repeat clichés, condescendingly lamenting his 'inspired safe taste', the 'precious curiosity of our period'; an English artist, typically concerned with the Sublime, whose talent did not match his ambition. [16] More revealing was Harold Rosenberg, the principal art critic at *The New Yorker* in the 1960s and 1970s, who finally wrote about Bacon in 1975. He recognised that Bacon's aim was '"to report" – to use a favourite phrase of Bacon's – on the post-war world in its physically menacing and psychologically deranging aspects'. For Rosenberg, the problem was one of language and style:

> An art of objective reality untainted by parody would seem attainable only in styles shared by society as a whole. The essential obstacle to an art of 'feeling in the grand sense' is the social and psychological fragmentation reflected in the advanced art of the past hundred years, and this obstacle cannot be overcome by an intellectual act of force … [Bacon's] reporting has not surpassed the insights of Abstract Expressionism, though it does point to a different issue on which art today can test its limitations. [17]

The key here is Rosenberg's acknowledgement of the threat that Bacon's art posed for the signal American post-war contribution to high art, Abstract Expressionism. It is a key that opens the door on to the defensiveness of most American critics prior to 1990, though, paradoxically, American collectors and museums contributed greatly to the widespread recognition of Bacon's art in the West.

The history of writing about Bacon falls neatly into periods. The early mentions and reviews were written almost exclusively by British writers for a British audience, during which period Russell and David Sylvester emerged as sympathetic proponents and interpreters of his work. The 1962 retrospective at the Tate Gallery provoked a more widespread response to his art; important appraisals by young American critics – notably Michael Fried – appeared in the early 1960s.

The 1971 exhibition at the Grand Palais, Paris (fig.19), canonised Bacon as a living master of modernism, an accolade made all the more meaningful because it was bestowed by the city where Pablo Picasso had made his reputation and where Surrealism emerged, the country whose artists always provoked feelings of inadequacy in Britain. This exhibition brought to the fore Michel Leiris's attempt to write Bacon into the history of European Surrealism and Existentialism, and the French press followed his lead. Sylvester had by this time established himself as the official *porte-parole* for the artist, an interpreter who has been cleverly characterised as a 'cat walking along the mantle aware of everything but never disturbing anything'. [18] The dramatic death by drug overdose of Bacon's former lover and muse, George Dyer, on the eve of the Grand Palais exhibition added an aura of authenticity to Bacon's repertoire of desperate themes. (As David Plante has written convincingly, Bacon actively sought tragedy, and considered that his own life had had tragic aspects.) [19] Following Dyer's death, Bacon's life, art, words (as reported by Sylvester) and public reputation began to synchronise closely.

By the time of Bacon's death in 1992 there was general agreement that the modernist experiment – at least the American notion of an optimistic and progressive modernism – had come to a close. Critics and art historians were newly open to art that deviated from the prescribed norm. As Linda Nochlin observed to Plante, younger, Postmodernist critics were 'drawn to the paintings not in spite of their being confessional but because they were confessional – because of what the work said about sex and history and beliefs from Bacon's particular point of view'. [20] Now Bacon could be re-examined by writers who felt free to explore his art and life posthu-

mously, without fear of censure. The success of the Young British Artists – many of whom, such as Cecily Brown (David Sylvester's daughter), Damien Hirst and Gary Hume, referenced Bacon in their own art – established Bacon as a formative figure. Today he is without doubt considered to be the best-known and most influential British artist to emerge after the Second World War.

Early Responses

It is remarkable how quickly British critics understood Bacon and got to the heart of his art: the brutality of the imagery, the ties to Chaïm Soutine, Picasso and Surrealism, the use of photography, and the chic design aesthetic. The first reproduction of a work by Bacon, *Crucifixion*, in Herbert Read's 1933 *Art Now* (fig.16), established the twenty-four-year-old artist as noteworthy. Only since his death has it been remembered, however, that this early stroke of luck was the result of a coterie of friends: Douglas Cooper, a rich, aspiring writer and dealer, two years younger than Bacon, provided the reproduction to Read and arranged to sell the work to the prominent collector Sir Michael Sadler through the Mayor Gallery in Cork Street, where Cooper worked.[21] On the basis of this quick celebrity, Bacon organised a show at a basement space called Transition Gallery in London the following year, but it backfired: a hostile review in *The Times* discouraged the artist: 'The difficulty with Mr Francis Bacon is to know how far his paintings and drawings … may be regarded as artistic expression and how far as the mere unloading on canvas and paper of what used to be called the subconscious mind.'[22] He drifted through the war years, exhibiting only a small number of works in the decade before 1945.

Bacon exhibited regularly in London from 1945 onwards, and although his subject matter continued to baffle and repel, critics increasingly complimented him on his technique and compositional skill while respecting the power of the imagery. David Sylvester's first published mention of Bacon, in a 1948 article in French in *L'Age nouveau*, was equivocal but on balance positive:

Bacon … is the inheritor of some aspects of expressionism – as in Soutine's *écorché* – and of Picasso's Surrealist period … It's a weakness – his vision possesses him, he does not possess it – but he is one of the most dramatic and most powerful of the current painters.[23]

'Mr Bacon is a very capable artist,' wrote the reviewer of the remarkable 1949 Hanover Gallery show, for *The Times*,

> there is some breadth in his drawing and his paint is laid on in a workmanlike way. But the subjects of his pictures are so extraordinary, and, indeed, so repellent, that it is impossible to consider anything else. His themes are as vivid and as meaningless as a nightmare and they leave the same long-continued feeling of disquiet as a thoroughly bad dream.[24]

For its assault on bourgeois sensibility, the 1949 show, which included *Head I* (fig.17, p.102) and *Head II* (p.103), among others, provoked particularly strong responses. Robert Melville, in a marvellously vibrant text, described his visceral response to Bacon's human figures: 'but how did this man come to get a skin of such a disquieting texture?' he writes. 'I cannot divorce the facture from what it forms.'[25] Wyndham Lewis described 'the shouting creatures in glass cases, those dissolving ganglia the size of a small fist in which one can always discern the shouting mouth, the wild distended eye'.[26] Looking back, Russell memorably described Bacon's figures as resembling 'the disintegration of the social figure which takes place when

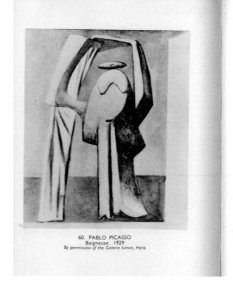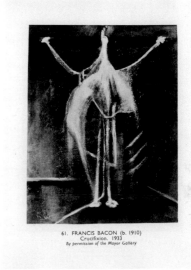

fig.16 Herbert Read, *Art Now: An Introduction to the Theory of Modern Painting and Sculpture* (1933), plates 60 and 61, Pablo Picasso, *Bather* 1929 and Francis Bacon, *Crucifixion* 1933

one is alone in a room which has no looking glass ... [where] we may well feel ... that the accepted hierarchy of our [facial] features are collapsing, and that we are by turns all teeth, all eye, all ear, all nose.'[27] Lawrence Gowing vividly recalled the rather different impact of the show on fellow painters: 'It was an outrage. A disloyalty to the existential principle, a mimic capitulation to tradition, like inverted intellectual snobbery, a surrender also to tonal painting, which earnestly progressive painters have never forgiven, it was everything unpardonable. The paradoxical appearance at once of pastiche and of iconoclasm was indeed one of Bacon's most original strokes.'[28] Gowing points to the recidivist aspect of Bacon's art, as it was perceived in the 1940s. Sylvester recalled something similar in his retrospective comments that accompany an anthology of his writings, but made an important distinction:

> In the search for figurative art that was new and grand it was imperative not to be confused by the retrogressive attempts which a host of painters and sculptors were making ... [and] insistently promoted by the most influential critic on the scene, John Berger ... It was not surprising that Berger failed to recognize the value of Bacon, he was too much of a boy scout not to see Bacon as a monster of depravity.[29]

As Andrew Brighton has recently argued, it was in fact Bacon's fatalism and his absolute rejection of a socially progressive role for art that prevented Berger from appreciating his painting.[30]

The American critic and curator Sam Hunter introduced Bacon to the art-historical community in a remarkable article for the January 1952 *Magazine of Art*. Calling him 'another of the magnificent, incalculable freaks that English painting has periodically sponsored', Hunter felt that Bacon's art was a product of his environment:

> A combination of the distorted human atmosphere that prevails in any modern postwar metropolis, but peculiarly in London, and an uncompromising search for extreme expression has made Bacon carry his imagery from

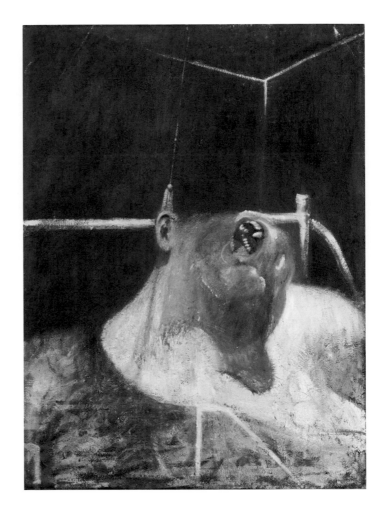

> contemporary actuality to its farthest frontiers ... The transfiguration to horror and a dedication to the most unpleasant expression of contemporary life are the basic conscious forces at work in Bacon's paintings.[31]

Hunter noted Bacon's 'Bergsonian horror of the static' and desire to move painting closer to the 'optical and psychological sources of movement and action in life'. And he attributed the 'haunting effect of his art' to 'Bacon's fascination with photography'. Hunter published, for the first time, photographs of a selection of the reproductions – of Velázquez, Eadweard Muybridge, Georges Seurat and photographs of Nazis (figs.2, 88, 89) – that Bacon utilised:

fig.17 *Head I* 1947–8
Oil and tempera on board, 100.3 × 74.9
The Metropolitan Museum of Art, Bequest
of Richard S. Zeisler, 2007

The fascination of Bacon's art is that, while remote from any of the directions of contemporary painting, it is thoroughly contemporary in its vitality. No one has interpreted the acute postwar moods more vividly … Bacon's thoroughly modern horrors are concocted still with a neo-Edwardian sense of luxury; and his Satanism, despite an up-to-date clinical note, can suggest the *Yellow Book*. If Aubrey Beardsley's generation were alive and given the benefits of a modern education, it would no doubt be painting in the style of Francis Bacon.[32]

The impact of the post-war atmosphere on Bacon that Hunter perceived has been intelligently analysed by Simon Ofield, who finds that 'anxiety over order and disorder was particularly animated in Britain in the 1950s, when tension between the stabilities of the past and the instabilities of a modern future was palpable across a broad range of institutions and cultural products.'[33]

Bacon was included in two important exhibitions at The Museum of Modern Art in the 1950s, Andrew Carnduff Ritchie's *The New Decade: 22 European Painters and Sculptors* of 1955 and Peter Selz's *New Images of Man* of 1959. Oddly enough, these inclusions, as well as Bacon's presence at the British Pavilion of the 1954 Venice Biennale and the 1959 São Paulo Biennial, did not provoke much writing. In his article for the *Burlington Magazine*, Douglas Cooper, who had quarrelled with Bacon long before, mentioned him only in passing, dismissing him with his characteristic disdain for all things British.[34] More prescient was an anonymous article in *The Times* of 13 November 1953, which described, with remarkable accuracy, Bacon's painting practice and his reliance on photographic reproductions:

> Mr Francis Bacon always paints on the wrong, the unprimed, side of the canvas and perhaps this may be considered typical of his whole approach to his art and of the way in which he always makes difficulties for himself … no painter, it is safe to say, has ever used photographs in a more extraordinary way. Instead of merely taking them as a guide … he actually seeks … to give the picture the

horrible look, and even the disagreeable colour and texture, of a photographic enlargement … The effect of these, as so often with Mr Bacon's recent work, is to suggest that one is in the cinema but that the film has suddenly stopped being wound; the dramatic tension is at its height, and then suddenly frozen and fixed.[35]

The writer for *The Times* may have been prompted by Hunter's 1952 article, though he is more insistent on the effect of photography on Bacon's technique. Now that most of Bacon's studio leavings may be consulted at the Hugh Lane Gallery in Dublin, the identification of the source of all of the photographic and printed, reproductive imagery that Bacon consulted and manipulated has become a central goal of Bacon scholars at the beginning of the twenty-first century.

The 1960s

The retrospective at the Tate Gallery in 1962 (fig.18) and the subsequent show at the Solomon R. Guggenheim Museum, New York, in 1963, prompted a broad assessment of Bacon's achievement and the first serious American responses. Some of the artist's early supporters, such as Sylvester, had already begun to doubt the merit of his recent work. By 1958, Sylvester found Bacon shockingly bad: 'at that moment and for nearly four years afterward I felt his work to be incomprehensible and alienating: it seemed to me that it had become illustrational, caricatural, monstrous.'[36] The 1962 *Three Studies for a Crucifixion*, the last work on view in the Tate exhibition, rehabilitated Bacon for Sylvester, and most critics were positive. In an anonymous review of the show at the Tate, Russell compared the experience of viewing Bacon's painting to the shock of Francisco de Goya's late works: 'This is the black night of the twentieth-century soul, images of man which are terrifying, violent and at times bestial.' The reviewer stated that 'Bacon's figures are essentially flesh (the quality of his paint and brushstroke renders it with something of the same morbid sensitivity as Soutine's)', and he compared this to the existentialist writing of Jean-Paul Sartre and Albert Camus. It was 'the most

stunning exhibition by a living British painter there has been since the war'.[37] Reviewing the same exhibition for the *Burlington*, Anita Brookner was attracted to Bacon's work because 'it contains a human drama which involves the spectator as much as it does the artist'. 'Bacon does something only possible after the first generation of Freudians: he paints traumas'. Rather than referencing contemporary horrors of war or 'other modish causes for despair', Brookner saw the work addressing the 'inconsistencies in [the viewer's] own behaviour as a civilised and rational being' when confronted with terror. Repeating Bacon's creation myth, Brookner questioned the artist's claim that he was self-taught:

> Certainly his vision has never been corrupted by an art school training or too great an acquaintance with the works of other masters ... But on the basis of this exhibition alone, we can plot him quite comfortably in the history of European art ... Here at last is a contemporary painter of true stature, whose endless communion with the realm beyond our understanding marks a definite breach in the polite tyranny of formal conventions.[38]

The Tate exhibition prompted a review by Michael Fried, the young American disciple of Clement Greenberg. He examined Bacon's achievement – 'almost monumental and, perhaps, monumentally perverse as well' – through Bacon's own self-stated aim 'to make idea and technique inseparable'. The idea, he finds, is not 'the agony of Auschwitz and Hiroshima ... it is more akin to that of [Sartre's character] Roquentin's uncontrollable nausea'. But, there is a flaw:

> it is precisely this interlocking of image and idea that does *not* happen ... If I am right, then, there is a fairly clear sense in which the figure and setting pull against one another in these paintings. It is as if there were two images, one literal or explicit and the other more or less abstract. And the second paradox that lies near the heart of Bacon's work – it is, I think, intimately related to the first – is that often the literal or explicit image embodies the more general and hence uninteresting emotion, while the abstract image is by far the more precise and venturesome and even shocking.[39]

Is it any surprise that an active proponent of American Colour Field painting should admire Bacon's abstract background fields? For Fried there was a sign of hope:

> it is perhaps all the more significant that Bacon's work of the recent past has been marked by an increasing tendency toward abstraction ... It is less literary and more exclusively visual, more painterly. And this has led not only to a more effective interlocking of image and paint than ever before, but also to a terrific sharpening of the emotions they jointly hold forth.[40]

For his part, Bacon often expressed his lack of interest in abstract painting: 'One of the reasons why I don't like abstract painting, or why it doesn't interest me, is that I think painting is a duality, and abstract painting is an aesthetic thing.'[41]

On the heels of the Tate retrospective, the Solomon R. Guggenheim Museum presented an exhibition in New York. It was organised by Lawrence Alloway, the English critic who favoured the new development he called Pop art, a trend that was anathema to Greenberg (and to Bacon, who claimed to have had no use for it) because it threatened the hegemony of American Abstract Expressionism. In his introductory essay to the catalogue, Alloway rejected the reading of Bacon's paintings as a 'cultural barometer' and refused to see the artist as the 'Goya of the Early Space Age'. Taking perhaps a cue from Fried, he wanted 'to write about Bacon as a painter, rather than as an allegorist of *Angst*, and about his works as paintings, rather than documents of a 20th century problem, predicament, crisis, or what have you'. Alloway adopted an American approach to a European problem, but his insistence on technique would have pleased Bacon, with his horror of illustration. Alloway thought that Bacon, like Giacometti and de Kooning (but not Jean Dubuffet), produced ambiguity by knowingly perpetuating time-honoured forms while transforming them.[42] Although Alloway found all the usual references to European painting in Bacon's works – 'the Grand Manner', and 'tradition' – he asserted above all the primacy of photography, which allowed Bacon to be 'simultaneously grotesque and realistic'. And, in what may have been the first

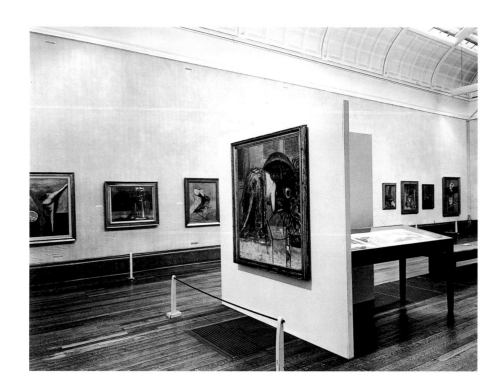

printed reference to Bacon's sexual orientation, Alloway recognised the eroticism of Bacon's art. He made an analogy to Michelangelo: when isolated from the iconographic programme, the *ignudi* of the Sistine Chapel 'are swung into a new context; his athletes take on the attributes of muscle-eroticism rather than Neo-Platonism'. With Bacon, 'it is not a matter of recovering, after bourgeois suppression, the socially sanctioned and culturally normal homosexuality, of say, a Greek poet. On the contrary, Bacon asserts the presence of latent homosexual meanings within the tableaux of the Grand Manner.'[43]

The Tate and Guggenheim shows also prompted a prize-winning assessment by Brian O'Doherty, the Irish critic and artist, who was then working in New York. A proponent of an existentialist reading of Bacon's work, O'Doherty wrote that Bacon's 'is the first major expression in paint of a sensibility [Sadism?] that runs from de Sade through Rimbaud to Genet', adding that Jean Genet is probably the best comparison since

'Bacon is attached to a style of ceremonious presentation that allows him to extend the definition of life to include the underworld of rape, suicide and murder'.[44] It is the ceremonious staging that occurs in the work, the luxurious or formal backdrops, that allows for the depictions of such horrors.

Deeply in debt to the Hanover Gallery, Bacon left his long-time supporter Erica Brausen for the well-funded Marlborough Fine Art in 1958, but, with the exception of a small show at Durlacher Gallery in October 1953, he did not receive a major gallery display in New York until 1968.[45] By then, Bacon's celebrity was well established and critics were therefore generally respectful. Gregory Battcock, to cite one, coined the term 'Surreal-Expressionist' to describe Bacon's new 'existentialist' paintings at Marlborough-Gerson Gallery, New York, and found the artist's subject to be modern man and 'his contemporary psychological, sociological, and metaphysical condition'.[46]

fig.18 Installation view of *Francis Bacon* at the Tate Gallery, London, May 1962

The 1970s

The timing of the 1971 retrospective at Paris's Grand Palais (fig.19) could not have been better. Prior to the opening, the leading French art review *Connaissance des Arts* conducted its poll (held every five years) of the top ten artists in the world. For the first time, Bacon emerged as the leader, beating Dubuffet, Alexander Calder and Jasper Johns. So surprising was the result that *Le Figaro*, Paris's primary Conservative daily, questioned the method.[47] After all, Picasso was still alive. The critic for *Le Monde*, Michel Conil Lacoste, praised the 'perfectly selected and installed masterworks' as a revelation at the Grand Palais.

> It's more than a successful exhibition. Everything has come together for this retrospective, in preparation for the past two years, an event marked by exceptional signs: the power and the radical originality of a painter whose vision and methods are situated against the current of recent, panurgic trends; the renewal he draws from an exploration of the human and the quotidien and the classical *métier* one thought was exhausted, the suddenness of this revelation, long deferred in France; his irreproachable installation in the most recently installed galleries at the Grand Palais.[48]

(As if to return the compliment, Bacon rented an apartment near the Place des Vosges and spent much of the decade in Paris.)

The catalogue introduction by Michel Leiris contributed to the impression that France was co-opting one of Europe's leading talents. One of the most prominent intellectuals of his day – a living link to Surrealism, to Sartre, and to prominent artists such as André Masson and Picasso (Leiris's sister Louise was Picasso's dealer) – Leiris essentially followed his party line that Bacon's art was neither illustrational nor anecdotal, it was realist. For Leiris, in a later text, Bacon's pictures viscerally affected the viewer: 'the spectator who approaches them with no preconceived ideas, gains direct access to an order of flesh-and-blood reality not unlike the paroxysmal experience provided in everyday life by the physical act of love … which makes it a sensuous delight, but one so intense that

… to some people … it can appear wholly abhorrent'.[49] Leiris found the work different from that of the Surrealists, 'who,' he writes, 'turned their painting into a receptive screen for highly imaginary projections'; from the Cubists, 'for whom the validity of painting … lay in its strongly structured composition, free of any optical trickery'; and also from the Impressionists, 'for whom a picture was an open window or a key hole'.[50] André Breton, Leiris's great Surrealist associate, was invoked with the phrase 'beauty will be convulsive or not exist at all', and it is this Surrealist idea that ultimately seems to underlie Leiris's reading of Bacon: that the artist 'does not simply alter the form … but also the substance of the motif, and in particular the flesh of the model, which is rendered in its very warmth and elasticity'.[51]

British writers commented on the distinctively French response to the exhibition at the Grand Palais. Writing for *The Times*, Guy Brett stated that the French held 'a fascination for paint, the material texture of painting', something 'deeply ingrained in France'. Brett aligned the texture of the paint with Art Brut, Dubuffet and Antoni Tàpies. 'Bacon has said that the subject of his painting is "The History of Europe in My Lifetime",' writes Brett. 'He has made of it a cramped, violent stage, which reflects Europe's obsession with itself and refusal to look outside.'[52] Patrick Brogan wrote that, because of the success of Bacon's show, 'French intellectuals are therefore likely to think rather better of Britain after a disturbing visit to the Grand Palais … French critics were struck by Mr Bacon's apparent brutality and offered many a learned and psychological analysis to explain it. Painters, however, admired his colours and his technique.'[53]

In 1975, Henry Geldzahler, the curator of modern art at The Metropolitan Museum of Art, organised an exhibition of Bacon's recent paintings (fig.20). This exhibition, the first one-man show of a living British artist ever held at the Metropolitan, included the striking black triptychs that Bacon produced after the death of Dyer, such as *Triptych – August 1972* (pp.208–9). American critics necessarily took notice: finally there was late commentary from the ageing American proponents of Abstract Expressionism, such as Harold Rosenberg.

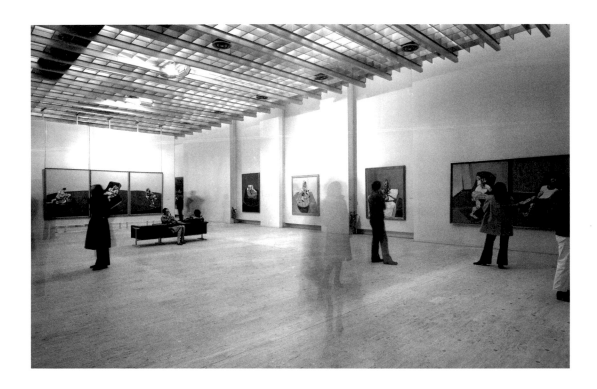

Although half of the works had never been seen publicly, some writers questioned the ethics of showing recent work that was available for purchase. Worse, Douglas Davis wrote that the paintings were 'intentionally ugly'. The Met 'has chosen to focus upon the work ... since 1968, not the vivid early works that captured the world's imagination'. As a result, 'Bacon's art loses its celebrated vulgarity. It becomes instead a parade of predictable images'.[54]

On the occasion, Hugh M. Davies published an important article on the late triptychs. Davies had written a doctoral dissertation on Bacon (for Sam Hunter) at Princeton University, and had therefore spent much time with the artist. His article included several previously unpublished statements by Bacon, which, though new, essentially followed the lines of the aphorisms that Sylvester had previously published.[55] Despite – or perhaps because of – his access to the artist, Davies tiptoed around the pretext for the Dyer triptych: the death by drug and alcohol overdose of Bacon's male lover since

1963, the handsome, sometime thief whose anti-social behaviour appealed to Bacon's attraction to danger and risk. The nearest Davies came to describing their relationship was the phrase 'closest friend'. But in what may have been the beginning of a shift, Donald Kuspit discussed the homosexual content of the pictures through what he called Bacon's 'aphoristic approach', calling upon, for instance, Sartre's writings on Jean Genet, the author of *The Thief's Journal* (1949) and, like Bacon, a lover of working-class men.[56]

The 1980s

The final decade of Bacon's life and career was marked by frequent exhibitions, record-setting prices, and a new ease and calm that resulted from his friendship with John Edwards, an illiterate Londoner invariably described as decent and kind. Critically, however, the tide was turning. For some, Bacon's ubiquity brought contempt in its train (even Sylvester

fig.19 Installation view of *Francis Bacon* at the Grand Palais, Paris, October 1971

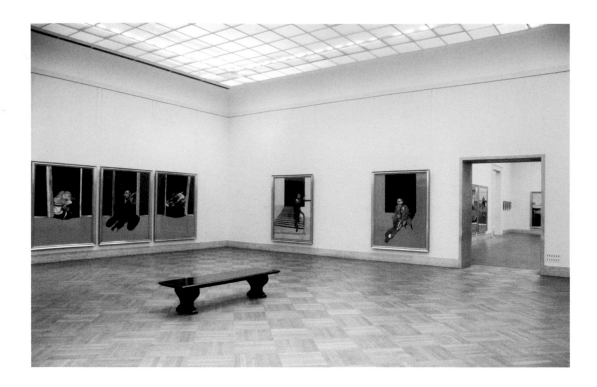

concluded in private that Bacon was a secondary, though great, figure);[57] for others, the interest was no longer in his technique – the use of chance and accident in the creation of images – nor in the source of his imagery in mechanical reproductions. *Pace* Fried's 1963 hope for a tendency toward abstraction, Roberta Smith found, in 1987, that

> in Mr Bacon's work, the psychological situation is always more interesting than the painterly and visual one … the formal formula of figure to monochrome ground and line to plane – like the relentless gold frames that surround each panel – eventually erodes the emotional impact of the work and we feel shortchanged … It makes one think that, at least recently, the courage with which Mr Bacon confronts the human condition somehow fails him in the actual, and potentially liberating, materials of painting itself.[58]

Bacon's 'psychological situation' became grist for a post-structuralist mill, as a new generation of writers – among them Andrew Benjamin, Dana Polan and Ernst van Alphen – used Bacon's recorded statements to demonstrate, to quote Simon Ofield, 'that his paintings are about the deformation, dissolution, disintegration, decomposition and deconstruction of subjectivity, each insisting that the pictures question mastery and undermine traditional forms of rationality and order'.[59] As Ofield has shown, this post-structuralist approach, with its heavy reliance on the artist's statements, results in interpretations similar to those of British critics, such as Read and Sylvester, in the 1950s.[60] A similar thesis was undertaken by French deconstructionist Gilles Deleuze, whose text on Bacon, subtitled 'the logic of sensation', aimed to counter the notion that Bacon painted bodies that are literally tortured. Rather, Deleuze suggested that the paintings represent ordinary situations of discomfort (the sneeze, the spasm, the shiver), the 'invisible forces that model flesh or

fig.20 Installation view of *Francis Bacon: Recent Paintings, 1968–1974* at The Metropolitan Museum of Art, New York, March 1975

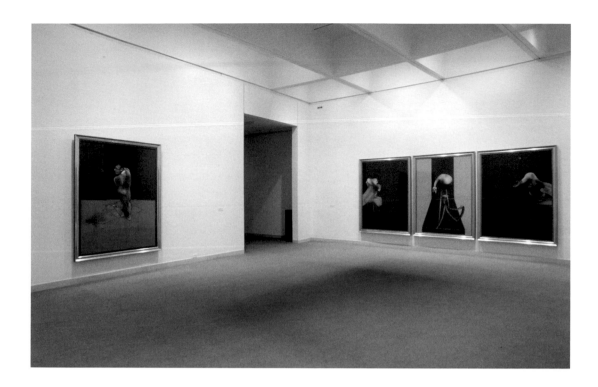

shake it … the entire body trying to escape, to flow out of itself'. Like Leiris, Deleuze thought that Bacon's deformations revealed an underlying, intensified realism.[61]

After Bacon's death, friends and acquaintances – Daniel Farson, Michael Peppiatt, David Plante and Andrew Sinclair, to name four – began to publish biographical works that added considerable texture and nuance to the diffident, carefully managed statements that Sylvester had published earlier.[62] This, and the availability of Bacon's studio contents, donated by John Edwards and moved to the Hugh Lane Gallery in Dublin in 1998, have fuelled new approaches to his work. In the stunning proliferation of writing on Bacon spawned since

his death, two trends are noteworthy: a frank accounting of the impact of Bacon's sexuality – and the repressive environment in which he lived – on his practice and imagery, whether sensational (Daniel Farson's *The Gilded Gutter Life of Francis Bacon* of 1993, or John Maybury's 1998 film *Love is the Devil*) or scholarly (articles by Simon Ofield and Richard Hornsey); and a much more precise examination (studies by Margarita Cappock and by Martin Harrison) of the extraordinary way in which Bacon mined modern media – from medical textbooks and golfing manuals to commercial tabloids and art books – to create his inimitable art.

fig.21 Installation view of *Francis Bacon*
at the Hirshhorn Museum and Sculpture
Garden, Washington, D.C., October 1989

BACON'S PAINTINGS *Martin Harrison*

Francis Bacon's relationship with art of the past was dynamic, if complicated. He borrowed or stole wholeheartedly from his inspirations, often more cogently than Pablo Picasso (compare the latter's variations of *Las Meniñas*), and insofar as his subversive interactions alter our perception of paintings such as Velázquez's *Portrait of Pope Innocent X*, they are prime candidates for the art historian Michael Baxandall's theory of 'reversed influence'. This essay draws on documents that have come to light during the preparation of the Bacon catalogue raisonné, in order to consider his dialogue with the European tradition of art, the interpretation of his paintings and the role of chance in his working procedures; it also touches on a neglected aspect of his milieu in the 1930s. While Bacon's views on Grünewald, Michelangelo, Titian, Rembrandt and Rubens are fairly well documented, he was less forthcoming about other artists who were evidently equally meaningful for him: the reworkings of the Grand Manner do not, of course, fully explain what his paintings mean, but it is hoped that the enlargement of his art-historical canon may usefully inform further studies.

Art into Art

In 1959 James Thrall Soby, a curator at The Museum of Modern Art, New York, and the author of studies of Jean Arp, Salvador Dalí, Giorgio de Chirico, Juan Gris, Paul Klee, René Magritte and Georges Rouault, embarked on a monograph which, had it been published, would have been the first on Bacon. But Bacon was being carefully shielded from interruptions, and Soby was required to correspond with Harry Fischer, a director of Marlborough Fine Art, London, and with the critic Robert Melville. In an effort to coax answers to Soby's questions from the recalcitrant artist, Fischer took Bacon and Melville to dinner, and reported to Soby:

> Very early in his career, he was much impressed by Zurbarán. He considers Daumier's *Don Quixote and Sancho Panza* and El Greco's *View of Toledo* to be among the great paintings of the world. He admires Seurat's oil sketches, late Monet, early Matisse, Picasso, Soutine.[1]

Soby enquired which version of the Daumier and El Greco paintings this referred to, and was informed that the Daumier was in the collection of the Courtauld Institute of Art but that Bacon had only seen the El Greco in reproduction. *Don Quixote and Sancho Panza* (fig.22) had been at the Courtauld Gallery since 1932, and Bacon was probably thoroughly conversant with it. Daumier's starkly elemental conception and his evocation of the novel's human tragicomedy are eloquently translated into fluid pigment: idea and technique are interdependent in precisely the way Bacon sought to achieve, and no doubt Cervantes' psychological insights and dismantling of preconceived ideas also resonated with his fatalism. To gaze at this great painting is comparable with experiencing a slightly scaled-down Bacon of the 1950s: virtually *en grisaille*, Daumier's free brushwork is echoed in many of Bacon's paintings, for example *Elephant Fording a River* 1952 (private collection), and *Figure in a Mountain Landscape* 1956 (p.160). The dialogue with Daumier was continued in Bacon's 1960s portraits, as evinced in the affinities between Daumier's caricatural polychrome terracotta *Jean-Auguste Chevandier de Valdrôme* c.1832 (fig.23) and the distorted physiognomy of Bacon's *Study for Portrait* 1966 (fig.24). John Rothenstein, Director of the Tate Gallery from 1938–64, recalled that Bacon,

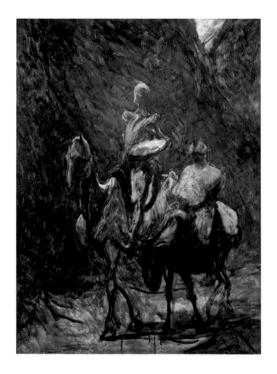

fig.22 Honoré Victorin Daumier
Don Quixote and Sancho Panza c.1870
Oil on canvas, 100 × 81
The Samuel Courtauld Trust, Courtauld
Institute of Art Gallery, London

when visiting the gallery, would glance quickly round each room before scrutinising a few paintings 'intently and at length, ignoring the rest. Occasionally he looked at almost everything – for example, the Daumier exhibition.'[2]

On the other hand, Bacon's admiration of El Greco's *View of Toledo* – given that it was based on reproductions – is less likely to have depended on particularities of painting technique. He may have appreciated the softly swaying grasses in the foreground – he responded viscerally to the grass of Vincent van Gogh and Georges Seurat, and grass was prominent in many of his paintings in the 1950s – but this can only be speculated upon, as neither the version of *View of Toledo* to which Bacon alluded is certain, nor the state of its reproduction; it is also possible he meant the markedly different *View and Plan of Toledo* c.1610–14 (Casa Museo El Greco, Toledo). Bacon is not often associated with El Greco and presumably, though astigmatic himself, he did not subscribe to the theory that this was a cause of his putative 'distortion'. But there are clear correspondences between the two artists, not least in the twisting of anatomies and flesh, and in Bacon's *Painting* 1946 (p.101), the crucifixion posture formed by the hind limbs of the suspended carcass is reminiscent of the ominously swirling clouds in El Greco's *Crucifixion* c.1590, which mimic Christ's outstretched arms.

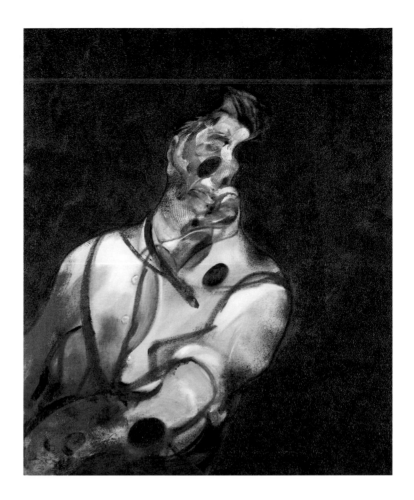

Perhaps most unexpected, given that none of Bacon's early paintings discloses an obvious debt to the Spanish master, is that Bacon had been 'much impressed' by Francisco de Zurbarán. Since no monographs on Zurbarán were published in English between 1926 and 1945 it is unclear in what form Bacon encountered his paintings, though he probably saw the eleven at Auckland Castle, Durham (several of Bacon's relatives lived nearby), as well as those in the Louvre Museum. But the *Saint Francis in Meditation* (fig.25) in The National Gallery, London (a later version of this title was not acquired by the gallery until 1945) is among Zurbarán's most affecting and sombre paintings. It is direct in its expression and dramatically illuminated: shadowed under the top-lit Capuchin cowl, St Francis's features are at first glance almost imperceptible

fig.23 Honoré Victorin Daumier
Jean-Auguste Chevandier de Valdrôme
c.1832
Polychrome ceramic, 19 × 14.9 × 13
Musée d'Orsay, Paris

fig.24 *Study for Portrait* 1966
Oil on canvas, 198 × 147.5
Private collection

save for the edges of the nose and mouth, and he cradles the skull, contemplating death, with anxiously clasped hands. Conceivably this austere and mysterious painting fascinated Bacon without his having felt the compulsion to make quotations from it. But the Zurbarán was absent from the eighteen paintings Bacon chose in 1985 for *The Artist's Eye* (one of a series of exhibitions, held in the 1970s and 1980s, selected by leading British artists from the collections of The National Gallery), which suggests that his impact on Bacon was indeed confined to 'very early in his career'.

Bacon famously inserted himself into the legacy of Spanish Baroque art with his variations of Velázquez's *Portrait of Pope Innocent X* c.1650 (fig.68). He said he was disinclined to confront the portrait while he was painting from it, and instead his metamorphoses were based on half-tone mechanical reproductions, in which the process of fragmentation he would undertake was intrinsic. Bacon's re-inventions of the 'original' (which remains intact) are frequently characterised as iconoclastic, yet the target of his iconoclasm was not Velázquez but patriarchal power. His irony was directed at the pretension to grandeur in general, rather than Velázquez's sophisticated recording of it, and he extended the irony by painting his dissonant mutations on a grand scale and presenting them under glass and in gilded frames. He said of the *Portrait of Pope Innocent X*: 'I became obsessed by this painting and bought photograph after photograph of it',[3] and he converged these with another photograph, a still frame of the screaming nanny on the Odessa Steps, from Sergei Eisenstein's film *Battleship Potemkin* (1925, fig.80). Thus the father-figure that Bacon disputed the Popes signified was superimposed on a surrogate mother-figure redolent of his revered nanny, her bloodied eye and shattered spectacles revisiting the myth of Oedipus's self-blinding. The agency of photographs was crucial to Bacon's strategy, yet he believed they communicated only indirectly with the 'nervous system'. His tactile modifications of them (clipping, folding, over-painting, damaging, spattering) were what he substituted for conventional preliminary drawings – they were the 'sketches' he translated into oils on canvas.

The Velázquez books Bacon acquired in the 1940s were generally of recent publication, and their illustrations almost exclusively in monochrome (hence Bacon's initial misunderstanding that Innocent's skirt was purple). The confluence of Velázquez and photography had been posited much earlier, by the art historian and collector William Stirling. The fourth volume of Stirling's *Annals of the Artists of Spain* (1848) comprised sixty-six Talbotypes and was the first art-history book to be photographically illustrated. In *Velázquez and his Works* (1855), Stirling was again the first to propose a parallel between Velázquez's vaunted realism and naturalness and that of the daguerreotype. Of another Velázquez, *The Toilet of Venus (The Rokeby Venus)* 1647–51 (The National Gallery, London), Bacon declared with unusual candour to Hugh Davies: 'If you

fig.25 Francisco de Zurbarán
Saint Francis in Meditation 1635–9
Oil on canvas, 152 × 99
The National Gallery, London

don't understand the Rokeby Venus you won't understand my paintings.'[4] The implications of this remark warrant further study, but at a literal level there are affinities between the mirror held up by Cupid and the mirror reflections of the figures in *Study of George Dyer in a Mirror* 1968 (p.197) and *Three Studies of the Male Back* 1970 (fig.108). Velázquez's *Las Meniñas* was one of Bacon's favourite paintings, and the right panel of *Triptych, March 1974* (fig.111), refers to its structure and content: the self-portrait (significantly holding a camera, not a paintbrush) is situated on a black background intersected by what appears to be a picture frame which, like the reverse of Velázquez's canvas in *Las Meniñas*, reveals no image.

Bacon's reference to 'early Matisse' is of particular interest, for he was an artist about whom he later equivocated saying he lacked Picasso's 'brutality of fact'.[5] While there is no reason to doubt Bacon's preference for Picasso, it is plausible that he underplayed his familiarity with Matisse's early paintings in order to deflect enquiries about his borrowings from them. The pose of the crouching figure in Matisse's *Bathers with a Turtle* 1908, in combination with Eadweard Muybridge's motion studies of male rowers, was reworked by Bacon in *Study for Crouching Nude* 1952 (p.118), and both the upholstered bed and raised arm in Matisse's *Odalisque with a Tambourine* 1926 informed Bacon's *Henrietta Moraes* 1966 (p.192). Little is known about Bacon's friendship with Matthew Smith, but Smith's acquaintance with Matisse (he had attended Matisse's Académie in 1910), as well as his un-English Fauvist palette, probably increased his authority in the eyes of the Francophile Bacon. It is hard to understand why he later sought to distance himself from Chaïm Soutine, for in 1958 he classed him with Picasso as one of 'the very finest artists of our time': he identified particularly with Soutine's eschewal of preliminary drawings, his method of painting 'absolutely direct' in order to 'keep the thing cleaner and rawer'.[6]

The emphasis placed on an artist's biography (and intentions) has diminished in recent art discourse, despite which Bacon's views have already been quoted several times above. If any value is to be attached to what Bacon said, as opposed to what he created, it should be stressed that his thoughts remained outside the public domain until 1963, when the first of David Sylvester's interviews was published. Other than a few brief statements to journalists and his encomium for Matthew Smith in the catalogue of Smith's 1953 Tate Gallery retrospective (a personal manifesto as much as a commentary on Smith), nothing was heard from Bacon until after he was fifty-three; by then the trajectory of his fame was in the ascendant and his earlier thinking had begun to be distorted by time and memory. Bacon presented his art, as Jean-Claude Lebensztejn observed, within 'an inextricable combination of contradictions',[7] and his assessments of it were similarly in constant flux. For example, he began to disavow the 'Pope' paintings in 1966, despite having recently completed a triumphant valediction to the theme, *Study from Portrait of Pope Innocent X* 1965 (p.190): it would be more convincing if Bacon had embraced this as his equivalent masterpiece. He followed closely Velázquez's format (though in a redefined spatial matrix) in a palette that ranges from a vivid, almost Venetian sumptuousness to subtly pale pinks and eau-de-nil, rendered in surface textures that alternate from a rich, scumbled density to the breathtakingly abbreviated; and, as though in a gesture of finality, Innocent's features are evoked then partly erased, defaced.[8]

In the 1950s Bacon was compared in the art media not only with the cinema and photography but also Rembrandt and Seurat, associations to which he raised no objection. But he was also classified with artists he deemed mere 'illustrators', such as Henry Fuseli and William Blake, and he reacted by co-opting these quintessentially Romantic artists as his artistic nemeses (indeed, John Constable and J.M.W. Turner were virtually the only English artists he ever praised). Under the modernist impulse to break abruptly with the past it tended to be forgotten that most great art had evolved in response to, or as a recapitulation of, art of the past. In the context of the postwar avant-garde, Bacon understood that to be a painter of the human figure was risky, that his reformulations of existing imagery must be original, non-mimetic. He neither fits into the tradition of artists learning by imitating masters, nor was he a plagiarist in the sense that Nathaniel Hone defined

in *The Conjuror* 1775: Hone represented Joshua Reynolds in a room littered with Old Master prints, conjuring up new paintings and exposing his sources.⁹ But Bacon was not a copyist, and the comparison between his *Head VI* 1949 (p.104) and Amédée Ternante-Lemaire's replication of Velázquez's *Portrait of Pope Innocent X*, or Théodule-Augustin Ribot's syntheses in the manner of Jusepe de Ribera (impressive as these 'copies' may be), underlines the gulf in intention.

Bacon's ambiguous relationship with the *techniques* of the Old Masters is more problematical. Unfortunately it was a topic he seldom discussed publicly, except to conjecture whether Rembrandt shared his predilection for unconventional painting tools, or to relish the colour (no doubt the striking patches of flame red that disrupt the dominant monochrome) in Mathieu Le Nain's *A Quarrel* c.1640.¹⁰ Though a trenchant critic of his own paintings, Bacon took some pride in his abilities as a colourist and adroit colour-mixing skills: his unconventional colour combinations, which have not always found critical approval, would reward a special study. In 1972 he took part in a radio broadcast in support of the campaign to save *The Death of Actaeon* (fig.26) for the nation, but again he only engaged with Titian's technique in terms of its being locked into the psyche.¹¹ The mauling of Actaeon by his hounds (the freedom of execution in this passage, which surely impressed Bacon, has prompted debate over whether the painting was unfinished) reminded him of his Furies, and suggested new ways of using these ciphers of the malign in his own paintings. Yet he was familiar with many original paintings by Velázquez, and evidently responded to their virtuosic paint handling. Their fluency was manifested not only in the Popes but in details such as the deliquescent leash in *Man with Dog* 1953 (pp.120, 130), which echoes the bravura, flickering brushwork of the silver threads on the King's costume in *Philip IV of Spain in Brown and Silver* c.1631–2 (fig.27).

Interpretations

James Thrall Soby's protracted struggle to complete his manuscript was overtaken by events when Bacon produced *Three Studies for a Crucifixion*, shortly before the first Tate Gallery retrospective of his paintings, in 1962. Photographs of the triptych were sent immediately to Soby, who, in common with

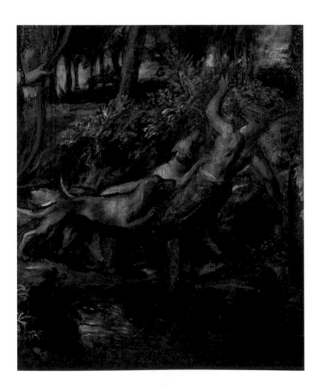

fig.26 Titian
The Death of Actaeon
c.1565–76 (detail)
Oil on canvas, 178.4 × 198.1
The National Gallery, London

fig.27 Diego Velázquez
Philip IV of Spain in Brown and Silver
c.1631–2 (detail)
Oil on canvas, 195 × 110
The National Gallery, London

many critics, greeted it as a pivotal if not completely resolved work. Despite its ostensibly explicit title, *Three Studies for a Crucifixion* has proved resistant to interpretation (pp.148–9). In front of the painting at the Kunsthistorisches Museum, Vienna, in 2003, I asked several distinguished curators to describe what the forms in the outer panels represented, and without exception they responded: 'Oh, I hadn't considered that,' or 'I have no idea'. The only hint Bacon offered, that the central panel was influenced by Cimabue's *Crucifixion*, scarcely explains his spectacular deviations from it. Rolf Læssøe read the two figures in the left panel as autobiographical. He suggested the figure on the right wearing a 'black body stocking or tights' referred to the story Bacon related of his expulsion from the family home after his father had caught him wearing his mother's underwear.[12] This was precisely the kind of speculation about first-person narratives that Bacon deprecated, but he himself described the *Crucifixion* as 'just an act of man's behaviour, a way of behaviour to another,' and 'about your feelings and sensations … almost nearer to a self-portrait'.[13] A lifelong asthmatic, he was painfully accustomed to near-death experiences, and given that from childhood he identified with hanging meat it is tempting to read the carcass in *Painting* 1946 as another self-portrait.

Soby assumed the central panel of *Three Studies for a Crucifixion* was a Deposition and the right panel ('the figure seems to be hanging upside down') a St Peter, but he was 'baffled by the two figures in the left panel and by the strange bird-like forms in the extreme foreground' and 'puzzled by the dark form in the extreme foreground of the right panel and by the haunting hose-like form on the ground behind St Peter'. Harry Fischer talked again with Bacon, and told Soby: 'the two figures on the left are Himmler and Hitler opening the doors of the gas chambers – that you may quote.'[14] But Soby and Bacon had never met, and when Soby sent his draft foreword to London, Bacon reacted in a manner that would often be repeated, insisting the text misrepresented him and that he wanted the book postponed until they had spoken. He also denied that the two figures were 'Hitler and Himmler shoving Jews into the gas-oven'.[15] Fischer confirmed that while

he had quoted Bacon's comment accurately, 'perhaps he did not mean it seriously': as he wryly added, 'The iconography of the Triptych is difficult to ascertain'.[16]

If Bacon intended his remark as dark humour, in his next triptych, *Crucifixion* 1965 (pp.150–1), the swastika armband worn by the discobolus figure in the right panel caused a furore. Bacon's disingenuous responses to such criticisms – that he needed the colour red in that position or that the syringe in *Lying Figure with Hypodermic Syringe* 1963 was merely a visual rivet – were typical diversionary tactics. Irrespective of its transgressive content, the iconography of the triptych was again sufficiently obscure that, beyond the usual expressions of 'horror', closer interpretation was nullified. Above the 'discobolus', seated at a kind of bar, the two 'attendants', as Bacon termed the disengaged onlookers in his paintings, are among the most astonishing but acutely observant of his borrowings (fig.29). The fragment Bacon recontextualised was extracted from a 1913 photograph by Jacques Henri Lartigue (of his father's racing car in the French Grand Prix; fig.28), a strange and apparently arbitrary detail of race-track marshalls or spectators, blurred and distorted by the teenage photographer's panning technique and the movement of the camera's focal plane shutter. The bloodied figure in the left panel, overlooked by a nude woman adapted from a Muybridge photograph, was described by Bacon as 'someone shot about on a bed'.[17] One of his few genuinely disquieting images, it was probably indebted to photographs of shattered bodies in *The True Aspects of the Algerian Revolution* (1957, fig.131), a copy of which Bacon owned, although John Richardson thought the related 'crucifixion' in the 1962 triptych was based on 'a nude photograph of an American poet on a folding bed'.[18]

Bacon professed to be indifferent to the interpretations attached to his paintings, yet he suppressed texts of which he disapproved. His preferred writer and close friend, Michel Leiris, embraced Duchamp, Giacometti and Picasso, Beckett, Eliot and Mallarmé in his essays, without implying there were causal links with Bacon's paintings; his elegant, poetic if oblique prose discussed Bacon in the context of debatable concepts such as 'realism', while avoiding modes of analysis

his subject would have found contentious. Similarly, in the otherwise stimulating and original *Francis Bacon: The Logic of Sensation* (1981, translated 2003), Gilles Deleuze cited Jean-François Lyotard's distinction between 'figural' and 'figurative' in contriving to remove Bacon into the sphere of abstract 'sensation', of 'non-illustration' and 'non-narrative'. Yet Bacon was somewhat at variance with Deleuze in stating 'I don't want to avoid telling a story, but I want very, very much ... to give the sensation without the boredom of its conveyance'.[19] To convey the essence of a story in the most economical way is not the same as being anti-narrative: Bacon was concerned that straightforward narrative readings of his paintings would necessarily be reductive, but decoding their iconography is not incompatible with recognition of their formal, 'abstract' or more ineffable qualities. His decision to be a figurative artist was not a whim; it was taken in the face

of the weight of history – the German philosopher Theodor W. Adorno, for example, claimed that after 1945 the sum of human atrocities eliminated the possibility of representation – and it might be productive to consider how (or if) his paintings transcend the autobiographical impulse to resonate universally. If resistance to interpretation was inherent in Bacon's elusive, ambiguous pictorial formulations, they nonetheless embody a multiplicity of meanings: contingent, fragmented, unstable, they refuse to conform to narrowly exclusive theories and insist on being opened up to the widest scope of inter-disciplinary approaches.

Origins

The unreliable and patchy accounts of Bacon's first forty years do not help to apprehend his relationship with twentieth-

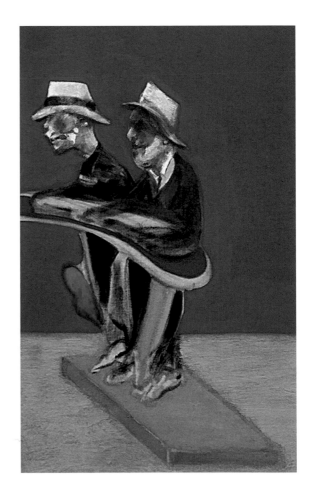

fig.28 Jacques Henri Lartigue
The Grand Prix of the A.C.F.
June 26 1912

Gelatin silver print
Donation J.H. Lartigue – Ministère
de la Culture – France

fig.29 Detail of right-hand panel from
Crucifixion 1965 (p.151)
Oil on canvas, 198 × 147.5
Bayerische Staatgemäldesammlungen,
Pinakothek der Moderne, Munich

century art. Clearly he orientated himself in relation to Picasso (in addition to less celebrated artists he seldom discussed), but it is hard to reconcile his claim that an encounter with Picasso's paintings in Paris inspired him to become a painter with the fact that he returned to London in 1929 and set up as an interior designer: before 1933 the exposure to Picasso is only indirectly evident in his paintings. Moreover, while Bacon hinted at greatness in the 1930s (notably with *Crucifixion* 1933, p.145), his aesthetics scarcely deviated from those of Roger Fry and Clive Bell, which by then had entered the mainstream: one can imagine his self-educational primers included, besides Amédée Ozenfant's *Foundations of Modern Art* (1931), Fry's *Vision and Design* (1920) and *Transformations* (1926), and Bell's *Since Cézanne* (1922). Fry's appointment as Curator of Paintings at The Metropolitan Museum of Art, New York, in 1906 coincided with the revelation of Paul Cézanne and the diversion of his scholarly attention from the Italian Renaissance to modern French art, and *Copies and Translations*, which he organised at the Omega in 1917, was the first British exhibition of paraphrases of Old Master paintings. Bacon similarly telescoped art history, and his commitment to the 'deeply ordered' as well as spontaneity was reflected in his respect for the Florentine 'primitives'. The dog in Bacon's *Interior of a Room* c.1934 (private collection) is probably indebted to Piero della Francesca's *St Sigismund and Sigismondo Pandolfo Malatesta*, at Rimini, the unadorned factuality of Piero doubtless as resonant for Bacon as it had been for Fry,[20] and Masaccio's *Virgin and Child with Angels* was among the paintings Bacon selected for *The Artist's Eye* in 1985.

The crucial importance of Edgar Degas and Edouard Manet for Bacon requires lengthier explication than space permits here, but other aspects of Impressionism and Post-Impressionism also filtered into his paintings. His predilection for painting in series (the Popes, Blake life-masks, van Gogh paintings) recalls the incremental variations in Monet's Rouen Cathedral façades, or his haystacks. Unlike Fry, Bacon greatly appreciated late Monet, slightly overstating that he did so 'when most people said it was like ice-cream'.[21] Paul Gauguin and Pierre Bonnard were important to him in the late

1950s, but Gauguin's *Arearea* 1892 (fig.30) was among several modern French paintings that informed *Figures in a Garden* c.1936 (fig.31). Bacon said his preference for painting on the unprimed side of the canvas occurred fortuitously, as an expedient adopted in Monte Carlo in the late 1940s when he ran out of prepared canvases, but he must have been aware of areas of canvas left 'raw' by not only Gauguin but also Henri de Toulouse-Lautrec and van Gogh.

Bacon's Bloomsbury connections would repay detailed research. He is said to have lunched once with Virginia Woolf and V. Sackville-West, but he was also acquainted with figures on the Bloomsbury fringe, notably Dorothy Todd and Madge Garland. In the mid-1920s Todd was editor and Garland fashion editor of *Vogue*, where Todd was responsible for disseminating the Bloomsbury writers Clive Bell, Roger Fry, Aldous

fig.30 Paul Gauguin
Arearea 1892
Oil on canvas, 75 × 94
Musée d'Orsay, Paris

fig.31 *Figures in a Garden* c.1936
Oil on canvas, 74 × 94
Tate. Accepted by H.M. Government
in lieu of Inheritance tax and allocated
to Tate 2007

Huxley, Raymond Mortimer and Virginia Woolf. But the high-brow tone Todd upheld had a deleterious effect on the magazine's circulation, and she and Garland were fired. Todd threatened to sue for unfair dismissal, but was forced to withdraw when Condé Nast threatened to expose her lesbian relationship with Garland. Todd and Mortimer's *The New Interior Decoration* (1929) was published slightly too early to have included Bacon's modernist furniture, but Garland decorated her Bruton Street flat with Bacon's surgical white rubber curtains and publicised his work in the interior design magazines to which she contributed. The flat Bacon took in 1933 at 71 Royal Hospital Road, Chelsea, was previously occupied by Todd and Garland and before them by the founding editor of British *Vogue*, Elspeth Champcommunal. Like them, Bacon negotiated the prevailing social mores with the support of a partly covert homosexual subculture, in which the importance of sympathetic patrons and friends such as Eric Allden, the design director Arundell Clarke, Eric Hall, and Roy De Maistre should not be underestimated.

Chances

In the 1930s photography hovered around the margins of British modernism, an under-acknowledged presence despite its significance for the paintings of Edward Burra, William Coldstream, Paul Nash and Walter Sickert. But Bacon was not engaged by the creative potential of camera vision so much as the strangeness, immediacy or deflected violence of medical, wildlife or documentary photographs, and the transient pulse and flicker of the movies. Reclaiming the initiative from photography, he infused the base images with the life and intensity he said they lacked, transforming them through the physicality of paint. He was adept at selecting and manipulating photographs (including reduced-scale reproductions of artworks) whose 'slight remove from fact' [22] facilitated their transference into another dimension in his paintings. The conflation of high art and 'found' popular imagery was adumbrated in David Gascoyne's poem 'Camera Obscura', published (with illustrations by Graham Sutherland) by *Poetry London*

in 1943: Gascoyne's lines 'Marlowe's Leander, Michaelangelic gods, that young/ High-diving Mercury I once cut from a sports-page' uncannily anticipate the array of Bacon's 'sources' recorded in Sam Hunter's photographs taken in around 1950.

Convulsive beauty, the crucial precept Bacon absorbed from Surrealism, was itself most effectively mediated through photography. And until 1962 most of the photographs Bacon collected were mechanically printed, through a half-tone dot-screen process. Thus the 'screen' operated on two levels for Bacon. When the human body became his principal subject, in 1949, his 'realism' appears to have been too unflinching even for him, and he painted figures at a remove – striated, veiled or encased in glass. He seldom painted from life, and until 1963 most of his nude figures were based on the sequential photographs made by Eadweard Muybridge in the 1880s, published as *The Human Figure in Motion* and principally intended as a resource for artists. *Three Studies for a Crucifixion* 1962 was, therefore, transitional in another sense, for subsequently most of Bacon's nude figures were painted from photographs of George Dyer and Henrietta Moraes, which he commissioned specifically for this purpose from John Deakin. Bacon's later nudes diverge conspicuously from those in his tonal paintings of the 1950s. In the 1970s, extrapolating from the particular to the universal, he characterised his project as lifting some of the veils that screen our existence: yet while he lavished some of his most visceral painterly skills on these figures, in their isolation – raised on armatures and situated in artificial environments – they appear to be conceived in parentheses (paradoxically, another form of screen, or indirectness), like specimens, or self-reflexive ciphers of nudes.

Conscious of a tradition that stretched back to Degas, Bacon was alert to the effects of the photographic accident, to blurred motion, unusual cropping and random juxtapositions. Indeed 'the accident' was a constant: 'The way I work is totally, now, accidental, and becomes more and more accidental,' he insisted in 1962.[23] But Bacon, who was addicted to gambling, appears to have believed that chance was synonymous with the instinctual, that the marks he made on the

canvas were not intentional or had suggested unforeseen implications: only later (when he appears to have become an avid reader of Freud) did he link this with the unconscious or the subconscious. He described the expressive power of Rembrandt's *Self-Portrait* c.1659 as having emerged from a balance of the artist's 'profound sensibility' and exploitation of accidental marks, as 'non-rational' and 'almost completely anti-illustrational', and 'a coagulation of non-representational marks which have led to making up this very great image'.[24]

Among intimates Bacon may even have invoked the accident as a joke at his own expense. In 1935 he was painting

> a figure in a garden which has I think come very well. It has some how by accident got a rather strong feeling of the Webster lines about the fish in the garden and the sunlight at least I don't think it is purely something I read into it.

From this description, either John Webster's *Duchess of Malfi* or *The White Devil* could have inspired the 'accident'. He had been impressed by a Toulouse-Lautrec painting of 'a woman in a garden' (probably *Aux Batignolles* 1888), when it was on loan to the Tate Gallery in 1935, and plausibly both this and the passage in Webster were catalysts for *Figures in a Garden* c.1936 (fig.31).[25] He wrote in similar vein to Michel Leiris in 1976:

> I am currently working on quite a large triptych in which the accidents were based on The Oresteia of Aeschylus and Heart of Darkness by Conrad, and now that I am at work I find that Frêle Bruit comes in as well, all the time. So I do not know what accident will occur.[26]

The forty-year period separating these comments emphasises the endurance of his notion of the accidental, although it is hard to comprehend how an image that evolves from stimuli assimilated prior to its commencement qualifies as an accident.

Bacon destroyed many of his paintings and said he wished he had destroyed more of the approximately six hundred that survive. But some retained a lasting potency for him, among which *Painting* 1946, purchased by Alfred Barr on behalf of The Museum of Modern Art, New York, in 1948, was the first of his paintings to enter a museum. This alone could account for his fondness for it, but only months before he died he still cited *Painting* 1946 – completed forty-five years earlier – as the prime exemplar of accident in the evolution of his paintings.[27] The Detroit *Study for Crouching Nude* 1952 (p.118) was another persistent touchstone, both for its formal structure and the figure itself, and for many years he pinned illustrations of it on to his kitchen wall, the site of his most important 'source', his self-referencing image bank. In 1958 Bacon noted his idea to paint a 'man crawling on rail as in detroit',[28] and in 1962 he proposed another variant: 'I've been trying to use one image I did around 1952 and trying to make this into a mirror so that the figure is crouched before an image of itself.'[29] In addition to the instinctual, visceral thrill of gazing at them, Bacon's paintings continue to offer limitless opportunities for deconstruction. Reviewing the first catalogue raisonné, *Francis Bacon* (1964), John Richardson criticised John Rothenstein for sidestepping the issue of assigning Bacon his place in the artistic hierarchy, suggesting he had recoiled from offending 'the Establishment'. Richardson had no hesitation in declaring, 'Correctly situated in the context of modern British art, Bacon towers over the scene'.[30] Irrespective of the relevance of such assessments in a catalogue raisonné, ultimately his judgement has been vindicated by an oeuvre that continues to challenge and to stimulate new audiences.

FILM, FANTASY, HISTORY IN FRANCIS BACON *David Alan Mellor*

Going to the Pictures

Film and the cinema, its memories and most of all its still images, which Francis Bacon collected and archived, formed him as a painter. Bacon was quite sure that his personal iconography and cinema were intertwined. In 1975 he told David Sylvester: 'I think I might even make a film. I might make a film of all the images which have crowded my brain, which I remember and haven't used.'[1] From almost the time of the first critical writing on Bacon, in 1949, film was seen to be the indispensable point of reference for any understanding of him.[2] He went to the pictures, he was a cinema-goer: at thirteen he watched D.W. Griffith's *Intolerance* on its second or third run, in a Newcastle suburb, and it was there, he said, that he grasped the 'great possibilities of the cinema and I wished I could be a director'.[3] At eighteen he watched Abel Gance's *Napoléon* in Paris (fig.44); at twenty he watched Fritz Lang's melodramas and the wave of Soviet films, by Sergei Eisenstein and others, which were released in Berlin from the autumn of 1928. In Paris, soon after, he saw Luis Buñuel's *Un Chien andalou* and *L'Age d'or*; in the mid-1930s he attended the London Film Society.[4] Writing on Bacon, John Russell compared the cinema screens of the 'gigantic cathedral-like movie-houses of the 1920s and 1930s' with the high altars of actual cathedrals; as places where 'revelation was forthcoming. In this sense, D.W. Griffith and Abel Gance and Fritz Lang did for their generation what Rubens and van Dyck did for their contemporaries in Antwerp and Malines: and something in painting withered as a result. Bacon's purpose has been to bring that something back to life.'[5] Film had stolen something of the vitality and the powers of disclosure of painting; it could transcribe history. And it would be this cultural aspect – the power to figure history, formerly the prerogative of the 'Grand Manner' in painting – which would give force to Bacon's use of film; not as a director, but as a painter.

When Bacon made the vital transformation of his own art, in the mid- to late 1940s, he did so through a personal iconography supported by a contemporary interest in the history of cinema in Britain and France.[6] In essence, Bacon seemed to want to attend the primal scenes of cinema; its 'archaeology', in the title of C.W. Ceram's survey of the cinema of 1965, a copy of which he owned; scenes that had already been archived by popular magazines as well as by a newly conscious film literature. Beyond this, and into the 1950s, his taste for popular and arcane cinema incunabula fitted the tastes of two post-war London critics. One of them, Lawrence Alloway, the prophet of Pop art and associate of the Independent Group, helped organise Bacon's first retrospective at the Institute of Contemporary Arts (ICA), London, in 1955. Bacon and Alloway shared with David Sylvester – Bacon's other early champion – an interest in cinema stills. Sylvester had proposed an exhibition for the ICA, in the mid-1950s, of film stills; 'and if I couldn't curate it, then Lawrence would have.'[7] So Bacon's taste for film images, as richly suggestive documents for triggering the making of art about contemporary life and history, was not unique in advanced circles in London at this time; as Alloway would point out, such a critical engagement and insight arose 'from the routine of movie-going'.[8]

The Realm of the Cine-Cameraman

Bacon's cinephilia led him to a fascination with cinematographers, as is evident in the right-hand panel of his *Triptych – Studies from the Human Body* 1970 (fig.112), in which he sought to incorporate the mechanisms and makers of cinematic production as well as voyeuristic spectatorship, perhaps conflating the figure of the witnessing film cameraman with his own. The cinema of Eisenstein held a fascination for Bacon, and the painted portrait head of the cameraman appears to have taken the hawkish features and swept-back hair of Grisha Alexandrov, one of the two gifted cine-cameramen who worked with the Soviet director.[9] Alexandrov might have been one of the film makers and players in Bacon's internal, imaginary film-world – like Rudolf Klein-Rogge, the actor who resembled Bacon and who played Dr Mabuse in the first of Lang's super-criminal Mabuse films – that is, figures from the cinema whose facial appearances were close to Bacon's own and open to a narcissistic identification. Yet the identity of

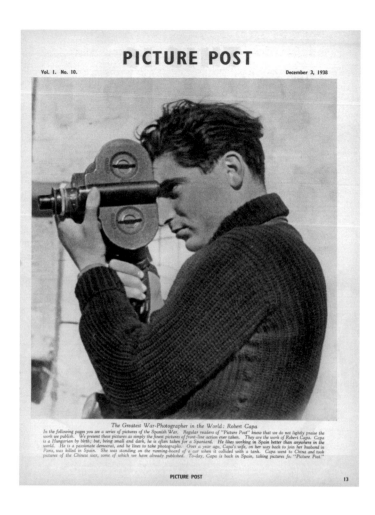

this portrait head of the cameraman is still open to question.[10] There are alternatives. Another possibility would be the photograph of Robert Capa operating a small movie camera in the large, annunciatory *Picture Post* photograph, captioned 'The Greatest War Photographer in the World' (fig.32).[11] In this image, as in Bacon's, cameraman and camera are fused, interdependent; a camera condensed with the human body. A similar effect is achieved in the fantasy promotions of German and Soviet iconography of the cameraman from the late 1920s, in the *Neue Sachlichkeit* (New Objectivity) and the *kino-glas* (cine-eye), with which the painter was familiar.

At some point in the late 1920s, while visiting Berlin, Bacon was photographed in extreme close up by the cinematographer and photographer Helmar Lerski at his Halensee studio (fig.121). Bacon later described their encounter as a fortuitous street meeting, but Lerski's Berlin address and photographs by him had been published in the original catalogue of the 1929 Stuttgart exhibition *Film und Foto*.[12] If their meeting took place two years later, it could be that Bacon had sought him out after the publication of his book, *Köpfe des Alltags* (Heads from Everyday Life).[13] The book was known in London following an enthusiastic review by Kenneth Macpherson in the avant-garde film magazine *Close Up*, in September 1931. Macpherson recommended Lerski's portraits on the grounds that they put the viewer into the psychic position of the infant encountering the colossal presence of parents, and that this was analogous to 'cinema at its best'.[14] Even at this early date, such an effect might have appealed to Bacon's agenda of staging the scene of parental, particularly patriarchal, authority, as with his series of Papal portraits and their glaring looks. Bacon recalled that it had been extremely uncomfortable and hot inside Lerski's top-floor studio and that he had been dazzled by a proliferation of lights, 'like those in a film studio'.[15] Lerski had been film cameraman on several key German films of the 1920s: he was special-effects cameraman on Lang's *Metropolis* (1926), a film Bacon had been astonished by, and Paul Leni's gothic horror *Wachsfigurenkabinett* (Waxworks Museum, 1923).

As the thematics of his painting evolved over the next two decades, Bacon returned to the kind of uncanniness he may have found in Lerski's practice and the combination of film, the vulnerability of his exposed body, and the overwhelming inquisitorial patriarchal presence. When he discussed the film-within-a-film in Michael Powell's *Peeping Tom* (1960), he recalled Powell's mocked-up *grand-guignol* footage of behavioural experiments, in which the director (played by Powell himself) startles his actual son with a lizard; for Bacon, Powell was 'terrifying his son just like my father did ... of course, he [Bacon's father] hated me'.[16]

fig.32 Robert Capa holding a film camera,
Picture Post, 1 January 1938

Phantoms and Dissolves

From 1949 onwards, film techniques – particularly superimpositions, double exposures and dissolves – with their affective suggestions of memories, melancholia and ghostliness, established a precedent for Bacon's deployment of painterly plasmatic forms. Martin Harrison has given a convincing context for Bacon's appropriation in his work of occultist photography and literature, and what can be allied to this is Bacon's continuing interest in the darkened and melodramatic formats found in the films of Lang.[17] Bacon's 1949 depictions of semi-transparent portrait heads and later, in 1955, his reworkings of James S. Delville's cast of William Blake (p.157) recall a similar motif in Lang's *Dr Mabuse der Spieler* (1922), in which a murderous patriarchal head is superimposed on the floor of the Stock Exchange, in the vast room's perspectivised space. Bacon's spectral apparitions held in *kabinett* confinements rhyme with Lang's, as in the climax of the second part of *Dr Mabuse*, which revolves around a public performance by Sandor Weltmann, the charismatic super-criminal Mabuse in disguise.[18] It was the critic Robert Melville who, in 1949, linked Bacon to silent-film melodrama, specifically identifying the styles and anti-naturalism of silent-film acting technique as a kind of key to Bacon's painting.[19]

The painter tore out still reproductions of early film actors, such as Mae Marsh and Rudolph Valentino. But it was, felt Melville, their histrionics that were significant; their revelation of underlying hysteria:

> [Bacon's] temperament leads him to propound an hallucinatory condition as a primary attribute of man ... In terms of visual association the parallels that propose themselves come from the silent cinema. The obsolete technique of acting in silent films – its system of explanatory gestures and facial movements – now seems like the badly concealed agitation of the actors themselves, breaking though the parts they play: in retrospect, the wooden gestures and grimaces of Edna Purviance, and the blood, the crumpled pince nez and the soundless scream of the woman shot through the eye in Eisenstein's 'Odessa Steps' sequence seem involuntary disclosures of the soul's maladies.[20]

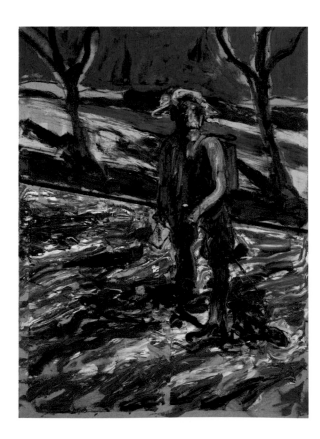

fig.33 *Study for Portrait of Van Gogh III* 1957 Oil and sand on linen, 198.4 × 142.5

Hirshhorn Museum and Sculpture Garden, Smithsonian Institution, Gift of the Joseph H. Hirshhorn Foundation, 1966

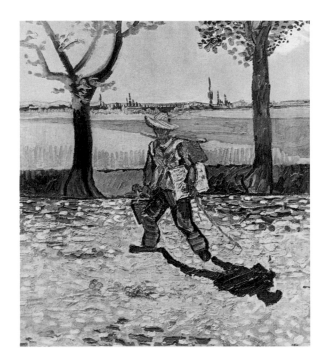

fig.34 Vincent van Gogh *The Painter on the Road to Tarascon* 1888 Oil on canvas, 48 × 44 Destroyed in the Second World War

Such grotesque revelations of inner states arose from a model of the human as an abject, plasmatic being, one that existed in movement, like a filmed figure. It corresponded to the theories of the French writer and painter Henri Michaux, whom Bacon admired. In his theory of portraiture, Michaux elaborated his intuition about essential man as a phantom, deformed and grimacing, like his monochrome anthropomorphic *automatiste* ink abbreviations, one of which Bacon owned. In 1946 Michaux had spoken about a kind of impoverished psychic portraiture as a form of self-projection:

> Since we lead an excessively facial life, we are in a perpetual fever of faces ... Behind the face with its motionless features, deserted, no more than a mask, another superiorly mobile face contracts, seethes, simmers in an unbearable paroxysm ... Lost, sometimes criminal faces ... Faces of sacrificed personalities ... [which appear] cinematographically.[21]

Bacon's cinematic vision of portraiture and his vision of the cinema comprised overlays of fugitive images, still and filmed, of fantasy and the loss of portrait image, as well as body, of fire and heat. It was this matrix that was active in his sudden plunging into the filmic referents for Vincent van Gogh, in the spring of 1957.

By the beginning of 1957, Bacon had already completed one painting of van Gogh, which was an adaptation of his self-portrait, *The Painter on the Road to Tarascon* 1888, a painting only known to Bacon as a vanishing photo-generated trace, a colour reproduction of a destroyed painting (fig.34).[22] His was testimony dense with suggestive meanings around the loss of a cherished object and the erasure of that original for a ghostly, fateful entity: 'I'd always loved that picture – the one that was burnt in Germany during the war – and as nothing else had gone right I thought I'd try to do something with it ... that haunted figure on the road seemed just right at that time – like a phantom of the road, you could say.'[23] But what had been timely and decisive in further advancing Bacon's attention on the image of van Gogh walking the sun-baked road, was the arrival in London of Vincente Minnelli's biopic film melodrama, *Lust for Life* (fig.35). This was a very proximate

reinforcement and gave Bacon an incentive to produce paintings for his show at the Hanover Gallery. Scheduled to open on 21 March 1957, Bacon had, in fact, produced hardly any paintings for it, but just over a week prior to that date, Minnelli's film opened at the Curzon Cinema in London's West End. Jean-Yves Mock, assistant to the Hanover Gallery's Erica Brausen, has confirmed that Bacon visited the Curzon to see *Lust for Life* just before starting his van Gogh series.[24] Given that – notoriously – the van Gogh paintings were still wet at the opening, it is entirely possible that Bacon, a prodigiously fast worker, could have seen the film while still making them and incorporated transformations of the cinematic narrative in the oils.[25]

fig.35 Advertisement for *Lust for Life*
(1956), published in *Art News & Review*,
early 1957

What may have caught Bacon's eye in Minnelli's film were the moments when the lost painting of *The Painter on the Road to Tarascon* was animated and improvised – perhaps with the outcome of suggesting to Bacon a series of long shots of the artist walking and seeking out motifs in bright sunny weather. At first, on leaving Arles, Kirk Douglas as van Gogh walks along a road parallel to the camera, miming the placements and tree configuration in *The Painter on the Road to Tarascon* but from a more distant viewpoint, and compressed, like the figure seen in Bacon's *Van Gogh in a Landscape* (fig.81). There is then a dissolve into the artist, in medium shot, moving to the right of the frame, along a diagonalised dirt track, so that, for a fraction of a second, the smaller, mannequin-sized figure of van Gogh from *The Painter on the Road to Tarascon* faces a larger, ghostly version of himself coming the other way, at an angle; a momentary encounter with himself, as the 'phantom on the road' of which Bacon had spoken. The cinematic also has its place in dynamising space and narrative in Bacon's van Gogh series, in the creation of what amounts to a long shot in *Van Gogh in a Landscape*. Less than six months after the Whitechapel Gallery exhibition *This is Tomorrow* announced the first vectors of Pop art, Bacon had seized upon the Pop possibilities of van Gogh as a sanctified image overlaid by Hollywood melodrama and processes of colour reproduction, of something which had been lost but rose again through the mediums of Technicolor and CinemaScope.

Narratives of Fatality

If the spectacular cinema of Lang, Eisenstein or Minnelli represented one pole in Bacon's interest in the cinema, then the sombre and subdued late 1930s French cinema of Poetic Realism, chiefly that of Marcel Carné and the later 1950s and 1960s *neo-noir* of Jean-Luc Godard, could stand for the other.[26] Bacon's collection of stills contains the entrapping spatialities of Carné, the intimate, often domestic, containing vistas that were also admired by John Minton and were part of the visual structure of taste in post-war neo-romantic London. In particular, Bacon had a still from Carné's *Le Jour se Lève* (1939), from

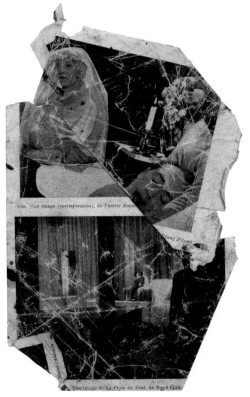

fig.36 Loose leaf from Nicole Vedrès, *Images du Cinéma Français* (1945), showing Jean Gabin in Marcel Carné's *Le Jour se Lève* (1939), 26.9 × 20.8 Dublin City Gallery The Hugh Lane

fig.37 Loose leaf torn from a book in French with black-and-white photographic illustrations of film stills, 24 × 14.9 Dublin City Gallery The Hugh Lane

a sequence that supported a proto-existentialist narrative comparable with the isolating cells and surroundings in the writings of Jean-Paul Sartre, Arthur Koestler and Camus.[27] François (Jean Gabin) is shown in his room, under siege from the police after shooting the former partner of a lover. Bacon's chosen still is of Gabin contemplating his extreme situation, lying on his bed, the wall riddled with bullets, the mirror decorated with Photobooth portraits of his lover (fig.36). Such horizontal figures on beds recur regularly in Bacon's collection of stills: beds that are both zones of anguish and sites of abandoned bliss. For example, from one torn-out page (fig.37) there are two images: the top captioned 'Une image (surimpression), de Thérèse Raquin', and, below, 'Une image de La Proie du Vent, de René Clair'.[28] The top one, the still from *Thérèse Raquin*, was folded by Bacon so that a sleeping (male) figure is split, flanked by semi-transparent, superimposed veiled women, 'witnesses'.[29] And while Harrison has conjectured that Bacon's painting *Sleeping Figure* 1974 (fig.38) was based on a photograph of the painter in bed in hospital, a significant supplementary influence may have been this 'Working Document' of this disarticulated sleeper.[30]

While *Thérèse Raquin* belonged to that conjuring world of 1920s avant-garde films that Bacon admired, the staircases and darkened rooms of more popular French Poetic Realist crime dramas prefigured, for him, the *film noir* universe. The art historian Michael Leja has compared the shift in codes of painting in the later 1940s – in terms of spatial metaphors – to the darkened imaginary space of hideaways, cells and incarceration in *film noir*: 'that eternally imprisons the noir characters … the ideal literal expression of this condition – the prison, the modern labyrinth – is seldom out of mind in these films, it is a threat.'[31] Leja has gone on to suggest, in the context of Jackson Pollock's work, that this is an engagement with what he has dubbed 'Modern Man discourse'; that is, a certain packet of existential, philosophical and ethical concerns: 'When its metaphorical dimensions are restored, Pollock's work represents the space of that discourse – the space of entrapment and ensnarement, the space of disorientation, the space of the interior, mental landscape … Pollock achieved his

thoroughly metaphorist ambition to render "the experience of our age in terms of painting".'[32] It could be argued that Bacon can be aligned with this same ambition to 'represent the experience of our age' through his deployment of claustral spaces, in the late 1940s, by that peculiarly anxious space occupied by Bacon's constrained male figures. As Robert Melville observed in 1949, 'Every activity in these paintings of men going in and out of curtains, or imprisoned in transparent boxes, has an air of extreme hazard'.[33]

Fatality, mourning and existential hazard met under the sign of communist martyrology in Eisenstein's films. Bacon recalled seeing in the early 1930s a vanguard magazine reproduction of frame enlargements and stills of Eisenstein's *Que Viva Mexico* (or *Thunder Over Mexico*, as it was then known).[34] He was still full of admiration for the cine-cameramen on

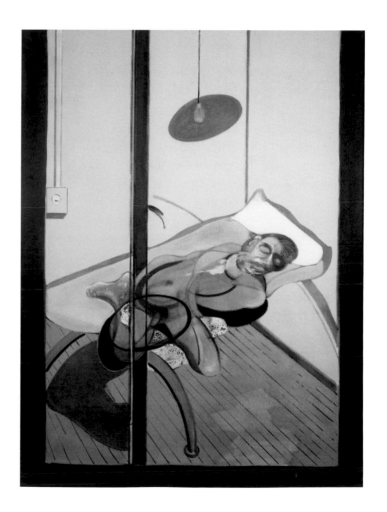

fig.38 *Sleeping Figure* 1974
Oil on canvas, 198 × 147.5
A. Carter Pottash, New York

Eisenstein's films – in this case Edouard Tissé – and the contribution to the film made by the American author Upton Sinclair, as late as the end of the 1980s.[35] Already impressed by tripartite *tableaux* on his earlier viewing of Gance's *Napoléon*, Bacon found in the still images of *Que Viva Mexico* repeated assemblages of compositional triads. For example, the outstretched necks of the three peons (workers) martyred by the landowners' goons in the Maguey episode of the film anticipate the trio of the wretched and condemned in Bacon's *Three Studies for Figures at the Base of a Crucifixion* 1944 (pp.146–7). 'Certainly, death was one of Eisenstein's great interests in Mexico and the film he worked on there reflected that fascination,' Anne Nesbet has observed, identifying Eisenstein's 'passionate interest in things macabre', an interest paralleled in Bacon's meditations on the photo-mechanical macabre.[36]

The Reign of Crime

Bacon 'loved' the film *Performance* (1970), directed by Nicolas Roeg and Donald Cammell, which explicitly incorporated aspects of his own pictorial world, and more than fifteen years later discussed it in detail with the lead actor, James Fox.[37] Cammell contrived the beating of the London gangland enforcer – a 'performer' – called Chas (James Fox) in a Bacon interior, bloodied by red paint thrown across the walls, with male bodies in an embrace of ecstatic violence; additionally, as the beating proceeds, close ups within the interior reveal crumpled and creased photographic prints of Chas in homoerotic athletic poses.[38] Bacon had an acute, scopophiliac, interest in males driven by extreme passion to violence and murder, such as those in the fictional roles taken by Jean Gabin, who 'would not recognise any script but one which incorporates his own destiny – a fit of anger, murder, leading to his own death … A crisis scene of homicidal fury', or the case of the late 1940s serial killer John George Haigh, an occasional resident of the Onslow Court Hotel in Bacon's South Kensington neighbourhood.[39] Together with the writer Graham Greene, Bacon visited the Metropolitan Police's Black Museum to see Haigh's murderous paraphernalia, and the

case appears to have become attached in Bacon's mind, over the years, to Michael Powell's film *Peeping Tom* (1960), about a cine-cameraman who is a serial killer.[40] When it was released, there was a wave of press revulsion.[41] 'I suppose it was banned,' Bacon later said, which was not in fact the case,[42] and his speculation that *Peeping Tom* had been censored may have been triggered by the memory of the London County Council ban on Eisenstein's *Battleship Potemkin*, following the London Film Society's showing of it in 1929.[43]

Additionally, larger contemporary censorship furores over *L'Age d'or* (1930) may also have been active in Bacon's memory. Bacon was consistently enthusiastic about this and Buñuel's other film of the time, *Un Chien andalou* (1929). Among Bacon's archives were pages from Raymond Durgnat's 1968 monograph on Buñuel, including a calculatedly creased and anamorphised still portrait head of the actress Lya Lys sucking the big toe of a statue of Diana, from a scene late in *L'Age d'or*.[44] Another kind of censorship was rendered by his manipulation and deformation of this sort of still source material featuring the screened face at moments involving intimate acts; kissing, particularly.[45] He indicated his fascinated, but conflicted, scopophiliac gaze upon Buñuel's films when he spoke of viewing *Un Chien andalou* in Paris: 'I was filled with horrors.'[46]

Transgression, the abject and crime all came together. In 1954 he made a note to himself – 'The Bed of Crime' – possibly as a subject to paint.[47] There is a master trope of social guilt and criminality in Bacon, evident in his tearing out of a sensationalist Weimar magazine a photograph of Soho acquaintance Jack Bilbo's photographs of himself – an artist – posing as a Chicago gangster (figs.2, 88).[48] Bacon's encompassing vision, in its panorama of political atrocity and crime, has the imperative of the melodramatic instruction given by Dr Mabuse to his psychiatrist, in *The Testament of Dr Mabuse* (1933), to initiate a 'Herrschaft des Verbrechen' (Reign of Crime). In Lang's earlier *Dr Mabuse* (1922), the 'great unknown' – Mabuse – escapes from the gambling club Palais Andalusia, and is driven away. The street is more crowded, with houses, but essentially it is a reversal of the street we see in Bacon's

Street Scene with Car in the Distance 1988 (Faggionato Fine Art, London), with a similar sinister car obliquely quitting the scene.[49] Lang's repeated evocation of dread, by the use of a closed departing car, is a motif Eisenstein may have borrowed from him in *Strike* (1924) and it may have become condensed within Bacon's visual repertory.[50]

The Grotesque Cinematic Body

Eisenstein's film *Strike*, like his *Battleship Potemkin*, represented a despotic power that Bacon suspected was at work at all points and times. This was imaged through a deployment of the grotesque as a form of visual rhetoric. The abattoir scene in *Strike*, which cuts between the slaughter of cattle and the massacre of rebellious workers, and crowns the narrative, may be a crucial point of contact between Bacon and Eisenstein.[51] As he himself confessed to a still-Soviet Russian readership in 1988: 'In my youth it seems to me that I was strongly directed towards painting after having been struck by the remarkable visual imagery of the films of Eisenstein: *Strike* and *Battleship Potemkin*.'[52] Bacon was moved by the metaphors generated by the ostentatious display of sides of rotten meat that were crucial to the narrative of *Battleship Potemkin*, and their instrumentality in inspiring a revolt among the sailors against oppressive power structures. Gilles Deleuze has insisted upon Bacon's representation of the animal body as fundamentally intermingled with the human in a zone of indiscernability, a 'becoming-animal'.[53] Nowhere was this more so than in his collection of stills and photographs of actors or gangsters with monkeys; there was, for example, a decidedly Darwinian overtone to the *singeries* of French film buffoon Michel Simon and his intimacy with a chimp (fig.39).[54]

A perturbed, grotesque version of the human body was on display in Tod Browning's film *Freaks* (1932), about which Bacon was enthusiastic.[55] The spectacle of a mutable body – exclusively the mutable male body – and its supports, was discovered by Bacon in the early scenes in *Battleship Potemkin*, in the below-decks sleeping quarters: 'It was a film I saw

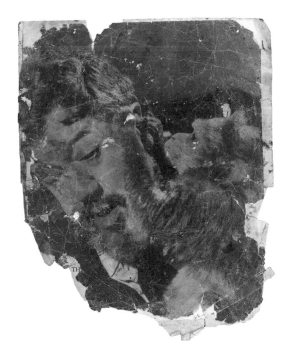

almost before I started to paint, and it deeply impressed me – *I mean the whole film as well as the Odessa Steps sequence*,' he said.[56] The spatial apparatuses that abound to support the male body in *Potemkin* may have had a compelling effect on Bacon. For example, the iconography of hammocks in his *Triptych* 1970 (National Gallery of Australia, Canberra) may have an aspect of them.[57] In the film, below decks, as the inter-title indicates, sailors are 'sleeping heavily', and one bare-backed recruit is lashed and rises up from his hammock, as in the right-hand part of the Canberra triptych. The centre panel includes two more naked males, as in the below-decks assembly of flesh in the film. The leader and martyr of the mutineers, Vakulinchuk, falls, mortally wounded, into the rigging, where he lies awkwardly but still supported. Bacon may have felt a kinship with Eisenstein's iconograpy of male bodies circumscribed by industrial-military apparatus, and identified a shared visceral masochism and a predilection for representing the brutality of despotic power. The billowing, deflating canvas that shrouds the Potemkin mutineers before the summoned firing squad resembles the typical indiscern-

fig.39 Mounted loose-leaf illustration of the French actor Michel Simon with a monkey (date unknown), 32.5 × 25 Dublin City Gallery The Hugh Lane

able forms, such as the male nudes, in Bacon – horizontalised and organic in outline.

These forms were anamorphotic distortions, cloaking and pleating the body and its fleeting states, seeing it astigmatically.[58] This vision was one Bacon found – extended beyond the male body and into the semiotics of female experience and historical time – in Alain Resnais's film *Hiroshima Mon Amour* (1959). In 1982, asked if the terror and destruction of the Second World War had ever been adequately represented in a plastic medium, Bacon replied: 'No, not in paint, but in that film by Marguerite Duras, *Hiroshima Mon Amour* with those sequences, those flashbacks. They, the film-makers got close to it … The camera does these things so much better– I mean the cine-camera … Film is a wonderful art.'[59] One significant aspect of this comment by Bacon is his giving priority, as creator, to Duras, the screenwriter, rather than to the director Resnais. Bacon came to know Duras personally, in Paris in the 1970s, through the mediation of Sonia Orwell, and took an interest in her writings. She had developed a theory that speech and meaning resided in the pre-symbolic *chora*, the (female) body, a belief that the philosopher Julia Kristeva developed still further in her book *Desire and Language* (1980). Again, Bacon's painting addressed this un-figurable body by colliding or juxtaposing an inchoate (but almost universally male) body with the invested power of the memory traces of photography and film. As we now know, Bacon used a creased and pleated still from the film *Hiroshima Mon Amour* (fig.40) in the process of making portraits of Henrietta Moraes. Bacon's creasing made the physiognomy of the actress, Emmanuelle Riva, malleable, like a counterpart of those drastic facial and bodily distortions that disfigured the filmed survivors of the atomic bomb attack on Hiroshima. The article in which the still from *Hiroshima Mon Amour* appears, from an unidentified film book, contains a telling description of Resnais's technique, in its resemblance to 'that over-wrought manner which is characteristic of some female writers … astigmatic vision … trying to see life entirely through their emotions'.[60] It was the traumatic memories of the Second World War, mediated through flashbacks, ele-

ments in a melancholic narrative which, in their turn, indicated a failure of signification, a loss, a blind spot.[61] What the film demonstrated was ambivalence towards photographically documented memories as (inadequate) signs for the reconstruction of history, which still awaited their deformation through subjectivity. In the course of the film Riva, in the role of 'Elle', ironically recounts her experience of the museum at Hiroshima, where 'people walk pensively past photographs, reconstructions, since there is nothing else … but photographs, photographs, reconstructions … the reconstructions were made as conscientiously as possible … the films made as conscientiously as possible.' Echoed here, for Bacon, would have been his wish to represent the unrepresentable history of the twentieth century through the powers of subjectivity, and the powers of horror.

fig.40 Mounted black-and-white photographic film still of Emmanuelle Riva in Alain Resnais's film *Hiroshima, Mon Amour* (1959) on cardboard envelope and affixed with two paper-clips (date unknown), 32.4 × 24.6 Dublin City Gallery The Hugh Lane

Guns and Lenses and Mouths

In Bacon the cine-eye can be deadly. In *Hiroshima Mon Amour* it prompted intrusive melancholy memories and thwarted mourning. More drastically, in his transformations of source material from Eisenstein's *October* and *Potemkin*, and from his rootings in the prehistory of cinema, there comes about a rough equivalence, for Bacon, between the cine-lens and the barrel of a gun. It had been the right-wing authoritarian German writer, Ernst Junger, who in 1930 had detected deep connections between the killing technologies of war and the technologies of photography and film. He outlined his opinions in the foreword to a book of graphic First World War photographs, *Krieg und Lichtbild*: 'Included among the documents of particular precision … are photographs, of which a large supply accumulated during the war. Day in and day out, optical lenses were pointed at the combat zones alongside the mouths of rifles and cannons.'[62]

It seems possible that one of the single canvases that derived from Bacon's attempts to paint a triptych on the theme of the 1936 death by firing squad of Federico García Lorca, is *Painting* 1980 (Faggionato Fine Art, London).[63] The double-barrelled shotgun is an agglomerated, fetishistic hybrid, with a stock that could hold cine-film magazines, like Etienne-Jules Marey's early cine-camera, the *Fusil Photographique*.[64] Deleuze related the camera in Bacon's *Triptych, March 1974* (fig.111) to Marey's camera-gun and rifles: 'a camera that sometimes resembles a prehistoric beast, sometimes a heavy rifle (like Marey's rifle, which decomposed movement).'[65] Bacon came to 'appreciate' Marey above Muybridge, and at the 1991 exhibition *The Moving Image*, in a space given over to the two, Bacon was engrossed by a specimen of Marey's *Fusil Photographique* as a condensation of gunshot death and image-making.[66]

This connection between gun and vision was made in D.W. Griffith's *Intolerance*, which Bacon saw just three years after it had energised Eisenstein in Moscow.[67] The inter-title caption for the industrial strike sequence in *Intolerance* was 'Story of Today', casting contemporary history as a melodramatic filmed document of insurgency and gunfire, with a narrative thread that included the massacre of strikers at an industrial plant. Given Bacon's later fixation on *Potemkin*,

Strike and *Napoléon*, what emerges is a recurrent iconography of the repression of the innocent by the brute power of gunshot. Based on the killing of up to sixty strikers by National Guard militias at a Colorado coal mine in April 1914, at the fictional Jenkins Mills (where the proprietor's desk is set in a Baconian agoraphobic, circular space of light), local contingents of the State Militia raise their rifles and bring up a machine-gun on a wheeled carriage like the one that fires on the protesters in the July Days sequence in *October*. A striker falls, mortally wounded, and the inter-title reads: 'The Loom of Fate weaves death for the Boy's Father.' Fates and father's deaths were associated in a blaze of cinematic violence in, for Bacon, an aesthetic of intertwined catastrophes and their paramilitary agents; catastrophes in history, befalling civilians on film. Griffith's montage – which in turn triggered Eisenstein's montage – looks down the barrels and into the suppressive fire that is being laid down. It is a viewpoint echoed in *Painting* 1980, and it becomes an allegory of seeing and death. As Anne Nesbet has argued, 'The guns of the *Battleship Potemkin*, then, are the guns of a peculiarly deadly stereoscope: it is perilous to look down their barrels, but we must – for they are sternly looking at us, their human screen.'[68]

In fact, in *Potemkin* there is initially a flinching away from depicting those same eyes that look into gunfire. A short way into the Odessa Steps sequence, the inter-title 'I vdrug' ('Suddenly') is followed by a sign of oppressive violence (jackboots) and then a series of close ups of a woman's face (the actor Olga Ivanova) almost entirely concealed by her black hair, but with her mouth gaping open (fig.84). David Cook has described the appearance of this occluded face, which only displays a shocked mouth: 'The dark, bobbed hair of the woman in white fills the screen from one edge of the frame to the other.'[69] Bacon may have utilised this series of abrupt frames in *Painting* 1946 (p.101), in which a similar head is concealed by blackness, apart from its open mouth. In a sense, this is the primordial cinematic scream for Bacon, rather than that of the sabre-slashed nurse on the same steps a few minutes later (fig.80). Significantly, this image is followed by a mid-shot of a white parasol, which comes into close up.

In *Painting* 1946, we might imagine this as a reversed-out image, as if in a persistent, monochrome after-image, of the black umbrella in *Painting*, which in turn echoes the bell-like splaying of Olga Ivanova's black hair. *Potemkin* laid down an indispensable layer of iconography and pictured trauma for Bacon.

The (Filmed) History of Europe in My Lifetime

There is a trail of violent images that leads back from what some have seen as a 'machine-gunner' in Bacon's *Figure in a Landscape* 1945 (p.97), via Eisenstein's July Days reconstruction in *October*, to Griffith's strike narrative in *Intolerance*. In these examples we encounter armed bands, an iconography familiar to Bacon since his experiences of seeing the shotgun-wielding IRA volunteers in the countryside in which he grew up. They recur in the machine-gun Cadets and the Red Guards in Petrograd; the implacable Cossacks on the Odessa Steps;

the brown-shirted *Sturm Abteilung* in Berlin at the turn of the 1930s, and the *Falange Española* in Spain who murdered Federico García Lorca in 1936. These new armed agents of history haunted Bacon, even up to the 1980s when he was curious to know more about the Red Hand Commando of Ulster, an extreme Protestant paramilitary unit.[70] They might, we could conjecture, be incarnations of the arbitrary military brutality of his father, but they could also be – in Bacon's thanatophile fantasy – licensed Sadian males.

A necessary detachment from the infliction of violence seems to have found a particular locus in the abstracted reportage photograph of the massacre by the machine-gun Cadets of protesters at Nevsky Prospekt, in Petrograd in July 1917, and Eisenstein's filmed reconstruction of it (fig.41).[71] Bacon was filled with wonder at Viktor Bulla's news photograph of the event (fig.42): 'Not one of these hundreds of people look remotely like a conventional figure; each one, caught in violent motion, is stranger and at first sight less intelligible

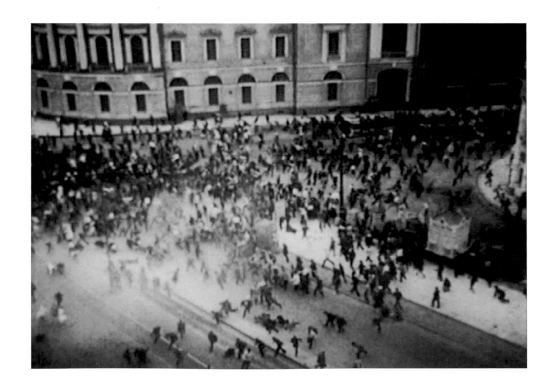

fig.41 Sergei Eisenstein
Nevsky Prospekt crowd fleeing seen from
above, film still from *October* (1927)

than one could possibly have imagined it.'[72] It was the singular power of the Bulla photograph to do this; to go beyond orthodox renderings of the human and to make the body stressed, anamorphotic, grotesque, unintelligible, in a representation that appeared to be moulded by violence and shock. John Russell reported that Bacon prized the Bulla photograph for 'the strange kinship between this panic-striken populace and the distortions of cave painting'.[73] Bacon owned at least two versions of the Bulla photograph and it was this still photograph on which Eisenstein based his filmed reconstruction.[74] Jay Leyda, the historian of Soviet film whose books Bacon owned, wrote that Eisenstein's reconstruction, shot from almost the same height as the Bulla photograph, was taken as an accurate record of the event, rather than a reconstruction, and that Eisenstein himself was well aware of this.[75] Murray Sperber has described the sequence:

The camera is perched above the intersection of Sadovaia and Nevsky Prospects and there are sharp newsreel-like shots of masses of people fleeing across public spaces. Then comes the famous montage of the machine gunner intercut with his firing gun. In the montage fusion, the soldier becomes his machine, he is reified into a brutal dehumanised object ... The director relentlessly shoots down into the fleeing crowd to produce the sense of the distant and brutal bourgeois government always aloof from the masses below.[76]

The capped, obscured machine-gun Cadet, morphing, at a subliminal flicker of only a couple of frames, into his weapon (fig.43), may have a link to Bacon's *Figure in a Landscape* 1945 (p.97), in which an ambivalent microphone, to the right of the *Cagoulard* figure, can – in any analysis that admits the surrealist dynamic of a polyvalent iconography – be read as doubling as a machine-gun barrel.[77]

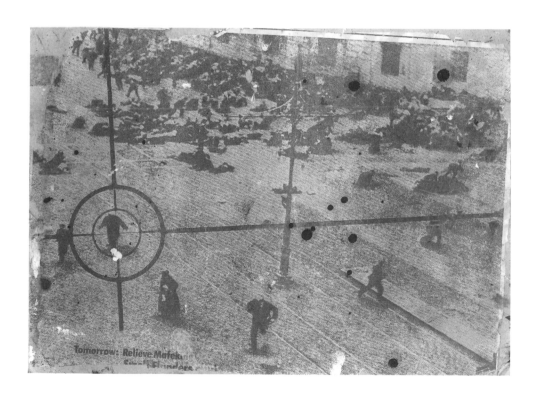

fig.42 Mounted black-and-white illustration of Viktor Bulla's photograph of Nevsky Prospekt demonstrators being fired on in Petrograd, 17 July 1917, 28 × 38.8
Dublin City Gallery The Hugh Lane

Bacon laid claim to being the painter of modern life in a political sense, through his ingestion of film. Specifically:

> In the Soviet films of the 1920s and especially in Eisenstein's, there was adumbrated the great subject which Bacon always has at the back of his mind: 'The History of Europe in My Lifetime' … the subject … presides over everything that Bacon has done: portraits, figure subjects, landscapes, even. And the initial push – the idea that a single image could summarise the self destructive courses of an entire continent – came as much from the silent cinema as from anywhere else.[78]

Besides Eisenstein, the French director Abel Gance also had a critical influence over Bacon's development as an artist with a claim to depict history, specifically over his turning to the use of triptych formats (fig.44). In 1985 Michel Leiris confirmed that Bacon had derived his use of tripartite framing from Gance's use of it in his film *Napoléon* (1927), which Bacon had seen on its first run in Paris, where it premiered in April 1927.[79] Gance had aimed for a sublimely violent cinema of history, which used disjunctive formal expression: superimpositions, double exposure, and rapid montage, what he called a 'paroxystic' cinema.[80] Gance had the capacity to condense

gun, bullet and the cine-camera's eye. As, one journalist recorded, *Napoléon* included an 'incredible crescendo of rapid cutting': 'The soldiers open fire, an enormous gun fills the screen. A face in extremes of terror, a jolt, a forehead covered with blood, the eyes turn upward. Then the lens itself becomes a bullet, rushing towards one victim, then another, until it enters their skulls.'[81]

Bacon's work was related directly to the concept of the paroxystic by France Borel, when she saw in it the 'Moment of Paroxysm … Fact exceeds appearances, increased presence, paroxysm; to the limit of breaking point'.[82] This paroxystic aesthetic – one reportedly reinforced by the art historian Elie Faure in correspondence with Gance in the mid- to late 1920s – suggests parallels with Bacon's continued insistence, from the late 1940s onwards, on a convulsive unlocking of valves of sensation and particular kinds of extreme sensation. Bacon's art, it might be said, revolved around paroxysms of the body,[83] but the paroxystic as mediated photo-mechanically, through film, and as a spectacle of history.

fig.43 Sergei Eisenstein
Machine gunner's face, film still from
October (1927)

fig.44 Abel Gance
Triple screen effect, film still from
Napoléon (1927)

COMPARATIVE STRANGERS *Simon Ofield*

There is a copy of *Physique Pictorial* in Francis Bacon's studio, on top of a pile of books by one of the radiators, near to a book on Velázquez (fig.45). The magazine is clear to see and placed on top of David Gower's 1980 autobiography *With Time to Spare*, which is in turn placed on top of what seems to be a book about Mick Jagger, but from the photograph this is a little difficult to identify for sure. We have no way of knowing if this *Physique Pictorial* had been hanging around Bacon's studio since its original purchase or if it was a later acquisition. We do know that Bacon moved to 7 Reece Mews in the autumn of 1961, and the materials that informed his paintings created a kind of multi-layered and shifting sketch- or scrapbook in this eight by four metre studio. We also know that *Physique Pictorial* could be purchased in Britain from 1952 onwards and was advertised in a number of somewhat similar British publications. In another essay I have explored the ways in which popular physique and wrestling images provide a context for making sense of Bacon's paintings *Two Figures* 1953 (fig.46) and *Two Figures in the Grass* 1954 (p.134).[1] It is therefore reassuring to have photographic and archival confirmation that a copy of *Physique Pictorial* had a place in the artist's studio.

In the 1950s and 1960s *Physique Pictorial* played an important role, alongside *Adonis* and *Male Classics* and other magazines, in making connections between photographic images and certain (and uncertain) knowledges of social, sexual and aesthetic practices and pleasures. In 1956 an editorial appeared in *Physique Pictorial* that made an explicit contribution to the ongoing public debate around practices and personalities that had over the past three years become increasingly identified in public as 'homosexual'.[2] It may have been that, around this time, just a year before the publication of what would become known as the Wolfenden Report, the integral ambiguity of physique magazines required some form of identification.[3] Under the title of 'Homosexuality and Bodybuilding', the following appeared:

> In a recent issue, *Iron Man* magazine sounded the alarm that homosexuals are invading the bodybuilding field and that 'this evil must be stamped out'. While we do not claim the apparent intimate acquaintance with homosexuality of some of the editorial writers who seem to be preoccupied with the subject, we wonder if this quality is more

fig.45 Perry Ogden
Bacon's studio at 7 Reece Mews (detail
showing a copy of *Physique Pictorial*)
Dublin City Gallery The Hugh Lane

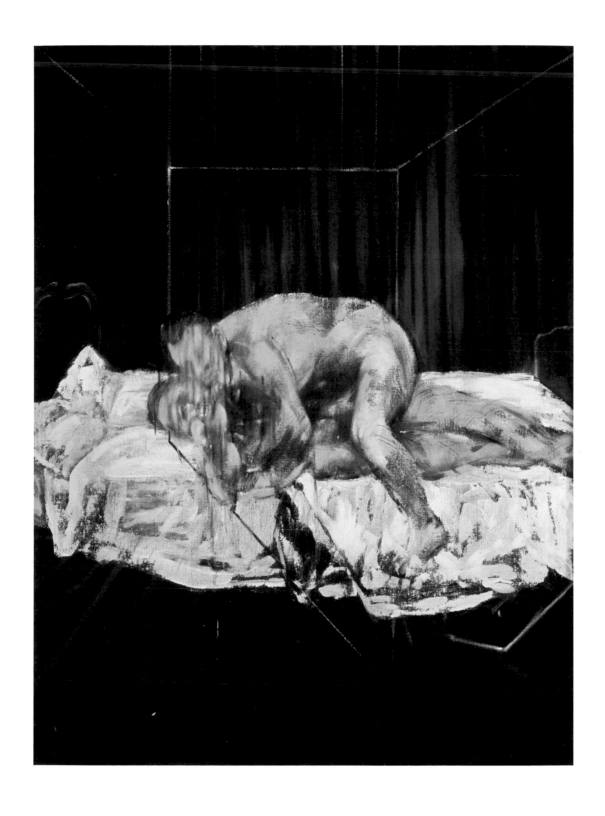

fig.46 *Two Figures* 1953
Oil on canvas, 152.5 × 116.5
Private collection

found among bodybuilders than in any other segment of our population … At any rate, we wonder if really good people show prejudice against any minority group … So let us consider only what we have in common with one another and not seek to erect unnecessary barriers. And before attempting to condemn others for their particular 'sins' which we do not share in, let us attend to putting our own life in exemplary order. We understand that those who want factual information about the so-called homosexual problem can get free literature without their name and address going on a mailing list by sending a large self-addressed stamped envelope to One … or Mattachine Review.[4]

Though perhaps somewhat disingenuous, this editorial provided readers with the opportunity to link the photographs and drawings in the magazine with more official, and indeed political, knowledge of homosexuality. Simply printing the word 'homosexual' on the pages of *Physique Pictorial* may have provided a reader with new forms of understanding – and new opportunities. In the next issue of the magazine a number of letters were published that may have also helped readers to formulate an increasingly collective understanding of their interest in its content. I do not want to conceive of an overly naive reader – certainly not Francis Bacon – but it is important to realise that the pages of physique magazines in the 1950s were formative and experiential 'environments' that enabled readers to form new kinds of knowledge, and indeed new kinds of pleasure. Perhaps more than any similar magazine, *Physique Pictorial* demonstrated an awareness of being part of a community of publishers and readers, and its pages often referenced other magazines including those produced in Britain. In 1956 *Physique Pictorial* promoted the launch of the British magazine *MANifique*, produced and edited by 'John Paington' (the pseudonym for John S. Barrington) who was, according to the editorial, 'one of England's most talented artists as well as an accomplished photographer'.[5] Further, in 1957 the magazine promoted the work of Tom Nichol of Scott Studios, and published the following alongside some of his photographs:

John was sunning himself in London's beautiful Hyde Park by the Serpentine when he met the handsome young photographer Tom who does the beautiful photos for Scott Photos, 171 Holland Road, London, w14, England.

While John had done some considerable fashion modelling in London, he did not consider himself qualified to be a physique model, when Tom insisted he gave in. The pictures reproduced here have already appeared in magazines all over Europe and the USA, and Tom's many other fine pictures have made the young traveller famous.[6]

Clearly this text has the potential to attach pleasures found on the pages of the magazine to those that may be found around the Serpentine lake in Hyde Park, and so provide readers with knowledge of a well-established place where men could meet one another.[7] Indeed, the relationship between the pleasures of popular publishing and physical environments in and around 1950s and 1960s London are intriguing and, I want to suggest, important for understanding Bacon's paintings and the work of some other artists of the period.

More often than not the sexual content of Bacon's work is understood either with reference to a narrative of homosexual liberation that equates the obscurities of his paintings with a time prior to when, in the early 1970s, gay identity found a more coherent form, or with a glancing reference to his apparent interest in violent forms of sexual encounter that are represented by the aggressive forms within his paintings. I would not want to negate either understanding entirely but I believe there is something more to be said if the relationship between some magazines, places and kinds of men are considered with care.

In the Hall-Carpenter Archive there are just a few British and American muscle and physique magazines from the 1950s, and some of the photographs and drawings from them have been cut out of the copies in the archive and I presume either stuck on walls or more probably pasted into scrapbooks.[8] These magazines were an important resource for men interested in looking at other men, and a means for constitut-

ing male comportments and figures. They were also places where desire took shape – sites of production and seduction. There are historical difficulties in trying to comprehend the meanings readers made in and around these magazines when they were first published – meanings made as they moved between articles and adverts, photographs and drawings, in just one magazine and between magazines, and in the moves they made between magazines, other texts and the pleasures and practices of their everyday lives. I am sure it is safe to presume that some men opened them and found exactly what they wanted, but I want to propose that others were seduced by the complex economy of identification and desire of the magazines, and the access they provided to new pleasures and lives. In addition to just looking, many men clearly engaged in the personal process of cutting out images and texts to create their own scrapbooks, their own private publications through which they came to understand and also form themselves and their interests and desires.

In 1957 the publication of *Adonis* moved to England and *Male Classics* soon followed, establishing itself in an editorial office on Wardour Street in Soho. For a couple of years in the early 1960s *Male Classics* began to exploit design techniques reminiscent of personal scrapbooks, with cut-up photographs positioned somewhat haphazardly becoming elements within an almost amateur montage that often involved either drawing directly on to photographs or using them as elements within drawings (fig.47). These designs recall the processes of appropriation that many men used to produce scrapbooks, or sketchbooks, of their own. Jack 'Boy' Barrett's scrapbook, which in the 1961 film *Victim* had to be retrieved from a public toilet by the police, is just one example. Consisting of newspaper clippings of the fatally attractive Melville Farr, played by Dirk Bogarde, the police pieced it back together and would have used it as evidence against them both if 'Boy' had not committed suicide.[9]

I think it is clear that Bacon's studio is also a form of scrapbook, and I have in the past suggested that the ways in which he formed his paintings has a formal relationship to this kind of production. The disharmonies of Bacon's paintings and his explicit appropriation of images propose a connection between them and more banal and personal forms of cultural production, in which different textual and pictorial elements

fig.47 Tom Nichol of Scott Studios
Photographs and drawings from
Male Classics, June 1960

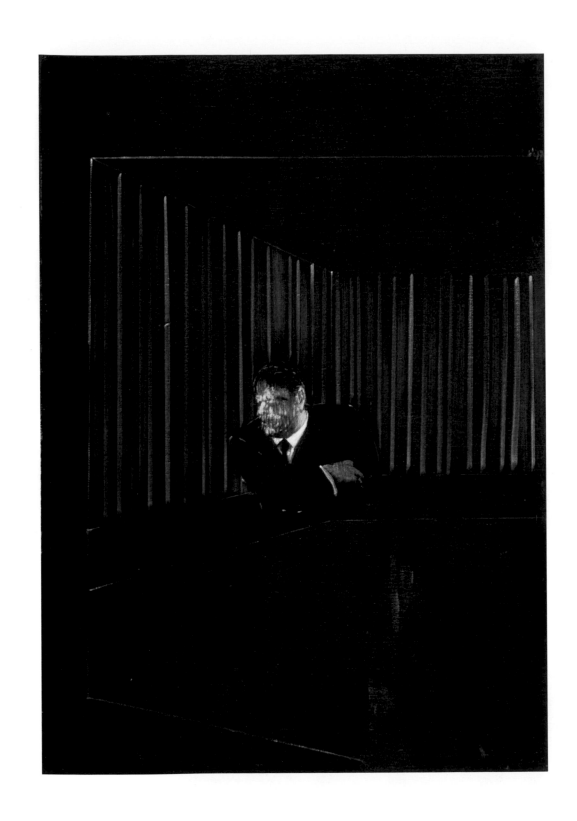

fig.48 *Man in Blue I* 1954
Oil on canvas, 198 × 137
Museum Boijmans Van Beuningen,
Rotterdam

are pieced together in ways that do not insist that the individual bits and pieces make just one kind of sense but encourage different associations within and beyond the picture frame. My point is that in the early 1960s *Male Classics* and other magazines formalised in their design what many men, including Bacon, had been doing for some time – making sense and pleasure from within a complex intertextual environment and explicitly sticking together different images and texts to make their own meanings. Looked at in this way, Bacon's paintings of the 1950s are quite directly related to David Hockney's of the early 1960s that demonstrate a similar informality and range of formal characteristics – the rapid sketch-like inconclusive line combined with a collage form of explicitly appropriated images and texts. Of course, Hockney's commitment to physique magazines as source material and his interest in Bacon's work is a matter of art-historical record. Whilst the comparison between the work of Bacon and Hockney is of interest, I believe the comparison between Bacon and Keith Vaughan is more useful as it is not one of precedent but perhaps of antipathy – and furthermore they share an interest in the more local figures and figurations found within the pages of physique magazines.

Francis Bacon and Keith Vaughan were comparative strangers, though they knew some of the same people, including Graham Sutherland and John Minton, but I can find no evidence they ever met. However, Bacon does make a few appearances in Vaughan's published journal – another important sketchbook of the period. In his journal entry for 27 January 1955, Vaughan recounts an incident told to him by the artist Dennis Williams, who apparently at this time idolised Bacon:

> It was moving to see how affected D. was by the recollection of this incident. I [Vaughan] felt how so easily I could occupy the same role in relation to him [Williams, or perhaps Bacon]. His impressive dignity, his ardour and natural grace, his extraordinary physical beauty – supple – gentle – sensuous. 'He [Bacon] sees people as mountains of flesh,' Dennis said. 'He is obsessed by this extraordinary capacity of flesh to breathe, walk, talk.'[10]

If Vaughan seems to both identify and compete with Bacon in this account, it is worth mentioning that Bacon's success certainly overshadowed his own by 1955. In a journal entry in 1972 Vaughan approves of an article by William Feaver in which he 'demolished the reverential accolade that has built up round' Bacon and commends him for saying 'some sharp, accurate and penetrating things which certainly needed saying'.[11] Vaughan is not the only person to make a connection between himself and Bacon; Malcolm Yorke in his biography of Vaughan compares them thus:

> Bacon is by temperament a gambler who likes to approach his raw canvas without the support of preliminary drawing and splash his paint with a freedom Vaughan never aspired to. Bacon also lacks reticence; his sexual obsessions and his lifestyle are out in the open, both in the pictures and the press. One can see why Vaughan found Bacon's debased creatures gibbering in harshly lit windowless rooms or crouched so little to his restrained tastes. His own work, where man stands outdoors with his dignity and body intact, could be seen as a direct reply to Bacon's. Vaughan's males were in search of love and integration, whereas Bacon's wallowed in their own degradation and disintegration.[12]

Further, according to David Thompson in 1962, almost certainly making an indirect reference to Bacon, Vaughan's paintings are 'centuries away from modern angst and the modern inability to conceive of men in anything but a tortured, shattered, primitive or else flippant image'.[13] These liberal and humanist understandings of Vaughan and his work are not unrelated to the philosophy that sustained the recommendations and rationales of the Wolfenden Report and the campaigning of the Homosexual Law Reform Society, both of which demonstrated a commitment to discrete and restrained homosexual subjects, on which the arguments for law reform were founded. This form of homosexual subject repeatedly required a flamboyant and perhaps abject alternative as a necessary comparison. These accounts make it somewhat perilous to suggest that Bacon and Vaughan may have more in common than it initially appears.

Around the same time as Bacon produced *Two Figures* (fig.46) and his *Man in Blue* series (see fig.48 and pp.132–3), Vaughan began to produce paintings of male figures assembling in the open air, including his 1953 painting *Second Assembly of Figures* (fig.49). These paintings and some others, though quite different from one another, have the potential to bring these two artists quite close together when approached alongside some of the men and environments of the 1950s. Firstly however, there are some quite obvious differences. Vaughan's figures are outside, do not touch and are contained by dark outlines or contrasts, whereas Bacon's are at times indistinct from one another and located within a darkened interior. Vaughan's figures are longer and thinner than Bacon's thick-set wrestlers or suited figures, and though still well developed they do appear somewhat younger. Vaughan applies paint evenly and steadily in brush strokes of equal length, unifying the surface of the painting, there is little sign of reworking and he favours balanced contrasting tones. In *Two Figures* parts of the painting do not quite fit one another, and this and other paintings are formed by applying paint in different ways – the impasto bed placed upon the stained

ground within a box formed by chalk dry lines. The working and reworking of the figures, disparities of scale and the vertiginous placing of the figures on the edge of the bed together produce a contained form of disharmony. Though different the paintings are also somewhat similar, most notably the shared insistence on a simple structure and balance that coheres their modern forms. Taken together, this group of paintings have something to do with the sexual and aesthetic encounters that were represented on, and orchestrated by, the pages of physique magazines, and share in a modern graphic visual culture.

Johnny Walsh was the sometime lover of Vaughan and his name appears on the pages of *Adonis*, in an advert for a collection of photographs by Scott Studios. Vaughan took photographs of Walsh, including one of him standing naked in his studio, and drew his figure and sketched his portrait a number of times. Similar to Bacon's relationship with George Dyer, a prefiguration of Johnny Walsh existed in Vaughan's paintings prior to their 1956 meeting. According to Malcolm Yorke, Johnny was 'rough trade' and able to fulfil Vaughan's interest in 'dangerous sex', suggesting that his physical and emotional

fig.49 Keith Vaughan
Second Assembly of Figures 1953
Oil on board, 103 × 122
Manchester City Galleries

fig.50 Keith Vaughan
Highgate Ponds 1956
Pencil, crayon and wash, 28 × 20
Private collection

attraction were intimately related to his criminality and class. By all accounts he spent time in Pentonville Prison every year Vaughan knew him and was a 'pick-pocket, car thief. Larcenist, ponce, con-merchant, exploiter of older homosexuals, and liable to turn destructive when drunk'.[14] Everything in fact that a reader of the brief biographies detailing the dissolute and criminal pursuits of the models appearing on the pages of *Physique Pictorial* could hope for – including Francis Bacon – and hope to find in and around Soho.

Their shared interest in working-class men with insider knowledge of London's criminal underworld may be just the thing to bring Bacon and Vaughan together. Again, whilst this is an important similarity, there are some distinctions too that may be best characterised by the different sites of male encounter where Bacon and Vaughan found their regular pleasures. Whereas Bacon frequented a sexual geography from London's Soho to its East End, Vaughan appears to be more committed to London's parks and swimming ponds. Both geographies caused the Wolfenden Committee great anxiety as each disturbed the protocols they were seeking to establish in support of a change in the law. Parks, like public toilets and the streets of Soho, seemed to some members of the committee to offer the seductive potential of social and sexual encounters between men without insisting on them becoming responsible and coherent forms of homosexual subjects. Whilst Vaughan certainly passed through Soho, it was not his world, whereas we do know he spent time at the men's enclosure at Highgate Ponds on Hampstead Heath, where he sometimes took photographs or made drawings (fig.50). The men's enclosure was, like Soho, a site of male encounter where men hung around with and without purpose, where the distinction between the social and the sexual were unclear, and where looking at men could be legitimate but also run the risk of queer or homosexual imputation.

For Vaughan, the ponds on Hampstead Heath evoked the beach at Pagham where before the war he spent weekends taking photographs of his brother and working-class young men. These all-male social environments and experiences also recalled the comradeship he had experienced during the war,

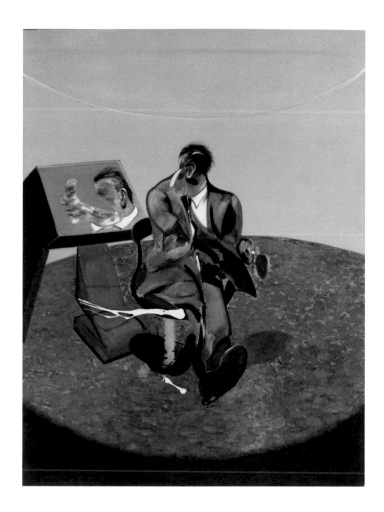

which is carefully represented in his published journal. Vaughan understood these experiences within the context of romantic socialism, perhaps best exemplified by the work of Edward Carpenter. For Bacon, the environments are somewhat different but the context is similar, if not so explicitly romantic. The war had provided the backdrop for unspecified social and sexual pleasures between men both within the armed forces and on the streets of London, most particularly in and around Soho, and these possibilities were sustained in the post-war years by the continuation of National Service. Further, Soho also provided the excitement of a certain kind of lawlessness and the presence of real and imagined, perhaps

fig.51 *Study of George Dyer in a Mirror* 1968
Oil on canvas, 198 × 147.5
Museo Thyssen-Bornemisza, Madrid

Hollywood-inspired, gangsters. The clothed figures in Bacon's paintings are insistent representations of a sharp-suited, fairly blunt and brutal form of working-class masculinity (fig.51).[15]

Johnny Walsh existed in and around this criminal fraternity even if he was not quite the same kind of criminal figure as Francis Bacon's friends George Dyer or John Edwards, who in their turn were not quite the same as Ronnie Kray.[16] However, these were all the kinds of men that once again caused the Wolfenden Committee a great deal of anxiety. Young men unwilling to make a commitment to society's productive or reproductive mandates, who had perhaps passed through the institutions that some members of the committee believed generated homosexuality, most particularly prisons and borstal. Prisons and borstals were important sites of real and imagined sexual encounters, and prisoners played important roles in the real and imagined pleasures of many men. The brief biographies printed in *Physique Pictorial* repeatedly characterised them as dissolute and criminal youths who had just been released from or would soon find themselves inside a correctional facility of some kind. These imported young sociopaths, alongside some home-grown models, played a part in forming the fantasies and realities of some men in the 1950s and 1960s.

Peter Wildeblood presented himself to the Wolfenden Committee when he gave evidence as a discreet and discrete homosexual subject. However in his autobiography, *A Way of Life*, published in 1956, he clarifies the sexual fantasy behind the comradely and romantic relationship he presented in *Against the Law*, first published in 1955. In *A Way of Life* he describes a young man called Sidney Crabtree:

> With his large, square hands, broad shoulders and Hollywood haircut, he looked like a typical young labourer, and I was surprised when he greeted me in a voice that was almost pure BBC.[17]

Crabtree has spent time in prison but his formative experiences were in borstal. As the Wolfenden Committee feared, and a number of experts testified, in borstal Sidney had developed a taste for pleasure of the homosexual kind. As with a number of other more ambiguous scenes in fictional and theoretical texts, Wildeblood's account of Crabtree's encounter with a warder makes sense as a continuation of scenes often suggested on the pages of *Physique Pictorial*, and perhaps evoked by some paintings:

> There was a warder called Prosser that we were all rather frightened of. He was about twenty-four, quite good-looking in an American sort of way; you know, a snub nose and big shoulders and short blond hair, with funny eyes that seemed to look right through you. Well, I got into trouble with him one day, it was nothing much really, but he shouted at me and I answered him back, which was a silly thing to do. He got me locked up in my cell, and that evening he came to see me.
>
> It was in the summer, and the cell was stifling hot, so I was sitting at the table with just a pair of pants on, trying to write a letter. Prosser came in and stood by the door. He started talking about how he was going to report me, and said that I was sure to be punished and so on, but I just sat there and didn't say anything, which annoyed him very much. He told me to stand up. I thought he was going to hit me, but he didn't, he just stood there looking at me. Then he said: 'You know, you're not a bad-looking lad.' And he came quite close, and smiled in to my face.
>
> As I said, I was afraid of him, and I didn't quite know what to do. He put his arm round my shoulder, and I could feel his uniform sleeve rough against my bare skin. It was frightening and somehow exciting at the same time; I didn't know what was going to happen next. I must have looked stupid, because he laughed, and suddenly he grabbed me tight and kissed me on the mouth. His tongue tasted of cigarettes and tea, and I could feel the buttons of his tunic pressing into my chest.
>
> Well, I suppose nobody enjoys the first time much. I thought I was going to die or something; he was very rough, and I was scared as hell. Afterwards I wanted to cry, and he gave me a packet of Woodbines to cheer me up.[18]

In *Against the Law*, the book of his arrest, trial and conviction for homosexual offences, Wildeblood provides a more discreet account of his relationship with a working-class prisoner, Dan Starling, a figure formed from well-established class-based myths and realities. Vaughan's interest in Walsh, and Bacon's in Dyer, were attuned to the physical attractions of an erotic figure we can characterise as working-class, criminal and rough-trade, perhaps a sociopath, almost certainly a borstal boy. In his journal of 13 May 1960, Vaughan writes about a report in the newspaper concerning the Home Secretary's regretful response – in Vaughan's view – to the sexual assault of three youths in Cardiff prison by two young cellmates:

> And I am supposed, like any 'decent' member of society, to throw up my hands in outraged horror. Well I don't. I can think of nothing less shocking or harmful to anyone than five boys in a prison cell passing the time in a little vigorous and enjoyable sexual combat. Is one to believe that a boy of nineteen 'sentenced to Borstal' (i.e. not exactly a milk-fed calf) could not, if he wished, defend himself against the advances of a boy one year older? What do people imagine by the term 'sexual assault' in such cases?[19]

Clearly by 1960 Vaughan was committed to the real and imagined attraction of working-class young men who had spent some time in borstal. Richard Hauser's *The Homosexual Society*, published in 1962, provides further evidence that such a figure had by this time become firmly established in the panoply of available erotic types. As with many so-called serious books about homosexuality published in the 1950s and 1960s, Hauser's account of life in prison provided opportunities for men to formulate and exercise an erotic imaginary, and perhaps by extension an erotic practice, devoted to all-male environments and the sexual attraction of criminals and prisoners:

> The Prison Queer often starts off in a juvenile institution where many things go on in the dormitories of which authorities suspect little, and know less. The good-looking young boy may be held down by some toughs and used as a surrogate girl time and again, without complaining to the authorities. He may find it pays him to have a 'protector' or he may prefer to use his sexual attraction to get benefits form a number of people.[20]

More discreet and professional texts like Kenneth Walker's *The Physiology of Sex* (1940), and indeed the Wolfenden Report itself, also made men aware of the dangers and delights of prison and prisoners. The anxieties that permeated and circulated sites of certain and uncertain male encounter, combined with anxieties over the irresolute sexuality of adolescents and the dissolute sexuality of sociopaths, coalesced to create the borstal boy as a potent erotic type, and made the places where they might be found sites of sexual excitement and tension. For men intrigued by or committed to sexual pleasures and practices with other men, professional anxiety about the effect of prisons certainly had the potential to invest this environment and the men who could be found there with an erotic charge, and perhaps encouraged them to seek other all-male environments where similar men could be found.

So, on the pages of some physique magazines and in locations around the streets and parks of London, the paintings of Francis Bacon and Keith Vaughan make sense in pretty close proximity to one another. Not as different representations of the same form of sexuality, but within a complex visual, geographic, social and sexual economy, in which the complex inter-relationship of diverse images, texts and contexts refuses to be streamlined into a straightforward narrative of gay or homosexual becoming. Within this environment, Bacon's paintings and drawings are not extraordinary one-offs, or ahead of their time, but – much more interestingly – part of a range of moves and conversations between elite and popular cultures, class and criminality, visual images and everyday pleasures, which provided possibilities that were neither singular nor infinite, in which men found ways of forming themselves and making paintings that enabled them and others to make some kind of sense.

'REAL IMAGINATION IS TECHNICAL IMAGINATION'[1] *Victoria Walsh*

Like Oscar Wilde, with whom he shared a love of literature, theatre and creative artifice, Bacon was acutely conscious of the value of constructing a public image and perfectly adept at carefully orchestrating both it and the reception of his work from an early stage. Marking out his serious pedigree in 1950, he identified himself in the catalogue to the exhibition *London – Paris: New Trends in Painting and Sculpture* as 'the collateral descendant of the Elizabethan philosopher'; he later admitted in an interview in 1973 that he had no firm evidence for this, although he shared a homosexual disposition with his purported eponymous ancestor.[2] In interviews Bacon held tight control of the final published texts and indeed, while they have attained a canonical status in Bacon studies, the published interviews with David Sylvester only represent a fifth of the original exchanges between the two. In the Preface to the interviews, Sylvester acknowledged, in what almost reads as an apology or disclaimer, just how radical their reformatting and editing had been:

> since the editing has been designed to present Bacon's thought clearly and economically … the sequence in which things were said has been drastically rearranged. Each of the interviews, apart from the first has been constructed from transcripts of two or more sessions, and paragraphs in these montages sometimes combine things said on two or three different days quite widely separated in time. In order to prevent the montage from looking like a montage, many of the questions have been recast or simply fabricated. The aim has been to seam together a more concise and coherent argument than ever came about when we were talking.[3]

Whether it was Bacon's concern to maintain the accumulative aura of his work or his disdain of potentially reductive interpretations, his desire to frustrate an empirical analysis of his oeuvre was highlighted in a now legendary anecdote: on a visit to the artist, a researcher enquired of Bacon whether he intended to bequeath his archive at the end of his life, to which Bacon promptly responded by sweeping up everything in sight, placing it in plastic bags and creating a bonfire of all the contents.[4] As Martin Harrison has also noted, Bacon

effectively censured … the iconological study of his paintings, initially by denying their iconographies. Most critics acquiesced in this denial of content, and those who transgressed risked his non-co-operation regarding reproduction rights: this enforced collaboration in this information clamp-down helped to ensure that Bacon's paintings, and his procedures were investigated and understood largely on the terms he dictated, or of which he approved.[5]

The official iconography of Bacon's paintings was repeatedly rehearsed in Bacon's lifetime, including the well-known highlights of the nurse in Sergei Eisenstein's film *Battleship Potemkin* (1925, fig.80) and Velázquez's painting *Portrait of Pope Innocent X* c.1650 (fig.68), but many more evidential and nuanced accounts of Bacon's visual and art-historical sources have been pursued since his death and with them the opportunity to reassess his work, particularly within the specific context of British art in the 1950s.[6] As Dawn Ades noted in 1985, 'Bacon has seemed an isolated figure, his paintings set in a direction counter to most post-war art', but there is much to suggest that Bacon shared many aesthetic and conceptual interests with his post-war British art contemporaries, particularly those gathered around the Institute of Contemporary Arts (ICA) in London during the 1950s. Bacon's desire to create the 'perfect image' can arguably be related to the contemporary debates around the concept of the 'image' at this time, which were in part aligned to the prevailing interest in the aesthetic of collage, an aesthetic that inherently challenged the old order of Aristotelian aesthetics. Collage, as championed by the Independent Group at the ICA, celebrated, through its embrace of ready-made found imagery in newspapers, books and magazines, the anti-traditional and non-hierarchical value relationships it offered between genre, medium and composition.[7] It is in this context that Lawrence Alloway (critic, one-time Deputy Director of the ICA and one of the 'fathers of Pop') would claim in 1962 that 'Pop Art begins in London around 1949 with work by Francis Bacon'.[8]

Bacon's paintings, however, were also realised through

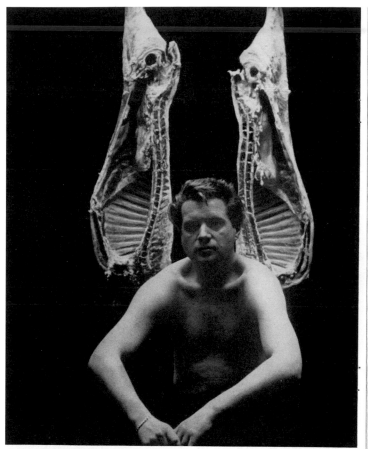

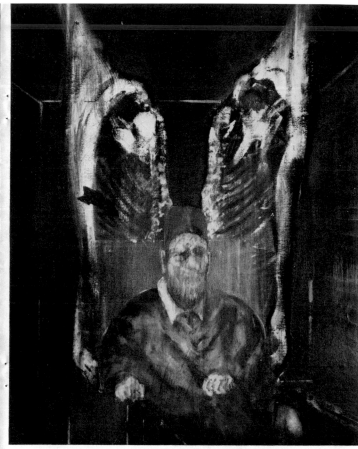

Francis Bacon's retrospective exhibition at the Tate, painful and appallingly compelling, has
78 focused attention on this elusive man who is probably the outstanding English painter of

our time. On the left is photographer John Deakin's in-the-mood study of the artist, faced by
the artist's study of a pope, after Velasquez, which is one of his most constant themes 79

a highly complex, synthetic form of thought and practice, equally rooted in the Romantic tradition, which held significant cultural import for artists and writers in the 1950s. Developed through a conceptual relationship to photography as much as a visual one, informed by the history of painting, interpreted through Romantic ideology, and translated into paint, the following discussion will suggest how Bacon's quest to capture and convey a sensual memory of experience through the image was more in sympathy with other artists at this time than previously considered. Although Bacon rarely spoke outside of his own personal motivations, and rarely

commented on or alluded to the work of his contemporaries, it is clear from letters and accounts of his friends and peers that he was well integrated into the life of the London galleries and, as he asserted, 'to be a painter now, I think that you have to know, even in a rudimentary way, the history of art from pre-historic times right up to today. You see, I have looked at everything in art.'[9]

* * *

fig.52 John Deakin, feature on Francis
Bacon, *Vogue*, July 1962, pp.78–9

I think of myself as a kind of pulverising machine into which everything I look at and feel is fed. I believe that I am different from the mixed-media jackdaws who use photographs etc more or less literally or cut them up and rearrange them.[10]

Bacon's reference to 'mixed-media jackdaws' was undoubtedly a sideswipe at a generation of artists around the ICA, most notably Eduardo Paolozzi, Nigel Henderson, Richard Hamilton and John McHale, who, among others, had embraced the idea of collage. But, despite Bacon's distancing from this group and their experiments in a collage aesthetic of ready-made printed imagery, his relation to much art practice during the early 1950s clearly held sufficient sway for Lawrence Alloway to assert that Pop art 'began' with Francis Bacon. In this 1962 article Alloway went on to refer to Bacon's use of imagery from Eisenstein's *Battleship Potemkin* and photographic images of animals and people in motion by Eadweard Muybridge as setting a precedent for subsequent Pop artists in borrowing from ready-made image sources.

As Alloway developed his argument, he went on to cite key sources of inspiration in the early 1950s: Amédée Ozenfant's *Foundations of Modern Art* (1931), Siegfried Gideon's *Mechanization Takes Command* (1948) and László Moholy-Nagy's *Vision in Motion* (1947). These three books were conceived with as much emphasis on the visual as the textual, collectively representing an almost encyclopaedic range of imagery across visual forms, traditions and periods, including new forms of visual experience made possible by varying photographic processes and techniques. As Harrison has identified, Bacon explicitly drew on images from Ozenfant in his painting *Untitled (Marching Figures)* 1950 and later in his *Triptych* 1976 (pp.224–5), and in this respect we can surmise that he would have equally absorbed some of the tenets of Ozenfant's writing, despite Alloway's view that the texts held little interest compared to the visuals.[11] Early on in the section on painting and, significantly, opposite the distorted photograph of Joseph Chamberlain that Bacon then incorporated into the 1976 *Triptych*, Ozenfant noted in a subsection titled 'Distortion' that 'The search for intensity dominates the whole of modern painting. There can be no intensity without simplification, and to some degree, no intensity without distortion: the distortion of what is seen naturally. Simplification, distortion of forms, and modification of natural appearances, are ways of arriving at an intense expression of form.'[12]

It is arguable that Bacon would have been equally familiar with Moholy-Nagy's *Vision in Motion* given its popularity on publication in 1947, and indeed given that Bacon himself had exhibited in 1930 a range of furniture and textiles he had designed directly influenced by the Bauhaus.[13] In this instance, the underlying thesis of Moholy-Nagy's work was the need for the artist in an industrial society to 'bring the intellectual and emotional, the social and technological components into balanced play', thereby creating an art relevant to its time, rather than a nostalgic and moribund one. For Moholy-Nagy, the abandonment of the Renaissance fixed perspective in favour of an emerging multi-perspective form of vision, or rather 'vision in motion', had manifested, in the realm of painting such as in Cubism and Futurism, a new 'space-time' aesthetic. This not only demanded a dynamic handling of form by the artist, synthesising his own intellectual and emotional rendition of the image, but one that prompted an equally dynamic and emotional response in the viewer. Having asserted that 'distortion … can be understood as a space-time synonym', Moholy-Nagy went on to discuss the various forms of distortion available to the artist and the 'eight varieties of photographic vision' that could be considered, all of which were illustrated by example through an array of photographic images capturing different types of natural distortion (by water) or artificially created by the camera.[14] For both Ozenfant and Moholy-Nagy, images characterised by distortion and space-time allusions were fundamental to creating the equivalent experience of sensations in the viewer.

The value that such texts and distorted photographic images held for Bacon, in terms of developing a technique for animating the perception of the figure, is suggested not only by the range of images that Bacon produced in the early

1950s, which depicted various forms of distortion such as the extended and stretched seated figure of *Head VI* 1949 (p.104), the striated form of *Study after Velázquez* 1950 (p.112) and *Study after Velázquez's Portrait of Pope Innocent X* 1953 (p.119), but also in a statement of 1952:

> Real imagination is technical imagination. It is the ways you think up to bring an event to life again. It is in the search for the technique to trap the object at a given moment. Then the technique and object become inseparable. The object is the technique and the technique is the object. Art lies in the continual struggle to come near the sensory side of the objects.[15]

Bacon was also aware at this time of the experimental work of his friend, the artist-photographer Henderson, who, prompted by Moholy-Nagy's examples, began creating 'stressed' images, one of which from a series of bathers has recently been found in Bacon's archive (fig.53). Henderson had begun producing what he termed 'stressed' images in 1949, which were created by pleating the original photograph and rephotographing it. For Henderson, the term 'stressed' was 'the best way to describe the optically distorted photographic image which also creates an emphasis. The effect (which we would now call cinemascopic) is in some degree to destroy the boundaries of the image, by appearing to lap them round the seeing eye, thus drawing it within the frame.'[16] It is possible that Bacon was given this by Henderson as early as 1950, by which time they had become friends through mutual acquaintances, or he may have purchased it from an exhibition of stressed images that Henderson exhibited at the ICA in 1954. Knowledge of this type of stressed photograph would have also been gathered from the reproduction in the February 1952 edition of the *Architectural Review* of an image of the sculptor Paolozzi, Henderson's close friend and collaborator, taken by Henderson in Italy (fig.54). By 1950 Bacon was also well acquainted with Paolozzi, with whom he had come into contact the year before when Paolozzi had shared a studio with fellow artist and mutual friend Lucian Freud.[17] Bacon's interest in capturing the emotional force through the manipulation of an image's 'space-time' was picked up by Sam Hunter in his review of 1952, in which he wrote: 'Bacon has a Bergsonian horror of the static. Consequently he has tried to quicken the nervous pulse of painting by moving it closer to the optical and psychological sources of movement and

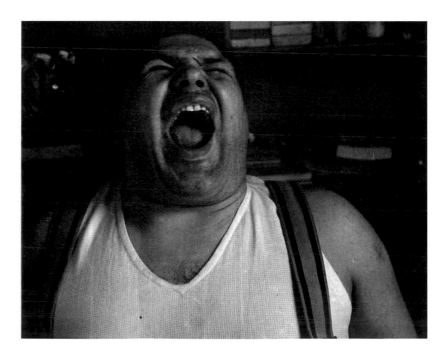

fig.53 Nigel Henderson
'Stressed' photograph of bathers
9.7 × 12.7
Dublin City Gallery The Hugh Lane

fig.54 Nigel Henderson
Eduardo Paolozzi c.1950,
published in *Architectural Review*

action in life. To stimulate sensitivity to the significant instant of action and gesture he has collected a whole literature on the mechanics of motion.'[18]

The extensive range of sources and different types of photographic images that Bacon collected and drew on at this time was equally reflected in the widely disparate and eclectic interests of both Paolozzi and Henderson and their wider circle of friends and colleagues gathered around the ICA (fig.55). The ICA represented a new kind of space in post-war London, and by 1950 it presented itself as 'a centre where the living arts of painting and sculpture, of architecture and music, of theatre and film, can meet and mutually inspire one another'.[19] Bacon's relationship with the ICA was initially anchored in his friendship with the patron and collector Peter Watson, who became one of its principal benefactors by the late 1940s.[20] Bacon was also familiar with the founding figures of the ICA, E.L.T. Mesens, Herbert Read and Roland Penrose, who had devised the idea of the institute in the aftermath of the *International Surrealist Exhibition* in 1936, for which they had considered and rejected Bacon's painting as 'insufficiently surrealist'.[21] By the early 1950s, Bacon had friendships and social contact with virtually all the individuals involved in the

ICA, and in 1951 was asked to contribute to the ICA exhibition for the Festival of Britain, *Ten Decades: A Review of British Taste 1851–1951*, although he did not accept the offer.

Rooted in its Surrealist origins, the ICA exhibition programme at that time reflected the anthropological and ethnographic interests of the movement, revealed in shows that celebrated an almost encyclopaedic approach to visual culture, juxtaposing work by 'primitive' societies with iconic and lesser-known examples of modern and contemporary art. A distinct feature of ICA exhibitions was not only the breadth of periods covered, but the fact that photographic images of works were readily presented as equally valuable representations of the individual works as the originals themselves, emphasising their formal qualities as 'images' rather than their physical forms, be it two- or three-dimensional. In 1951 the exhibition *Growth and Form*, initially suggested by Henderson and Paolozzi, but realised by Richard Hamilton, depended exclusively on photographic images taken from the natural sciences, with the aim of 'concentrating attention on the formal qualities of scientific material'.[22] Two exhibitions staged in 1953, however, expanded this approach dramatically: *Parallel of Life and Art*, organised by Henderson and Paolozzi with the architects Peter and Alison Smithson (fig.56); and *Wonder and Horror of the Human Head: An Anthology*, organised by Read and Penrose, to which Bacon contributed the oil painting *A Laughing Man*.

While *Wonder and Horror of the Human Head* brought together 238 works 'to stimulate poetic reflexion upon our human condition', *Parallel of Life and Art* was seen by its organisers to form 'a poetic-lyrical order where images create a series of cross-relationships'.[23] Bringing together over a hundred photographic panels (including many images of motion represented through distortion by scale and manipulation), *Parallel of Life and Art* rapidly attracted attention, dividing critics and artists, although Bryan Robertson assuredly declared, 'This beautiful and rewarding exhibition … should be seen by everyone … its value is very great'.[24] The exhibition's celebration of the new 'visual order' opened up by photography was further indicated by the organisers' open references to their

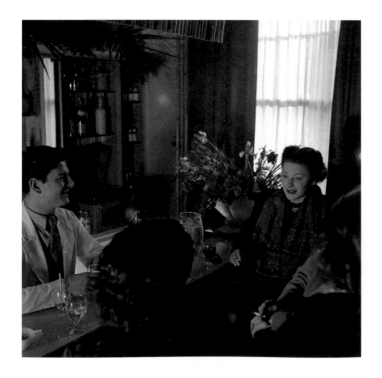

fig.55 Nigel Henderson
Colony Room, including Isabel
Rawsthorne (then Lambert), 1951
Tate Gallery Archives

desire to create their own 'imaginary museums', a direct reference to André Malraux's 1947 essay 'Le Musée Imaginaire' (subsequently reprinted in 1951 as part of the larger work *Les Voix du silence*, published in 1953 as *The Voices of Silence*), and their further acknowledgement that they had hoped to invite Malraux to open the exhibition.

The influence of Malraux's writing on artists in the late 1940s and early 1950s cannot be underestimated. In Malraux's view, photography had liberated the history of art from being constrained by only that which the museum could acquire and display.[25] Presenting the artist with this new and infinite resource of imagery, this 'museum without walls' not only enabled artists to create their own 'imaginary museum' of selected images, but also revealed the extent to which art imitates art. Calling on the artist to welcome this new pantheon of imagery, Malraux emphasised the intertextual nature of art's development:

> We interpret the past in the light of what we understand ... It is not research-work that has led to the understanding of El Greco; it is modern art. Each genius that breaks with the past deflects, as it were, the whole range of earlier forms ... Metamorphosis is not a matter of chance; it is a law

fig.56 Installation view of *Parallel of Life and Art*, ICA, London 1953
Tate Gallery Archives

governing the life of every work of art. We have learned that, if death cannot still the voice of genius, the reason is that genius triumphs over death not by reiterating its original language, but by constraining us to listen to a language constantly modified, sometimes forgotten – as it were an echo answering each passing century with its own voice – and what the masterpiece keeps up is not a monologue, however authoritative, but a *dialogue*, indefeasible by Time.[26]

In bringing together such a disparate body of photographic imagery, Henderson, Paolozzi and the Smithsons were in many respects extending on a much larger scale the Surrealist project of collage to the exhibition environment, creating a more integrated physical and imaginative experience for the viewer, rather than a merely optical one. This was further enhanced by the radical multi-layered, multi-viewpoint hanging of the exhibition that demanded the viewer's physical reorientation in space to see the images, which were suspended from the ceiling as much as from the walls, and at varying angles to be seen from the front and behind: a three-dimensional 'vision in motion' or, put another way, a space-time experience. But while Malraux lamented the levelling out of texture and colour that photographic reproduction imposed on the work of art, it was this very quality of simplification and reduction that produced 'graphic equivalents' and an 'all-over' appearance that the collaborators welcomed in the photographic medium.

Despite instances of critical praise, the exhibition provoked much controversy due to the apparent 'poor quality grainy' status of the images, the reliance on visual 'abstraction', and the ready-made origins of much of the material. At a debate organised by students at the Architectural Association, Henderson was called to explain the intentions of this 'anti-art', 'anti-classical', 'brutal' exhibition and, in so doing, reflected 'we ourselves were concerned first of all with the subjective impression, the impact upon our senses, rather than upon our intellects … We should like to bring about a situation in which people felt like undergoing a strong visual experience.' While closely echoing Moholy-Nagy's call for

a synthesis of the emotional with the intellectual in image-making, Henderson also made reference (as indeed the show did) to the work of Paul Klee and the 'multi-evocative image', an extension of the critical term 'multi-evocative sign' coined by David Sylvester in a 1951 essay on Klee.[27] For Henderson, the 'multi-evocative image … stood for a punchy visual matrix that triggered off a number of associational ideas … so it might be an "ambiguous" art image interpreting known things, or a thing rendered ambiguous by technical fault or manipulation'.[28] In 1954 in a review of Bacon's work, Sylvester identified the role photography was playing in the artist's process and the technical qualities being produced as a consequence:

> he has discovered in photographs the extraordinary extent to which forms can be distorted without losing an air of reality – and it is one of his main preoccupations as a painter to see how far it is possible to twist appearances out of shape without depriving them of conviction, and by this act of taking reality to the brink of unreality, to heighten our awareness of it … Bacon is fascinated by the peculiar tonal unity of photographs, their 'all-overness' of texture.[29]

At the beginning of 1954, the exhibition committee at the ICA (Alloway, Penrose, Robert Melville, Dorothy Morland and Colin Wilson) met to discuss the possibility of holding a Francis Bacon retrospective the next year, following Bacon's selection for the Venice Biennale that year. As the Tate had no plans to do this, and the British Council had approved the idea, it was agreed the exhibition should go ahead. The suggestion of holding a symposium organised on Malraux's book *The Voices of Silence* was also put forward at the same meeting. The event took place in May, the speakers being Henderson, Ernst Gombrich, Alloway and Stephen Spender.[30] By October that year, the suggestion was to invite Samuel Beckett to write the preface for the Bacon exhibition catalogue, which Watson offered to facilitate, and by December Alloway had been appointed to hang the show with the assistance of the artist John McHale.

At this time, the ICA was marked out by very different

interest groups among its artist members and committees. Frustrated by the seemingly conservative approaches to art and its history represented by Read, a group, initially labelled by the ICA as 'the young group', and subsequently the 'Independent Group', had emerged through a series of informal gatherings and debates questioning the old order of classical value in the arts and introducing new ideas of visual culture that drew directly on contemporary experience and sources, rather than classical forms and teachings based on the principles of universal truth and beauty.[31] The founding moment of the Independent Group is generally identified as the meeting in 1952 at which Paolozzi presented a series of images taken from American magazines and fed through an epidiascope (a magnifying screen projector) in no apparent order, but rather randomly, prompting associations, connections and other images through visual impact alone, mimick-

ing in motion the collage approach of the Surrealist artists he admired (see fig.57). By 1954, *Parallel of Life and Art* had come to represent the summation of this new anti-art approach, and among the Independent Group members could be included Henderson, Paolozzi, Alloway, Hamilton, McHale, among others, all of whom were in direct or indirect contact with Bacon, as previously discussed.

Bacon's retrospective was perceived and received within this specific context, and its selection and support clearly reflected the sympathetic relation felt between his work and this group of individuals, not only through his embrace of the contemporary, through found material, but also his aesthetic sensibility towards Surrealism and collage (fig.58).[32] Likewise, he clearly shared with his contemporaries at the ICA an extensive knowledge of the tradition of art, and a conceptual pleasure in interplaying references to the past with the present

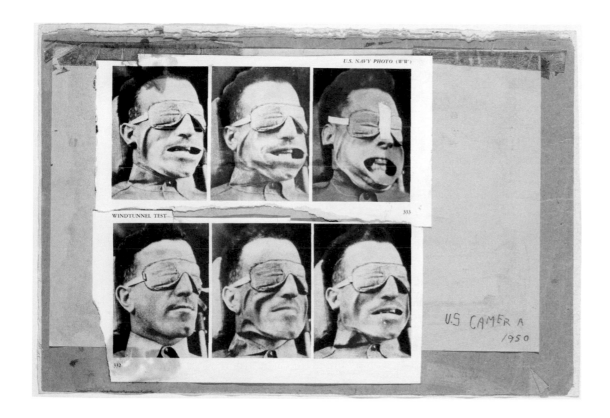

fig.57 Eduardo Paolozzi
Windtunnel Test 1950
from *Ten Collages from BUNK*
Collage mounted on card
24.8 × 36.5
Tate. Presented by the artist 1971

fig.58 Invitation to private view of the
Francis Bacon exhibition at the Institute
of Contemporary Arts, London,
19 January 1955
ICA Collection, Tate Gallery Archives

to create a contemporary idiom redolent with meaning and dependent on recognition that could be experienced through a visual, intellectual, emotional and sensual synthesis of imagery – as Malraux, Ozenfant, Moholy-Nagy and other celebrated figures at this time had encouraged.

Comprising thirteen works dating from 1930–1954, the exhibition included *Fragment of a Crucifixion* 1950 (fig.59), with its dissonant and ambiguous depictions of a road intersection in the background, *Study after Velázquez* 1951, *Three Studies of the Human Head* 1953 (p.123), *Study for a Portrait* 1953 (p.126) and *Study after Velázquez* 1954.[33] Collectively, the works on display demonstrated Bacon's technique of synthesising both explicit and implicit references to high art and low culture, which would not have been lost on his contemporaries. Writing two years before his article 'Pop Art Since 1949', Alloway wrote a stinging attack in 1960 on the critical approach to Bacon's paintings that interpreted them as images of horror and terror, as in Robert Melville's writing. Dismissing Melville's approach, Alloway clearly asserted what had become evident to him in the early 1950s:

> Bacon's references to popular and fine art can be related to his reliance on the format and tonality of Grand Manner painting, and his technique is, in some respects, an abbreviated version of 'Venetian' painterliness. Bacon has a built-in taste for the slice-of-art, beat images similar to Sickert's 'echoes' in which he took off-beat images and pulled them into easel painting, leaving their origins awkwardly, frankly visible. This play of conventions, a Malrauxesque intrigue between artists, seems as useful a way into one aspect of Bacon, as through Melville's dining-room over the torture chamber.[34]

One of the final and most iconic exhibitions defining the Independent Group took place at the Whitechapel Art Gallery in 1956, having been initially conceived in 1954. Attracting over a thousand people a day, largely due to Alloway's energetic publicising on press, radio, television and cinema newsreel, *This is Tomorrow* brought together twelve groups of artist-collaborators to create a series of installations that engaged with the interdisciplinary relationship of architecture, design, science and art to create cultural comments on and visions of the future (fig.60). Among these installations, key members of the Independent Group came together: Henderson and Paolozzi linked up with Alison and Peter Smithson as they had for *Parallel of Life and Art*; Alloway joined up with Geoffrey Holroyd and Toni del Renzio; and Hamilton linked up with McHale and John Voelcker. The latter team, forming Group Two, created a structure that housed two different types of imagery: 'sensory stimuli and optical illusions from the Bauhaus and Duchamp (the theme of perception) and images from popular art … the theme of what we perceive at the moment.'[35] The most iconic image from the exhibition and one that has become the defining icon of Pop art was, it is often forgotten, created as an image for the group's poster: 'Just what is it that makes today's homes so different, so appealing?' (fig.61).

Extensive research into the provenance and fabrication of this photographic collage has brought to light the complex and troubled history behind the image, with conflicting accounts of whether Hamilton or McHale conceived the idea, sourced the imagery and compiled it.[36] Among these accounts is one provided by McHale's son, in which he discusses the poster's iconography.[37] Putting aside the politics of conceptual ownership of the image between the original collaborators, what is apparent from any account is the extraordinarily complex, intermeshed, interweaving, cross-referencing, intertextual coding and highly sophisticated 'in-jokes', from which the image is constructed. Purportedly based on Giorgione's *The Tempest* 1506–8 (not incomparable to Bacon's use of Velázquez), among the in-jokes was one direct reference to Francis Bacon in the form of the can of ham on the table, although it also carried meaning in relation to Paolozzi. As McHale Jr. observed:

> The tin of ham is also a visual pun reminding the collage viewer that McHale and Alloway mounted the ICA retrospective exhibit on Francis Bacon. In addition, the tin of ham is intended as a humorous dig at Paolozzi's collage, containing downmarket Spam, and the implication that

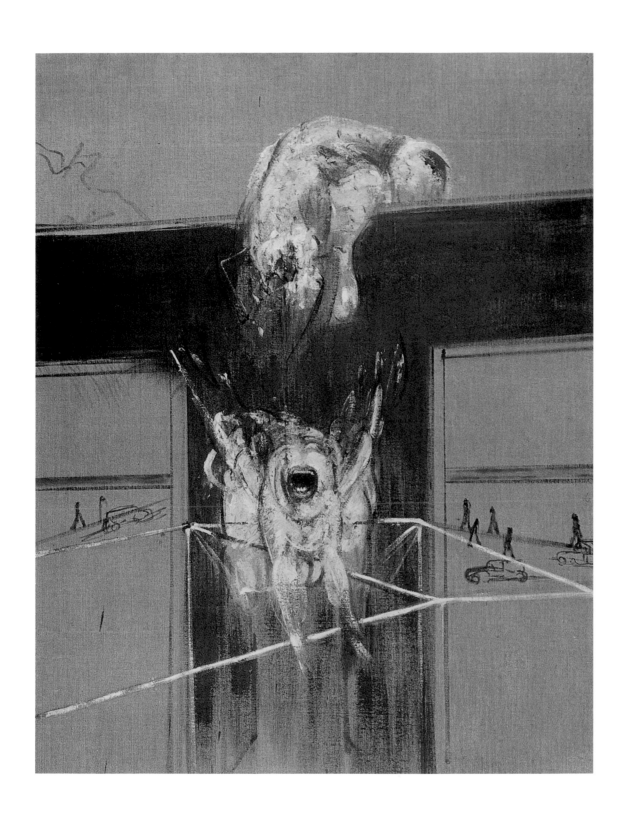

fig.59 *Fragment of a Crucifixion* 1950
Oil and cotton wool on canvas
140 × 108.5
Van Abbemuseum, Eindhoven

McHale, the Yale artist, can afford up-market ham in his luxury sitting room depicted in the Pop art collage.[38]

For anyone familiar with the Surrealists or the Independent Group, this kind of referencing was not only de rigueur, but a highly pleasurable form of coded communication between those who shared a mutual respect and sense of humour within a larger group of highly competitive and creatively mischievous set of individuals.[39] It is not implausible to make an extended interpretation of another observation McHale Jr. made regarding the Tootsie Pop image. This is presented as a joke reference to Henderson's photographs of sweet shops in the East End forming 'another home run and conceptual smash hit', along with the body-builder type of figure, which McHale was aiming at his close friend Paolozzi through reference to Marlon Brando:

> Part of the joke about Brando at the TIT [*This is Tomorrow*] was the fact that Paolozzi was Italian ice cream Scots and he considered himself a 'Brutalist' artist. Brando was considered part Italian, a damn fine artist like Paolozzi, and he rode into town America on a British Triumph motor bike.[40]

The juxtaposition of 'Brutal Brando' with 'Mr Sideburns', the Victorian gentleman depicted in the traditional portrait hanging on the wall in the background, was also discussed by McHale as 'a symbolic surrogate connected to a famous contemporary at the ICA', and it is not inconceivable that this too was a reference to Bacon and his admiration of working-class boys. This conjecture finds more support in light of Simon Ofield's discussions of the circulation of gay imagery at this time, and the identification of gay culture with gymnasiums. As Ofield has also brought into the picture, homosexuality was high in public consciousness at this time following Peter Wildeblood's prosecution in 1954 for inciting a young man to commit indecent acts, the publication of his account of life in prison in *Against the Law* in 1955 and the ongoing inquiry through high-profile interviews being carried out by Lord Wolfenden in 1956, which was subsequently published the next year. All of this would have held interest and meaning for Bacon and those around him. Friends and contemporaries

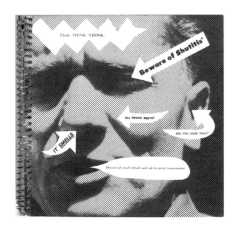

fig.60 Richard Hamilton
Collage of the Senses, from the 1956
This is Tomorrow exhibition, Whitechapel
Art Gallery
Whitechapel Archives

fig.61 Richard Hamilton
*Just what is it that makes today's
homes so different, so appealing?* 1956
Collage, 26 × 25
Kunsthalle Tübingen, Collection Zundel

would also have picked up on the multi-association between Group Two's front installation image for the senses (*Collage of the Senses*), which presented a male face with arrows directing the commands of 'think' and 'listen' and highlighting the senses 'It smells', which echoed not only the arrows of Klee's *Pedagogical Sketchbook* (1923), but arguably also Bacon's arrow markings in his own paintings, which had attracted as much comment from the critics.

What can be drawn from this discussion is just how integrated into the visual currency Bacon's practice was in terms of his absorption of the same photographic sources and collagist strategies as the Independent Group artists. As E.L.T. Mesens had also identified in a lecture that was presented on his behalf to coincide with the 1954 ICA exhibition, *Collages and Objects*, 'The Empire of collage extends far beyond the plastic arts' and, providing an example to illustrate his point, concluded that 'This is where the true effect of 'collage begins – its mystery, its power … its dimension in the conceptual field.'[41]

* * *

there is no such thing in painting as mystery … The only true mystery is the way you bring the image about.[42]

Further distancing himself from the 'mixed-media jackdaws', Bacon noted in an interview with Michael Peppiatt in 1964 that 'Pop art is made for kicks. Great art gives kicks too, but it also unlocks the valves of intuition and perception about the human situation at a deeper level'.[43] For Bacon, unlocking the 'valves of intuition' was inextricably bound up with the visceral qualities of paint as a medium: 'There is an area of the nervous system to which the texture of paint communicates more violently than anything else.'[44] The series of paintings after Vincent van Gogh that Bacon produced for his show at the Hanover Gallery in 1957 (see p.161), which were characterised by their thick layers of roughly applied paint and sketchy form, not only revealed Bacon's sympathetic alignment with much *Tachiste* painting at this time, but in their close identification of medium with form, creating an 'all-over' effect, demonstrated one of Bacon's key concerns:

the synthesis of subject with form.[45] As Bacon had written in the catalogue introduction to the Tate exhibition of Matthew Smith's work in 1953:

> He seems to be one of the very few English painters since Constable and Turner to be concerned with painting – that is, with attempting to make idea and technique inseparable. Painting in this sense tends towards a complete interlocking of image … because the very substance of the paint, when used in this way, can make such a direct assault upon the nervous system.[46]

In contrast to the abstract painters included in the ICA 1951 exhibition, *Opposing Forces*, among them Jackson Pollock and Alberto Burri, Bacon was committed to the human form in painting and aware that any engagement with the genre of portraiture or figure painting had to move beyond the limits of the photographic image or the over-determination of a historical tradition. Bacon's explicit subversion of historical precedents, as in referencing Velázquez's *Pope Innocent X*, was clearly one way of transgressing this tradition, further subverted through the technical mediation of the visual effects of photography into paint. The role of photography in Bacon's work was acknowledged from the early 1950s, most comprehensively perhaps in an article Sylvester wrote in 1952, in which the critic also offered wider reflections on the limits of photography, its lack of freedom to control the image compared to painting, its inability to 'suggest tactile sensations' and to create the kinds of distortion that painting can.[47] This relationship between distortion and sensation, the painted image and the nervous system, remained a prevalent theme in Bacon's conversations about his work for over three decades, and echoes Ozenfant's discussion of the role of distortion in painting and his call to painting as 'The organising of optical phenomena in such a manner as to create sensation, the associations connected with which provoke thought and feeling'.[48]

Bacon's emphasis on sensation, 'to come near to the sensory side of objects', as the press release for his 1955 ICA show stated, was invariably bound up with his disdain of illustrational painting and his desire to suspend any allusion

sant love for them, which before allowing the images that their faces present to reach us catches them in its vortex, flings them back upon the idea that we have always had of them, makes them adhere to it, coincide with it.[58]

Bacon's referencing of Proust, his description of the impact of photographs as 'memory triggers' and his use of photographic effects in his paintings all testify to Martin Harrison's assessment that: 'Although the specifics of his image sources are ultimately secondary to the syntheses that Bacon performs on them ... the essential modernity and rich complexity of his figurative idiom depended to a considerable extent on its mutable dialogue with photography's engagement with transience, mortality and memory'.[59] But Bacon's engagement with mortality and memory was also inextricably bound up with his reading of contemporary literature rooted in the Romantic and Symbolist tradition, and his admiration for T.S. Eliot and W.B. Yeats provided again both a wealth of imagery to be transmuted into paint and a modern idiom that combined the epic nature of classical literature and the mythology of poetic drama into domestic and urban experience. As Michael Peppiatt has also recorded, 'Bacon occasionally admitted that some of his literary admirations had more effect on his painting than anything else' but, as Peppiatt also acknowledged, Bacon was as 'skilful in talking about his pictures as he was in painting them. He knew how to give out enough information to make the work more vivid, intensifying its allusiveness as well as the impenetrability of its enigma.'[60] In this respect, the example of Baudelaire was, it could be argued, most significant. Understanding the

relationship to language, the need to control its frame of reference, and continuing the tradition of Baudelaire as Eugène Delacroix's translator and champion, and Algernon Swinburne as Whistler's, Bacon created his own translator in David Sylvester.

Behind all the interviews that Bacon gave, the need is apparent to go beyond his own words to understand the inter-related literary and visual concepts of distortion, the conditions for his use of abstraction, and the visual and imaginative synthesis realised through a conceptual collaging of sources. Writing in 1996, Sylvester reflected on the level of erudition and knowledge that underpinned Bacon's art, highlighting just how iconographically complex the paintings were:

> Bacon takes a variety of things and incorporates them into a mixture in which their separate identities are glimpsed, more or less changed, sometimes changed hardly at all, but which has a perfectly individual style. It is very like what Eliot did and a consummation that could have happened only in our own age because it depends on our unprecedented breadth of reference. Fragmentary memories of many times and places, of many myths and styles, are brought to mind, some clearly, some vaguely as we look. It seems that all human history is present.[61]

In many respects the iconographic and iconological project to deconstruct Bacon's paintings is in its infancy, as the mythology of Bacon as a 'culturally parentless phenomena' is negotiated through new evidence and new perspectives.[62]

CATALOGUE

ANIMAL

ZONE

APPREHENSION

CRUCIFIXION

CRISIS

ARCHIVE

PORTRAIT

MEMORIAL

EPIC

LATE

ANIMAL

The idea of the animal in man, of humankind as nothing but another beast, was never clearer in Francis Bacon's work than in that of the 1940s. The surviving paintings from that time are relatively few and yet it was with those works that Bacon secured his reputation as the most exciting painter in Britain. A better idea of Bacon's concerns may be gleaned if we extend our study to a more complete range of his production from that time. That is to say, to consider those works that are known but which he considered 'abandoned' or actually destroyed. In the centre of this larger group – and of the decade – stands his *Three Studies for Figures at the Base of a Crucifixion* (pp.146–7), his first masterpiece and the work that announced the re-emergence of an artist barely heard of since the publication of his *Crucifixion* (p.145) in Herbert Read's 1933 *Art Now*. Much has been made of the impact the triptych had when shown in a group exhibition at the Lefevre Gallery in 1945, just as the war ended and the horrors of the Concentration Camps were revealed. It was shown alongside *Figure in a Landscape* 1945 (p.97), and was succeeded the following year by *Painting* 1946 (p.101), described as a picture of a butcher's shop, that equally seemed to have conjured up the atmosphere of horror at manmade violence. In fact both great works belonged to a wider group of images that brought together the bestial depiction of the human figure with specific references to recent history and historical characters.

At the end of this period of work, the young American journalist and art historian Sam Hunter spent the summer of 1950 in London hanging out with Bacon and his friends, in particular Lucian Freud, Sonia Orwell and Peter Watson, owner of the seminal, though recently defunct, cultural journal *Horizon*.[1] In his report of Bacon's painting – the first published in the United States,

though *Painting* 1946 was already in The Museum of Modern Art, New York – he framed the work within a description of London as bomb-ravaged, grey and miserable. 'Bacon's paintings could only be possible in contemporary postwar London, with its exacerbated nerves, its own distinct psychological atmosphere,' he wrote.[2] He went on to describe Bacon's Cromwell Place studio as lying between 'the bizarre face of Victorian London' and 'one of the dreariest of urban areas, which produces the kind of intense impression of respectability in reduced circumstances that must have inspired Eliot's lament for the living-dead of London in *The Wasteland* [sic].'

So the perception of Bacon as somehow epitomising the pessimistic feeling of the time was secured. Hunter also, famously, recorded some of the photographs and illustrations that covered tables at one end of Bacon's studio at 7 Cromwell Place. While the artist looked on bored, Hunter assembled into three arrangements on the floor a group of photographic prints, pages torn from books and magazines, and other pictorial fragments that typified the larger mass, and recorded them with his camera (fig.2).[3] Though the two published assemblages were cropped so that they appeared to be sampled sections of the actual studio chaos, the original negatives show the feet of Hunter's tripod and confirm that the material had been assembled into discreet arrangements (figs.88–9).

With these assemblages, the matrix of photographic reproductions from which Bacon drew inspiration, if not actual imagery, was secured in the public realm. There, carefully layered and revealed were: images of great works of art – Grünewald's *Mocking of Christ*, Velázquez's *Portrait of Pope Innocent X*, Auguste Rodin's *Thinker*; photographs of Nazi leaders – Hitler leaning out of a window,

Joseph Goebbels declaiming, his finger wagging and mouth gaping; photographic illustrations from books on African big game, facial expression in film, positioning in radiography; an elevated view of figures shot in the street during the Russian Revolution; a photomontage showing painter Jack Bilbo in sinister dark glasses accompanied by a snippet of an interview alluding to his claim to have been Al Capone's bodyguard and a shot of him wielding a pistol; a motorcyclist prone beside his crashed vehicle. Hunter summarised the content of Bacon's materials, saying they were united by 'some kind of mysterious topical and psychological pertinence. Violence is the common denominator'.[4] In a summary fashion, most of the essentials in the lexicon of mediated images and sources that was revealed when Bacon's Reece Mews studio was posthumously unveiled and excavated had been presented early in his career. In 1949 Robert Melville cited Sergei Eisenstein's *Battleship Potemkin* as a direct source and Salvador Dalí's and Luis Buñuel's *Un Chien andalou* as a point of reference.[5] David Sylvester made similar references to Eisenstein, Velázquez and Eadweard Muybridge's photographs in 1954, and discussions of photographic and other source material recurred in his interviews with Bacon that started in 1962.[6] That albums of Muybridge's photographs were, unusually, displayed in Bacon's 1962 Tate Gallery retrospective suggests their importance to him, though Denis Wirth-Miller's claim that Bacon kept a suitcase of such material ready to be grabbed at a moment's notice suggests an urgency less plausible.[7]

By his own account, photographs of Nazis had been a source for Bacon as early as 1936 when his *Figures in a Garden* (fig.31) had derived in part from a photograph of Hermann Göring. Of the few known works from the years that immediately followed,

most took their inspiration from similar sources. The military references of *Man in a Cap* (fig.62) are clear, and the relationship of both the wide-open mouth and the headgear to the famous picture of Goebbels recorded by Hunter seems equally evident. More intriguing is *Figure Getting Out of a Car* (fig.63), not least because it is lost under a later reworking, now called *Landscape and Car*. Dated to 1944 by Sylvester, this work shows a grotesque grey creature (not unlike the imagined renderings of the Loch Ness monster), with a tail reaching to the right balanced by a long, serpentine neck, at the end of which is a mouthful of vicious-looking teeth.[8] The beast is mounted in a realistically depicted motor car and its neck reaches down towards a bank of microphones. While the figure has been associated with the late 1920s work of Picasso, the car was taken from a photograph of Hitler arriving at a Nuremberg rally (fig.123), the Führer being replaced by this monstrous biomorph (figs.63, 123). Ironically, the creature's neck is encased in what might be described as an elongated, starched white collar that might call to mind the infamous photographs of Neville Chamberlain arriving home from the Munich negotiations of 1938.

Though Bacon came to see *Three Studies* as the first work in his mature canon, it would seem that this position had not yet been established in summer 1950. If we credit Sam Hunter with the wit to have included in his selection of studio detritus photographs relating to paintings he knew, we might deduce that, among those works he saw that summer, were those later begrudgingly acknowledged as 'abandoned'. In one of his assemblages appears the *Picture Post* photograph of Goebbels that provided the inspiration for *Man in a Cap* (fig.88). Another shows the photograph of Hitler leaning out of a Prague window (fig.89), on which *Man Standing* 1941–2 (fig.64) was based. Finally,

the third, unpublished montage (fig.2) includes the photograph of Hitler stepping out of a motor car at a rally that was the point of departure for *Figure Getting Out of a Car*. The paradox of Bacon's subsequent insistence on the *Three Studies* as his inaugural work is visibly evident in Hunter's text, which reports that 'Bacon's paintings all date from after the war', even though it is illustrated with the pre-war *Figures in a Garden* (as *Seated Figure* 1937). Perhaps it was between Hunter's visit and the publication of his essay eighteen months later in January 1952 that Bacon decided to erase his wartime history. Certainly, it was in spring/summer 1951 that he 'abandoned' those earlier works when he vacated Cromwell Place.[9]

One might surmise that, in leaving those works behind, Bacon wished to distance himself from the specificity of the Nazi references to something more universal in which the sense of threat and brutality had been distilled. Nevertheless, certain thematic and formal characteristics are shared by some of the 'abandoned' paintings and the acknowledged works of the mid-1940s. The central figure in the *Three Studies* is clearly related to the emerging beast in *Figure Getting Out of a Car*, and the latter's snarling mouth that reaches down to a bank of microphones is repeated in *Figure in a Landscape*.[10] The microphone motif also appears in *Study for Man with Microphones* (fig.126), another mid-1940s work that was reworked before being cut up.[11] One can reasonably imagine the hollowed-out torso of *Figure in a Landscape* having once been a similar serpentine monster. Vestiges of such a creature can also be identified in the bending anthropomorph of *Figure Study II* (p.99), which turns its face towards us in a similar fashion. Finally, as the spiny foliage in that work relates it to the reworked *Landscape and Car*, so the black umbrella, which accompanies the herringbone greatcoat to identify

the creature as in part a respectable man like Bacon's lover Eric Hall, looks forward to *Painting* 1946.

Like all great, pivotal works, *Painting* 1946 (p.101) both stands apart from Bacon's other paintings and brings together key characteristics. It belongs to a group of works on the theme of the Crucifixion. His preoccupation with the subject informed more works than are generally acknowledged: he initially described *Figure Study I* and *II* (pp.98, 99) as 'studies for the Magdalene' and, during the summer of 1947, worked on a series of three paintings to be hung together as 'they are a sort of Crucifixion'.[12] In *Painting* 1946 he laid claim to a descent from Rembrandt and Chaïm Soutine, by substituting two sides of a carcass of beef for the body of the crucified Christ. Further joints of beef are arranged lower, in the foreground, where the attendant figures would stand in a conventional Crucifixion. The scene is adorned with garlands that recall both some grand ceremony and the traditional decoration of English butcher's shops. Though Melville thought it like 'the foyers of super cinemas built in the Thirties', the garlands also match those adorning the balcony from which Hitler spoke in Vienna in 1938.[13] They might also bring to mind the scene that confronted the priestess at the Delphic Oracle in Aeschylus' *Oresteia*:

As I went towards the inner shrine,
 all hung with wreaths,
There on the navel-stone a suppliant
 was sitting,
A man polluted – blood still wet
 on hands that grasp
A reeking sword.[14]

In the middle of Bacon's charnel house rises up the dark-suited figure of a man whose demeanour, snarling mouth and half-hidden face mark him out as a dictator figure. Closer

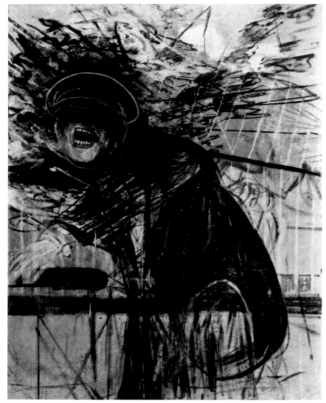

fig.62

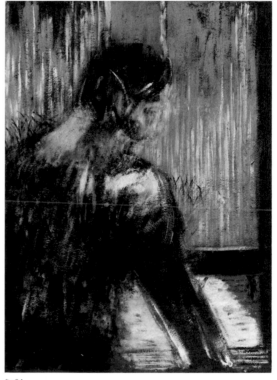

fig.64

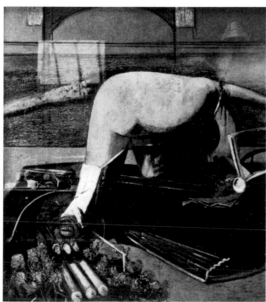

fig.63

fig.62 *Man in a Cap* c.1943
Oil on board, 94 × 73.5
Private collection

fig.63 *Figure Getting Out of a Car* 1943
Oil on canvas, 145 × 128, reworked as
Landscape and Car
Private collection

fig.64 *Man Standing* 1941–2
Oil on board, 99 × 71.5
Private collection

examination might suggest that, despite Bacon's insistence that he had set out to paint a 'bird alighting on a field', this man seems to have grown from a form not dissimilar to that of the *Figure in a Landscape*. Though the nature of the subject makes Bacon's comparison of the Crucifixion to a butcher's shop a profanity, it is precisely consistent with his belief in a godless world. In an existence without god or afterlife there is nothing to distinguish man from animal, living flesh from meat. That comparison is made literal here but, as John Russell has said, Bacon could later make the viewer feel the proximity of the charnel house without actually painting the meat.[15] That this scene of butchery and implied ritualistic sacrifice is presided over by a dictator links it inevitably to recent historical events. A more direct but comparable reference to the horrific images of the Concentration Camps was made in Picasso's *Charnel House* 1945. It was not included in the *Picasso Matisse* exhibition that opened at the Victoria and Albert Museum in December 1945, though it was illustrated in the catalogue, having been shown in the Salon d'Automne in Paris that year; it was also reproduced (unfinished) in 1946 in Alfred H. Barr Jr.'s *Picasso: Fifty Years of his Art*. If any visual debt is not immediately evident in Bacon's *Painting* 1946, Picasso's title certainly resonates, and Bacon may have found it stimulating fifteen years later when it was a centrepiece of the Arts Council's Picasso retrospective, shown at the Tate Gallery in 1960. This was two years before Bacon resumed his fascination with the parallel between the Crucifixion and the slaughterhouse in *Three Studies for a Crucifixion* 1962 (pp.148–9). For the moment, however, Bacon abandoned such subjects for an even more generalised focus on the human body.

In fact, after *Painting* 1946, Bacon abandoned much else as well. On Graham Sutherland's recommendation the dealer Erica Brausen visited Bacon's studio and bought the work straight away. With the proceeds the painter went to Monte Carlo, where he spent much of the time until his ultimate return to London in 1950. No paintings survive from 1947 and only one from 1948, the first of a series of six heads that he exhibited at the Hanover Gallery – newly established by Brausen – in November 1949. In the best of these works, Bacon's philosophical attitude to the human body and human nature were distilled and condensed. Stripping the composition of the incident and detail of *Painting* 1946, Bacon concentrated down on to the animal nature of humankind. In *Head I* (p.102) and *Head II* (p.103), there is little to suggest the head of the title beyond the same snarling mouth of an ape superimposed on to a human chin. The first work has a precisely delineated ear, the second one half of a pair of spectacles (see p.90). These details add a disquieting reminder of the figure's humanity while the contrast of their stillness with the dynamism of the mouth makes it seem as if the figure is possessed, taken over by this animal force. While the fangs leave one in no doubt of the mouths' animal origins, it is not clear whether they snarl aggressively or in fright. Though Bacon had successfully excluded specific references in favour of a more universal bestiality, *Head I* does include the tasselled light or blind cord that would be a recurring feature in his work, and which seems to have derived ultimately from the photograph of Hitler at a window recorded by Hunter.

By the time he reached the sixth in the series of heads, Bacon had arrived at a new facility with his medium. *Head II* is remarkable for the sheer weight of paint, the curtained background being thick with it and having as a consequence a texture that has been compared to a rhino's skin. Or, in Melville's words, the paint had 'an inexplicable order of tangibility' and the 'colour of wet, black snakes lightly powdered with dust'.[16] It was, Bacon later recorded, one of the few works that he had taken too far but which had still survived. *Head VI* (p.104), in contrast, is about as economic in its paint as it is possible to be. It is the earliest surviving reworking of Velázquez's *Portrait of Pope Innocent X* (fig.68), though it shows only the head and shoulders, prompting some to speculate that Bacon based it not on the main painting but on bust-length copies such as that in Apsley House, London. In fact, he had written to Sutherland two years earlier saying that he was 'working on 3 sketches of the Velasquez portrait of Pope Innocent II [*sic*]. I have almost finished one.'[17] In *Head VI* the figure and its setting is described with dry strokes of paint, rarely blending on the bare canvas and barely even overlaying each other. A few cursory marks of golden yellow describe the finials on the back of the Pope's throne; curling strokes of two different purples and a few touches of white the silk robes; thin strokes of black form an indeterminate background. Only the gaping mouth has been treated with more precision, each tooth carefully delineated and contained by the pink lips. The texture of the paint is flatter here than elsewhere on the canvas, and the attention makes the orifice the focal point of the painting. The obsessive individuation of the teeth may associate the image with the same photograph of Goebbels that Bacon had used during the war. The mouth is close in appearance to that in *Figure Study II* 1945–6, again linking the otherwise distinctive image back to that earlier campaign of work.

Thus Bacon launched his famous series of screams, of screaming popes specifically. Much ink has been spilt in discussion and speculation of the nature of this convulsive gesture. Are such figures really screaming, some have asked, or gasping for air – a common and anxious experience for the asthmatic Bacon. 'I wanted to paint the scream

more than the horror,' he told Sylvester.[18] For Gilles Deleuze the scream makes visible invisible and insensible forces.[19] Others have focused on the sources for Bacon's image: the screaming nurse from the Odessa Steps section of Eisenstein's *Battleship Potemkin*, the frantic mother in Nicolas Poussin's *Massacre of the Innocents* 1630–1. Bacon himself cited his fascination with a hand-coloured book on diseases of the mouth. Dawn Ades drew attention to Georges Bataille's 'critical dictionary' entry on 'La Bouche', which proposed that 'on great occasions human life is concentrated bestially in the mouth, anger makes one clench one's teeth, terror and atrocious suffering make the mouth the organ of tearing cries'.[20] Bataille goes on to describe how the human scream is accompanied by extreme physical movement as the neck extends in mimicry of the animal, much like the figure in the right-hand panel of Bacon's *Three Studies for Figures at the Base of a Crucifixion*. The scream in *Head VI* is quite different, however. Much of the ambiguity around the image derives from the fact of the figure's apparent implacability. The quality about Velázquez's original portrait that sets it apart from most others is the artist's ability through subtle gesture, expression and the sheer capacity of his medium to communicate the human frailty and potential cruelty lying behind the inscrutable face of Innocent X. It is this quality that Bacon seems to capture, too. His exquisite description in paint of the scream manages to carry similar expressions of the human condition in all its complex ambiguity underlying the static body.

In the same year as *Head VI*, Bacon painted his first nude. *Study from the Human Body* (p.105) captured the frailty of the human figure as eloquently as the reworking of Velázquez's portrait had captured its agony. Bacon's new facility with his medium allowed him to achieve a tenderness in his description of the male form. Passing between two curtains, the muscular figure consists of almost nothing at all. Yet the musculature and the underlying skeleton are described precisely. With only a few strokes of thin, dry paint the figure's buttocks are achieved with delicacy and an erotic charge. Physically forceful and tender, vital and yet fragile and fleeting, with the most economic of means Bacon again articulated his understanding of the human condition.

CHRIS STEPHENS

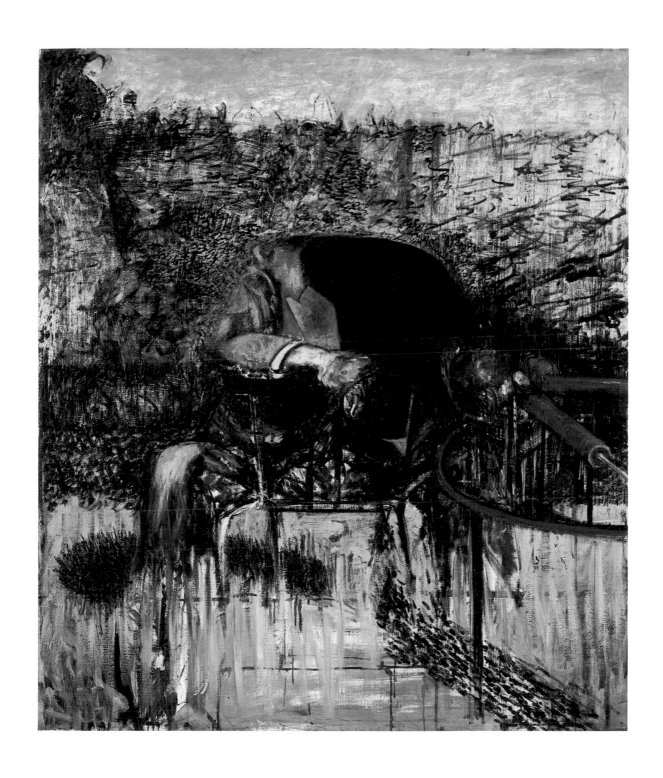

Figure in a Landscape
1945, oil on canvas, 144.8 × 128.3
Tate. Purchased 1950

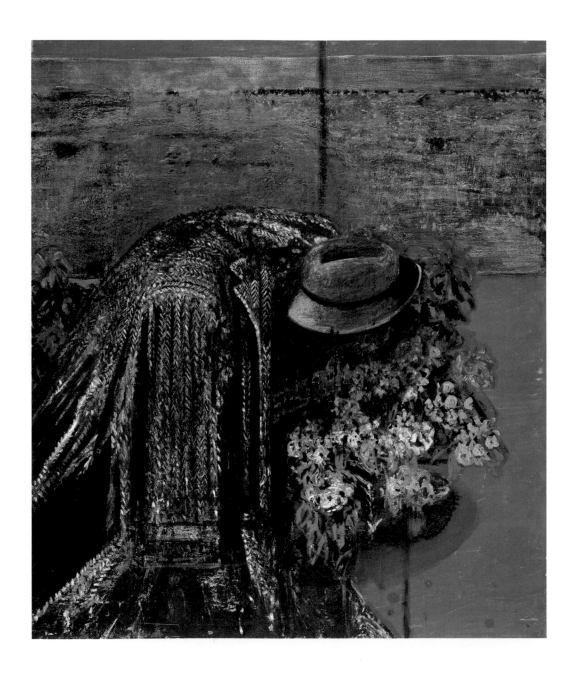

Figure Study I

1945–6, oil on canvas 123 × 105.5

Scottish National Gallery of Modern Art, Edinburgh. Accepted by H.M. Government in lieu of inheritance tax on

the Estate of Gabrielle Keiller and allocated to the Scottish National Gallery of Modern Art in 1998

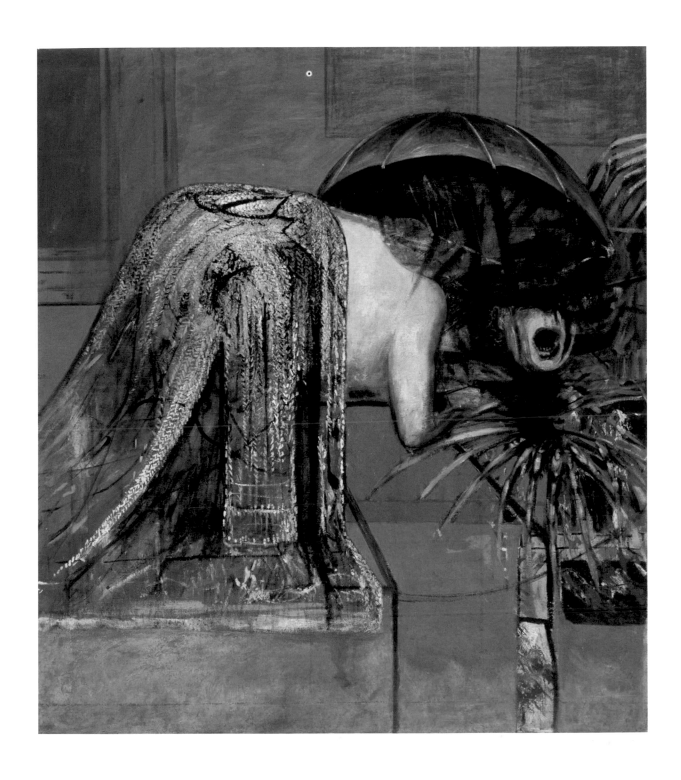

Figure Study II
1945–6, oil on canvas, 145 × 129
Huddersfield Art Gallery

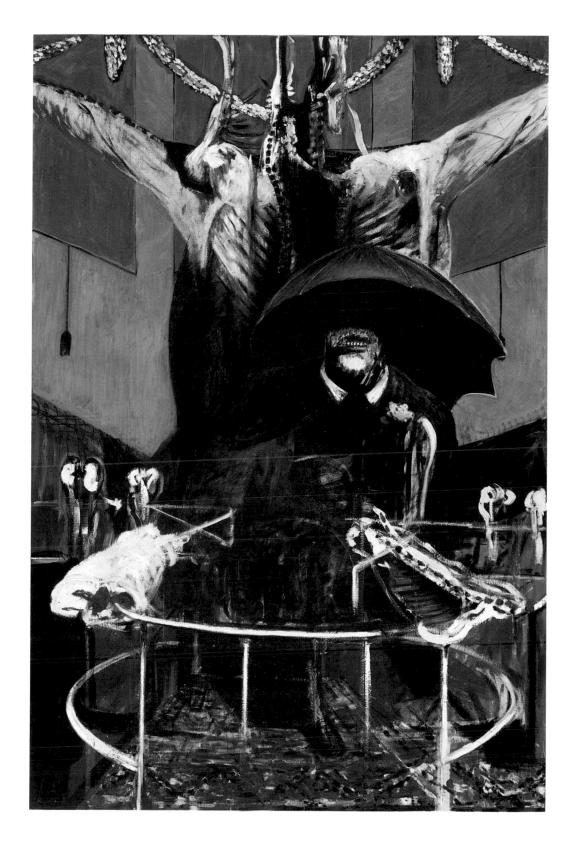

Painting
1946, oil and pastel on linen, 197.8 × 132.1
The Museum of Modern Art, New York

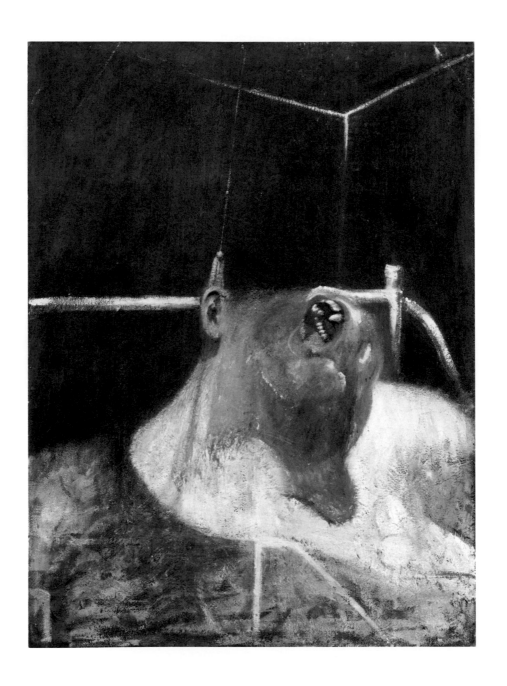

Head I

1947–8, oil and tempera on board, 100.3 × 74.9
The Metropolitan Museum of Art,
Bequest of Richard S. Zeisler, 2007

Head II

1949, oil on canvas, 80 × 63.3
Ulster Museum, Belfast
Gift of the Contemporary Art Society, London

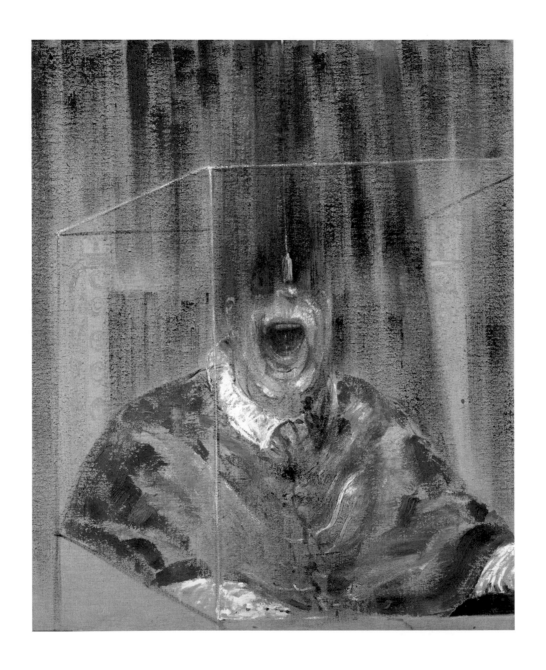

Head VI

1949, oil on canvas, 93.2 × 76.5

Arts Council Collection, Southbank Centre, London

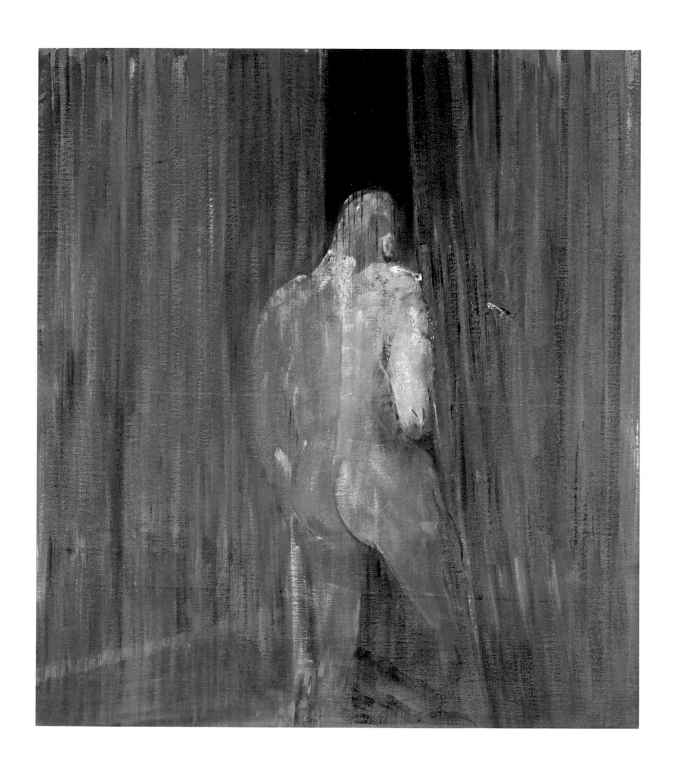

Study from the Human Body
1949, oil on canvas, 147 × 134.2
National Gallery of Victoria, Melbourne, Australia. Purchased 1953

ZONE

Made during a period of considerable personal upheaval, Bacon's paintings of the early 1950s display a new complexity in the way in which he was thinking about pictorial space. From the simple delineations of preceding works, he made increasingly sophisticated zones that draw attention to the confinement of his figures within the picture's fictive space. He emphasised their removal from the viewer in a way that Gilles Deleuze has described as 'an attempt to eliminate every spectator'.[1] Such a distance was achieved through a variety of devices. The space was often controlled by curved foreground railings, a detail that would run through the ensuing works. Bacon acknowledged that these, first seen in *Painting* 1946 (p.101), derived from his 1930s furniture designs, but he saw their function in paintings as 'an attempt to lift the image outside its natural environment'.[2]

A more emotional charge was soon added through the vertical veils of brush strokes, such as found in *Head VI* 1949 (p.104), that became more active in the form of the curtain in *Study after Velázquez* 1950 (p.112). Isabel Rawsthorne's contemporary account of this work pinpointed the articulation of this important detail as the reason for the artist withdrawing the painting at the last minute from his Hanover Gallery exhibition. She noted: 'The background is the same grey curtain, with a suggestion of the folds in front of the head – "dissolving" is Francis' own expression, for this kind of double vision. I gather he wants to make it even more accentuated.'[3] This is the curtain through which the nude man passed in *Study from the Human Body* 1949 (p.105) and it is very similar to that actually found in Bacon's Cromwell Place studio (see back cover). It seems to be associated with a space of repression and desire, which is extended in this 'doubling', whereby the face and curtain conjoin in their striated

structure. The effect is curiously ectoplasmic, akin to the mysterious apparitions of early paranormal photography, and achieved by collapsing the details so that they exist in the same plane, neither one physically painted over the other.[4] This aspect was the focus of Robert Melville's analysis, who also saw this painting in the studio and recalled a few months later: 'the mysterious and wholly inexplicable thing about Bacon's painting was the fact that the figure and the chair were not behind or in front of the curtain but somehow materialised within it.'[5] Melville reported that *Study after Velázquez* was then destroyed and, as Bacon himself lost sight of it, the possibility remains that he considered that the planned accentuation was never resolved.[6] However, in his contemporary remarks on Matthew Smith, Bacon gave a sense of this aspiration, as 'a complete interlocking of image and paint, so that the image is the paint and vice versa'.[7] This emphasis on the material of the paint, as well as its identity with the image and its impact, would be a continual thread in Bacon's view of his own work.

In drawing upon Velázquez so consistently at this moment, Bacon emphasised the ambiguous zone of portraiture that the Spaniard could only imply (fig.68).[8] He recharged this atmosphere with a tense proximity that is at once intimidating and distant. The hierarchy of details in *Study after Velázquez* – robes, throne, dais, veil, railing, curtain, hexagon – mark out the removes associated with power, while simultaneously undermining the effect through the detail of the small box on which the Pope is perched (and which recalls the pedestal-table of the central creature of *Three Studies for Figures at the Base of a Crucifixion*, pp.146–7). Constructed *terribilità* is here subverted. Just as it had been in *Head VI*, so the attention in *Study after Velázquez* is concentrated in the Pope's open

mouth. This focus exposes the tension in the relationship between this interior (physical and psychological) space of the body and the layered spaces in which the figure is located. While the primal sexual aspect of the mouth was identified by Sigmund Freud, its place as a site of the bestial aspects of man's existence – cries of pleasure and pain – had been explored in Georges Bataille's writings.[9] There are also parallels with the suppressed rage felt by Frederick Rolfe's fictional (Edwardian) Pope Hadrian VII who, on accepting the kisses of the electing cardinals, experiences 'physical loathing which nauseated Him secretly … He would have liked to tear off His Own cheek with clawed tongs'.[10]

In *Study after Velázquez* Bacon added the perspectively rendered red hexagon to the 'dissolving' veils in order to ground and circumscribe the figure's space. It is symptomatic that this device also served that purpose in quite different circumstances. It appears, most notably, in *Study of a Dog* 1952 (p.113), in which a mastiff located in a formal flowerbed becomes an image of feral rummaging and considerable strangeness.[11] The blur of the dog's legs (derived from a favourite Eadweard Muybridge photograph (fig.67), and the energy of revision, lend an urgency that some interpreted as filmic,[12] while, by lowering the viewpoint to that of the dog, a comment on status is inevitably implied.[13] The shared use of the hexagon underlined this levelling of hierarchies that could result in the linking of the pope and a dog, though this was also explicit in the (seemingly) loose handling of these images that simultaneously blurred and energised.

Yet another layer of inflection may be discerned, as Ronald Alley (presumably on information from the artist himself) reported that this motif was 'partly suggested by the gigantic stadium prepared for the National Socialist party's conventions at Nuremberg'.[14]

Detail from *Study for Crouching Nude* 1952 (p.118)

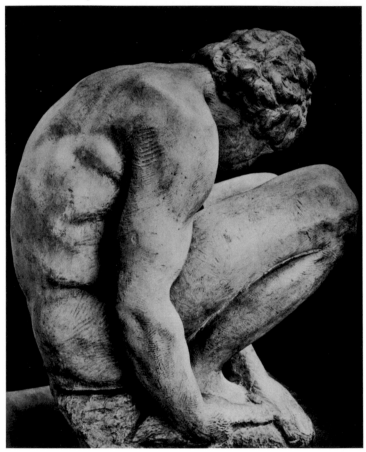

fig.65

fig.66

fig.65 Attributed to Michelangelo
Crouching Boy or The Adolescent
c.1530–4
Marble, height 54
Hermitage, St Petersburg

fig.66 Lichtdom (Cathedral of Light):
Party Rally, Nuremberg, 1937

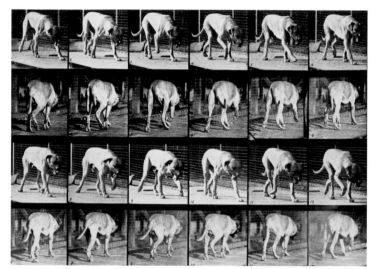

fig.67

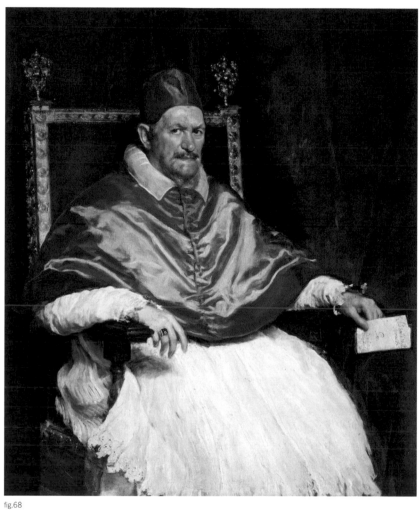

fig.68

fig.67 Eadweard Muybridge
Plate 704, *Dog Walking. Mastiff dread,*
from *Animals in Motion* (1887, 1907 ed.)

fig.68 Diego Velázquez
Portrait of Pope Innocent X 1650
Oil on canvas, 114 × 119
Galleria Doria Pamphilj, Rome

Although no image accompanied this assertion, a telling comparison can be drawn with a night-time photograph, in which the Nuremberg crowd coalesces into such a form (fig.66). It is particularly striking how the searchlights pointing vertically into the night sky resemble the shuttering of the veiled curtain in *Study after Velázquez*.[15] The red hexagon, therefore, allows for a coalescing of Velázquez's Old Master painting, Nazi propaganda and Muybridge's time-lapse photography: the august, the awesome and the abject. There is also a sense of a wider language of these forms functioning alongside an alertness to forces that most of Bacon's contemporaries recognised as violent. It is often noted, for instance, how Alberto Giacometti's cage structures for sculptures and pictorial frames within paintings have parallels with Bacon's space-frames, which became more evident as the early 1950s moved on. Furthermore, harsh geometry and post-war existential anxiety gained a wider currency among those who, like Bacon, Giacometti and Germaine Richier, showed at the Hanover Gallery, including the British sculptors Reg Butler, Eduardo Paolozzi and William Turnbull, whose work Herbert Read had designated at the 1952 Venice Biennale as representing 'the geometry of fear'.[16]

Looking back in 1962, Bacon confirmed to David Sylvester how Velázquez's *Portrait of Pope Innocent X* (fig.68) 'just haunts me, it opens up all sorts of feelings and areas of – I was going to say – imagination, even, in me'.[17] He had begun working from it in 1946,[18] and reconceiving the image became the leitmotif around which he conjured elaborations that, cumulatively, become almost cinematic. He acknowledged that this interest came to be transferred to the office of the pope as, 'like in certain great tragedies, he's as though raised onto a dais on which the grandeur of this image can be displayed to the world'.[19]

This is implied in *Pope I – Study after Pope Innocent X by Velázquez* 1951 (p.114), in which the sketched-in vaulting confirms an upward view and which, despite its elaborate title, derived from a photograph of Pius XII being processed in the *sedia gestatoria* (fig.89).[20] The pince-nez, seen in *Head VI* and associated with Bacon's admiration for *Battleship Potemkin*, return, but the Pope's lips, in this variation at least, are sealed.

Closely related details are captured in the extraordinary *Study after Velázquez's Portrait of Pope Innocent X* 1953 (p.119). Veils of paint sliding through the face and screaming mouth achieve the 'doubling' of which Rawsthorne wrote. The encircling structure is more emphatic still, with the yellow delineation of the throne entangling with paired curved rails across the foreground. From one of these falls the lowered curtain, already familiar from the earlier paintings in the sequence, which gives a curious sense of upward propulsion. Bacon famously claimed never to have seen Velázquez's painting (even during the months spent in Rome in 1954), and later regretted his variations as 'records of it – distorted records'.[21] Nevertheless, *Study after Velázquez's Portrait of Pope Innocent X* condenses the 'raw estrangement from the world' attributed to Bacon's work,[22] and justifies that most powerful of Deleuze's observations: 'Bacon's scream is the operation through which the entire body escapes through the mouth.'[23]

The rail that reins back the Pope describes almost exactly the same curve as the fictive structure in *Study for Crouching Nude* 1952 (p.118), so that formal similarities again reveal a levelling across Bacon's subject matter. This may relate to his contemporary definition of art as a 'method of opening up areas of feeling rather than merely an illustration of an object'. To this he added: 'A picture should be a re-creation of an event rather than an illus-

tration of an object: but there is no tension in the picture unless there is the struggle with the object.'[24] Quite what the event might be is less significant than this sensibility. Where the Pope was enthroned, the nude crouches in unidentified action. Hierarchies are thus upended, and the spiritual and physical equated. Even the sense of the noble and heroic nude is undermined by the simian pose, as the physically compacted man becomes bestial. Like so much else in Bacon's work, *Study for Crouching Nude* also appears to combine different possibilities and he continually returned to it, listing it as a source in 1959 and later attempting 'to make this into a mirror so that the figure is crouched before an image of itself'.[25] His potential for self-referentiality indicates that this particular painting was, in itself, a potent synthesis of Bacon's disparate vocabulary of images. The careful numbering that checks off points beyond the figure (p.106), for instance, recalls the markings used by Muybridge and was a device already applied to the more threatening *Study for Nude* 1951 (p.115). In both paintings the naked body is primal and solidly modelled in a way that recalls Masaccio's *Expulsion from the Garden of Eden* and Paul Cézanne's large *Bathers* in London's National Gallery. The figure in *Study for Crouching Nude* carries these implications, as well as suggestions of Muybridge's sequence of rowers, but its major impulse almost certainly derives from a photograph of the *Crouching Boy* sculpture at one time attributed to Michelangelo (fig.65),[26] which shows the same musculature and bears with it homoerotic overtones. As Bacon remarked much later: 'Michelangelo and Muybridge are mixed up in my mind together.'[27]

If this sense of the body was filtered through reproductions, it was the disjunctures to which Bacon submitted his sources that enabled him to bring about his

characteristic vision of the world. The strange indeterminacy of the activity in *Study for Crouching Nude* is echoed in the, otherwise quite different, *Study of a Figure in a Landscape* 1952 (p.117). Without the structuring devices but at some remove within the flicked brushwork of savannah grasses (that suggest Bacon's recent experience of southern Africa), a pallid nude man crouches. The fictive distance and outdoor setting bring an openness and warmth, while smudged blue and flecked greens and black sketch in the sky and forest. The figure's action remains ill-defined. His scale is somewhat larger in the related work on paper, *Figure in a Landscape* (Tate), and the remnants of another body (bending to the left) suggest a sexual charge. Something predatory and atavistic is implied in the oil painting, as the concealed body appears to be posed rather more shamefully than the frank sexuality of the slightly later *Two Figures in the Grass* 1954 (p.134).[28]

In shifting between the structures of his paintings and their settings, Bacon sustained connections across different zones that establish what Gaston Bachelard has termed, in a different context, a 'dialectic of division' between 'inside' and 'outside'.[29] While *Study of a Dog* and *Study for a Figure in a Landscape* were presented as being outdoors, they shared (most evidently in the first case) certain compositional structures with the portrayals of disturbed papal figures. This confirms that the painter's confusion of references – what has been called his 'zone of indiscernibility ... between man and animal' – was very deliberate.[30] Indeed, twenty years later, he spoke to Sylvester of this blending: 'animal movement and human movement are continually linked in my imagery of human movement.'[31] Alive to the traditional acceptance of the evolutionary characteristics of humans – the abilities to walk upright and to communicate through complex speech - Bacon favoured the prehensile crouch and the irrepressible scream. Such a tapping of the primeval recalls Bataille's identification of the soldier in uniform as the ultimate exemplar of the upright man, though qualified with characteristic astringency: 'If ... this mathematical military truth is contrasted with the excremental orifice of the ape ... the universe that seemed menaced by human splendour in a pitifully imperative form receives no other response than the unintelligible discharge of a burst of laughter'.[32]

MATTHEW GALE

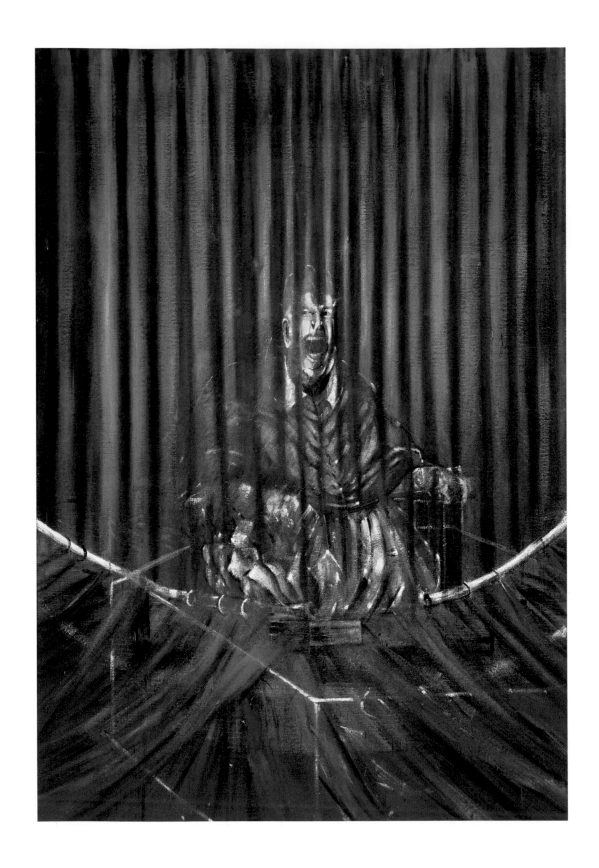

Study after Velázquez

1950, oil on canvas, 197.8 × 137.4

Private collection to The Steven and Alexandra Cohen Collection

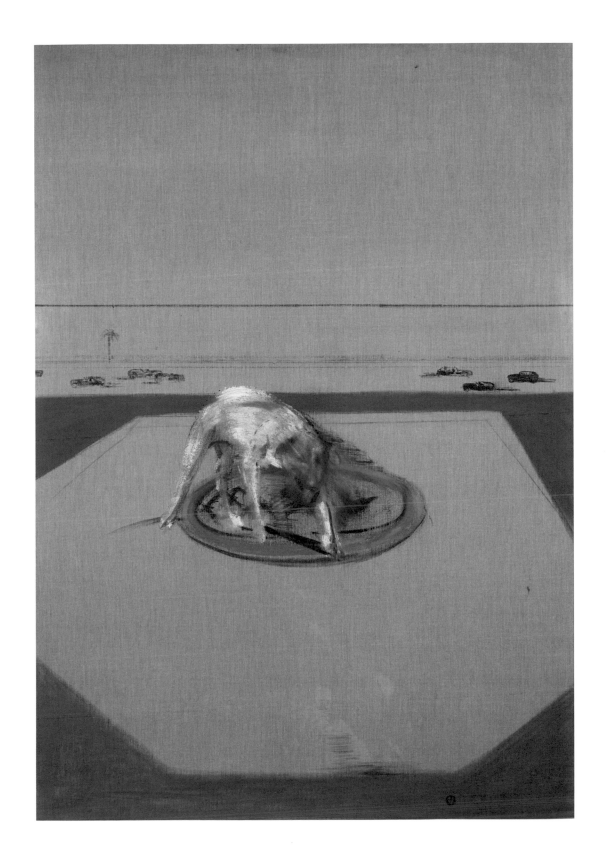

Study of a Dog
1952, oil on canvas, 198.1 × 137.2
Tate. Presented by Eric Hall 1952

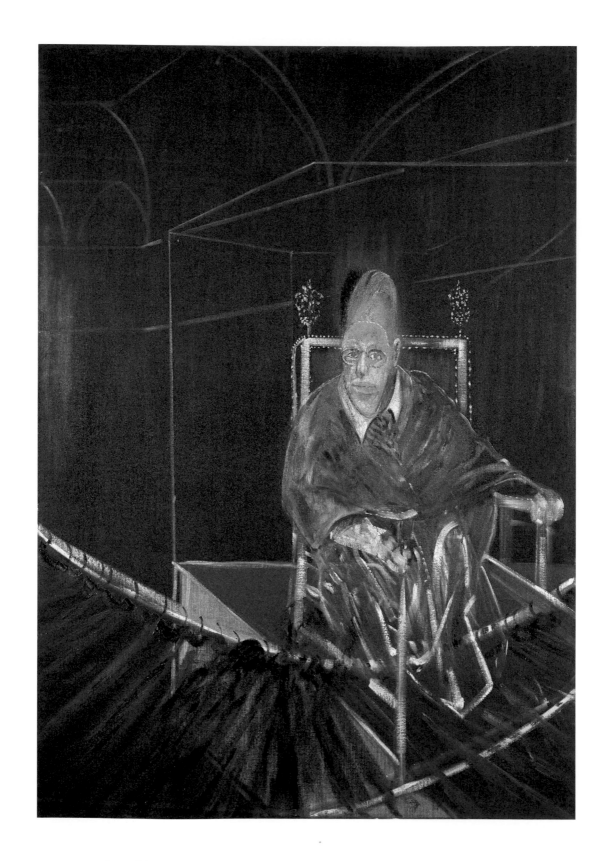

Pope I – Study after Pope Innocent X by Velázquez

1951, oil on canvas, 197.8 × 137.4

Aberdeen Art Gallery & Museums Collections

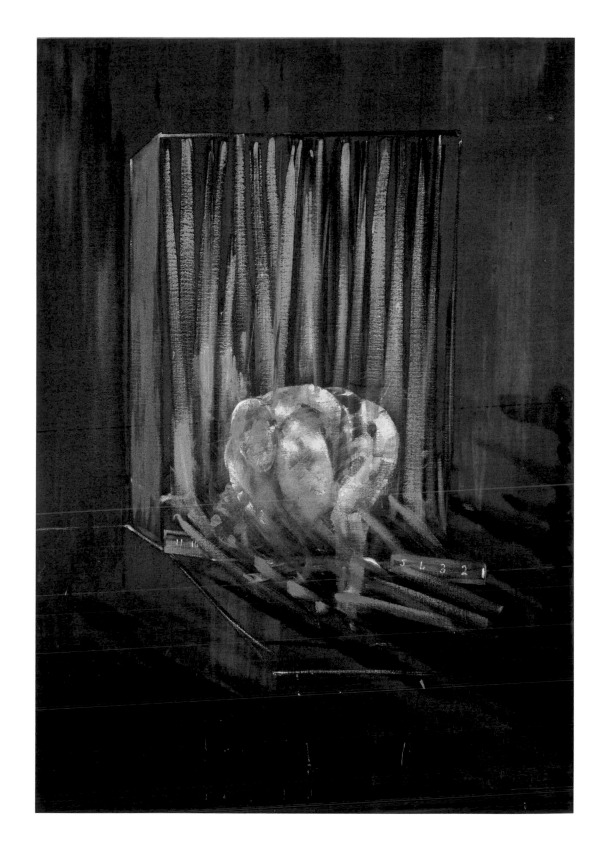

Study for Nude

1951, oil on canvas, 198 × 137

Collection of Samuel and Ronnie Heyman

Study of a Figure in a Landscape

1952, oil on canvas, 198.1 × 137.2

The Phillips Collection, Washington, D.C.

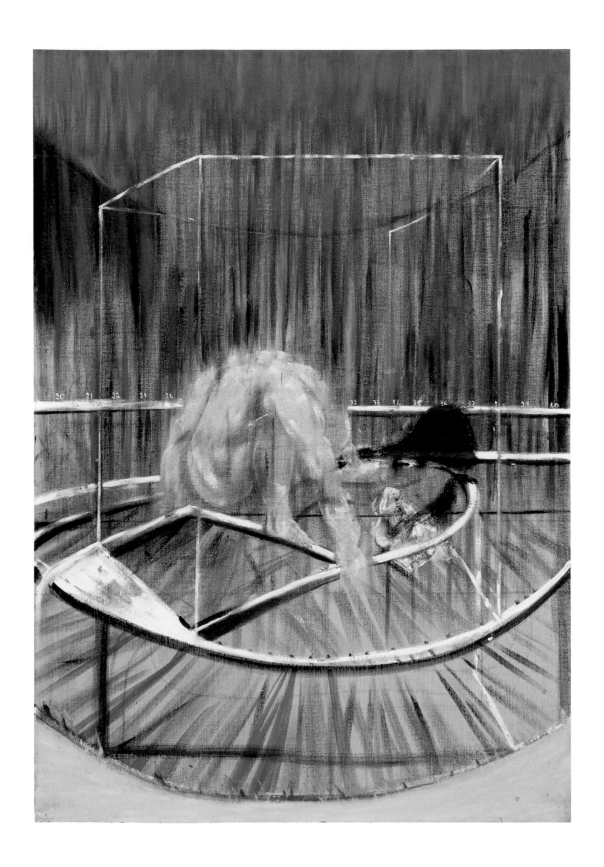

Study for Crouching Nude

1952, oil on canvas, 198 × 137.2

The Detroit Institute of Arts. Gift of Dr Wilhelm R. Valentiner

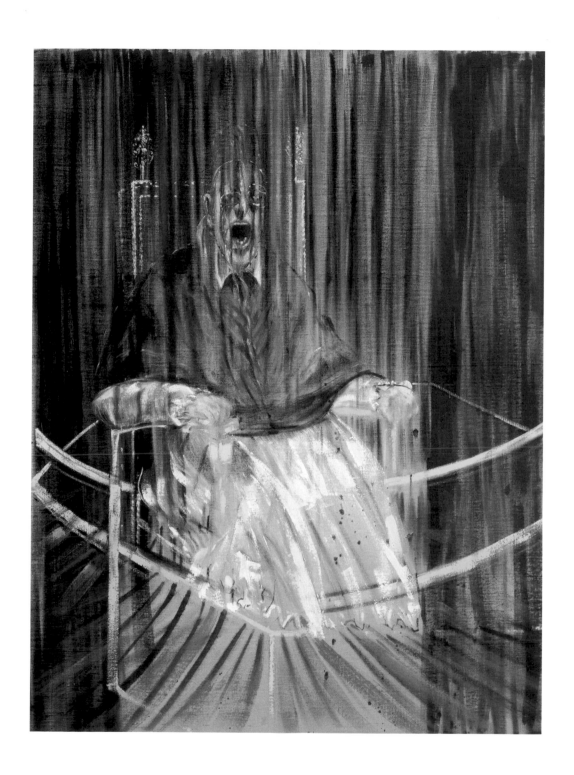

Study after Velázquez's Portrait of Pope Innocent X

1953, oil on canvas, 153 × 118

Purchased with funds from the Coffin Fine Arts Trust;

Nathan Emory Coffin Collection of the Des Moines Art Center

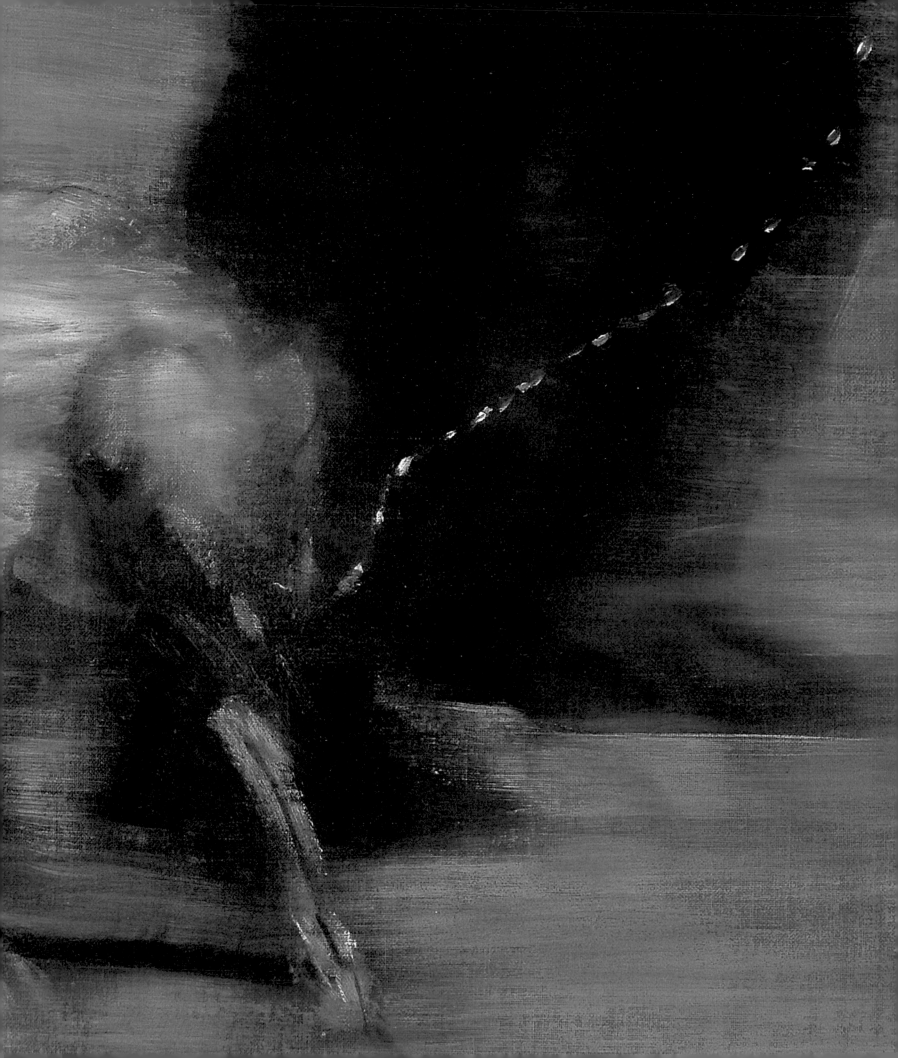

APPREHENSION

In 1954 Bacon began a series of works quite different from those that had come before. United under the shared title *Man in Blue*, these seven paintings are characterised by a deep blue-black ground extending evenly right across the canvas (see fig.48 and pp.132–3). Against that ground is a single male figure in a dark suit, collar and tie. As the suit has no colour other than the ground, each figure consists of little more than its face and shirt beneath. Each is set within a cursory context described by a few lines and strokes of pale paint. The space they occupy is created with a simple painted frame and vertical striations to suggest two walls. Between the subject and the viewer there is some sort of table or counter. On first glance, the paintings appear to be grisaille, made only of black and white. The colours are more subtle than that and, on closer inspection, the faces of the figures are seen to be delicately painted in a mixture of reds and whites to create a range of flesh tones. The best of these are virtuoso passages of painting, the face and its expression captured precisely and yet smudged and abstracted enough to avoid the particular. Close to, what appeared a deathly pallor is revealed to have more red and pink about it. Rather than injecting it with life, however, this colouring serves more as a reminder that, for Bacon, the human body is just meat.

In 1950–2 Bacon had set his figures – popes, athletes, dogs – in the middle distance within a polygonal field, or enclosed by a rail. Thus were the subjects caught somewhere between the world of the picture – the motor cars buzzing along the corniche in the distance – and the viewer's own space. After that, the figure was pushed forward in its pictorial space and sandwiched between the viewer and some close-to backdrop, a curtain for instance or the gold-framed furniture of the series of popes from 1953 (p.128). In the *Man in Blue* series, however, the face that stands for

the entire man seems much more to sit on the surface of the painting. Indeed there is a visual paradox within the compositions. The suggestions of a room and the counter or table that sits between viewer and subject imply an illusory space within which the sitter is confined. Conversely, the contrast between the physical mass of smooth paint that constitutes the head and the thin ground on which its sits emphasises the flatness of the painting.

In this way Bacon was, perhaps, engaging with current debates about modernism in painting. Though the American Abstract Expressionists had not yet been seen to any great extent in Britain, their work was known from exhibitions at the Venice Biennale, the inclusion of odd paintings in group exhibitions and through private collections. More importantly, the critical framework that had been built around their work by Clement Greenberg had been exported and, indeed, had been anticipated in Patrick Heron's writing. Both writers defined modernism in painting according to pictorial depth, or lack of it. For Greenberg increasing flatness, the recognition of the picture plane as a painting's unique defining characteristic, was the key criterion of progress in painting. For Heron it was the achievement of shallow but non-illusionistic depth, as in the work of Georges Braque for example. Following his replacement as art critic for the *New Statesman* by the advocate of social realism John Berger, Heron described 1954 as the year of realist reaction as the Kitchen Sink group of painters came to prominence. Bacon's dismissal of abstract painting is well known, but it is hard to imagine that he would have had any more time for the Kitchen Sink artists' realistic depictions of working-class kitchens and outdoor lavatories.[1]

One might more usefully consider Bacon at this time in relation to developments in

France, specifically, the phenomenon dubbed *Tachisme*, another marginalised part of the history. Bacon himself used the term to capture a wider range of abstract artists, including Jackson Pollock, within his understanding, and he spoke of a work by Henri Michaux that he owned. This throws the emphasis on the 'free marks' from which the term derived its name, but there is another aspect of post-war French painting that provides an important context for Bacon's treatment of the *Man in Blue* series. In his 1953 essay on Matthew Smith, Bacon described the importance of the interconnection of a painting's image and the paint itself and associated it with a tradition that might encompass Titian, Rembrandt, Chaïm Soutine and, of course, Smith.[2] That total identification of medium with subject matter had reached new levels in France in the work of Jean Dubuffet and, in particular, Jean Fautrier. The latter's *Otage* paintings, inspired by his wartime experiences (fig.69), were first shown in 1945, and in them a direct equivalence is suggested between paint and threatened flesh. Fautrier lay paste-like paint on to his support to produce a visceral image that had actual three-dimensional substance. It was not simply the solidity of his images that was remarked upon, but the relationship of his practice to more basic bodily functions. Michel Ragon observed his 'continual allusion to sperm and filth', while Francis Ponge compared the quality of his work with a cat's excretion in the embers of a fire. With common roots in Georges Bataille's advocacy of the *informe* there is surely an echo there of Bacon's advocacy of dust as a painting medium.[3]

There is no question that Bacon's figures, on the brink of sinking into the black depths beyond, spoke more powerfully of the human situation than the Kitchen Sink artists' rather nostalgic depictions of

Detail from *Man with Dog* 1953 (p.130)

everyday environments. One might see him as addressing the questions of life rather than the spaces in which it is lived. The Men in Blue have normally been seen as executives or politicians: like the Popes, figures of authority revealed as vulnerable and solitary. Ronald Alley observed that they had been 'interpreted both as a victim (one of the pictures was exhibited in New York as "Man Trapped") and as a kind of ruthless interrogator, a Senator McCarthy figure'.[4] Bacon said that the series was based on a man he met at the Imperial Hotel in Henley-on-Thames where he stayed in March 1954. Far from a sinister omnipotence this reference suggests the petty powers of the minor businessman, the comfortable bourgeois drinking of the hotel bar or the illicit, twilit assignations of a gay pick-up. Bacon confirmed the specificity of the hotel as a source of inspiration in a letter from Ostia in November 1954 when he told Sylvester he was 'excited about the new series I am doing – it is about dreams and life in hotel bedrooms'.[5] Sylvester took it that it was to the Man in Blue series that Bacon was referring when he said that any 'sense of claustrophobia and unease' might have stemmed from the fact that they were of his lover Peter Lacy, 'who was always in a state of unease … this man was neurotic and almost hysterical'.[6] Photographs that Lacy and Bacon took of each other behind a large table certainly possess similar compositional qualities (figs.71–2).

Whoever the model for these images, it is their enigmatic generality that is striking. Penned in behind their desks or counters, their hands clasped together or arms resting one on the other, they can variably be seen as a solitary drinker or an ingratiating barman or bank manager. The combination of the fleshy description of their faces, the awkward veracity of their poses and the isolating scale of the figure pushed into the dark by the diag-

onals of the furniture serves to emphasise their pathetic vulnerability and aloneness. The ambiguities and solitariness of the figures resonated with contemporary public events, as they were made at a time when anxieties and debates around homosexuality were prevalent. An increased suppression of homosexuality in post-war Britain led to a number of high-profile cases, including that of Guy Burgess and Donald Maclean, spies who defected to the Soviet Union in 1951, bringing together in the public eye homosexuality and the shady world of espionage.[7] Arrested in January 1954 for homosexual offences, the elegantly dressed Peter Wildeblood spoke of himself as 'the blurred and shadowy figure of the newspapers', conjuring an image not unlike those described in paint by Bacon.[8]

As Sylvester and others have shown, these works are the descendants of a more varied group of paintings from the previous year. From these more contrasting works Bacon seems to have extracted a subtler, more enigmatic approach to his subject. The pivotal work that opened up this campaign of painting was probably the unusually small Study of a Nude (p.125). Demonstrating that size and scale need not mean the same, this is the quintessential image of the heroic figure teetering on the edge of the abyss. Taken from an Eadweard Muybridge sequence (p.169), the figure's arms are raised as if preparing to dive, to take the existential leap into the blue-black depths of the unknown. Perhaps Bacon used the smaller format because to have executed such an image on his normal scale would have been too corny, too melodramatic. To address so fluently the classic theme of the Sublime, the fragile body confronted by a monstrous nothingness associated most strongly with Caspar David Friedrich, on a minute scale was surely brilliant. The 1950s saw a revival of interest in the Sublime, a mighty and monu-

mental nature offering an apt metaphor for a period characterised as one of anxiety. The Sublime offered a way of understanding the work of Colour Field painters like Mark Rothko and Barnett Newman, while in Britain its revival was more generally associated with artists making images abstracted from nature such as Peter Lanyon and Terry Frost.

Bacon addressed the theme again – more obliquely – later in 1953 with his Man with Dog, one of several works that strengthen the claim for 1953 to have been his annus mirabilis. The dog, derived again from Muybridge, embodies the fragility and transience of life. The artist exaggerates the blurring of the original photograph to enhance the sense of this as a captured, passing moment. The fleetingness of the figures and the cutting off of the top of the composition both create the sense of this as a chanced glimpse of a moment. Everything else in the picture is made up of negatives. Apart from the dog itself, the image is defined by its surroundings. The trousers of the man are not painted but described by an area of ground which has been left blank when the mushroomy grey of the pavement was applied (p.120). Similarly, the kerb is untouched ground, as is the off-square drain, its detail determined with a few quick strokes of pink. With such economy of means Bacon conjures the abject liminality of the gutter. It is as if, in this moment, passing along the pavement, the dog glimpses its own mortality in the bottomless pit of the drain. What a powerful metaphor for the constant presence of mortality in life: the sewer running under the streets. As Julia Kristeva has written, excrement – that which is expelled – signifies death, 'the other side of the border, the place where I am not'.[9] And Bacon himself made the same association of excrement and death: 'At what age did you come to realize that death was going to happen to you too?' Sylvester asked him. 'I remember looking at

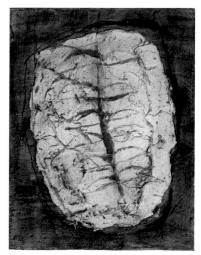

fig.69

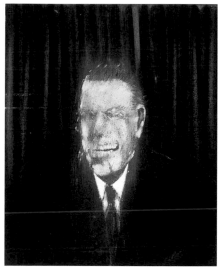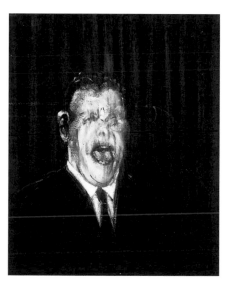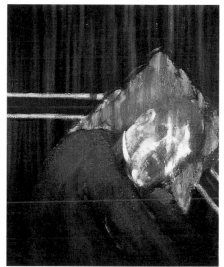

fig.70

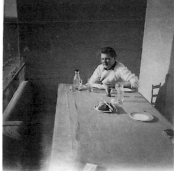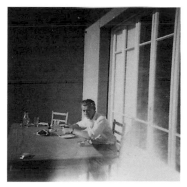

fig.71 fig.72

fig.69 Jean Fautrier
Head of a Hostage, No.14 1944
Oil on paper, 34.9 × 26.7
The Museum of Contemporary Art,
Los Angeles. The Panza Collection

fig.70 *Three Studies of the Human Head*
1953
Oil on canvas, each 61 × 51
Private collection

fig.71 Peter Lacy
Francis Bacon (date unknown)
Gelatin silver print
Dublin City Gallery The Hugh Lane

fig.72 Francis Bacon
Peter Lacy (date unknown)
Gelatin silver print
Dublin City Gallery The Hugh Lane

a dog-shit on the pavement and I suddenly realized, there it is – this is what life is like,' he replied.[10]

If these two extraordinary works preceded the *Man in Blue* series, the latter were more directly anticipated in two paintings of seated males, both entitled *Study for a Portrait* 1953 (pp.126, 131), and in a head of the same year to which Bacon added two more to make an awkwardly asymmetrical triptych: *Three Studies of the Human Head* 1953 (fig.70). The smaller *Study for a Portrait* 1953 (p.126) has many of the qualities of the Men in Blue, though the setting is described in a bit more detail. The figure with his square jaw, slicked-back hair, blue suit and black tie is impressive. His expression is as ambiguous as his attire. Is he dressed for a funeral? Or is he some kind of gangland criminal? We cannot tell if his expression is one of pleasure or pain. The pose is awkward, the crossed knee raised, with the hands disappearing underneath, so that the trouser leg opens at the bottom to reveal the figure's sock: a glimpse of human frailty.

If this figure seems to be a picture of awkwardness hidden behind a mask of dominance and respectability, the other *Study for a Portrait* seems to address the lonely pathos of the powerful. This hieratic figure towers over the viewer, investing him with a haughty dominance (p.131). The elevated pose and the disdainful downward gaze emphasise the sense that this figure alludes to some powerful businessman or politician. Indeed, the pose and manner recall photographs of Joseph Stalin at the Yalta Conference, and we might recall that Bacon stashed away the front cover of *Picture Post* that announced Stalin's death in 1953.[11] Though it predates it by a year, the powerful, seated figure can be interestingly compared with Graham Sutherland's portrait of Winston Churchill. If Churchill reviled the painting so much he burnt it, Bacon too was disdainful, describing it as 'a lesson in how not to use photographs'.[12] The contrast

between the two artists' approaches is striking. By seeking a likeness, Sutherland was forced to express the Churchill-ness of his sitter, while Bacon evokes a universal sadism and solitude that attends such powerful figures. It is surely telling that the period during which he was painting such men was framed at either end by his *Study of a Baboon* 1953 (p.127) and *Chimpanzee* 1955 (p.135), each of which suggests the human qualities of the primates despite their vicious fangs, the same fangs that had been imposed on the human heads of 1948–9.

Of the *Three Studies of the Human Head* (fig.70), the first was that now on the right, which shows the upper part of a man, his mouth gaping as if shouting or crying in pain as his head crashes into or is cradled by a cushion. The central panel is said to be based on a news photograph of the Canadian Prime Minister, while the third has been identified as Peter Lacy.[13] Thus Russell, reading left to right, sees the first panel as standing for 'quiet and easy sociability', another for the 'Public Man in full flood' and the third the dissolution of the public mask.[14] Typically, however, the figures' expressions are too ambiguous for such a precise reading. The central, politician figure could be gasping for air, Lacy's smile is as menacing as it is sociable, and the third is replete with possible meanings. What sets the last apart from the others – as well as its composition – is that the other two seem to capture a momentary expression. As such they might be related to a type of work of the same period in which Bacon observed men in banal, everyday situations: drinking from a glass, eating a chicken leg. In both of these he records how a dull, ordinary action can reveal the animal nature always lying under the surface: the teeth magnified in the gaping mouth by the glass, the ape-like relishing of the dead bird.

The animal brutality of everyday life is implicit throughout the works of the mid-

1950s. This is nowhere more true than in the other great painting of 1953, *Two Figures* (fig.46). Here, a frame from Muybridge's sequence of wrestlers (fig.91) is faithfully transcribed and yet transformed into a scene of homosexual intercourse. The faces are blurred as if in movement or to protect their identity, though we are assured that the figures are recognisably Bacon himself and his lover Peter Lacy. Their bodies are sensitively described in tones of flesh colours and blue-greys, which contrast with the sharp white of the bed-linen to suggest a deathly pallor. The bared teeth of the lower figure confirm the ambiguity – the confusion of pleasure and pain – that such expressions might communicate. The shuttering effect – the dragging of thin striations of paint vertically over the composition – serves to distance and dematerialise the scene. The dissolving or materialising of the figures within this shuttering takes on a particular significance in the representation of an illicit and illegal sexual act. Possibly Bacon's most fluent and most challenging work, it is appropriate that *Two Figures* has come to occupy a particularly mysterious space within the Bacon story. The work was first shown in an upstairs room at the Hanover Gallery, was sold privately within Bacon's circle of friends and, at the time of writing, has not been exhibited for nearly forty years.

'Birth, copulation and death/ That's all the facts when you come to brass tacks,' said Eliot through Sweeney.[15] It was a sentiment with which Bacon would have had some sympathy. Refusing any idea of a deity or an afterlife, he insisted on the fact of this life being all there is and on the ever-presence of death. Certainly, a sense of apprehension and mortality pervades the dark paintings of the mid-1950s. 'If life excites you,' he told Sylvester, 'its opposite, like a shadow, death, must excite you'.[16]

CHRIS STEPHENS

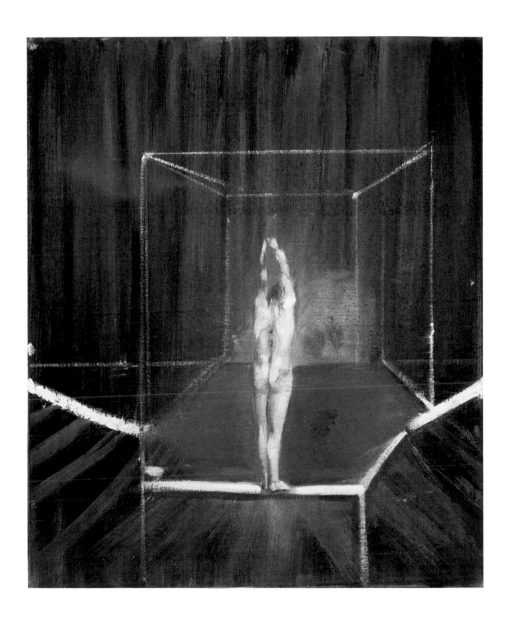

Study of a Nude

1952–3, oil on canvas, 59.7 × 49.5

Robert and Lisa Sainsbury Collection, University of East Anglia, Norwich

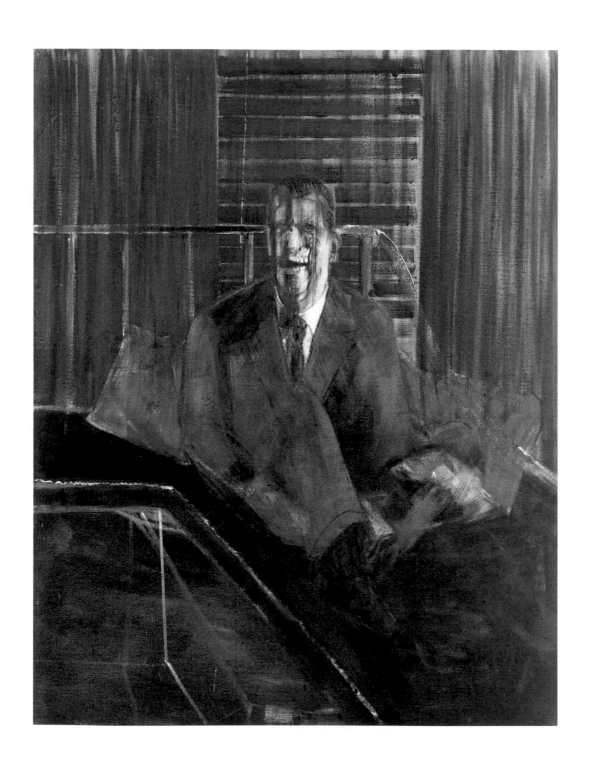

Study for a Portrait

1953, oil on canvas, 152.2 × 118
Hamburger Kunsthalle

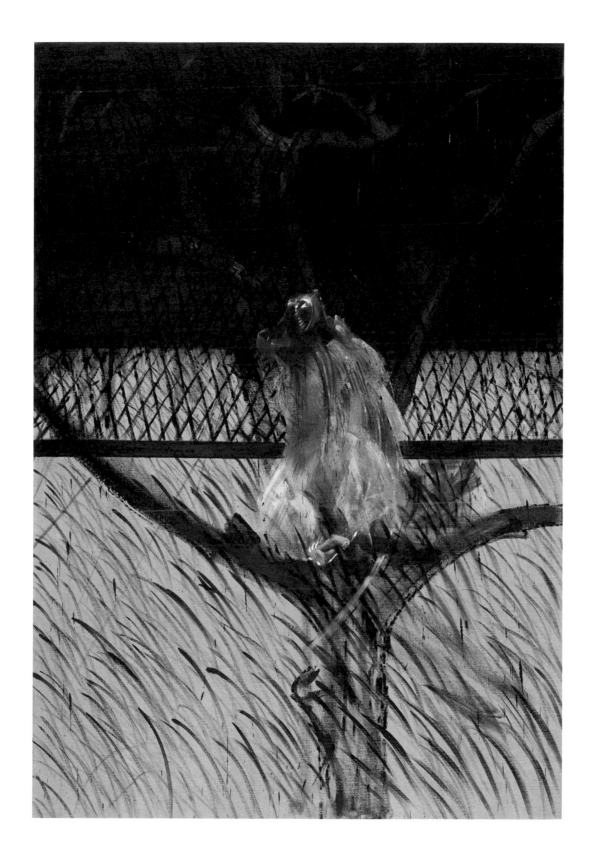

Study of a Baboon

1953, oil on canvas, 198.3 × 137.3

The Museum of Modern Art, New York. James Thrall Soby Bequest, 1979

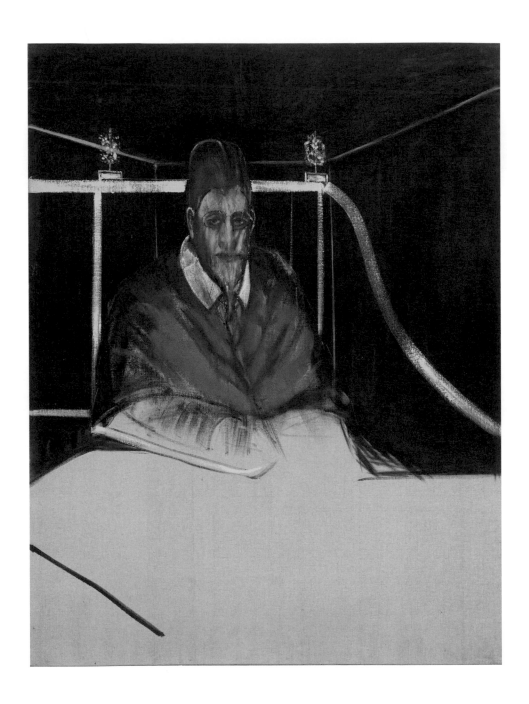

Study for a Portrait I

1953, oil on canvas, 152.1 × 118.1

Denise and Andrew Saul

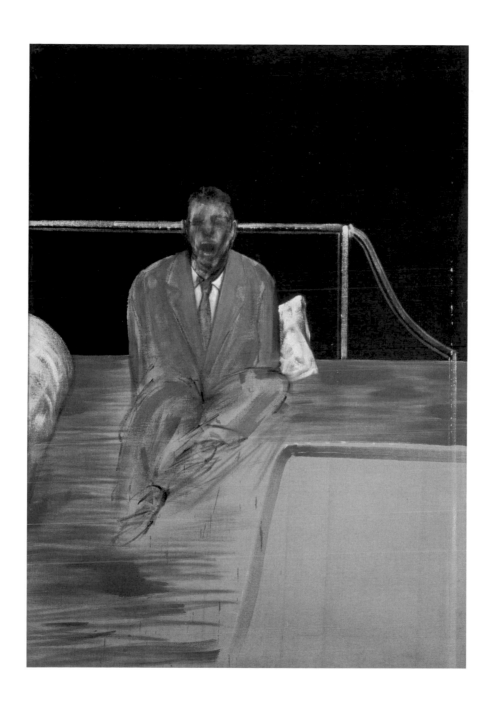

Study for a Figure II

1953–4, oil on canvas, 198 × 137
The Collection of Mr. and Mrs. J. Tomilson Hill, New York

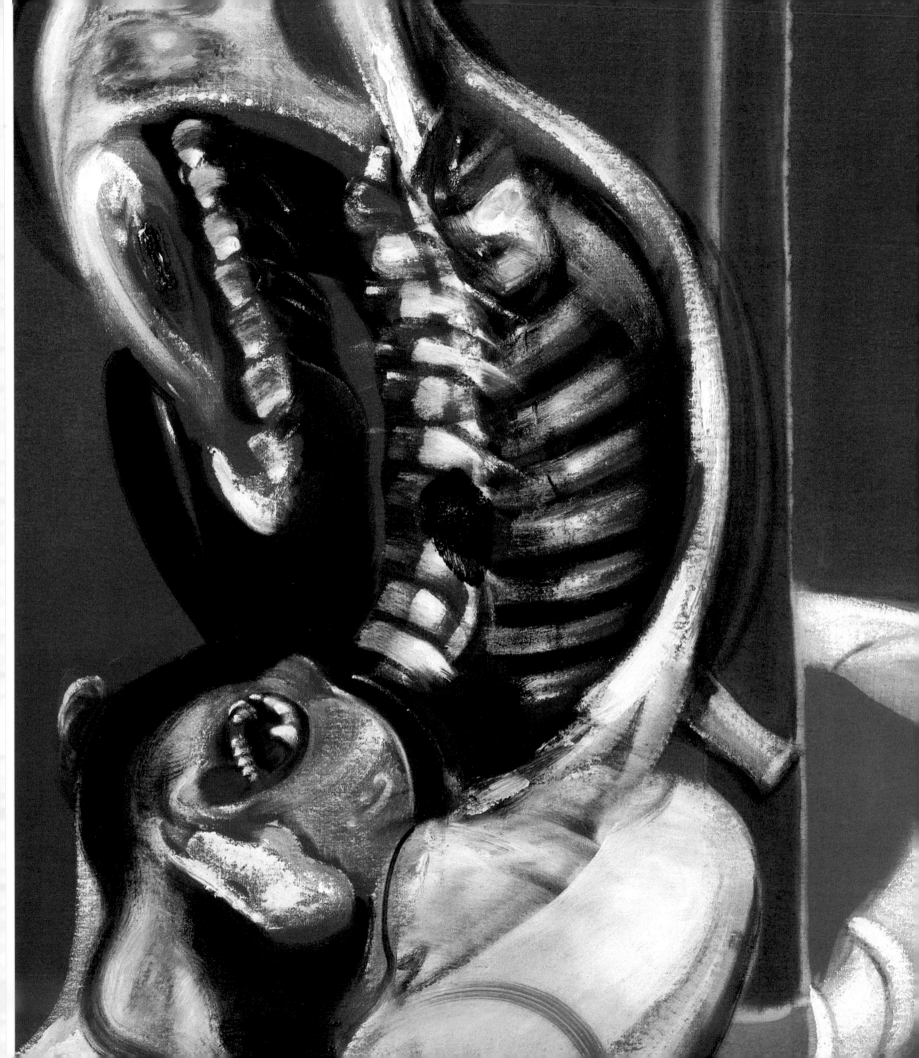

CRUCIFIXION

In a trio of extraordinary triptychs, Bacon made crucifixion images that set out to secularise this indelibly Christian motif. This distinction was emphasised in stressing the indefinite article in the title of his breakthrough work of 1944: *Three Studies for Figures at the Base of a Crucifixion* (pp.146–7).[1] He saturated this painting, and the triptychs of 1962 and 1965 (pp.148–9, 150–1), with intense orange, against which livid flesh and carcasses stand out. Comparing the theme to photographs of animals taken to slaughterhouses, Bacon told Sylvester in October 1962: 'I know for religious people, for Christians, the Crucifixion has a totally different significance. But as a non-believer, it was just an act of man's behaviour, a way of behaviour to another.'[2] By asserting the commonplace brutality of the act of the crucifixion (and drawing attention to the everyday violence of civilised society), the painter identified a powerful theme open to everyone's understanding. He took this further by focusing on the images of butchery that he brought to the subject, remarking to Sylvester four years later (and not long after the completion of the 1965 *Crucifixion*): 'Well, of course, we are meat, we are potential carcasses. If I go into a butcher's shop I always think it's surprising that I wasn't there instead of the animal.'[3] Behind the insouciance of his statements may lie layers of meaning that bear upon, but should (perhaps) not be too entangled with, the messages of the paintings themselves. Pairing Christian imagery with atheism allowed Bacon to distance himself from the work of more explicitly religious painters, and to fend off explanations that would limit his own work.

Making the connection between crucifixion and butchery exposed the animal in man, physically as well as behaviourally, and placed Bacon's treatment of the theme within a wider discourse of a contemporary reflection on culture after the Second World War and the Holocaust.[4] Nevertheless, the apparent indifference to religion was qualified in the same 1966 conversation, with the rather distanced acknowledgement: 'Of course one knows how very potent some of the images of Christianity have been and how they must have played very deeply on one's sensibility.'[5] It is this bedrock of crucifixion imagery in particular that comes to the surface at four key moments, each serving, rather mysteriously, as a turning point through which he sought to orientate his career.

It remains unclear what complex of ideas initiated Bacon's fascination with crucifixions, and how he came to address such a theme in *Crucifixion* 1933 (p.145) at the very beginning of his career as a painter. The institutional religion of Edwardian Britain would, however, seem a likely point of inculcation, perhaps inflected by an awareness of Catholic ritual witnessed in the Ireland of his infancy and youth. There may be some reinforcement for this speculation in the recent discovery of a postcard that reveals Bacon's visit to the Passion Play at Oberammergau in Bavaria in April 1930. As the play is only performed once a decade the stay would have required considerable planning, and might have been enough to reinforce (or to undermine) religious convictions. Although Bacon only commented that 'The play was lovely',[6] it is significant that he must have witnessed its stylised re enactment of the cruelty of the Crucifixion in an atmosphere of Catholic pilgrimage and devotion. By the time he made *Crucifixion*, three years later, this recent memory would have blended with other intimations of violence including the political enforcement that accompanied the rise of Hitler in Germany.[7] As Dawn Ades has pointed out,[8] Bacon also seems to have been attuned to the abject imagery of Georges Bataille's contemporary (para-Surrealist)

periodical *Documents*, which included André Masson's paintings of sacrifice and Eli Lotar's objective photographs of the Parisian abattoir at La Villette (fig.73).[9] The black-and-white images of slithery truncated forms in turn had parallels with the paintings of slaughtered oxen by Rembrandt and Chaïm Soutine.[10] Levels of tradition and contemporaneity, therefore, combine in this complex theme.

Herbert Read published *Crucifixion* in *Art Now* in 1933 (fig.16).[11] It was Bacon's first significant public exposure as a painter and was placed opposite a Pablo Picasso *Bather* of 1929, of the type that he later identified as having been his impetus to paint.[12] It was far from a straightforward rendition either of the Christian image or of Picasso's anthropomorphic structure. Instead, it is strikingly diaphanous, with a series of schematic lines making up the skeletal body and the upstretched arms. An attendant reaches out in a pose recalling the gesture of Thomas touching Christ's wound.[13] Apart from combining different aspects of the Easter story, this suggests a peculiarly Baconian preoccupation with the violated physicality of the body. A lost 1934 painting called *Wound for a Crucifixion* seems (as reported by John Russell) to have made this much more explicit: 'On a sculptor's armature was a large section of human flesh: a specimen wound, and a "very beautiful wound" according to Bacon's recollection.'[14] Like the exposure of society's hypocrisy identified by Bataille and Lotar's confrontation with the abattoir, Bacon's perception of the presence of the beautiful in the macabre had an honesty that would run through his work even, and perhaps especially, when it was considered horrific and associated with what David Mellor has called 'a generic horizon of fear'.[15]

As *The Crucifixion* (fig.74), a second oil painting, and a chalk and gouache *Crucifixion*,

fig.73

fig.74

fig.73 Eli Lotar
Aux Abattoirs de la Villette 1929
Gelatin silver print
Centre Georges Pompidou, Paris. Musée
national d'art moderne/Centre de création
industrielle

fig.74 *The Crucifixion* 1933
Oil on canvas, 111.5 × 86.5
Private collection

both of 1933, make clear, the theme reverberated through Bacon's practice, such as it was. To different degrees both recall the straight-armed pose of Paul Gauguin's *Yellow Christ* of 1889, but where the chalk embraces the Christian iconography of three crucified figures,[16] *The Crucifixion* is altogether more robust. Half flat red and half modulated chalky white, and set against a hot yellow, the main figure stands rather than hangs, having an air of defiant menace; the unexpectedly lipped skull derived from an x-ray supplied by Sir Michael Sadler.[17]

From this period Bacon worked closely alongside the Australian painter Roy De Maistre, who also treated the same theme. De Maistre introduced his immediate circle to the ideas of a violent existence under the dominance of a vengeful God proposed by the eighteenth-century theorist Joseph de Maistre (from whom he claimed to have descended).[18] While original in themselves, their reception at that moment in the 1930s may be seen in the context of a revival in individual spiritual and Catholic aesthetics that attracted many of Bacon's generation.[19] Although Bacon would later distinguish between the violence of conveying a powerful image and the violence of contemporary life to which Joseph de Maistre seems to have led,[20] he also acknowledged the importance of the times through which he lived. These two areas overlapped most famously when the outrage felt at the abandonment of the Republican government in the Spanish Civil War was fuelled by the exhibition of Picasso's *Guernica* in London in October 1938 (fig.124).[21] Coming on top of Bacon's likely awareness of Picasso's earlier variations on Grünewald's *Isenheim Altarpiece* (fig.75),[22] *Guernica* showed how the formal language of modernism could frame a response to contemporary events. Furthermore, only four months earlier, Bacon could have seen a different approach

to the same challenge in the form of Max Beckmann's *Temptation Triptych*, which adapted the tripartite format to a secular theme.[23]

The hot orange *Three Studies for Figures at the Base of a Crucifixion* 1944 (pp.146–7) became one of the most discussed paintings of its era.[24] If the foundations of the theme were laid in the early 1930s, the triptych made during the Second World War emerged from particular circumstances. It is clear, for instance, that the bestial figures evolved in Bacon's lost or marginal works; a surviving sketch and, more compellingly, two lost works of 1937 have been linked to them.[25] Another contemporary connection lay in his interest in the (now slightly comical) photographs taken by Baron von Schrenk Notzing of mediums experiencing ectoplasmic materialisations, from which, as Martin Harrison has shown, the painter clearly derived the features for the left-hand figure of *Three Studies* (fig.76).[26]

Furthermore, a sequence of wartime paintings, which transform dictators making speeches and getting out of cars into hybrid creatures of leering intensity, were testing grounds for the triptych.[27] From the photographs of pompous or charismatic Nazis Bacon derived a vision of the bestial that chimed with their characterisation in the British press, especially in the most desperate stages of the Battle of Britain and the Blitz in late 1940 and early 1941. Though recollections may play up the sexual licence of blacked-out London (together with the gambling den in Bacon's Cromwell Place studio), the painter – until his asthma proved debilitating – experienced the onslaught directly as an Air Raid Precaution Warden.[28] Graham Sutherland, whom Bacon met around this time, simply titled his official war paintings *Devastation*, and an eyewitness report on fire-fighters captures the nightly dangers of the Blitz: 'Just at that moment a wall … crashed down on them.

As we looked round all we could see was a heap of debris with a hose leading towards it.'[29] The spectacle of destruction was unconfined (fig.125). By 1942, Bacon and Eric Hall had escaped London for Petersfield in Hampshire, and the inscription on the back of one panel may suggest that *Three Studies* was begun there.[30] For his part, Sutherland later remarked that he had 'already had the idea of doing a *Crucifixion* of a significant size' and, by February 1944, had seized the opportunity, in accepting the commission on Henry Moore's recommendation, to make *The Crucifixion* for St Matthew's Church, Northampton (fig.77). In April 1944, he discussed with Keith Vaughan the potential for painting 'the great myths; Prometheus … or a Crucifixion or an Agony in the Garden'.[31] That this ran parallel to Bacon's view of his own emergence can be implied from the interest that he showed as Sutherland's painting neared completion two years later, when he wrote: 'I would love to see the details of the crucifixion.'[32] Their shared ambition to paint such 'great myths' tends to disguise the contrast between Sutherland's redemptive Catholicism and Bacon's Kierkegaardian atheism.[33]

When *Three Studies for Figures at the Base of a Crucifixion* was first shown in London in April 1945, alongside works by Moore and Sutherland, the reaction was mixed. Although the legend of its shock value grew quite rapidly, only one of the very few reviews expressed the dismay later recalled by Russell as 'total consternation'.[34] There is no doubt that it was a powerful assault on the mystical isolation of contemporary Neo-Romanticism (however much they held in common),[35] and shocking even to an audience inured to threat by the Blitz. Raymond Mortimer objected that 'these pictures expressing his sense of the atrocious world into which we have survived seem to me symbols of outrage rather than

works of art'.[36] In this very particular phrase, the writer conflated the recent suffering (of the Blitz and the Allies' vengeful devastation of German cities alike) and the, hitherto, unimaginable revelations of the Nazi death camps liberated in the same month as the exhibition opened. *Three Studies for Figures at the Base of a Crucifixion* appeared to offer a vision of a world (even before the apocalyptic strike on Hiroshima) that others would have preferred to put behind them. Furthermore, this vision demanded an artistic independence that contradicted the enforced standards of wartime propaganda. Though rarely seen as a political artist, and perhaps more in tune with contemporary existentialist isolation, Bacon thereby touched upon a live concern about the role of creativity in a society that had introduced seven thousand emergency measures during wartime in order to combat totalitarianism.[37]

In 1959 Bacon told the Tate that he had 'intended to use [*Three Studies*] at the base of a large Crucifixion, which I may do still'.[38] While this open possibility may have been speculative, *Painting* 1946 (p.101), with its more explicit references to crucifixion and butchery, may have been the surrogate for the larger composition. Bacon appears also to have measured this work against Sutherland's contemporary *Crucifixion*. The hieratic structure of each, with the splayed carcass reading as a crucified Christ, and the details of spacing and distancing (established by the foreground railing), show how closely parallel were the two painters' paths. The umbrella-ed dictator of *Painting* 1946 also encompasses different themes from Bacon's work at that moment, but its grandeur suggests the commanding breadth of a major statement.[39] By contrast, the strange *Fragment of a Crucifixion* 1950 (fig.59) manages to fix, albeit quite sketchily, a startling image of bestial encounter – between dog/cat and owl –

within the iconography of the descent from the cross. By thickening the paint used for these ambiguous creatures with dust, Bacon brought a causal inventiveness to his practice while also suggesting, through dust, a symbolism of mortality.

Details in both this 1950 painting and, pre-eminently, in *Three Studies for Figures at the Base of a Crucifixion*, came to be related, through the same letter of 1959, with the mythology of the Greek Furies. 'They were sketches for the Eumenides,' Bacon wrote,[40] referring to the ghastly ancient agents of justice and fate. By introducing them into the understanding of the 1944 painting, Bacon was underscoring a specifically non-Christian thread traceable to Aeschylus' *Oresteia*,[41] but also, perhaps, to Bataille's citation of Pausanias, who added that the Eumenides appeared as white to Orestes once 'he had bitten off his finger … and recovered his senses'.[42] The painter also expressed his enthusiasm for an academic study of Aeschylus by W.B. Stanford, as well as, somewhat less surprisingly, admiring T.S. Eliot's *A Family Reunion*, based on the *Oresteia*, in which the Furies feature as 'sleepless hunters that will not let me sleep'.[43] Eliot's ability to fashion timeless phrases seems to have attracted Bacon and offered prototypes for the painter's subsequent language; thus, the play's hero declares: 'That is the horror – to be alone with the horror.'[44]

In July 1960 the Arts Council gathered a major Picasso exhibition at the Tate Gallery. Among the 270 works it included the 1930 *Crucifixion*, from the artist's collection (fig.78), which Bacon knew from reproduction but whose red-orange-yellow colouring and biomorphic form he admired.[45] He also had the chance to see *Les Demoiselles d'Avignon* (fig.79).[46] It may be that when Bacon himself came to occupy the same exhibition space two years later for his first Tate retrospective,

the example of Picasso returned to him. Certainly *Three Studies for Figures at the Base of a Crucifixion* served as his *Les Demoiselles d'Avignon*, a critical 'battlefield on which he won his liberty' (as Roland Penrose described the Picasso).[47] Furthermore, Bacon closed the exhibition with a new work that was simultaneously (and self-consciously) an echo of his 1944 triptych and a tour de force of his painterliness: *Three Studies for a Crucifixion* 1962 (pp.148–9). He told Sylvester later that year: 'It was a thing that I did in a fortnight, when I was in a bad mood of drinking … I sometimes hardly knew what I was doing.'[48] While he stressed the impromptu nature of its making, the imagery was foreshadowed both by the 'Butcher shop hanging meat' listed among potential works earlier that year (fig.99),[49] and by the inscription 'Collapsed image of Christ/ Pool of Flesh' on a contemporary sketch.[50] Nevertheless, Bacon's emphasis on spontaneity barely masks an anxiety to provide the culmination of his landmark exhibition that would cement his reputation. 'Flawed though it may be,' Sylvester would write, 'it was a momentous turning-point'.[51]

It is typical of Bacon that this key painting looks back to his own work. The orange ground, the tripartite format and the crucifixion theme are extended from the 1944 painting to become the inception of an entirely new phase in his work. Although the facility of rendering the figure was already seen in the immediately preceding paintings, the intensity of this creative burst seemed to unleash a new flexibility and breadth of handling that would run through the 1960s, as well as establishing the large-scale triptych as a regular marker of major compositions. At the same time there is a step-up in the intensity in which violence is depicted (whatever Bacon's denials) that sets this painting apart from the 1944 triptych and even the carcass of *Painting* 1946. As well as a burst of activity,

fig.75

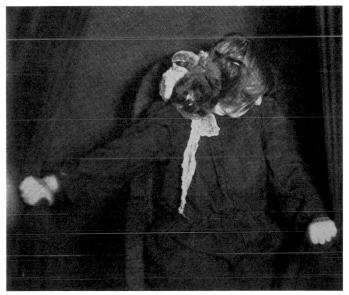

fig.76

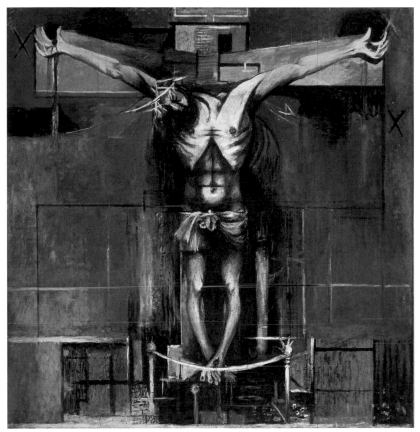

fig.77

fig.75 Matthias Grünewald
Isenheim Altarpiece 1512–16
Oil on wood, 269 × 307 (centre panel)
Musée d'Unterlinden, Colmar

fig.76 Illustration in Baron von Schrenk
Notzing's *Phenomena of Materialisation*
(1920)

fig.77 Graham Sutherland
The Crucifixion 1946
Oil on hardboard, 275 × 262
St Matthew's Church, Northampton

CRISIS

Following the achievement of the 1954 Venice Biennale and with a decade of mature work behind him, changes in Bacon's direction became evident around 1956. He had been more than usually peripatetic after giving up his Cromwell Place studio in 1951, making extended stays in Monte Carlo and the South of France, North and South Africa. Though his productivity remained restricted by his propensity to destroy works so that relatively few survived to go to the Hanover Gallery for exhibition, his attempts to work in locations marginal to the art world – from Henley-on-Thames to Ostia – seemed to reflect a disjuncture from London. Even with a base established in the Battersea flat of Peter Pollock and Paul Danquah, Bacon was in a 'bad way mentally and physically' in the summer of 1956,[1] and felt bound to leave for the Continent, travelling on (in Pollock's Rolls Royce) through Spain to Tangier, where his lover Peter Lacy had settled.[2] Bacon's letters to Erica Brausen at the Hanover Gallery, over subsequent Tangier summers, habitually sought advances of funds and delays of exhibitions.[3] North Africa was a particularly tempestuous region, with the passage towards independence in Morocco, the increasing violence in Algeria, and the twilight of imperialism exposed in the debacle of the Suez Crisis of November 1956. Bacon was hardly oblivious to these tensions, commenting that 'everything is so uncertain' prior to Moroccan independence, but adding: 'I prefer it this way.'[4] Furthermore, a crackdown on open homosexuality in 1957 demonstrated that Tangier's expatriate and sexually adventurous community was not immune to these pressures.[5] In this climate of personal and political uncertainty it is even possible to imagine Bacon being sucked back into obscurity by the necessary and hedonistic attractions of gambling, as had happened twenty years earlier.

Bacon attempted to paint his way through the rising crisis, reporting to Robert Sainsbury on arrival in Tangier in 1956 that he had completed a painting (that does not appear to have survived), improbably described as of '4 figures and a camel crossing a river'.[6] The new developments in his work extended his exploration of the possibilities in the manipulation of paint. The earlier veils of shuttering became more full-bodied in application, so that it is easy to see, in a painting like *Figures in a Landscape* 1956–7 (p.159), how his work was considered expressionistic at this time. It was here that the violence was embedded in the handling rather than the imagery, and this would lead Bacon into unexpected developments that, though ultimately cul-de-sacs, enriched the way in which he made and thought about his art.

Figures in a Landscape 1956–7, and the closely related *Untitled (Two Figures in the Grass)* (provisionally dated c.1952, p.158), take their point of departure from *Study for Crouching Nude* 1952 (p.118), a work to which Bacon continually referred.[7] In different ways these paintings of paired bodies lend urgency and focus to the crouching figure whose activity, now that another nude is present, is charged with sexual tension; whether indoors or out, it is clear that the crouching figure's hand is reaching between the recumbent figure's legs. Both have a formal and thematic relationship with another homosexual coupling, *Two Figures in the Grass* 1954 (p.134), with which *Figures in a Landscape* was shown in Bacon's first Parisian exhibition in February 1957.[8] Although the painter continued to disguise the subject sufficiently to exhibit the results even in Britain, where homosexuality between consenting adults remained illegal, the licence of Tangier may have liberated this more explicit imagery.

The seductions and heat of the South were underscored by the literature of the time.

Bacon must have known Albert Camus's *L'Etranger* and other fictions of neighbouring Algeria, and was familiar enough with Paul Bowles's mesmeric *The Sheltering Sky*, published in 1949, to recommend it to Daniel Farson.[9] He had certainly met Bowles and his wife Jane Auer by early 1957,[10] and may have read *The Spider's House* that charted the violent struggles towards Moroccan independence. In the book, the French suppression of a riot is pictured with striking immediacy: 'there came the sound of a lone shot ... the [crowd's] roar subsided for a second or two, then rose to a chaos of frenzy ... Then from what they would have said was the front of the café there was a phrase of machine-gun fire, a short sequence of rapidly repeated, shattered explosions.'[11] The far more bloody and notorious struggle in Algeria echoed such experiences into the 1960s. Bowles's sympathy for local sensitivities and his portrayal of the unbridgeable gap between them and the expatriots, captured the duality in which Bacon found himself and took up in his friendship with the painter Ahmed Yacoubi.[12]

It is possible to see the hot orange ground over which *Figures in a Landscape* is painted as part of Bacon's initially tentative engagement with the light and colour of the South. He had been working regularly in the South of France over the preceding years, but the intensity of the North African light, which had famously transformed the art of Henri Matisse and of Paul Klee, appeared to infuse his work with greater vibrancy. Whether painting in Tangier or on his return to London, the experience of Morocco seems evident. This was the case with *Figure in a Mountain Landscape* 1956 (p.160). With its stronger colouring (especially in the heavy sky) and its energetic paintwork, the image is subsumed in a way that may suggest a loss of individual selfhood portrayed in Bowles's writings and experienced in Peter Lacy's alcoholism. Though

Detail from *Figure in a Mountain Landscape* 1956 (p.160)

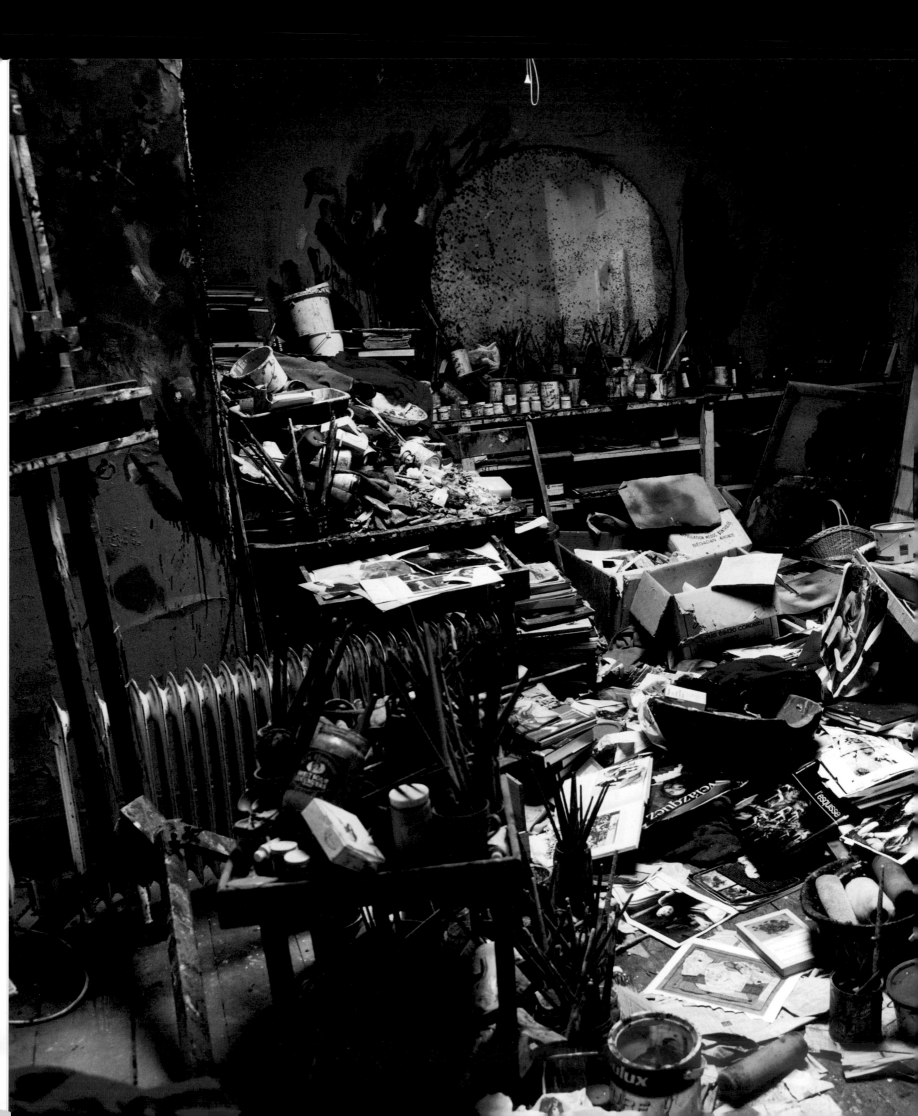

ARCHIVE

Francis Bacon's use of photographic and film images as reference points in the germination of his paintings has long been documented. As early as 1949, when the young artist was establishing his career, Robert Melville wrote of the influence of cinema on Bacon's practice by identifying in the painting *Head VI* 1949 (p.101) his quotation of the screaming nurse from the Odessa Steps sequence in Sergei Eisenstein's *Battleship Potemkin* (1925, fig.80).[1] Three years later the American art historian Sam Hunter published a detailed account of Bacon's art in post-war London, illustrated by the now famous montages of photographs that he witnessed in Bacon's studio and which contributed to the artist's 'shadowy and crepuscular world of imagination' (figs.88–9).[2] Throughout his career Bacon talked quite openly, if a little contradictorily, of his use of photographic sources, stating to David Sylvester in 1966 that 'photographs are not only points of reference; they're often triggers of ideas'.[3] But it was not until after the artist's death in 1992, when the contents of his studio were closely examined,[4] that the full extent to which such material was a consistent and vital tool in his working methods was made apparent.

Bacon's studio was described by Hunter in 1952 as a 'modern laboratory' in which the artist had amassed 'a whole literature on the mechanics of motion':

At one end stand his paintings, unique and extremely personal inventions. At the other are tables littered with newspapers photographs and clippings, crime sheets like *Crapouillot* and photographs or reproductions of personalities who have passed across the public stage in recent years ... Violence is the common denominator of photographs showing Goebbels waggling a finger on the public platform, the human carnage of a highway accident, every sort of war atrocity, the bloody streets of Moscow during the October Revolution, fantastic scientific contraptions culled from the pages of *Popular Mechanics* or a rhino crashing through a jungle swamp.[5]

This notion of the artist's studio as a 'chemist's laboratory' where 'unexpected phenomena might appear' remained true for Bacon to the end of his life.[6] Similarly, subsequent identification of Bacon's encyclopaedic cache of imagery, first documented by Hunter and later culminating in the chaos of the studio floor, confirm that the principal categories of material into which the artist's creative 'compost' can be sorted – war, political leaders, medical imagery, animal and human locomotion as captured by Eadweard Muybridge, cinema, wildlife, works of art by past masters, and society and news reportage – were, with the exception of portrait commissions perhaps, firmly established at the outset of his career.[7] But, as Hunter noted, 'a rigorous personal discipline of vision and a long period of trial and error in sorting and choosing relevant images, and of learning how to marry vision and technique' had been necessary for Bacon to refine his working practice and realise the transformative potential of his dictionary of sources.[8] Indeed, prior to his first solo exhibitions at the Hanover Gallery in London in 1949 and 1950, Bacon destroyed many of his paintings, dissatisfied with the results of his experimental phase when he considered himself lacking 'a real subject'.[9] From this point forward, however, Bacon's subject came into focus and he continued the recontextualisation of his 'strange family of images'[10] to explore the body in motion and 'unlock the valves of feeling and therefore return the onlooker to life more violently'.[11]

Although Bacon's obsession for imagery was non-hierarchical and ranged from magazine advertisements for cigarettes and reproductions from books describing spiritualist phenomena, to illustrations of Egyptian sculpture and snaps of close acquaintances, he was 'haunted' by certain photographs. This is evidenced by his obsessive collecting of multiple reproductions of the same images, namely, Velázquez's *Portrait of Pope Innocent X* 1650 (fig.68), film stills from Eisenstein's *Battleship Potemkin* (figs.80, 84), and plates from Muybridge's *The Human Figure in Motion* (figs.7, 67, 85, 90, 91). Bacon returned to this imagery repeatedly throughout his career, but it is perhaps the vast index of figures engaged in various activities – running, jumping, rowing, chopping wood – and captured mid-motion by Muybridge's that proved to be his most valuable resource from the 1950s onwards. Self-taught and receiving no formal artistic training, these sequenced images, as Margarita Cappock has noted, 'offered a virtual armature for the artist's newly ambitious figure painting'.[12] The clear quotation of *Paralytic Child Walking on All Fours (from Muybridge)* 1961 (p.163) pays homage to the pioneering photographer, while other compositions, such as *Study for Nude* 1951 (p.115), *Study of a Nude* 1952–3 (p.125) and the female figure in the left-hand panel of *Crucifixion* 1965 (p.150) reveal more subtle reworkings of the arrested forms lifted from the original Muybridge source and dynamised through paint (figs.85–6, 90–1).[13]

As his ideas evolved, Bacon's use of Muybridge's figures went beyond the literal transcription of form: 'I very often think of people's bodies that I've known, I think of the contours of those bodies that have particularly affected me, but then they're grafted very often onto Muybridge bodies. I manipulate the Muybridge bodies into the form of the bodies I have known.'[14] *Two Figures* 1953 (fig.46) is perhaps the best example of such metamorphosis. Although the formal composition of the coupled figure is faithfully

fig.83 Perry Ogden
Reece Mews Studio
Dublin City Gallery The Hugh Lane

PORTRAIT

The *Three Studies for a Crucifixion* (pp.148–9), which Bacon hurriedly and drunkenly painted to round off his 1962 Tate retrospective, brought to resolution a long period of uncertainty and experimentation. Aspects of the work anticipated what was to come in the later 1960s: the triptych format, the bloodied body on the rough ticking mattress. Indeed, he would return to the crucifixion theme within three years with his 1965 triptych (pp.150–1). In that work, and in other single canvases, the violated figure on the sordid bed would reappear. To a great extent, however, the bulk of Bacon's output from the rest of the 1960s and into the 1970s was ostensibly quite different. By far the larger part of his work was made up of portraits – or at least paintings – of a small number of close friends. Put simply, in this, the second half of his career, Bacon's work can be divided into two distinct types: the epic and the particular. On the one hand, as we shall see later, he drew upon great literature as a source and as a model to make grand statements that self-evidently concern themselves with the fundamental issues of the human condition. On the other hand, he made a series of focused depictions of individuals that, to varying degrees, seem to deal with the local and specific and with mundane details of observed, everyday life. In fact, of course, these, no less than the grand statements, concern themselves with the basic questions of what it is to be alive.

Many of Bacon's paintings of the 1950s had been based on people he knew: primarily Peter Lacy but also, for example, David Sylvester, Muriel Belcher of the Colony Room, a man he met in the Imperial Hotel, Henley-on-Thames, and an artist's wife from St Ives, where Bacon stayed for a few months in 1959. The 1960s campaign of work, however, seems to have been initiated with a small triptych (the first of a type that would proliferate) made as a cathartic act of memorial for Lacy,

who finally succumbed to his alcoholism in 1962 (p.106). It may be that Lacy also haunts the sombre *Landscape at Malabata 1963* (p.187), the title of which refers to Morocco and which is inscribed 'Tangier' on the back. This was Bacon's first resolved landscaped, though the swirling black form at its centre suggests a human presence obliterated. From 1963 Bacon made a series of works – single canvases, numerous small triptychs and the occasional large one – depicting, in particular, Isabel Rawsthorne, Henrietta Moraes, Lucian Freud and, Bacon's lover from autumn 1963, George Dyer. Famously, these were painted not from life but from a combination of memory and photographs, many if not all of which had been specifically commissioned by the artist from his friend, *Vogue* photographer John Deakin.

Bacon's first commission for Deakin was of Henrietta Moraes, an old friend of both painter and photographer who, among her many jobs, had worked as an artist's model. The model was photographed naked on a bed in a variety of poses prescribed by Bacon. According to Moraes the whole session had to be repeated as Deakin had reversed all the poses the painter had requested (fig.102).[1] In any event, the first painting to derive from these photographs – *Lying Figure with Hypodermic Syringe* (private collection) – was completed by February 1963, ending a five-month fallow period for Bacon.[2] This was a composition and subject to which Bacon would return several times through the 1960s (p.199). Positioned on the same ticking mattress that had been used in the 1962 triptych, the image seems to be one of sordid abjection. The body sprawls, inverted so the head is towards the viewer, knees raised and opened and one arm outstretched and pierced with the eponymous needle. Despite the obvious suggestion of drug use, deriving, Robert Melville speculated, from his association

with William Burroughs, Bacon was consistent and emphatic in his denial of any literal intention behind the syringe, insisting its function was purely formal.[3]

While his description of its purpose was akin to those given for his arrows and other such features – to pin down the composition – that given to Sylvester a decade after the first of the series was made was a little more loaded:

> I've used the figures lying on beds with a hypodermic syringe as a form of nailing the image more strongly into reality or appearance … it's less stupid than putting a nail through the arm, which would be even more melodramatic. I put the syringe because I want a nailing of the flesh onto the bed.[4]

This might be read formally but it seems also to state a desire to emphasise the raw physicality of the body. Bacon was fascinated by the fact that the human body is simply meat. Its fundamental physical presence is undermined or usurped, however, by the fact of life. The continual functioning of the muscles and internal organs prevents a living body from displaying its basic physicality. It is only in death that it becomes nothing more than an inanimate receptacle, unavoidably subject to gravity, a container of fluids. Bacon's gathering of morgue photographs and, specifically, of images of bodies fatally pierced by sharp objects reveals not simply a macabre fascination with death but with the attendant fundamental physical transformation.[5]

This was not the only form of physicality that came from Bacon's treatment of Deakin's photographs of Moraes. Given that almost all Bacon's subjects till then had been men, the raw sexuality of some of the Moraes works is striking. This stems in part from the photographs which, in the uncompromising nature of their poses and the rather down-at-

Detail from *Two Studies for a Portrait of George Dyer* 1968 (p.196)

181

heel everydayness of their setting, come close to soft pornography. Some have the quality of a view illicitly snatched, akin at times to the feeling of Victorian erotica; in others Moraes poses coquettishly. This aspect is carried through into such paintings as the 1966 *Henrietta Moraes* (p.192) in which the pose is that of the odalisque. In its luscious, sharp colouring, and the distortion of the face that recalls the adaptation of African masks in *Les Demoiselles d'Avignon* 1906–7 (fig.79) as well as the manipulated still from Alain Resnais's 1959 film *Hiroshima Mon Amour* identified by Harrison (fig.40), this work draws together, one might say, the legacies of Henri Matisse and Pablo Picasso. The rich colouring also relates Bacon's work with that of other artists at that time. The development of Colour Field painting and post-painterly abstraction out of Abstract Expressionism led to a higher key in the colour of abstract painting and, at the same time, the ascendant Pop art appropriated the strong colours of advertising and photography. The 1960s saw a proliferation of colour in visual culture as colour photography, film and magazines all became the norm.[6] At the same time, the development of acrylic paints allowed artists to achieve thin, smooth surfaces without losing any of the chromatic intensity of their pigments.

There is a sense in which one might see each of Bacon's cast of regular actors performing different roles. Moraes is the only one who appears totally naked and is shown as abject and exposed, sexually alluring but dangerously open. Though not exactly violated there is, nonetheless, something pathetic in her apparent sexual abandon. In contrast, Isabel Rawsthorne is consistently shown both in a more fully described environment and in command of her situation. She locks the door while looking away as if in conversation in *Three Studies of Isabel Rawsthorne* 1967 (Staatliche Museen zu Berlin,

Nationalgalerie), and in *Portrait of Isabel Rawsthorne* 1967 (p.191) she is shown dominating her urban environment. Lucian Freud tends to seem confident and yet physically awkward. He is often twisted around, his hand clasping his knee, or with his trouser leg riding up to reveal a glimpse of leg (fig.107). Of course, in each case the manner of the sitter's painted depiction may be determined by the photographs that Deakin took: Freud in a variety of poses on a bed, Rawsthorne out and about in central London (fig.104). We must also recognise that Bacon's primary, stated intention was to produce a portrait of each subject. In this endeavour he was seeking to reinvent portraiture in the age of the camera; in his own words, he sought 'to distort the thing far beyond the appearance, but in the distortion to bring it back to a recording of the appearance'.[7] This, it was, that he took from Vincent van Gogh more than anything else. It was also simply doing what he saw Velázquez doing, but remaking that project for the post-photographic world. Bacon told Sylvester that he wished to achieve a portraiture that communicated not only the appearance of a subject but 'all the areas of feeling which you yourself have apprehensions of'. To strike this balance between representation and abstraction was a challenge like 'walking along the edge of the precipice', and the remarkable thing about Velázquez for Bacon was that he could stay so close to illustration and still 'unlock the greatest and deepest things that man can feel'.[8]

The idea that an individual might be used by Bacon as the vehicle for certain aspects of the human condition seems especially evident in the paintings of George Dyer. A petty criminal from London's East End, he wore the dark suit and tie of a gangland criminal and boasted an impressive physique. He was, at the same time, neither especially masculine nor articulate. It was thought that, if there

was a problem in his relationship with Bacon, it was that he was too gentle for a man who sought sexual gratification from physical pain. He became the major subject for Bacon's paintings in the eight years between their meeting and Dyer's death in 1971 and, arguably, even more so afterwards.[9] In the paintings of the 1960s it is as if Bacon uses Dyer as a vehicle with which to articulate the absurdities, indignities and pathos of human existence. He appears in different guises, as he was photographed by Deakin: in the street, posing in the studio in his underpants. The detail of the white briefs, worn through modesty, becomes an especially poignant qualification of the body's heroic musculature (fig.101). Repeatedly Dyer appears as fragile or ridiculous, vulnerable to an air of absurdity. One apprehends an idea of the pathetic hopelessness of a brutish creature caught in the garb of the cultured sophisticate.

Dyer first appears in the triptych *Three Figures in a Room* 1964 (p.188). In two panels he poses awkwardly, one leg turning over the other to protect his modesty, perhaps, or twisting strangely as he raises one arm behind his head. In the left-hand panel, however, he is shown sitting on the toilet. Viewed from behind, set in an empty space, he could not be more lowly or vulnerable. The figure's spine is closely described – a detail, Bacon said in relation to Edgar Degas's *After the Bath* 1903, which he knew well from the National Gallery, which makes one 'more conscious of the vulnerability of the rest of the body'.[10] As well as the pathetic ordinariness of his situation, the frank acknowledgement of bodily function undermining any pretence to sophistication, the reminder of the abject is also a reminder of mortality. Subsequently Dyer was shown posing alongside a painting of himself in his pants (*Two Studies for a Portrait of George Dyer* 1968, p.196), crouching on a table, staring at a light cord, contem-

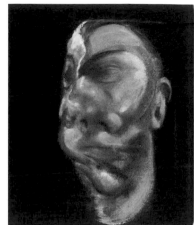

fig.106

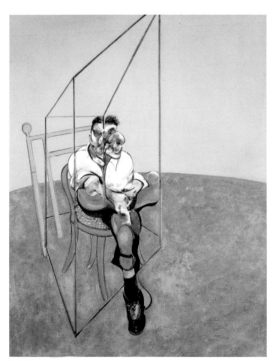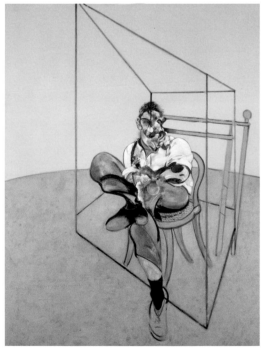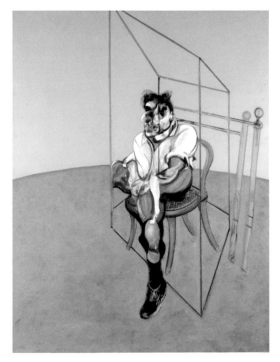

fig.107

fig.106 *Study for Three Heads* 1962
Oil on canvas, each 35.9 × 30.8
The Museum of Modern Art, New York.
The William S. Paley Collection

fig.107 *Three Studies of Lucian Freud*
1969
Oil on canvas, each 198 × 147.5
Private collection

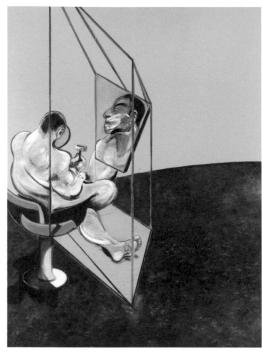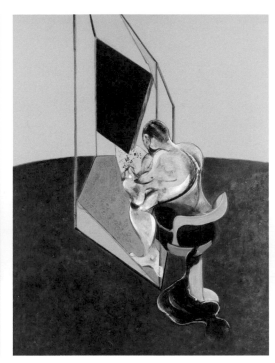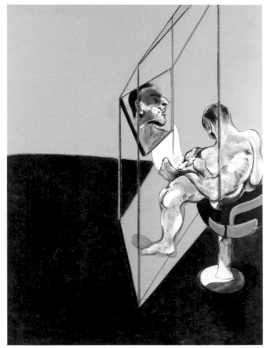

fig.108

fig.108 *Three Studies of the Male Back*
1970
Oil on canvas, each 198 × 147.5
Kunsthaus Zürich. Vereinigung Zürcher
Kunstfreunde

plating a sculpted portrait of himself next to a dog, gazing into a mirror in which his reflection is split in two (*Study of George Dyer in Mirror* 1968, p.197), and balanced precariously and comically on a bicycle (*Portrait of George Dyer Riding a Bicycle* 1966, p.195). These are portraits full of affection but also replete with a frank acknowledgement of a man faintly ridiculous and teetering on the edge. Of course, all of this is understood through the lens of hindsight with knowledge of Dyer's suicide attempts, the last of which was, perhaps unwittingly, successful.

If we accept Bacon's stated intention to capture a likeness of his sitter without making a visual replication of their appearance, then what we are discerning is his perception of Dyer. Bacon's sitters – maybe Dyer especially – are also, however, vehicles for observations of human nature and behaviour in a broader sense. This is demonstrated in a work for which Dyer again seems to have been the model but which does not acknowledge him in its title, *Three Studies of the Male Back* 1970 (fig.108).[11] The three panels present three male figures – probably the same one – from behind, sitting in a barber's chair. The one in the centre reads a newspaper, the others are shaving: the mirrors in front of them reveal the shaving cream on their faces, and the figure on the left holds a safety razor while that on the right may be sharpening a cut-throat on a strop, invoking perhaps the razor in Luis Buñuel's *Un Chien andalou*. Mirrors and reflections recur in Bacon's paintings and are conspicuous in photographs of his studios. Visitors to his flat at Reece Mews were confronted by a full-length mirror as they entered, and at the Limehouse flat (where he famously could not work) mirrors were placed at angles so one was continually surprised by one's own reflection.[12] He told Hugh Davies that, as a young man, he was once picked up by a wealthy Greek

businessman who took him to the Ritz for the night. The following morning, while his lover was in the bathroom, he went through his pockets in search of money but was spotted in the bathroom mirror and caught.[13] Mirrors in Bacon's art are signifiers of mortality – documenting life's passing – vulnerability and surveillance. Frequently he plays with the ambiguity between the mirror and the window, reflection and actuality.

In *Three Studies of the Male Back* the mirrors transform the figures, investing them with a heroic profile, while the nakedness of the figures reveals their impressively muscular physiques, and reinforces a sense of vulnerability by emphasising the exposed backs. The customer in the barber's chair, caught unawares, is a familiar image of fear and danger from gangster movies and such stories as Sweeney Todd. Bacon captures a similar sense of apprehension and dread, these magnificent physical specimens rendered vulnerable and exposed. The shadow of the central figure morphs, it seems, into a flowing fluid that anticipates those in the 1972 triptych memorialising Dyer, in which they represent the life leaking out of him (pp.208–9). Thus, Bacon employs an apparently banal subject as a vehicle for the most fundamental of reflections on mortality.

In these works Bacon steers a careful course between the specific and the general. In most, the sitters are recognisable and identified in the titles of the works. The settings are, however, generally ill defined. The figures are, presumably, in interior spaces. Light sources are rare, though items of furniture appear on occasion, often singularly. In some works, like *Portrait of George Dyer Riding a Bicycle* 1966 (p.195), the figure is set on a ground that extends across the entire canvas. In others there is the suggestion of a carpet or floor and a wall. Occasional everyday details appear: a light cord, a crumpled newspaper,

an ashtray full of spent butts. Like the main subjects of the paintings, these seem to gain both a symbolic scale and a kind of pathos through their isolation. An overflowing ashtray is a literal accompaniment in a portrait of a smoker, yet seems to stand as a metaphor for transience and loss, an echo of T.S. Eliot's Prufrock:

> And when I am formulated, sprawling on a pin,
> When I am pinned and wriggling on the wall.
> Then how should I begin
> To spit out all the butt-ends of my days and ways?[14]

The image of the figure like a butterfly on a pin also appears in *Two Studies for a Portrait of George Dyer* (p.196), in which a credible description of an image stuck to a canvas becomes a symbol of human frailty and insecurity. Like Eliot, Bacon used details of everyday life to address the big questions that might once have been addressed by Greek tragedy.

CHRIS STEPHENS

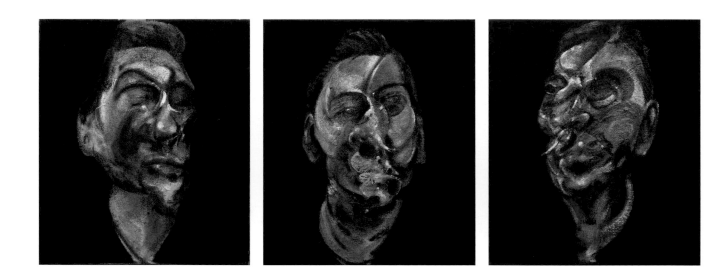

Three Studies for a Portrait of George Dyer
1963, oil on canvas, each 35.3 × 35.5
Private collection

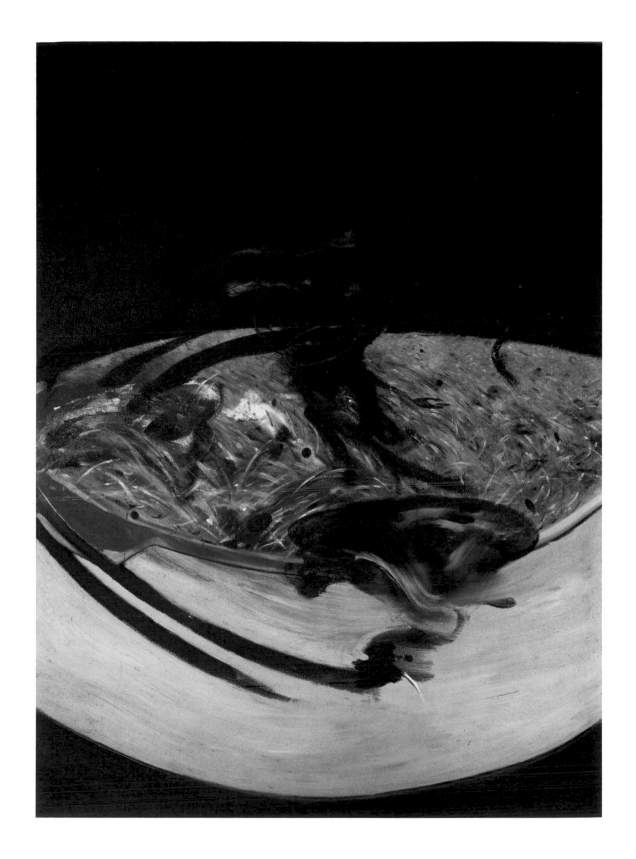

Landscape near Malabata, Tangier

1963, oil on canvas, 198 × 145

Private collection, London

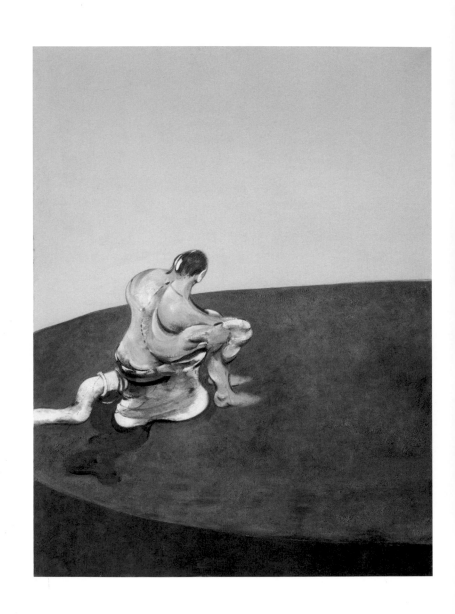

Three Figures in a Room
1964, oil on canvas, each 198 × 147
Centre Pompidou, Paris. Musée national d'art moderne /
Centre de création industrielle

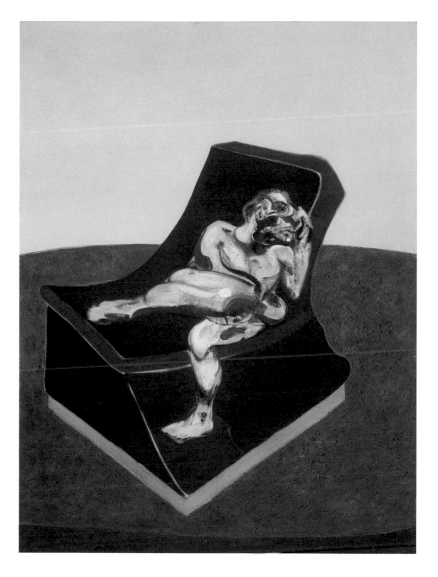 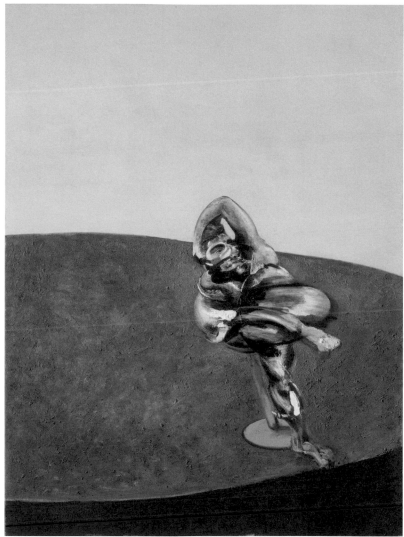

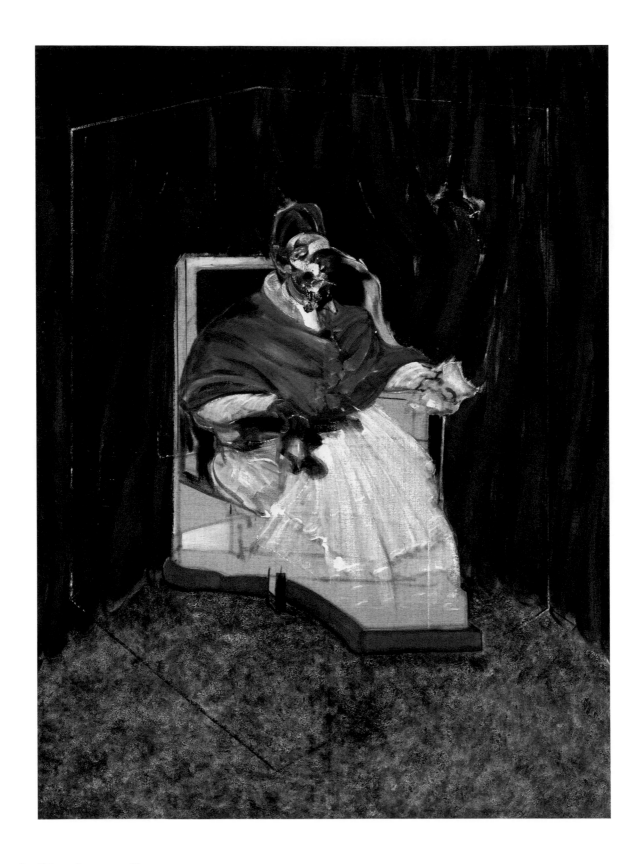

Study from Portrait of Pope Innocent X

1965, oil on canvas, 198 x 147.5

Private collection

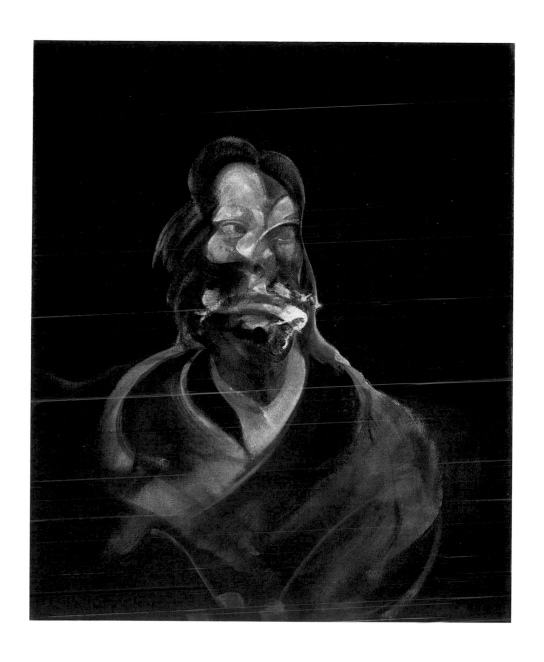

Portrait of Isabel Rawsthorne
1966, oil on canvas, 81.3 × 68.6
Tate. Purchased 1966

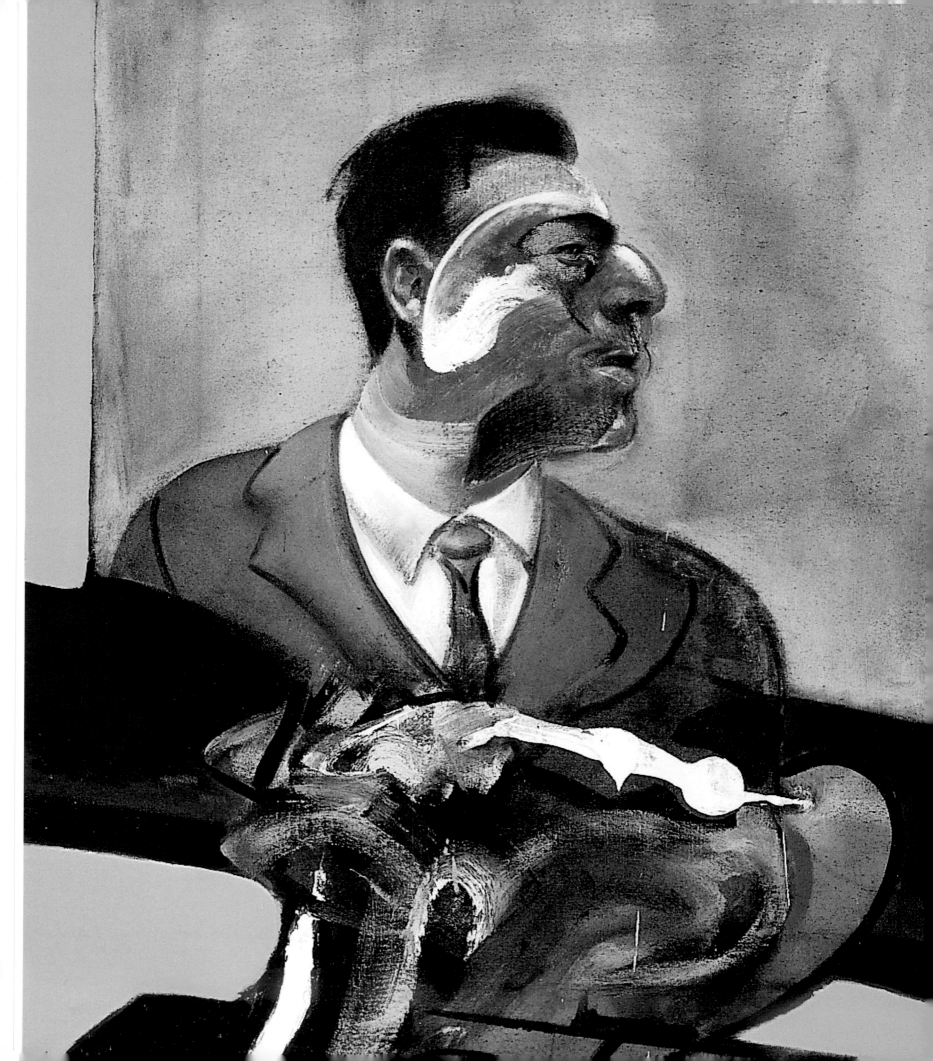

MEMORIAL

One of the briefest contributions to the book that David Sylvester edited from conversations with Bacon would appear to come from a session in December 1971. There Bacon contemplated mortality:

> people say you forget about death, but you don't. After all, I've had a very unfortunate life, because all the people I've been really fond of have died. And you don't stop thinking about them; time doesn't heal. But you concentrate on something which was an obsession, and what you would have put into your obsession with the physical act you put into your work. Because one of the terrible things about so-called love, certainly for an artist, I think, is the destruction.[1]

The year had taken its toll. In April, Bacon's mother had died in South Africa; this may have liberated him to reveal, in the same interview, the mutual dislike between himself and his father 'but I was sexually attracted to him when I was young'.[2] On 24 October, a matter of weeks before this exchange, the painter's long-time companion George Dyer committed suicide in Paris, two days before the opening of Bacon's triumphant exhibition at the Grand Palais. As implied by his transference of an 'obsession with the physical act' to his 'work', Bacon already appeared to be shaping his mourning in the image of Dyer in his paintings. Alluding to the loss, John Russell remarked that in Bacon's 'real life – his life as a painter that is to say – it came to the fore over and over again'.[3] The results would, eventually, constitute an accumulation of memorials that was entirely remarkable.

What seems clear about the Dyer triptychs is that they came together inadvertently, building towards a heroisation of their subject.[4] As opposed to Eric Hall, whom Bacon left in 1951, and the ex-RAF pilot Peter Lacy, who drank himself to death in 1962,[5] Dyer was a minor criminal whose strongly modelled head and athletic body fitted Bacon's aesthetic and sexual ideal. He was one of the painter's most important and constant companions, but in need of Bacon's guidance through the demanding bohemian world that would eventually take its toll. His death followed several suicide attempts, and his posthumous presence – unique in Bacon's art – is indicative of guilt as well as loss, as the occasionally absurdist portrayal during his lifetime (seen in *Portrait of George Dyer Riding a Bicycle* 1966, p.195)[6] gave way to memorialisation.

Bacon had been using photographs from which to paint his closest friends since around 1961, welcoming any manipulations of their features that this offered to pin down character. He described the process five years later: 'What I want to do is to distort the thing far beyond the appearance, but in the distortion to bring it back to a recording of the appearance.'[7] In stepping away from literal likeness, Bacon was acutely conscious that that role had been overtaken by photography. In his search to fix reality on the nervous system of the viewer, however, he was also in pursuit of a reality that could be disgorged by the nervous system of the sitter. This required long contact (and not all friends qualified) but, with the sudden removal of Dyer, this exteriorising of character could only take place through photography and memory. Somewhat later, in 1975, Bacon unexpectedly observed: 'It seems a bit mad painting portraits of dead people … once they're dead you have your memory of them but you haven't got them.'[8] Perhaps this expresses the contradictory obsession of the Dyer triptychs, even as they traced the way in which Bacon responded to his longstanding concern with the transience of life. In death, Dyer was transformed into an almost romantically irreproachable archetype, insofar as Bacon's visceral engagement would ever allow this.

As the first of the memorial paintings, it is hardly surprising that *Triptych – In Memory of George Dyer* 1971 (pp.206–7) should be the most fraught and complex. Its dating would indicate that it was completed within two months of the death and, even in its uneven structure, it has some sense of this immediacy. Inviting the narrative reading that Bacon had long fought, it presents a male typology of the athletic body in the left-hand panel and the suited formality of the right, with images of both boxer and spiv recalling the East End gang culture to which Bacon was attracted and to which Dyer had some connection. Boxers had already caught the painter's imagination, their public, partially naked combat being erotically charged.[9] Here the precariousness of the single boxer in the left-hand panel, tumbling (with one boot on) into a guitar-shaped form, on the liminal zone of the curved rail seems a direct acknowledgement of mortality. Even such a healthy body could be killed off,[10] and the smoky shadow, cast sideways and slightly upwards into the painting (with half the canvas below a blank, decoratively pink void), emphasises the fall.[11] On the other side, Dyer rises from the green rail, his profile offset against a slab-like form. He appears again below, giving the odd impression of liquefying: his tie and jacket have melted together, his forehead is condensed and double-exposed at the edge of the projecting slab, and his head seems to drain out into the pedestal below. He is adorned, even revivified, by energetic casts of white that – while obviously semen-like – inject vitality into his presence at the shirt-front, across the join between the two playing-card-like images and across the forehead and cheekbone in a way that suggests the bounce of flash photography. Though evidently triggered by John Deakin's photographs, the

profile image carries some of the nobility of Michelangelo's *Brutus*.[12]

The central panel is substantially more complex. Here alizarin gives way to the colour of cured ham, with the pink of the outer panels only introduced in the foreground area (that reads like light projected through a doorway) and the underface of the upper flight of stairs. It is not clear where this panel sat in the sequence of making,[13] but its spatial complexity far exceeded that of Bacon's other works at that moment, being closest to the chamber-cum-railway carriage of *Triptych – Inspired by T.S. Eliot's Poem 'Sweeney Agonistes'* 1967 (pp.220–1). The interlocking spaces of landings and staircases have conflicting light sources, of which the orange glow of the naked yellow bulb at the top lends eeriness. He captured the shabby gloom in shorthand: the uncertain progress of the central flight, the panelled door tellingly scuffed. While some have seen this as recalling the Parisian hotel in which Dyer killed himself,[14] it also conveys the awkward architectural conversions of London's bedsits, which is especially Eliotic as has long been recognised. Bacon seems to conflate two different Eliot references. The setting recalls 'Ash Wednesday' (1930):

> At the first turning of the second stair
> I turned and saw below
> The same shape twisted in the banister
> Under the vapour in the fetid air
> Struggling with the devil of the stairs
> who wears
> The deceitful face of hope and of despair.
>
> At the second turning of the second stair
> I left them twisting, turning below;
> There were no more faces and the stair
> was dark,
> Damp, jagged, like an old man's mouth
> drivelling, beyond repair,
> Or the toothed gullet of an aged shark.[15]

This ambiguous encounter with devilry in a disconcerting succession of spaces, seems to be married to a mournful existentialism in the 'deceitful' combination of hope and despair. Bacon also seems to lend menace to Eliot's anthropomorphised stair, while conflating this with one of his favourite passages from *The Waste Land*:

> I have heard the key
> Turn in the door once and turn once only
> We think of the key, each in his prison
> Thinking of the key, each confirms his
> prison.[16]

The artist is said to have drawn a 'faint pencil sketch for the triptych' in his copy of a new edition of the poem.[17] Like 'Ash Wednesday', this panel is laden with longing and loss, with the isolation of the individual unable to communicate. The muscled (Michelangelesque) arm reinforces an air of sexual tension, as does his gesture of inserting the key in the lock (which echoes the sexualised images favoured by Picasso in the 1930s), but the silhouette of Dyer enforces the sense of absence and loss.[18]

The rather livid pink unites *Triptych – In Memory of George Dyer* and *Triptych – August 1972* (pp.208–9); it is not the colour of sensuous flesh but of bubblegum shot through with blue. In *Triptych – August 1972* and in the subsequent *Triptych, May – June 1973* (pp.210–11), subjects of loss and memory are played out by isolating the figures against the dark openings beyond that gave rise to Hugh Davies's designation of these works as 'black triptychs'.[19] This staging has a profoundly dramatic effect, that might be in danger of melodrama were it not balanced by the matter-of-factness of the displayed bodies.

The formal echo between these two triptychs also carries, and allows their differences to carry, meaning. In *Triptych – August 1972*, the figures of the side panels occupy the foreground space, seated on bentwood chairs placed on a mushroom ground. Parts of these bodies – usually identified as portraits of Dyer – were omitted from their inception, an erosion that derives from the crushing and folding of Deakin's photographs.[20] Both figures ooze amorphous forms with a pink-blue colouring that recalls Bacon seeing images 'arise from a river of flesh'.[21] Two decades later Sylvester recalled the painter describing the figure in this painting as having 'the life flowing out of him'.[22] The central sexual coupling, derived from Eadweard Muybridge's *Some Phases in a Wrestling Match*,[23] seems to capture the loss of self in the physical act, balanced as it is on the threshold of the black beyond.

The portentousness of the void seems to be confirmed by the later painting, which chronicles the final death struggle experienced by Dyer alone. It is merciless in indicating how Bacon sought to relive the spiral of events that he could only reconstruct from the posthumous investigation of Dyer's despair, vomiting in the basin and final death on the toilet. This undignified end – in which life drains from the overdosed body like a daily excretion that Bacon had already captured in *Three Figures in a Room* 1964 (p.188) – is somehow immortalised in this painting. The dying body remains heroically muscled (its pose derived from the crouching figures that Bacon had been using for two decades), the situation partially masked by the glimpse through the doorway. It is in placing the figure beyond the threshold, which had been so significant in *Triptych – August 1972*, that Bacon directly envisaged Dyer's passage into death. Though the fury-like shadow of the central panel threatens melodrama, the grim simplicity establishes a terrible dignity even to the point of evoking Jacques-Louis David's *The Death of Marat* 1793 in the heroic exposure of the naked corpse.

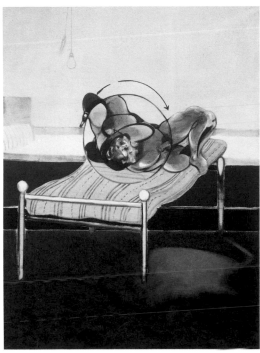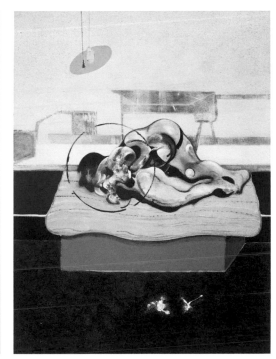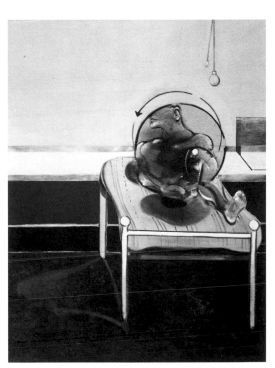

fig.109

fig.109 *Three Studies for Figures on a Bed* 1972
Oil on canvas, each 198 × 147.5
Private collection

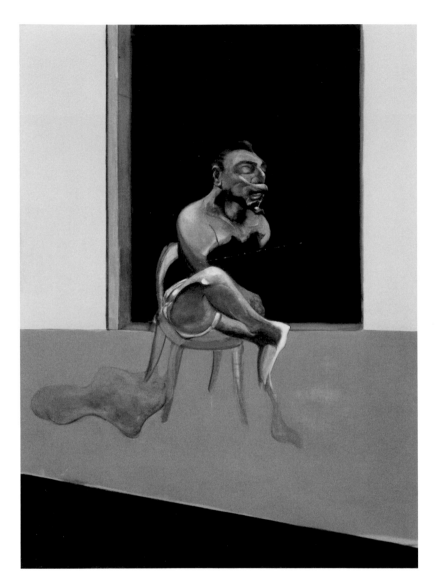
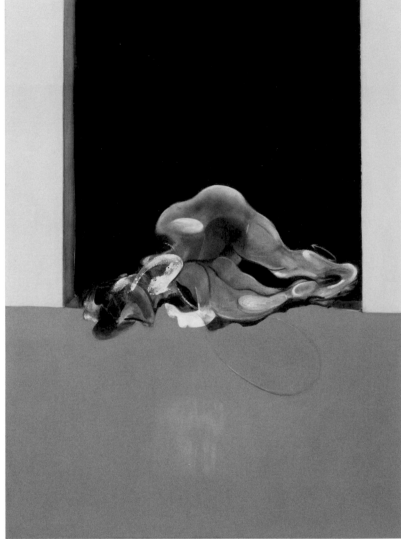

fig.11(

Triptych – August 1972

1972, oil on canvas, each 198 × 147.5
Tate. Purchased 1980

fig.11(
Port
Port
Oil o
Priva

204 208

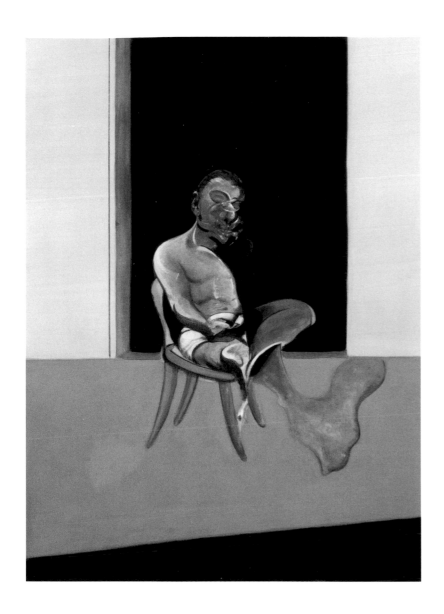

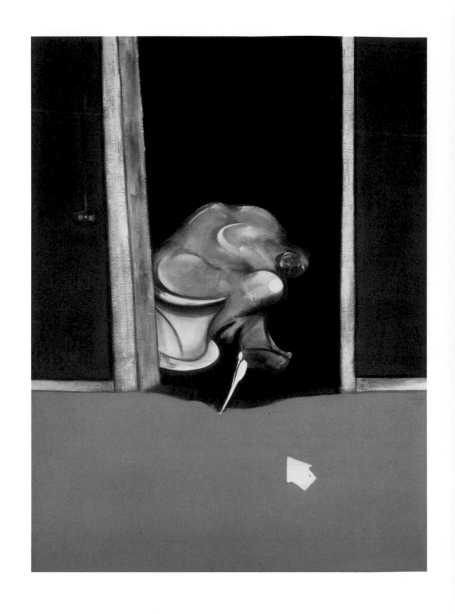

Triptych, May – June 1973
1973, oil on canvas, each 198 × 147.5
Private collection, Switzerland

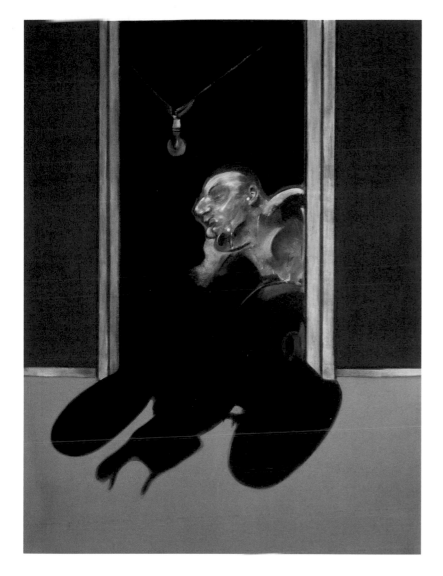
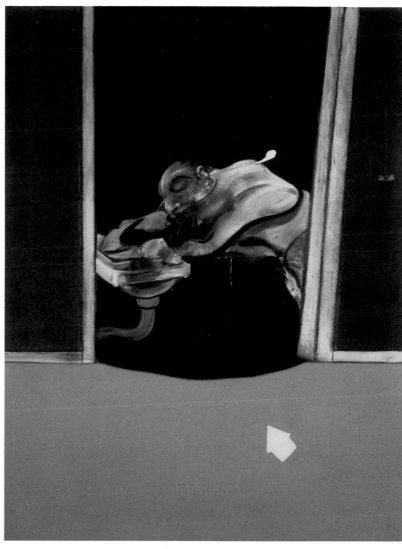

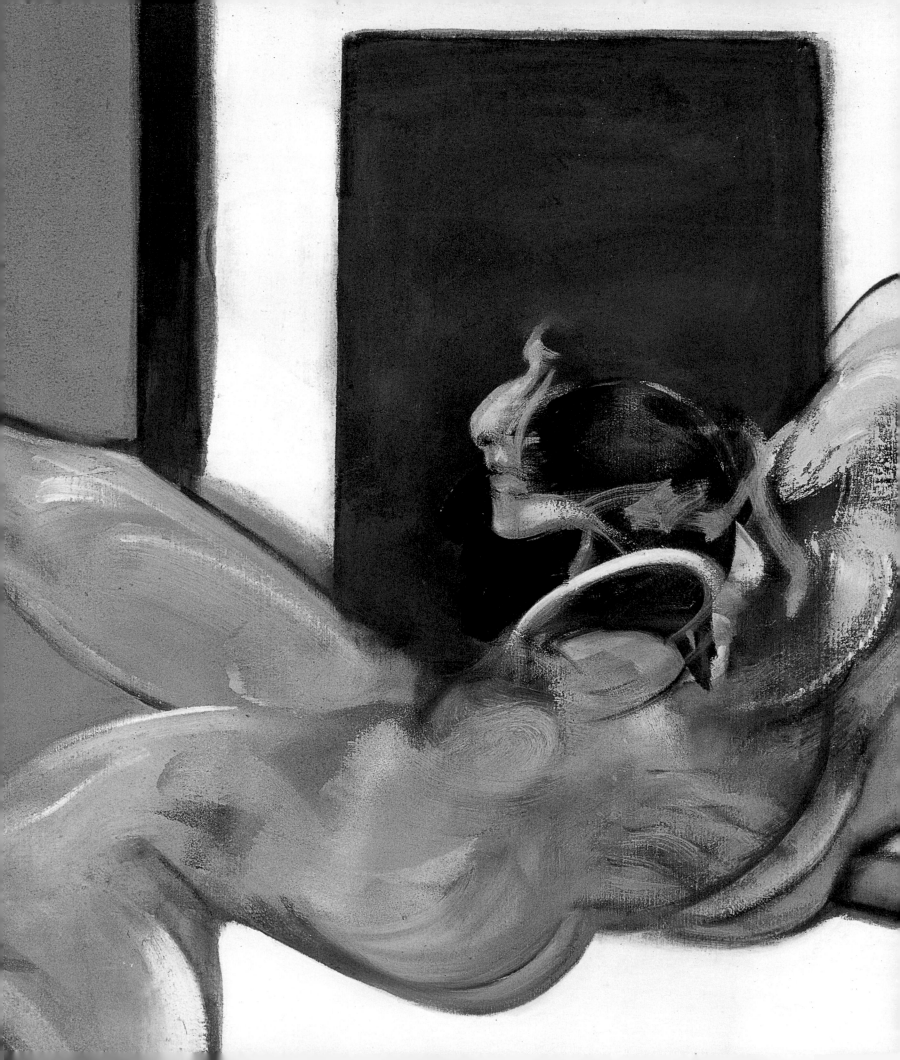

EPIC

In Bacon's paintings of his friends' bodies isolated in various, cursorily described surroundings, the suggestion of specific settings and situations inevitably invited narrative interpretations. These he was anxious to rebuff. One of the reasons he repeatedly gave for preferring the triptych format was its resistance to narrative: 'it breaks the series up and prevents it having a story,' he told Hugh Davies, 'that's why the three panels are always framed separately'.[1] Yet, compared to a single canvas, the triptych can equally create a narrative through its sequentiality. It is true that a number of triptychs did simply multiply a number of similar images, as in, for example, *Three Studies of Lucian Freud* 1969 (fig.107). Many others, however, invite narrative or at least symbolic readings through the interrelatedness of the three images and the apparently specific references within them.

Alongside the images of friends and single figures ran a strand of works of a more epic quality that seem to address Bacon's core themes through particular literary and historical references and allusions to narratives. The earliest of these may be *Triptych – Inspired by T.S. Eliot's Poem 'Sweeney Agonistes'* 1967 (pp.220–1), but the referencing of a specific story was of course present in the 1962 and 1965 *Crucifixion* triptychs (pp.148–51), and indeed in the 1944 *Three Studies for Figures at the Base of a Crucifixion* (pp.146–7).

Despite the specificity of its title and Bacon's tacit acceptance of it when it was proposed by Valerie Beston, it is hard to match the images of the Sweeney Agonistes triptych to the poem itself. Indeed, Bacon himself said, 'There's nothing specific, just the atmosphere of the poem that affected me'.[2] The right-hand panel appears to have been painted before the left and the latter's composition made in imitation of it. In the left-hand panel two women lie naked together, partially reflected in a mirror. In the right-hand panel, the two women

are balanced by a male couple observed by an onlooker, on the telephone, who is revealed by the mirror as if occupying the viewer's space. The central panel shows a confined, empty space, possibly a compartment on a train. Bacon claimed his only initial intention was to paint a scene without figures and this he has done, though a human presence is suggested by the dark grey jacket over the back of a chair, a shirt and a bag, the zip of which appears like an extended row of teeth. The scene is dominated by a blood-soaked pillow, so bloodied as to suggest a hideously violent crime in keeping with the title of the poem and painting, invoking the cannibalistic, mythic figure of Sweeney Todd. No such crime occurs in Eliot's poetic fragments although, as Rolf Læssøe has highlighted, it could relate to the notion of a nightmare that offers unconsciously a glimpse of one's own mortality.[3]

Similarly, the voyeur figure can be related to the ringing telephone of the poem and to the character Pereira, and the lesbian couple on the left to Dusty and Doris who are kept by him. Perhaps more pertinent to Bacon than these specific elements would be the assertion by Sweeney:

> Birth, and copulation, and death.
> That's all the facts when you come
> to brass tacks:
> Birth, and copulation, and death.[4]

The sentiment is certainly consistent with Bacon's own belief that there is nothing but this life, and that we can only make sense of it by what we do while we pass through.

The 1967 triptych brought into the open Bacon's life-long admiration for Eliot's poetry. In this passion he was not alone; the poet Kathleen Raine had noted in 1948 that, for her 'generation T.S. Eliot's early poetry, more than the work of any other poet, has enabled us to know our world imaginatively'.[5] 'Sweeney

Agonistes' was an especially obscure reference to make, the eponymous work being two fragments of an unrealised verse drama grouped under 'Unfinished Poems' in the anthologies but excluded from the popular *Selected Works*. Given Bacon's preference for qualifying his works as 'Studies for …', it might have been the very incompleteness, the contingent quality and consequent mystery and obscurity of the two fragments that attracted him. Bacon cited several other works by Eliot specifically, including the *Four Quartets*, despite the fact that Eliot's Christian faith comes through more strongly in their concern with resurrection than elsewhere. 'They're probably even greater poetry than *The Waste Land*,' he observed, 'though they don't move me in the same way.'[6]

Despite Eliot's later faith in an afterlife, his poetry is imbued with the inevitability and constant presence of death. This, as well as a shared fascination with the barbarity and pathos of everyday life, would have attracted Bacon. Indeed, he was willing to associate himself with Eliot not only in interview but in the works themselves. *Painting* 1978 (p.227) shows a male figure turning a key with his foot. Originally Eliot was acknowledged as the source in the subtitle, and even before the painting was complete Bacon was happy to write to Michel Leiris, 'I am working on a triptych after the lines of Eliot, "I have heard the key turn in the door once and once only". It's a line in the Waste Land.'[7] In fact Bacon abridges and misquotes the line which runs:

> *Dayadhvam*: I have heard the key
> Turn in the door once and turn once only
> We think of the key, each in his prison
> Thinking of the key, each confirms
> a prison.[8]

The same use of the locked domestic door as a symbol of existential imprisonment had been seen in the first triptych memorialising

LATE

Contemplating 'great art' and his own motivation for painting, Bacon professed in 1966: 'Why, after the great artists, do people ever try to do anything again? Only because, from generation to generation, through what the great artists have done, the instincts change. And as the instincts change, so there comes a renewal of feeling of how can I remake this thing once again more clearly, more exactly, more violently.'[1] Such instincts were perhaps most acute during the final decade of the artist's career when his output, which showed no sign of abatement during the last years of his life, was marked by a conscious return to earlier concerns and the re-engagement with enduring obsessions. In this respect he may be compared to Paul Cézanne, who resumed his early temperament in terms of his work, identified in an important exhibition of 'late' works held in 1977.[2]

The confrontation with mortality remained an overarching theme for Bacon during the 1980s. Michael Peppiatt recalled how he 'thought and talked constantly about death'.[3] The loss of his friends Muriel Belcher in 1979 and Sonia Orwell the following year – can only have intensified the artist's consciousness of ageing and eventual 'annihilation'.[4] Towards the end of his own life he affirmed: 'Life and death go hand in hand ... Death is like the shadow of life. When you're dead you're dead, but while you're alive, the idea of death pursues you.'[5] The very notion of 'old age' or 'late' styles, usually seen in formal terms, has been recognised recently. As Linda Nochlin has observed, they have been characterised either as an autumnal ripening and resolution (typified by Rembrandt and Titian) or a belligerent inventiveness (suggested by Ludwig van Beethoven and Henrik Ibsen).[6] Veering towards the latter, Bacon's continued exploration of human instinct may perhaps be compared to the late style of Pablo Picasso,

which was reassessed in the 1980s, with David Sylvester identifying its 'loss of everything but the ambivalent pleasures of voyeurism and the will and force to go on making art.'[7]

The overwhelming sense of guilt and despair that dominated Bacon's paintings of the 1970s, exorcised in the series of 'black' triptychs contemplating the death of George Dyer, gave way to a certain composure, restraint and assuredness of composition in the late paintings. The youthful figure of Bacon's friend John Edwards, whom he met in the mid-1970s, was perhaps the catalyst for this shift in stance, both personally and artistically. Vigorous painterly smears and gross distortions of flesh are replaced by more subtle and diffused colorations of skin on figures, such as the retreating male in *Study from the Human Body* 1981 (p.242) and the seated *Portrait of John Edwards* 1988 (p.244). Yet the freshness of form is countered by darker areas of shadow displaying all the colour gradations of bruising. Set against rectilinear, monochrome backdrops such details portend to the vulnerability and transience of the human condition to which even young life is subject.

A general refinement of composition and expression is evident in the late paintings, which has been attributed, in part, to the artist's long-held interest in certain aspects of the work of the nineteenth-century painter Jean-Auguste-Dominique Ingres – less so for the smooth perfection of his neoclassical style perhaps than for the anatomical licence of his figures.[8] Indeed several paintings of this period take direct inspiration from work by the French artist, notably *Oedipus and the Sphinx after Ingres* 1983 (fig.117). Bacon is known to have amassed in his studio reproductions of studies for *Le Bain turc* 1859–63 (fig.115); the compressed, rounded forms of Ingres's bathers are echoed in the

simplified and truncated torsos, especially of the female figure, in *Diptych: Study of the Human Body – From a Drawing by Ingres* 1982–4 (fig.116). The headless male of the left-hand canvas crouches on a raised platform, his legs curiously encased by cricket pads. Bacon first incorporated this item of protective equipment in an earlier painting *Study of the Human Body* 1982. Most likely extracted from a book about the English cricketer, David Gower,[9] the pads' recurrence in several of the late male nudes is typically ambiguous; the artist explained: 'I have often seen cricket, and when I did this image I suddenly said: "Well, I don't know why, but I think it's going to strengthen it very much and make it look very much more real if it has cricket pads on it." I can't tell you why.'[10] This amalgamation of incongruous source material was characteristic of Bacon's practice and provided him with a fertile motif in this mature period, which he reworked further in 1985 in *Figure in Movement* (p.243). Here the sexual charge of the earlier, statuesque figures has dissipated, the square focus on genitalia abandoned to explore the movement of the male form who, now part-clothed in flannels, lunges somewhat theatrically towards an ambiguous space between a blue door frame and the picture plane.

Bacon's re-engagement with particular sources and imagery at this time also extended to more obvious, self-reflexive gestures such as his reworking of his 1944 triptych, *Three Studies for Figures at the Base of a Crucifixion* (pp.146–7), the self-affirmed master work that marked the emergence of his career four decades earlier. Like the two further and final triptychs that punctuated his remaining years,[11] *Second Version of Triptych 1944* of 1988 (pp.248–9) is boldly theatrical. Bacon asserted: 'I had always intended to rework that painting in a much bigger format, and then one day I decided to do it.'

Detail from right-hand panel of *Second Version of Triptych 1944* 1988 (p.249)

But I didn't recreate exactly the same work.'[12] The fact that the original painting was considered too fragile to be lent to the many retrospective exhibitions that were organised during the 1980s may, however, suggest that it was practical concerns that eventually precipitated Bacon's re-engagement with the subject forty years later, and his gift of the result to the Tate. The painting was Bacon's last triptych of the Eumenides, and the extra space afforded to the figures together with the extreme symmetry of the composition invests the painting with formal grandeur. Moreover, the overwhelming saturation of all three panels with a deep red colour reintroduces an earlier reference Bacon made to the murder of Agamemnon in the gory and blood-spattered *Triptych – Inspired by the Oresteia of Aeschylus* 1981 (pp.228–9). As David Sylvester remarked, the substitution of orange for red 'meant the replacement of a colour which had been a metaphor for violence by one which was literally the colour of blood'.[13] Matthew Gale has discussed how Bacon's alignment of the crucifixion with butchery revealed 'the animal in man'[14] and, in asserting his atheistic position, allowed him to focus on the brutality and violence he associated with human behaviour.

Bacon was attracted to the aesthetic qualities of blood and the vividness of the colours of raw meat or flesh. In the mid-1970s he commented: 'If you see somebody lying on the pavement in the sunlight, with the blood streaming from him, that is in itself – the colour of the blood against the pavement – very invigorating ... exhilarating.'[15] Such fascination can be linked with the artist's interest in crime scenes. Images of corpses and morgues are to be found amongst material collected from his studio, and a number of handwritten notes detailing ideas for paintings make reference to 'scene of crime' and 'pavement with blood'.[16] *Blood on Pavement*

c.1988 (p.247), a stark composition verging on the abstract, encapsulates Bacon's preoccupation with an emphatic economy of means consistent with the period. The scene is the liminal threshold that had interested Bacon for so long as a means to locate the subject as if within reach. Describing what appears to be the aftermath of a violent or potentially fatal act, the implication of horror, which begs interpretation, is set ambiguously against Bacon's own apparent position of detachment: 'Things are not shocking if they haven't been put into a memorable form. Otherwise, it's just blood splattered against a wall.'[17]

He had been contemplating such imagery with a clinical and dispassionate eye since the 1930s, when he had painted a *Wound for a Crucifixion* c.1934, which he later regretted having destroyed, as it had been a 'very beautiful wound'.[18] Enduring within Bacon's iconography the theme is reintroduced in late works such as *Oedipus and the Sphinx after Ingres* 1983 (fig.117), in which Oedipus' bloody wounds and heavily bandaged foot become the emphatic focal point of the composition. By introducing a Eumenides at the window, Bacon brought out Aeschylus' conjunction of the physical result and the psychological tension of the myth. This was a link that he would also explore in the bullfight imagery of *Triptych* 1987 (pp.230–1), inspired by the poetry of Federico García Lorca; there the Eumenides' return is, as Martin Harrison has remarked, a sign 'of Bacon's own fury and despair'.[19]

Bacon chose to focus his painting activity almost exclusively on the figure, yet his last years are marked by a small succession of landscape paintings, notwithstanding his long-felt apprehension about the tediousness associated with picture making and the conventions of the genre.[20] Speaking of *Landscape* 1978, which he modelled on a

battered and fragmentary print of a 'marvellous photograph I had of grass', Bacon explained: 'I wanted it to be a landscape and look unlike a landscape. And so I whittled it down and down until in the end there was just a stretch of grass left which I enclosed in a box. And that really came about by trying to cut away, out of despair, the look of what is called a landscape.'[21] The 'extraordinary animal energy'[22] that Sylvester attributed to this painting applies equally to subsequent compositions which, devoid of figurative detail, nonetheless suggest a mysterious presence, as sand dunes, undulating plains and sprays of water are anthropomorphised through paint. The desolation and vacancy of these canvases have the same power of suggestiveness as Bacon's depictions of blood on the floor where violence, or the threat of it, is palpable. A tension between the natural and the artificial is also present in paintings such as *Jet of Water* 1988 (p.245), in which Bacon intended to capture the memory of a breaking wave he had seen in the South of France against a 'manufactured' industrial background. Described by Peppiatt as perhaps the 'grimmest' painting Bacon ever produced, mankind has supposedly 'been swept off the stage'.[23] True to his claims of working as a result of chance or accident, Bacon achieved the gush of water by throwing unmixed paints from a pot on to the canvas: 'I threw on what I hoped to be a wave, and it didn't make a wave ... it looked more like a jet of water, so I turned it into a jet of water.'[24]

Other painterly techniques employed by Bacon are notable in this period, aside from his continued preference for fast-drying acrylic or emulsion paint to achieve the large expanses of flat background colour. The use of car spray-paints and the softer effect of airbrushing to create fine, diffused clouds of colour augmented Bacon's ambition to reduce content and distil detail within his

fig.115

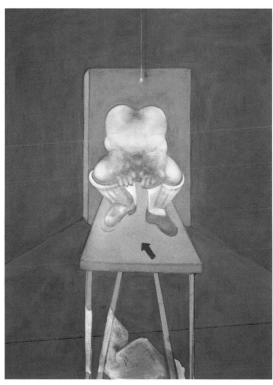

fig.116

fig.115 Jean-Auguste-Dominique Ingres
Le Bain turc 1859–63
Oil on canvas, 110 × 110
Musée du Louvre, Paris

fig.116 *Diptych: Sludy ot the Human Body
– From a Drawing by Ingres* 1982–4
Oil and transfer type on linen,
first panel 198.2 × 147.9
second panel 198.2 × 147.5

Hirshhorn Museum and Sculpture
Garden. Gift of Marlborough International
Fine Art and the Joseph H. Hirshhorn
Foundation, by exchange, 1989

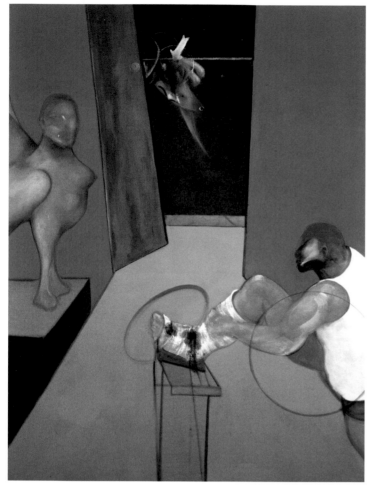

fig.117

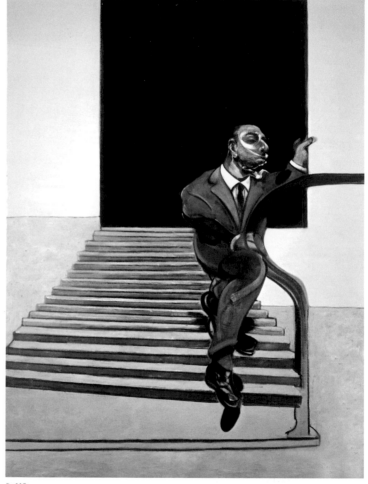

fig.118

fig.117 *Oedipus and the Sphinx after Ingres* 1983
Oil on canvas, 198 × 147.5
Private collection

fig.118 *Portrait of a Man Walking Down Steps* 1972
Oil on canvas, 198 × 147.5
Private collection

painting. In 1989 he commented: 'You're more conscious of the fact that nine-tenths of everything is inessential. What is called "reality" becomes so much more concentrated and can be summed up with so much less.'[25] Increasingly spare, even ethereal or benign, the late canvases are the antithesis of Bacon's earlier frenzied manipulation of pigment through which he attempted to 'remake the violence of reality itself'.[26] Such a shift was not without criticism, and the artist's work was accused in the 1980s of becoming formulaic and lacking in tension.[27] Reviewing the posthumous exhibition held in Venice in 1993, Jeremy Lewison commented: 'The primal energy and rawness of the earlier works has been replaced by a certain ironic distance, a cleanliness and a clinicalness which diffuse their impact. They are *grandes machines*.'[28]

Bacon claimed to like 'perfection on a very grand scale'.[29] The monumentality associated with the last paintings, particularly the triptychs, is perhaps vindication of an enduring ambition to achieve the 'deeply ordered' quality that he equated with 'great painting' at the mid-point of his career.[30] In all three of his late triptychs Bacon returned to existing themes, quoting emphatically from his own oeuvre. It is fitting that in the last of these, *Triptych* 1991 (pp.250–1), his focus remained with the 'endless subject' that he identified in 1953: the coupled figure derived from Eadweard Muybridge's wrestlers – the motif in which 'man is joined with his animal self in an internalized bullfight',[31] and which perhaps best encapsulated his struggle to recreate reality through paint, via the photograph. Indeed, as Harrison has noted, 'with poetic circularity [Bacon] was manipulating the same sources he had been using for more than 40 years'.[32] Two portraits – one of the Brazilian racing driver Ayrton Senna taken from a magazine cover and seemingly fused

with the likeness of Bacon's friend, José Capello, the other of the artist himself – are depicted as photographic prints pinned up, like the reproductions in Bacon's studio, above fragmented lower bodies. The left-hand figure appears to step out of a dark void towards the picture plane, while the one on the right – that of the artist – retreats towards an identical square of blackness with intimations of death. Spatial disconnection was a preoccupation for the artist at this time. Here, the figures' act of stepping in and out of the stage-like aperture of the painting recalls the fragmentary pair of legs in the middle panel of *Triptych* 1987 that cross a reflected threshold, by descending a doorstep towards the viewer (pp.230–1). Moreover, as Harrison has identified, 'Fragmented or dismembered forms and the fetishization of body parts became increasingly central to his externalisation of a personal sense of loss and his view of a society in decline'.[33] Indeed, the formal symmetry and isolation of the outermost figures in the last triptych evokes an atmosphere of loneliness, enhanced further by the flat, neutral rendering of the foreground. The importance of autobiography to Bacon's reinvention of 'what is called fact, what we know of our existence'[34] is clearly acknowledged in this work, and perhaps serves to reinforce the private preoccupations of his art and his assertion that: 'I'm just trying to make images as accurately off my nervous system as I can. I don't even know what half of them mean. I'm not trying to say anything.'[35]

RACHEL TANT

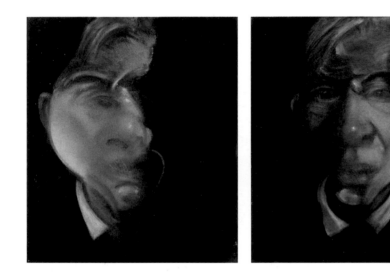
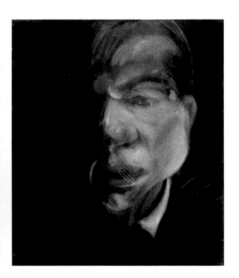

Three Studies for a Self-Portrait

1979–80, oil on canvas, each 37.5 x 31.8

The Metropolitan Museum of Art, New York.

The Jacques and Natasha Gelman Collection, 1998

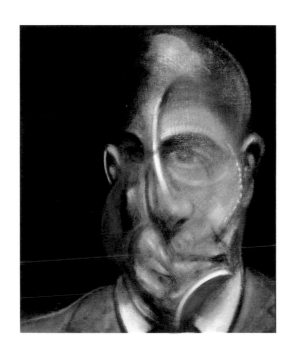

Portrait of Michel Leiris

1976, oil on canvas, 34 x 29

Centre Pompidou, Paris. Musée national d'art moderne / Centre de création industrielle.

Gift of Louise and Michel Leiris 1984

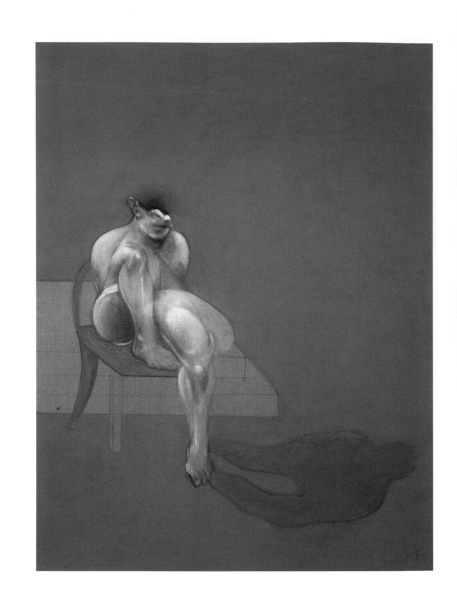

Triptych

1983, oil and pastel on canvas, each 198 x 147.5

Colección Juan Abelló

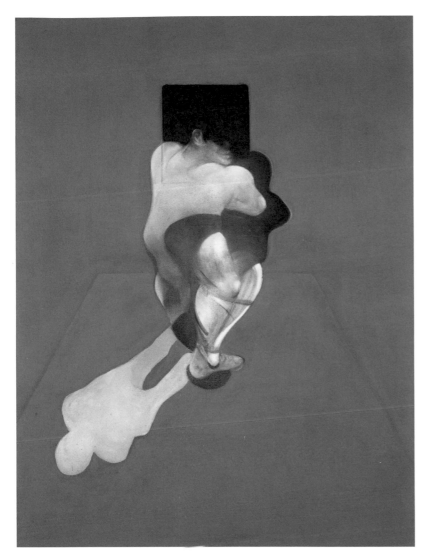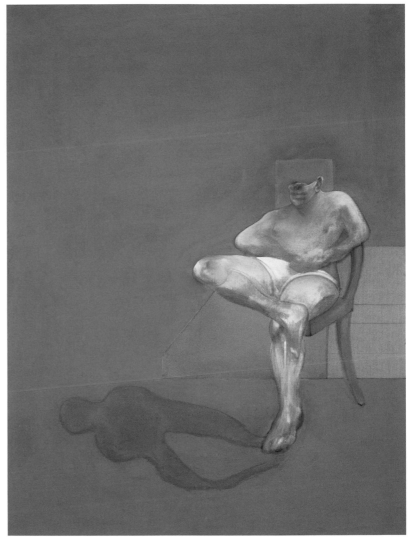

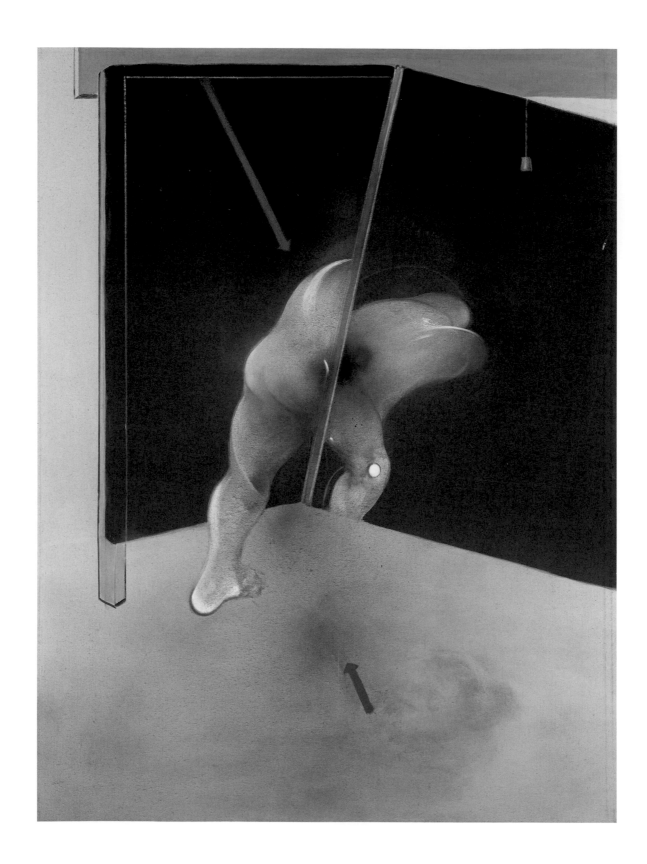

Study from the Human Body
1981, oil on canvas, 198 × 147.5
Private collection

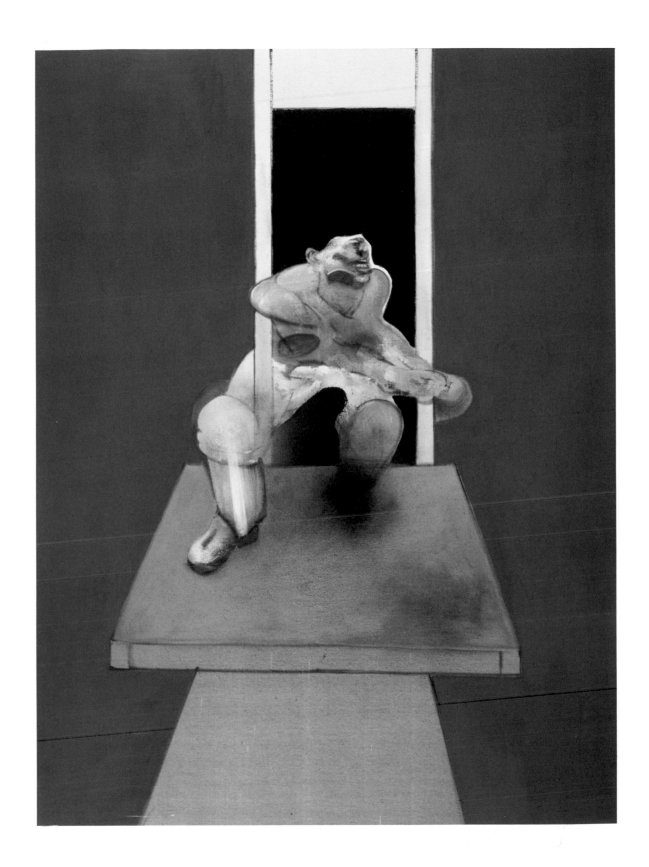

Figure in Movement
1985, oil on canvas, 198 × 147.5
Lent to Tate from a private collection 2000

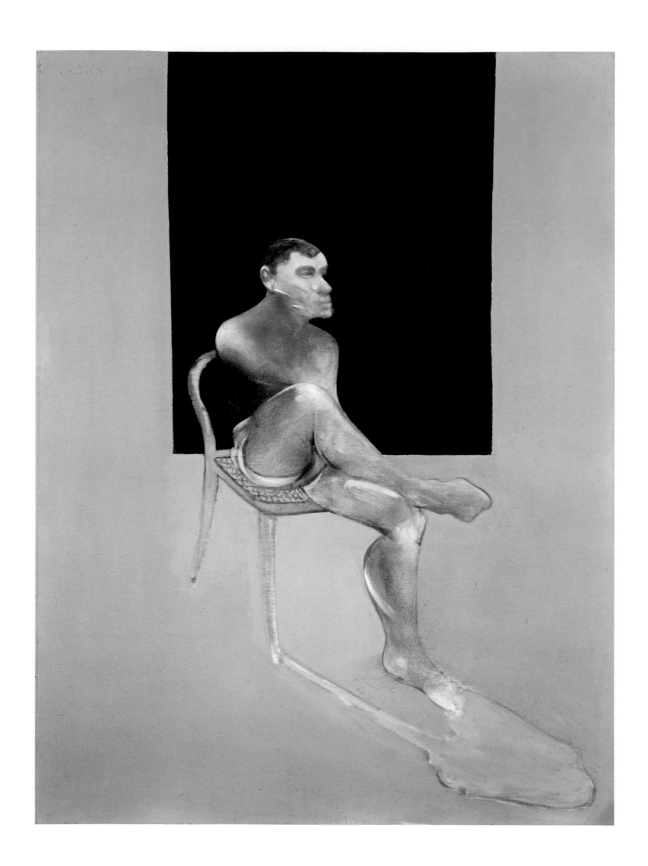

Portrait of John Edwards

1988, oil on canvas, 198 × 147.5

The Estate of Francis Bacon, courtesy of Faggionato Fine Arts, London
and Tony Shafrazi Gallery, New York

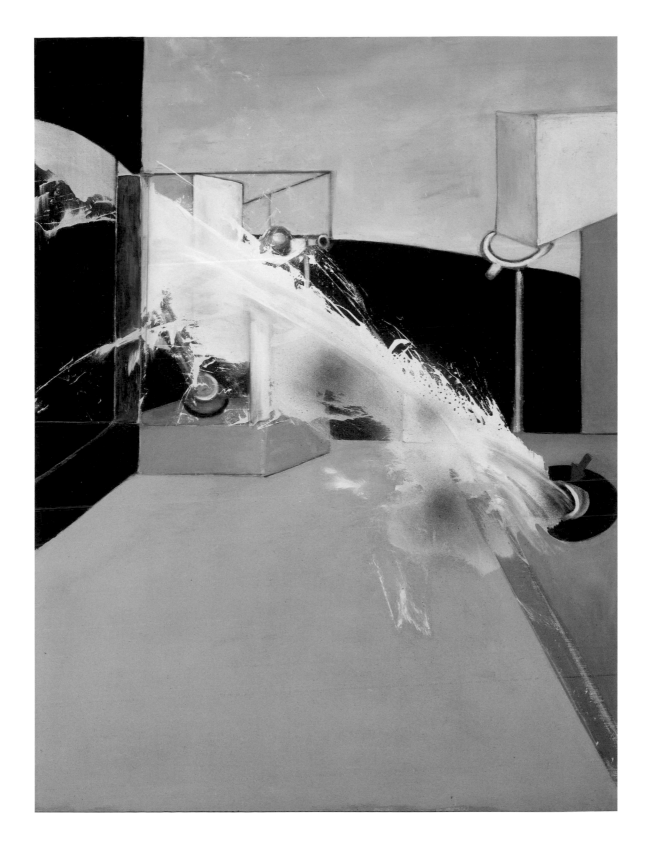

Jet of Water

1988, oil on canvas, 198 × 147.5

Collection of Mr. and Mrs. J. Tomilson Hill, New York

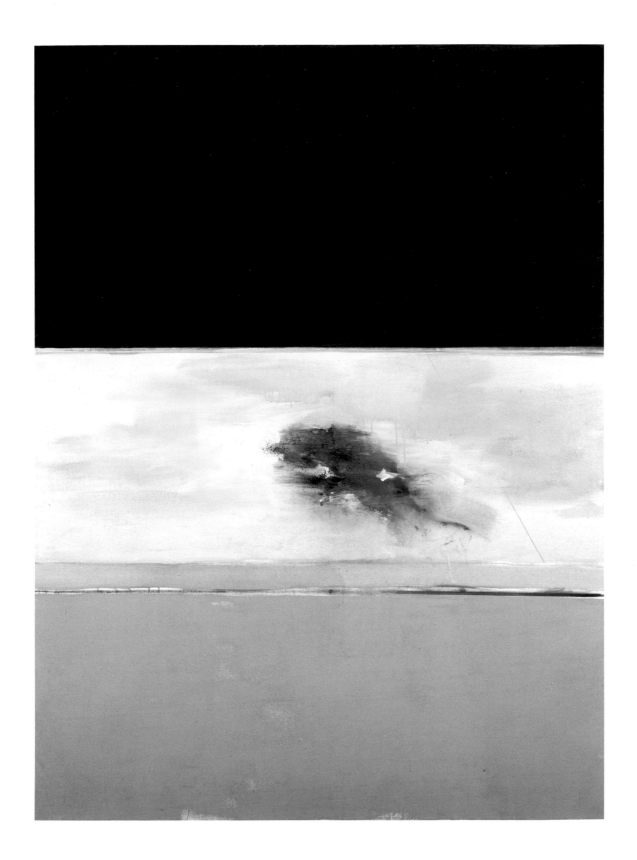

Blood on Pavement

c.1988, oil on canvas. 198 × 147.5

Private collection

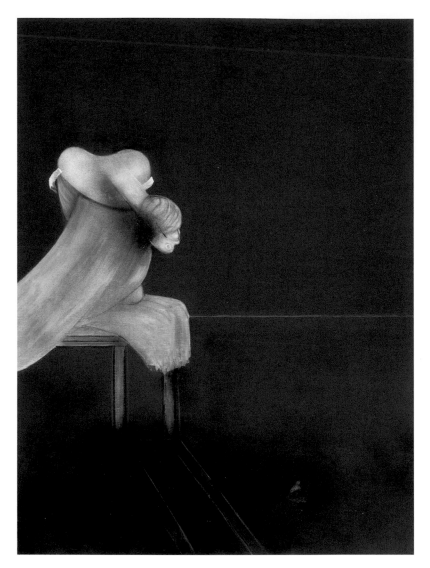

Second Version of Triptych 1944
1988, oil and acrylic on canvas, each 198 × 147.5
Tate. Presented by the artist 1991

Triptych
1991, oil on linen, each 198.1 × 147.6
The Museum of Modern Art, New York. William A. M. Burden Fund
and Nelson A. Rockefeller Bequest Fund (both by exchange), 2003

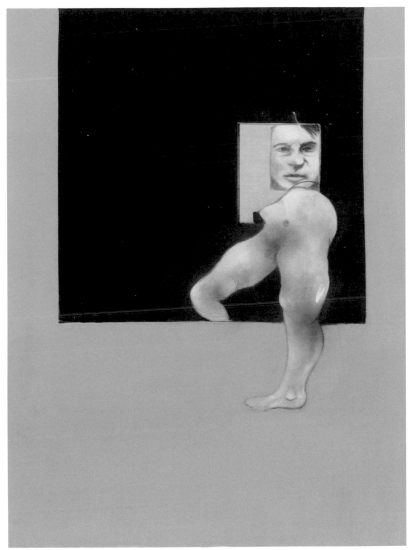

CHRONOLOGY

This chronology is based on information from a variety of sources including papers in TGA, NMWG and UCL. The principal published sources are Bacon's three biographies (by Daniel Farson, Andrew Sinclair and Michael Peppiatt), the chronologies in the catalogues for exhibitions at the Tate Gallery (1985) and Centre Georges Pompidou (1996), and Martin Harrison's *In Camera* (2005); see Selected Reading.[1] Unless otherwise stated, quotations are from Bacon.

1909

Born 28 October in a nursing home at 63 Lower Baggot Street, Dublin, the second of five children: an older brother, Harley, younger sisters Winifred and Ianthe, and younger brother Edward. Both brothers died young. Anthony Edward Mortimer ('Eddy') Bacon was of a military family while Bacon's mother, Christina Winifred Loxley Bacon, was of a wealthy family of Sheffield cutlery manufacturers. The family live in Cannycourt House near Kilcullen, County Kildare.

I was born in Ireland, though my mother and father were both English. My father was a trainer of racehorses and we lived near Curragh ... near a small town called Kilcullen in County Kildare.[2]

1913

Sept.: Ulster Unionists sign a 'solemn covenant' to resist Home Rule.

First English translation of Sigmund Freud's *Interpretation of Dreams* published.

29 Sept.: Home Rule for Ireland becomes law but is met with threats of violent resistance from Ulster Loyalists.

I like reading Freud very much because I like his way of explaining things ... The classic distinction today between the conscious and the unconscious is a useful one I think. It doesn't quite cover what I think about painting, but it has the advantage of not having to resort to a metaphysical explanation.[3]

fig.119 Bacon with his mother, 1913

1914

The Bacons move to London, living in Westbourne Crescent, while Eddy Bacon works at the War Office.

June: Assassination of Austro-Hungarian Archduke Franz Ferdinand leads ultimately to Britain declaring war on Germany on 4 August.

1916

Easter Rising against British rule in Ireland in April. Opening of the disastrous Battle of the Somme in France on 1 July.

1917

April: USA enters war on side of Allies, but in November the Bolsheviks, led by Lenin, take power in Russia and withdraw from the war.

1918

The Great War ends with an armistice on 11 November and is followed by political unrest throughout Europe.

1919

The Bacons return to Ireland.

The declaration by Sinn Fein MPs of a new parliament, Dáil Eireann, in Dublin in January 1919 is followed by the British deployment in 1920 of the Black and Tans to put down the Irish Republican Army (IRA) in the Irish War of Independence.

June: Germany forced to sign the punitive Treaty of Versailles.

Immediately after the war my father bought a house called Farmleigh in Abbeyleix in the county of Leix. He bought it from my grandmother ... Farmleigh was a very beautiful house where the rooms at the back were all curved ... then we drifted from one house to another.[4]

fig.120 Members of the Black and Tans, the armed auxiliary force of the Royal Irish Constabulary, search an Irish civilian suspect, 23 November 1920

1921

Anglo-Irish Treaty establishes an independent Ireland (with Ulster allowed an opt-out), but is followed by civil war, which ends in 1923.

1922

Oct.: Fascist leader Benito Mussolini takes power in Italy.

Nov.: Tomb of Tutankhamun discovered near Luxor, Egypt.

T.S. Eliot's poem *The Waste Land* published by Hogarth Press, London.

You can't really say that I'm Irish. It's true that I was born in Ireland and that there are some things that I like about Ireland, especially the way people construct their sentences. There are some very great Irish writers and poets such as Synge and Yeats. Perhaps I share with the Irish a certain desperate enthusiasm.[5]

The art that I prefer is really Egyptian art. I don't know why. I don't believe in death as it was perceived in Egypt. I think that one is born and one dies, and that is it. However, from their obsession with death, the Egyptians created the most extraordinary images.[6]

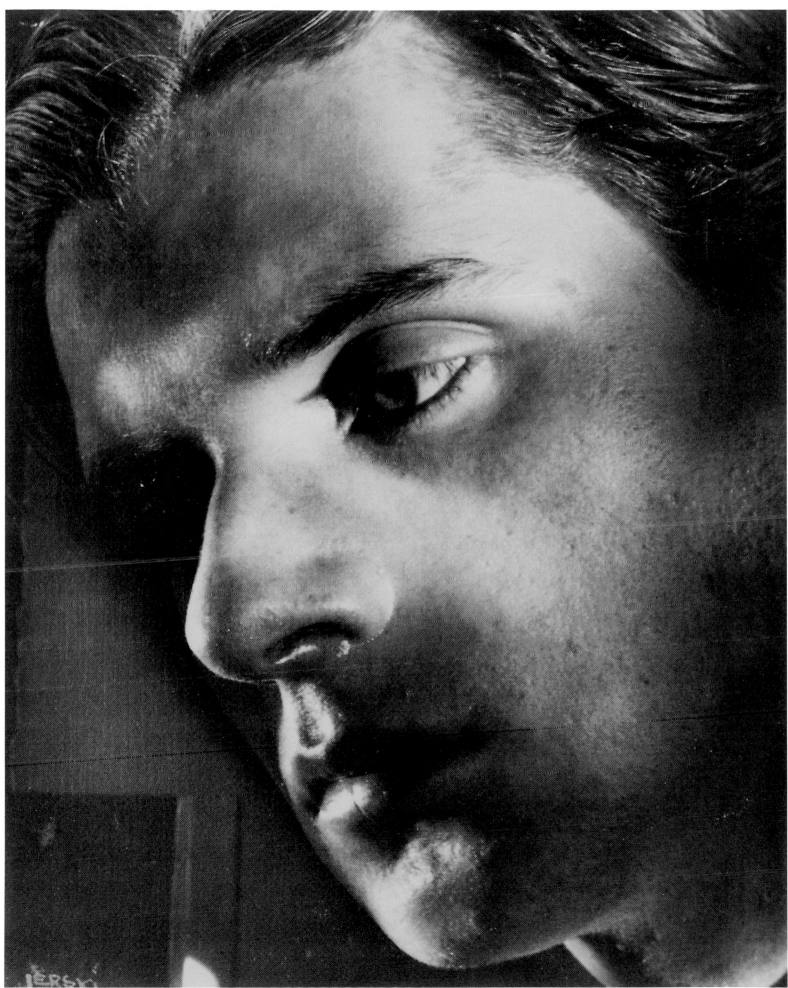

fig.121 Francis Bacon, Berlin c.1929–30 (Helmar Lerski)

1924

Around this time the Bacons move to Gotherington in Gloucestershire and, for a while, Francis boards at Dean Close School in Cheltenham.

Death of Lenin leads to Joseph Stalin taking power in USSR, and subsequent purges of his opponents, including Leon Trotsky.

1926

The Bacon family move back to Ireland, to Straffan Lodge near Naas, and it is from here that Bacon's father banishes him, having caught him wearing his mother's clothes.

May: General Strike in Britain.

1927

Bacon's younger brother Edward dies. Bacon arrives in Paris in the spring but soon moves to live near Chantilly, Champagne.

April: Abel Gance's three-screen epic film, *Napoléon*, is premiered at the Paris Opéra.

Around this time Bacon sees a Pablo Picasso exhibition at Galerie Paul Rosenberg that has a lasting effect. Chaïm Soutine and Giorgio de Chirico are shown in Paris and it might have been there that he first sees Sergei Eisenstein's *Battleship Potemkin* (1925). In the autumn Bacon moves to the Hotel Delambre in Montparnasse, where he lives until the end of 1928.

1929

Bacon returns to France, where he possibly sees Salvador Dalí's and Luis Buñuel's *Un Chien andalou*, and then travels to Germany.

In London, probably towards the end of the year, he sets himself up as an interior designer. It is most likely at this time that he moves into 17 Queensberry Mews West, South Kensington, and by 1931, his former nanny, Jessie Lightfoot, is listed as living there also. At the end of the year a studio exhibition of furniture and rugs includes one *Watercolour*. Around this time Bacon meets Eric Hall, a former merchant banker, Tory Alderman and Deputy Leader of London County Council, who becomes his lover.

Bacon supplements his income with odd jobs and work as a gentleman's gentleman, advertising himself as a valet under the name of Francis Lightfoot.

Dec.: Wall Street Crash.

When I was about sixteen my mother made me an allowance. She had a bit of money of her own; she came from Firth's steel – I expect you've seen the name on knives … I came to London and then on to Berlin.[7]

probably the best human cry in history was made by Poussin [in the Massacre of the Innocents at Chantilly] … I was once with a family for about three months living very near there, trying to learn French.[8]

And then I was in Berlin at the beginning of the Nazi thing, my whole life had been lived through a time of stress, and then World War Two, anyone who lived through the European wars was affected by them, they affected one's whole psyche.[9]

1930

Bacon returns to Germany, visiting Munich and Oberammergau for the Passion Play.

April–May: Mahatma Gandhi leads civil disobedience in India.

Australian artist Roy De Maistre arrives in London, becoming close to Bacon and teaching him to use oils. His circle of influential friends includes collectors Samuel Courtauld, Michael Sadler and Douglas Cooper. It is probably through De Maistre that Bacon first meets painter Graham Sutherland.

Bacon enjoys some success as a designer and features in 'The 1930 Look in British Decoration' in the August edition of *The Studio*.

I like to remember his pansy-shaped face sometimes with too much lipstick on it. He opened my eyes to a thing or two … He had an old nanny who used to go out shop-lifting whenever they were hard up, and as a lover there was an alderman.[10]
PATRICK WHITE, 1981

Fig.122 Double-page-spread from *The Studio: An Illustrated Magazine of Fine and Applied Art*, August 1930, pp.140–1

4 Nov.: Bacon shows paintings and rugs in exhibition at his Queensberry Mews premises, alongside De Maistre and Jean Shepeard.

Nov.: Haile Selassie crowned Emperor of Abyssinia, the second black ruler in Africa.

1931

Aug.: Faced by a national financial crisis the Labour government in Britain gives in to a coalition National Government. This is followed by a prolonged period of social and political unrest as the persistent economic crisis causes hardship.

Around this time Bacon begins to abandon his design work.

1932

Jan.: Japanese occupation of Manchuria threatens full-blown invasion of China.

By 1932 Bacon has left Queensberry Mews West.

1933

Jan.: Hitler appointed Chancellor of Germany; extends Nazi repressions nationally.

April: Bacon moves to 71 Royal Hospital Road, Chelsea, and that same month exhibits in the Mayor Gallery's *Exhibition of Recent Paintings by English, French and German Artists*.

Oct.: *Crucifixion* 1933 (p.145) reproduced in Herbert Read's book *Art Now* (fig.16) and shown in the accompanying exhibition at the Mayor Gallery. The work is bought by influential Leeds collector, Michael Sadler, who commissions a second painting, *The Crucifixion* (fig.74).

1934

Feb.: Bacon's exhibition at the Transition Gallery, London, in the basement of a friend's house in Curzon Street, Mayfair. Disappointed with the reviews, he destroys most of the works, later regretting *Wound for a Crucifixion*.

1935

Bacon is again included in two mixed exhibitions at the Mayor Gallery, including a second *Art Now*.

Bacon, Hall, De Maistre and others discuss re-forming the London Artists Association to subsidise and exhibit the work of young artists.

Oct.: Italy invades Abyssinia.

1936

Eric Hall leaves his wife and children, and moves in with Bacon at 1 Glebe Place, Chelsea.

June: *International Surrealist Exhibition* at the New Burlington Galleries, London, with British contribution selected by Read and Roland Penrose.

July: Spanish Civil War starts with Fascist rebellion against the Republican government.

Aug.: Egypt gains independence from Britain.

Oct.: While unemployed men march from Jarrow to London, another march by British Fascists provokes rioting in Stepney, East London.

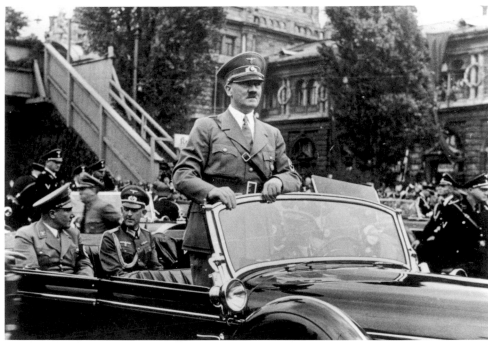

fig.123 The Chancellor of Germany, Adolf Hitler, standing in his car as he travels through Nuremberg to open the Nazi Congress, 6 September 1938

The difficulty with Mr Francis Bacon is to know how far his paintings and drawings ... may be regarded as artistic expressions and how far as the mere unloading on canvas and paper of what used to be called the subconscious mind. As the latter they are not much of consequence.[11]
THE TIMES, 1934

My pictures were in fact refused because they were not sufficiently Surrealist, according to the organizers. I myself think that my pictures were not at all Surrealist.[12]

1937

Jan.: *Young British Painters* at Thomas Agnew & Sons, organised by Hall, with Hall and Bacon selecting work by Victor Pasmore, De Maistre and Sutherland.

27 April: German aircraft bomb Basque town of Guernica; Picasso's great painting on the theme is shown in London the following year (fig.124) and tours Britain.

1938

April: Austria annexed to Germany in Anschluss.

Aug.: British Prime Minister Neville Chamberlain attends meeting in Munich that agrees German occupation of Sudetenland in Czechoslovakia in October.

Oct.: Japanese occupy Chinese city of Canton after relentless bombing.

Nov.: Destruction of German Jewish property reaches a height with Kristallnacht, when 7,000 shops are looted. Popular illustrated news magazine, *Picture Post*, launched in Britain. Publication of Karen Blixen's *Out of Africa* and Jean-Paul Sartre's *La Nausée* (first published in English as *The Diary of Antoine Roquetin* in 1949).

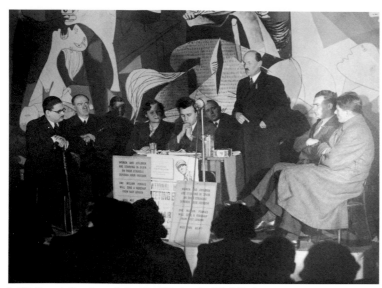

fig.124 Picasso's *Guernica* on display at the Whitechapel's 1938 *Aid Spain* exhibition organised by Roland Penrose, seated right

1939
Jan.: Fascist leader General Franco takes power in Spain.

The spring and summer are overshadowed by the build-up to war in Europe with Germany invading Czechoslovakia in March and, following a non-aggression pact, Germany and the USSR invading Poland in September. Britain declares war on 3 September.

Bacon evades enlistment due to bad asthma.

1940
May: British forces evacuated from Dunkirk; Winston Churchill becomes Prime Minister.

14 June: Fall of Paris.

June: Bacon's father dies, naming him as his sole executor and trustee. His mother remarries and moves to South Africa; both his sisters already live in Rhodesia.

Aug.: Battle of Britain as the Royal Air Force (RAF) fends off German air-force attacks on airfields in southern England.

7 Sept.: The Blitz starts in London, which is bombed for seventy-six consecutive nights, before the attacks spread to other major cities on 30 November.

1941
10 May: London Blitz culminates with largest raid, in which 1,400 people are killed by thousands of bombs.

Bacon works in the Civil Defence Corps rescue service and Air Raid Precautions (ARP), until worsening asthma forces him to give it up. He and Hall move to Steep, near Petersfield in Hampshire.

July: Germany invades USSR, where fighting will continue until Germany's defeat at Stalingrad 1943.

Dec.: Japanese bombing of Pearl Harbour precipitates USA joining the war.

1942
Oct.: British army defeat German army in North Africa at El Alamein.

Albert Camus publishes *Le Mythe de Sisyphe* (published in English as *The Myth of Sisyphus* in 1955).

1943
Possibly at this time Sutherland introduces Bacon to Lucian Freud.

By February Bacon is planning to spend more time in London, but it is later in the year that he moves to 7 Cromwell Place, South Kensington. Bacon works in the billiard room (frontispiece). Meets painter Peter Rose Pulham, who photographs some paintings.

Sept.: Following Anzio landings, Mussolini's regime falls and Italy surrenders; Hitler establishes Mussolini in puppet Republic of Salò.

The dowdy chintz and velvet sofas and divans with which the cavernous room [at Cromwell Place] was sparsely furnished gave it an air of diminished grandeur, a certain forlorn sense of Edwardian splendour in retreat.[13]
MICHAEL WISHART

fig.125 The Blitz, London, 1940–1

1944

Kenneth Clark, Director of the National Gallery and the most influential supporter of contemporary British art, taken to Bacon's studio by Sutherland.

6 June: Allied forces invade northern France (D-Day).

June: London and southern England under attack from German V1 bombs and, from September, V2 rockets.

25 Aug.: Paris liberated.

1945

12 April: Liberation of Buchenwald concentration camp, followed by Bergen-Belsen on 15 April; Germany surrenders 7 May.

April: Bacon shows *Three Studies for Figures at the Base of a Crucifixion* (pp.146–7) and *Figure in an Landscape* (p.97) in a group show at the Lefevre Gallery, London.

6 and 9 Aug.: Atomic bombs dropped on Hiroshima and Nagasaki lead to Japanese surrender and end of the Second World War, which has left 55 million dead.

Nov.: Nuremberg trials of Nazi leaders begin.

1946

Feb.: Bacon shows *Figure Study I* and *II* (pp.102–3) in group show at Lefevre Gallery; the latter is bought by the Contemporary Art Society.

March: Churchill warns of an 'iron curtain' dividing Eastern and Western Europe.

July: Bacon's *Study for Man with Microphones* (fig.126) shown at Lefevre Gallery.

Sutherland introduces Erica Brausen to Bacon. She buys *Painting* 1946 (p.101) for £200, and shows it at the Redfern Gallery.

By 20 August Bacon in Monte Carlo, which will remain his principal residence until 1950.

Nov.: Bacon in Paris, looking for a studio where he might work after the winter. He sees the UNESCO exhibition at the Musée d'Art Moderne (now Centre Georges Pompidou), which includes *Painting* 1946, and is disappointed by Balthus's work. Meanwhile, Sutherland's *Crucifixion* (fig.77) is unveiled at St Matthew's Church, Northampton, opposite Henry Moore's *Madonna and Child* 1944.

Three Studies for Figures at the Base of a Crucifixion seem derived from Picasso's Crucifixion, but further distorted, with ostrich necks and button heads protruding from bags – the whole effect gloomily phallic ... I have no doubt of Mr Bacon's uncommon gifts, but these pictures expressing his sense of the atrocious world into which we have survived seem to me symbols of outrage rather than works of art.[14]
RAYMOND MORTIMER, 1945

I am working on 3 sketches of the Velasquez portrait of Pope Innocent II [sic]. I have practically finished one. I find them very exciting to do but don't know yet if they are going to come off or not.[15]

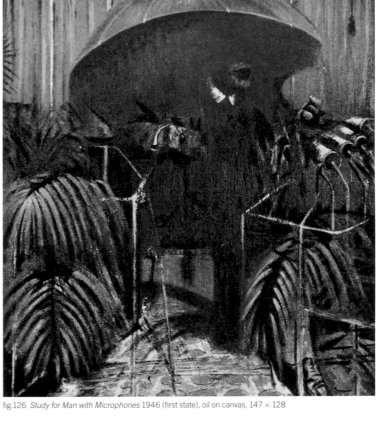

fig.126 *Study for Man with Microphones* 1946 (first state), oil on canvas, 147 × 128

1947

Feb.: Bacon is in London for ten days.

Feb.: In Britain severe weather brings economic crisis that deepens through the year, leading to austerity measures.

April: Bacon and Hall are joined in Monte Carlo by Graham and Kathleen Sutherland. They stay nearby for five weeks and return in September with Lucian Freud. Bacon is considering moving to America the following year.

Aug.: Independence of India declared from British rule, and the partitioning of India and Pakistan.

1948

May: State of Israel declared.

June: Erica Brausen opens the Hanover Gallery with a Sutherland exhibition. She also represents Bacon and sells *Painting* 1946 to The Museum of Modern Art (MoMA), New York, for £280. *Study for Man with Microphones* reproduced in James Thrall Soby's *Contemporary Painters*.

[Bacon] talks a lot, condemns everything with sweeping gestures – but I think there is something burning and alive there ... [He is] hopelessly young and dogmatic.[16]
BENEDICT NICOLSON, 1947

June: Berlin is blockaded by USSR, while British troops fight Communist insurgents in Malaya.

Sept.: Bacon in the South of France until at least November.

Dec.: Exhibition of Matisse and Picasso at the Victoria and Albert Museum, and of Paul Klee at the National Gallery, London.

1949
Reputedly introduced to Eadweard Muybridge's *Human Figure in Motion* and *Animal Locomotion* by Denis Wirth Miller.

Oct.: Mao Zedong declares a Communist Republic in China; Stalin establishes German Democratic Republic (East Germany).

Nov.: First one-person exhibition at the Hanover Gallery is a commercial success and accompanied by an important article by Robert Melville in the last ever issue of *Horizon*.

27 Nov.: Bacon leaves for Monte Carlo.

1950
By 1950 Eric Hall is no longer listed at 7 Cromwell Place, although he continues to support Bacon's career.

fig.127 Francis Bacon May 1951 (Cecil Beaton)

He is obsessed with the photographic delineation of form – wishes, as far as I can see, to seize such a quality in paint.[17]
ISABEL RAWSTHORNE, 1949

Every activity in these paintings of men going in and out of curtains, or imprisoned in transparent boxes, has an air of extreme hazard, and this powerful overtone obscures the modernity of Bacon's formal resources.[18]
ROBERT MELVILLE, 1949

Rumour has it that Francis has won at the tables and has taken a house for three months near Monte.[19]
ISABEL RAWSTHORNE, N.D.

Feb.: in USA Senator Joseph McCarthy launches a campaign to oust Communists from public office.

March: Bacon included in *London – Paris: New Trends in Painting and Sculpture* at the Institute of Contemporary Arts (ICA).

June: North Korea's invasion of South Korea leads to war between UN-backed British and American forces fighting for the South against the Chinese Communist-backed North. The conflict continues until July 1953.

Sept.: Second one-person Hanover Gallery exhibition is supposed to include three studies after Velázquez's *Portrait of Pope Innocent X* (p.112) but only two arrive and are later withdrawn.

In the autumn Bacon replaces his friend John Minton for a term as a teacher at the Royal College of Art (RCA). He does no formal teaching.

Oct.: Bacon is included in *The Last Fifty Years in British Art, 1900–1950* at Knoedler Gallery, New York, and in *The Pittsburgh International* at the Carnegie Institute.

Tate Gallery acquires *Figure in a Landscape* 1945 on the recommendation of Sutherland, a Trustee.

Towards the end of the year Bacon travels to South Africa.

1951
Returns home via Egypt.

Abandons plans to design a production of Sartre's *Les Mouches* in English translation.

3 April: Jessie Lightfoot dies. Bacon, in Nice, is inconsolable. Sells 7 Cromwell Place and moves often for the rest of the decade.

May: The Festival of Britain opens, primarily on the South Bank, London. Bacon is one of the few major artists not to participate, despite having been invited to do so.

Borrows Rodrigo Moynihan's studio at the RCA until autumn 1953.

Dec.: Solo exhibition at Hanover Gallery.

Francis supposed to have 4 or 5 pictures ready by Sept 14 for Erica – hasn't got one yet … he is working on the same kind of subject (well – I mean nude in open air) and using the brightest colours also.[20]
ISABEL RAWSTHORNE, 1949

there are a few artists here who have very little to say and say it in a high-handed manner … Francis Bacon's macabre shadows of paintings are over on the neurotic fringe of surrealism.[21]
ART DIGEST, 1950

I want to get off at Port Sudan and go to Thebes and rejoin the boat again at Alexandria to Marseilles … I should be home about the end of April.[22]

He left the door of his studio ajar … At one stage he filled a bucket with black house paint and with a broom from the corridor splashed it over the canvases. I noticed he drew on the canvas with chalk and pastel – working out compositional lines in a traditional way.[23]
ALBERT HERBERT, 1951–2

Bacon, more than any other painter of his generation, in any country, has evoked a visual equivalent of horror. With a power out of all proportion to the means employed, he can produce an almost physical nausea in the spectator by well-nigh abstract means.[24]
MICHAEL MIDDLETON, 1951

1952

Jan.: Sam Hunter's article 'Francis Bacon: The Anatomy of Horror' published in American *Magazine of Art*, featuring photographs of Bacon's source material (figs. 88, 89)

15 Jan.: Public discussion at the ICA on 'Bacon and Balthus'. The panel includes John Berger, David Sylvester, Robert Melville, Michael Ayrton, Herbert Read, Angus Wilson and Colin Matthews.

Bacon is photographed in his studio at the RCA by Henri Cartier-Bresson (fig.129).

Spring: Second visit to South Africa to see his mother and sister, also visiting Kenya. On his return to London, he lives for a time at John Minton's house, 9 Apollo Place; Sylvester lives downstairs.

Intense and violent relationship with Peter Lacy, ex-RAF pilot, who has been renting Long Cottage, Hurst, near Henley-on-Thames in Berkshire, since June 1951.

Lucian Freud paints portrait of Bacon.

fig.128 Lucian Freud, *Francis Bacon* 1952
Oil on metal, 17.8 × 12.7, whereabouts unknown

July: In Egypt King Farouk deposed by military coup.

July: Bacon's work included in the ICA's exhibition *Recent Trends in Realist Painting*.

London covered in Great Smog.

Bacon's *Study of a Dog* (p.113) is bought by Hall and donated to the Tate Gallery.

fig.129 Francis Bacon, 1952 (Henri Cartier-Bresson).
Henri Cartier-Bresson/Magnum Photos

Bacon's inspiration from the accidental distortions and monstrous infelicities of the photograph haven't prevented him, however, from remaining supremely a painter's painter. Away from the preoccupations of symbolism, he is capable of shimmering, silken graces in paint.[25]
SAM HUNTER, 1952

Francis was thrown out of a window 15ft into area below, by Peter, but being drunk survived without much damage.[26]
ISABEL RAWSTHORNE, 1952

Nov.: Mau Mau uprising against colonial rule in Kenya begins and will last until 1960.

Dec.: US test first Hydrogen bomb in Pacific Ocean.

1953

Bacon lives for a time at 6 Beaufort Gardens, Chelsea, but also with Lacy at Hurst.

March: Included in *The Wonder and Horror of the Human Head* exhibition at the ICA.

5 March: Stalin dies.

Bacon joins a seminar about his work organised by Sylvester at the Slade School of Art, where he is a regular visitor and, although he doesn't teach, an influence on students such as Michael Andrews and Victor Willing.

June: In USA Julius and Ethel Rosenberg are executed by electric chair for spying. In Britain the Coronation of Queen Elizabeth II is attended by a swelling of national pride and talk of a 'new Elizabethan age'.

Sept.: Bacon contributes text for catalogue of Matthew Smith exhibition at Tate Gallery.

Oct.: Shows eight *Studies for Portrait* (p.128) after Velázquez's *Innocent X* at Durlacher Brothers, New York, his first one-person exhibition in the USA.

A picture should be a recreation of an event rather than an illustration of an object; but there is no tension in the picture unless there is the struggle with the object.[27]

He came in ... wearing a tremendously elegant dark blue chalk striped suit, absolutely beautifully cut, very minimal, his hair streaming out of his head like petals out of a flower ... and a tartan shirt open at the neck ... and somehow that combination of formality and complete informality and the quality of his voice and his whole presence in the room was just utterly glamorous.[28]
ANDREW FORGE

Nov.: Solo exhibition at Beaux Arts Gallery, London, run by Helen Lessore, who continues to buy work through Sylvester.

Eric Hall donates *Three Studies for Figures at the Base of a Crucifixion* to the Tate Gallery.

1954

Jan.: Peter Wildeblood, Lord Montagu of Beaulieu and Michael Pitt-Rivers arrested and tried for 'homosexual offences'. Wolfenden Committee is established to examine the law.

Feb.: Bacon moves into a room at 19 Cromwell Road, but still spends time with Lacy in Hurst.

March: Bacon moves into the Imperial Hotel, Henley-on-Thames.

June: Another exhibition at the Hanover Gallery, as Bacon represents Britain at the Venice Biennale alongside Freud and Ben Nicholson.

Though he does not see the exhibition in Venice, Bacon travels in Italy with Lacy. They visit Rome and after a while they part in Ostia; Bacon remains alone for a few months.

July: The Indo-China war ends, with France capitulating to a division of Vietnam, and with the north being controlled by the Communist Viet Minh.

30 Nov.: Prime Minister Churchill's eightieth birthday is marked by the presentation of Graham Sutherland's portrait.

1955

Jan.: Bacon's retrospective exhibition at the ICA, selected by his friend Peter Watson. A complaint of indecency is levelled at *Two Figures in the Grass* (p.134) and dismissed by the police.

For a while Bacon lives on Sloane Street and borrows Michael Astor's studio at 28 Mallord Street, Chelsea.

Increasing numbers of migrants come to Britain from the West Indies.

March: Bacon is commissioned to paint portraits of Robert and Lisa Sainsbury.

May: Included in *The New Decade: 22 European Paintings and Sculptures*, The Museum of Modern Art, New York.

[Matthew Smith] seems to me to be one of the very few English painters since Constable and Turner to be concerned with painting – that is, with attempting to make idea and technique inseparable. Painting in this sense tends towards a compete interlocking of image and paint, so that the image is the paint and vice versa.[29]

If these images shock, it is to shock us into an awareness of reality. Whatever their impact may owe to their dramatic implications and to their evocations of human history – both the chaotic present and the battered past … in the long run it is the oppressive weight of their sheer reality that haunts us.[30]
DAVID SYLVESTER, 1954

And now there is Francis Bacon whose characteristics recall the engraving in which Dürer showed a horseman walking beside his mount unaware of the presence of Death following, step by step, behind him. If a broad meaning can be given to 'death' it can be said that the merit of Francis Bacon is to have turned around.[31]
MAX CLARAC-SÉROU, 1955

May: Warsaw Pact unites Eastern European countries in Communist alliance.

A commission from composer Gerard Schurmann for a cover design for his nine *Poems of William Blake* results in the series of paintings *Study for a Portrait I–V* (p.157), based on a postcard of Blake's life mask at the National Portrait Gallery.

Autumn: At the request of his framer Alfred Hecht, Paul Danquah and Peter Pollock offer Bacon space in their apartment at 9 Overstrand Mansions, Battersea, where he would stay for six years (fig.5).

From 1955 to 1961 Bacon is a frequent visitor to Tangier, where Lacy settles.

1956

Jan.: *Modern Art in the United States* at Tate Gallery concludes with one room of work by Abstract Expressionists.

March: Soviet leader Nikita Krushchev denounces Stalin as a despot. France grants Morocco independence, Spanish Morocco follows a month later.

May & June: Bacon included in two group exhibitions in Oslo and Copenhagen.

June: Bacon travels via Madrid to Tangier where Peter Lacy is now based, playing piano in a bar and increasingly alcoholic. An international zone until independence, Tangier is a liberal haven and a number of homosexual

I would like my pictures to look as if a human presence had passed between them, like a snail, leaving a trail of the human presence and memory traces of past events, as the snail leaves its slime.[32]

I am not at all interested in William Blake. Someone asked me to make those portraits, that's all … Someone gave me a cast of his death mask, that's all. But I really don't like him. I detest the work of Blake.[33]

fig.130 Peter Lacy outside the Museo del Prado, Madrid, en route to Gibraltar and Tangier, 1956 (?Francis Bacon).
Dublin City Gallery The Hugh Lane

artists and writers from Europe and America frequently visit or live there during this time. In Tangier Bacon meets artist Ahmed Yacoubi, close friend of Paul Bowles, whom he teaches to use oils.

July: General Nasser nationalises Suez Canal despite protests from Britain and France.

Nov.: As the Soviet Red Army crushes the uprising against Communist rule in Hungary, the Anglo-French occupation of the Suez Canal Zone is withdrawn under UN and US pressure.

fig.131 Illustrations from *The True Aspects of the Algerian Revolution*, produced by the French Ministry of Algeria, 1957 Dublin City Gallery The Hugh Lane

1957
The Wolfenden Committee Report into homosexuality released.

20 Jan.: John Minton commits suicide.

Feb.: Bacon's first solo exhibition in Paris, at Galerie Rive Droite.

March: Works from the Paris show augmented with the van Gogh series (p.161) at the Hanover Gallery in London.

May: Bacon returns to Tangier.

June: Arrest in Tangier of Ahmed Yacoubi marks a crackdown on the liberal culture.

July: New Prime Minister Harold Macmillan claims most Britons 'have never had it so good'.

Oct.: USSR launches Sputnik 1, the first satellite, into space.

[I never had the] energy Francis got from the feeling of profligate self waste that so many of his circle gave off ... feeling of just flushing themselves down the drain, in a way, with so much flourish and abandon, which he admired tremendously. [34]
ANDREW FORGE

One gets the uncomfortable sensation, that in these paintings Bacon has somehow taken possession of the personality of Van Gogh and fused it with his own. As one might expect, he emphasises Van Gogh's madness and isolation, and forces out a streak of morbidity which Van Gogh himself fought hard to suppress. [35]
JOHN GOLDING, 1957

I saw Francis yesterday for 5 minutes the day we left. He was in a state himself about the whole trouble, a good many people in Tangier are, since they have no idea who figures among the ones being investigated. [36]
PAUL BOWLES

1958
Jan.–March: Solo exhibitions in Italy at Galleria Galatea, Turin (Jan.), Galleria dell'Ariete, Milan (Feb.), with a catalogue by David Sylvester and Toni del Renzio, and L'Obelisco, Rome (March).

May: The crisis in Algeria, where Nationalist rebels are confronted by French settlers, leads General Charles de Gaulle to become French Premier.

June: Yacoubi released and the clampdown in Tangier is eased.

July: Military coup in Iraq creates anxieties throughout the Middle East, and American and British troops move into Lebanon and Jordan.

27 Aug.: Bacon films an interview as an episode of the TV series *The Art Game*, with Daniel Farson.

Sept.: Race riots in London's Notting Hill, an area with a large West Indian population.

Oct.: Bacon suddenly leaves Hanover Gallery for the recently established Marlborough Fine Art; Brausen considers legal action.

By the end of the year his relationship with Lacy has ended.

1959
Jan.: Fidel Castro takes power in Cuba.

Feb.: *New American Painting* at the Tate Gallery is the first UK exhibition devoted to Abstract Expressionism.

Alain Resnais directs *Hiroshima Mon Amour*, from a story by Marguerite Duras, a friend of Bacon.

Aug.: Bacon included in *Documenta II* in Kassel.

Sept.: Included in the São Paulo Bienal and in *New Images of Man* at MoMA, New York.

25 Sept.: Arrives in St Ives, Cornwall, in search of a studio to rent for six months. Rents 3 Porthmeor Studios from William Redgrave and Peter Lanyon.

Dec.: In preparation for a book on Bacon, James Thrall Soby sends him a questionnaire, answers to which are relayed via Robert Melville at Marlborough Fine Art. [37]

Francis was most effusive He showered love & goodwill on everybody 'You are the most ...' 'I think you are so amazing because ...' and yet there is no sinister motive in his goodwill – it is just a thick veneer of traffic – which for him obscures the inner terror that he has to live with. [38]
WILLIAM REDGRAVE, 1959

1960

5 Jan.: Bacon leaves St Ives, although he visits again in July and continues to do so in the future.

5 March: Fifty-six people killed in protest at Sharpeville, South Africa.

23 March: Bacon's first exhibition at Marlborough Fine Art, where Valerie Beston will look after him for the rest of his life. Cecil Beaton photographs Bacon and sits to him.

June: The Congo gains independence from Belgium.

July: Arts Council holds a Picasso retrospective at the Tate Gallery.

Bacon is included in *British Painting 1700–1960* exhibition in Moscow and Leningrad.

1961

Feb.: *Young Contemporaries* exhibition in London presents work by David Hockney and other emerging Pop artists.

April: Nazi Adolf Eichmann appears in court in Israel for war crimes. Russian Yuri Gagarin becomes first man in space.

fig.132 German Gestapo officer Adolf Eichmann listens to the guilty verdict read by the presiding judge, as he stands in a bullet-proof glass enclosure in a Jerusalem court in 1961, during his trial for committing wartime atrocities against Jewish Europeans

Death of Georges Bataille.

Bacon commissions John Deakin to take photographs for him to use as source material.

Release of Alain Resnais's film *Année dernière à Marienbad* from a story by Alain Robbe-Grillet.

Aug.: Wall erected dividing East and West Berlin.

In the autumn, he moves into 7 Reece Mews, which will remain his home and studio until his death.

Oct.: Mark Rothko retrospective at Whitechapel Art Gallery, London.

1962

Feb.: *The Sunday Times* publishes the first colour supplement magazine.

May: Retrospective exhibition at the Tate Gallery, for which Bacon paints *Three Studies for a Crucifixion* (pp.148–9). Peter Lacy dies in Tangier.

Through Isabel Rawsthorne, Bacon becomes friends with Alberto Giacometti.

July: After years of violence, including resistance from far-right French activists the OAS, France announces independence for Algeria.

Oct.: Bacon's first interview with David Sylvester, for the BBC.

Oct.: Cuban Missile Crisis brings world to the brink of nuclear war.

1963

July: Joint exhibition with Henry Moore at Marlborough Fine Art.

Autumn: meets George Dyer.

Joseph Losey's film *The Servant* stars Dirk Bogarde and James Fox.

Oct.: Retrospective exhibition at Solomon R. Guggenheim Museum, New York, travelling to the Art Institute of Chicago in Jan. 1964.

22 Nov.: US President John F. Kennedy assassinated in Dallas, Texas.

1964

Feb.: Robert Rauschenberg retrospective at the Whitechapel Art Gallery.

First major book, published by Ronald Alley, with an introduction by Tate Director John Rothenstein. Around this time, Bacon begins to use acrylic in his backgrounds.

The important thing is to put a person down as he appears to your mind's eye. The person must be there so that you can check up on reality – but not be led by it, not be its slave.[39]

I saw the Rothkos at the Whitechapel Gallery and I hoped to see marvellous abstract Turners, and what I saw were rather dismal variations on colour, which at any rate, from my point of view, gave me no excitement and no possibility of entering or communication whatsoever.[40]

Bacon has used his paint as if he were modelling the figure out of wet clay or as if he has forced his hands into the actual substance of the model and sculpted the bone-structure in order to intensify the pliancy of the flesh. The result is an effect of sumptuous deliquescence.[41]
ROBERT MELVILLE

Photography has covered so much: in a painting that's even worth looking at the image must be twisted ... if it is to make a renewed assault upon the nervous system ... and that is the peculiar difficulty of figurative painting now.[42]

It is, perhaps, time to write about Bacon as a painter, rather than as an allegorist of Angst, and about his works as paintings, rather than as documents of a 20th century problem, predicament, crisis, or what have you.[43]
LAWRENCE ALLOWAY, 1963

1965

June: US troops sent into Vietnam for first time in support of South Vietnamese.

July: At the opening of a Giacometti exhibition at the Tate Gallery, Bacon meets Michel Leiris, who has strong links back to the Surrealist movement, and who would become a key writer on his painting.

Bacon and Dyer travel to Greece on the Orient Express, accompanied by John Deakin.

1966

Nov.: Bacon exhibition at Galerie Maeght, Paris, with introduction by Leiris.

1967

Sexual Offences Act decriminalises homosexual acts in the UK.

March: Bacon visits his mother and sister in South Africa.

Bacon refuses the Carnegie Institute Award in Painting, but in June accepts the Rubens Prize, which he donates in aid of restoration of art damaged by the flood in Florence eight months earlier.

June: Six-Day War between Israel and its Arab neighbours.

Summer: Exhibition of small portrait triptychs at Marlborough Fine Art.

Rauschenberg is an artist who is always very, very inventive to me, and I find his works very, very interesting ... because he's always searching for something.[44]

One night at dinner the topic of Vietnam came up ... Bacon got quite heated in defence of war as the natural state of things ... saying 'everybody likes violence and the thrills'.[45]
HUGH M. DAVIES

Perhaps it is because this conflict between documentary precision and pictorial truth reaches its climax in the portrait, that when Bacon paints portraits, the art of painting which can, apparently, only exist for him in a state of high tension, becomes kindled to incandescence.[46]
MICHEL LEIRIS, 1967

1968

Bacon again visits his ailing mother in South Africa.

April: US Civil Rights leader, Martin Luther King, assassinated.

May: Students riot in Paris.

Aug.: 'Prague spring' of liberalisation is crushed by Soviet army.

Nov.: Bacon visits the USA for the first time, for his exhibition at Marlborough-Gerson Gallery, New York. He and Dyer stay in the Hotel Algonquin. Reported suicide attempt by Dyer.

1969

Bacon is again lent a studio at the RCA for six months, possibly due to a fire at Reece Mews late in 1968; he donates a painting to the RCA.

March: East End gangsters the Kray twins jailed for life.

21 July: Neil Armstrong is first man to set foot on the moon.

Aug.: British troops sent to Northern Ireland, where they continue to be deployed until 2007.

1970

Bacon acquires house in the historic Docklands area of Limehouse, east London, which he uses for entertaining only.

Relationship with Dyer is increasingly fractious and in September Dyer reports Bacon for possession of cannabis, for which he is acquitted.

April: Vietnam War spreads when US President Nixon sends troops into Cambodia. May: In the USA National Guards shoot anti-war protesters at Kent State University, Ohio.

1971

Publication of *Francis Bacon* by John Russell, which will become the main text on Bacon.

14 April: Bacon's mother dies in South Africa.

25 Oct.: Dyer is found dead in the bathroom at Hôtel des Saint-Pères, the day before the opening of Bacon's retrospective exhibition at the Grand Palais, Paris. The first of his 'memorial' triptychs (pp.206–7) is begun the following month.

I behold the cheapest, coarsest, least felt application of paint matter I can visualize, along with the most transparent, up-to-date devices ... I see all this in every picture of his I know of since the early fifties, in the ones that hook me as well as the ones that don't. Bacon is the one example in our time of inspired safe taste – taste that's inspired in the way in which it searches out the most up-to-date of your 'rehearsed responses.' Some day, if I live long enough, I'll look back on Bacon's art as a precious curiosity of our period.[47]
CLEMENT GREENBERG, 1968

The only time I've been in New York I went to the Museum of Modern Art to see the Jackson Pollocks – I'd heard so much about Jackson Pollock – and found that dribbling of paint all over the canvas just looked like old lace.[48]

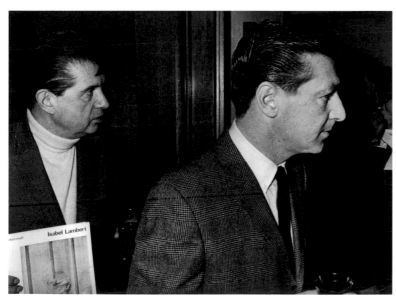

fig.133 Francis Bacon and George Dyer at Marlborough Fine Art, 1968
Tate Gallery Archives

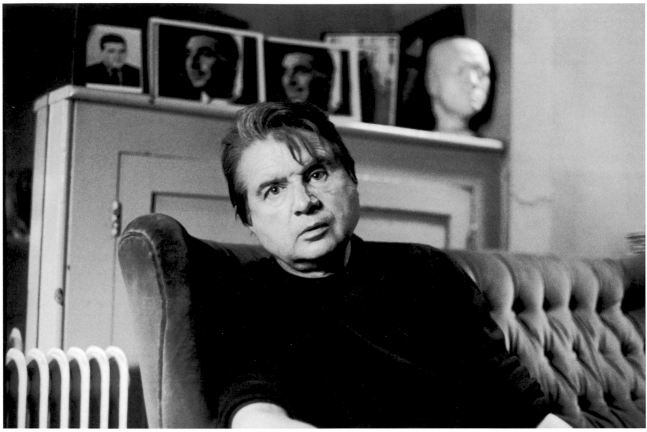

fig.134 Francis Bacon, Reece Mews, 1973 (Peter Stark). Archive of Modern Conflict

1972
Jan.: British troops shoot dead thirteen civil rights marchers in Londonderry on Bloody Sunday. The IRA's bombing campaign spreads to the mainland and, in March, the British government imposes direct rule on Northern Ireland.March: Grand Palais exhibition travels to Düsseldorf. That month Bacon speaks on the BBC about the necessity of the National Gallery acquiring Titian's *Death of Acteon*.

May: John Deakin dies in Brighton.

Film director Bernardo Bertolucci uses Bacon's paintings in the opening credits of the sexually explicit *Last Tango in Paris*.

Aug.: Withdrawal of US ground troops from Vietnam is followed by intensified bombing.

1973
Buys a house in Wivenhoe, Essex, near his friends Dennis Wirth-Miller and Richard Chopping.

8 April: Death of Picasso.

Nov.: Army coup in Greece.

Dec.: UK rising oil prices and industrial unrest force a 'three-day week'

1974
Bacon begins to spend time in Paris, where Michael Peppiatt finds him an apartment at 14 rue de Birague, near the Place de Vosges. July: Bacon visits the Musée Goya in Castres.

Aug.: US President Nixon resigns after Watergate Scandal.

1975
March: Bacon travels to New York for his exhibition of recent paintings at The Metropolitan Museum of Art; while there he meets Andy Warhol and Robert Rauschenberg.

Sylvester publishes *Interviews with Francis Bacon*, which is subsequently published in several revised editions and comes to stand as an uncommonly frank record of creativity. Sept.: Civil War breaks out in Lebanon.

The Junta *[by Goya, in Castres] is a very special painting because the figures seem to have been woven out of the air in such a mysterious way, as though the air actually entered into the being of each image of each person.*[49]

The grotesque, even sadistic, content of Bacon's art, realized through the masterful application of paint, lies at the heart of his aesthetic achievement. It is possible to feel excitement at the traditional bravura of the paint handling, and horror at the rawness of the subject.[50]
HENRY GELDZAHLER, 1975

Nov.: In Spain, following the death of General Franco, King Juan Carlos takes power.

1976
During the year, Bacon meets John Edwards.

1977
Jan.: Bacon exhibition at Galerie Claude Bernard, Paris, has introduction by Leiris.

1978
Exhibitions in Mexico (end 1977), Caracas (February), Madrid at Fundacion Juan March, and Barcelona (Fundació Joan Miró). Declines the Max Beckman prize.

1979
Jan.: Revolution in Iran sees Ayatollah Khomeini take power from the Shah.

May: Margaret Thatcher becomes British Prime Minister.

Sept.: Pope visits Ireland.

Oct.: Muriel Belcher dies.

1980
Sonia Orwell dies.

April: Rhodesia, the last British colony in Africa, gains independence as Zimbabwe.

Sept.: Iran–Iraq War begins; lasting until 1988.

fig.135 John Edwards seated in an interior, c.1980 (Francis Bacon)
Dublin City Gallery The Hugh Lane

1981
Bacon's sister Winifred dies in March.

Gilles Deleuze publishes *Francis Bacon: Logique de la sensation* and Leiris publishes 'Bacon, le hors-la-loi' (*Critique*, May).

April: Rioting in Brixton, a predominantly black area of London, is followed later in the summer by similar unrest in other cities.

Oct.: Egyptian President Sadat is assassinated.

Nov.: Bacon writes a personal tribute when the literary review *L'Ire des vents* is devoted to Leiris.

1982
April: Britain sends forces to recapture Falkland Islands following Argentinian invasion.

William Burroughs visits Bacon in London.

1983
Bacon's first exhibition in Japan, at the National Museum of Modern Art in Tokyo, and then Kyoto and Nagoya. Michel Leiris publishes his book *Francis Bacon, face et profil*.

1984
Miners' Strike causes disruption, civil violence and social division in affected areas.

Jan.: Bacon's exhibition at Galerie Maeght-Lelong, Paris, is accompanied by an issue of *Répères*, introduced by Jacques Dupin. Bacon gives up his Parisian apartment later that year.

May: He travels to New York for his exhibition at the Marlborough Gallery.

12 Oct.: IRA try to assassinate British government in Brighton hotel bombing.

1985
March: Leadership of Mikhail Gorbachev in USSR will lead to liberalisation of policy.

May: Second major Tate retrospective.

fig.136 Francis Bacon, Tate Gallery, 1985 (David Clarke)

I know it's quite a privilege that the greatest writer of our time has written texts about me.[51]

I like your idea of defining realism rather than writing a text exclusively devoted to my painting. For me realism is an attempt to capture the appearance with the cluster of sensations that the appearance arouses in me …I could not paint Agamemnon (etc) as that would have been an historical painting, therefore I tried to create an image of the effect that was produced inside me. Perhaps realism is always subjective when it is most profoundly expressed … we are rightly forced to invent methods by which reality can force itself upon our nervous system in a new way without losing sight of the model's objectivity.[52]
BACON TO LEIRIS, 1981

[Bacon's paintings] help us, most powerfully, to feel the sheer fact of existence as it is sensed by a man without illusions.[53]
MICHEL LEIRIS, 1983

Oct.: Bacon makes selection of National Gallery works for *The Artist's Eye* exhibition including Masaccio, Michelangelo, Rembrandt, Velázquez, Goya, Ingres, Turner, Manet, Degas, Cézanne, Seurat and van Gogh.

1986
Feb.: As his Tate retrospective travels from Stuttgart to the Neue Nationalgalerie, Berlin, Bacon returns to Berlin for the first time since the 1930s.

31 Aug.: Death of Henry Moore.

1988
Retrospective in Moscow is Bacon's first behind the Iron Curtain.

1989
Feb.: Diana Watson, Bacon's cousin and early collector, dies; at eighty, Bacon is slow to recover from a kidney operation.

Oct.: Major Bacon retrospective opens at the Hirshhorn Museum and Sculpture Garden, Smithsonian Institute, Washington, D.C., before travelling, in 1990, to Los Angeles County Museum of Art and The Museum of Modern Art, New York.

Oct.: Hungary becomes the first Warsaw Pact country to declare a new regime independent of USSR and, the following month, the Berlin Wall is pulled down.

The violent pulling together of man/beast in such a way that the traditional distinction between them is brought into question was part of Bataille's continual attack on the 'idealist deception' that man practices upon himself. In this case it involves the revelation of the animal or near-animal in man in those situations above all when he believes himself to be at his most human or noble. A comparable idea could be at work in Bacon.[54]
DAWN ADES, 1985

In my youth it seems to me that I was strongly directed towards painting after having been struck by the remarkable visual imagery of the films of Eisenstein: Strike *and* Battleship Potemkin.[55]

In a way, it becomes more difficult [to paint]. You're more conscious of the fact that nine-tenths of everything is inessential. What is called 'reality' becomes so much more acute. The few things that matter become so much more concentrated and can be summed up with so much less.[56]

1990
11 Feb.: After twenty-seven years in prison, ANC leader Nelson Mandela is released as a sign of the end of apartheid in South Africa.

Bacon travels to Madrid to see a Velázquez exhibition at the Prado, and to Colmar, Alsace, to see Grünewald's Isenheim Altarpiece.

Sept.: Michel Leiris dies.

1991
Jan.: in response to Iraq's invasion of Kuwait, USA launches war against Iraq.

He gives *Second Version of Triptych 1944* of 1988 (pp.248–9) to the Tate Gallery, as a substitute for the fragile *Three Studies for Figures at the Base of a Crucifixion* 1944.

From October Bacon conducts a number of recorded conversations with Michel Archimbaud.

1992
Jan.: Dismantling of federal state of Yugoslavia, which will lead to a series of Balkan conflicts.

Jan.: Isabel Rawsthorne dies.

April: Bacon goes to Madrid, against the advice of his doctor, to visit José Capello. Taken to hospital with pneumonia aggravated by asthma, he dies of a heart attack on 28 April.

It's only because I've been the first to admit to using photographs that people think I have used it a lot. But when I say that to me photographs are merely records, I mean that I don't use them at all as a model … A photograph, basically, is a means of illustrating something and illustration doesn't interest me.[57]

At the Saatchi collection there is a very interesting installation by a young man called Damien Hirst called 'a Thousand Years'. It is of a cow's head in one compartment and in the second part they breed the flies which swarm around the cow's head it really works.[58]

SELECTED READING

Selected publications on Francis Bacon are listed chronologically. Short titles are given in bold in square brackets for those publications cited most frequently in the texts.

Robert Melville, 'Francis Bacon', *Horizon*, vol.20, nos.120–1, Dec. 1949–Jan. 1950

Francis Bacon, exh. cat., Institute of Contemporary Arts, London, 1955

Francis Bacon, exh. cat., Tate Gallery, London, 1962

Francis Bacon, exh. cat., Solomon R. Guggenheim Museum, New York, 1963; Art Institute of Chicago, 1964

Robert Melville, 'Francis Bacon', *Studio*, vol.168, no.855, July 1964

Michael Peppiatt, 'From a Conversation with Francis Bacon', *Cambridge Opinion, Special Issue: Modern Art in Britain*, no.37, Jan. 1964

John Rothenstein and Ronald Alley, *Francis Bacon: Catalogue Raisonné and Documentation*, London 1964 [Rothenstein and Alley 1964]

John Russell, *Francis Bacon*, London 1964

Francis Bacon: Rétrospective, exh. cat., Galeries nationales du Grand Palais, Paris 1971, Städtische Kunsthalle, Düsseldorf, 1972

John Russell, *Francis Bacon*, London, Paris and Berlin 1971, 3rd ed. London and New York 1993 [Russell 1993]

Henry Geldzahler (ed.), *Francis Bacon: Recent Paintings 1968–1974*, exh. cat., The Metropolitan Museum of Art, New York, 1975

David Sylvester, *Interviews with Francis Bacon*, London 1975, enlarged 1980, revised (as *The Brutality of Fact: Interviews with Francis Bacon*) 1990, 4th ed. as *Interviews with Francis Bacon*, 1993 [Sylvester 1993]

Lorenza Trucchi, *Francis Bacon*, Milan 1975, London and New York 1976

Francis Bacon, exh. cat. Fundacion Juan March, Madrid; Fundació Joan Miró, Barcelona 1978

Gilles Deleuze, *Francis Bacon: Logique de la sensation*, Paris 1981, trans. Daniel W. Smith, as *Francis Bacon: The Logic of Sensation*, London and New York 2003

Michel Leiris, *Francis Bacon, face et profil*, Paris, Munich and Milan 1983, trans. John Weightman as *Francis Bacon: Full Face and in Profile*, Oxford 1983

Dawn Ades and Andrew Forge, *Francis Bacon*, exh. cat., Tate Gallery, London 1985; Staatsgalerie, Stuttgart 1985–6; Neue Nationalgalerie, Berlin, 1986 [Tate 1985]

Hugh Davies and Sally Yard, *Francis Bacon*, New York 1986

Francis Bacon, exh. cat., Hirshhorn Museum and Sculpture Garden, Smithsonian Institute, Washington D.C., 1989

Corps crucifiés, exh. cat., Musée Picasso, Paris, 1992

Ernst van Alphen, *Francis Bacon and the Loss of Self*, London 1992

Michel Archimbaud, *Francis Bacon: In Conversation with Michel Archimbaud* (Paris 1992) trans. London 1993 [Archimbaud 1993]

Achille Bonito Oliva (ed.), *Figurabile: Francis Bacon*, exh. cat., Museo Correr, Venice, 1993

Daniel Farson, *The Gilded Gutter Life of Francis Bacon*, London 1993

Andrew Sinclair, *Francis Bacon: His Life and Violent Times*, London 1993

Michael Peppiatt, *Francis Bacon: Anatomy of an Enigma*, London 1996 [Peppiatt 1996]

Francis Bacon, exh. cat., Musée national d'art moderne, Centre Georges Pompidou, Paris 1996; Haus der Kunst, Munich, 1996–7

Wieland Schmied, *Francis Bacon: Commitment and Conflict*, Munich and New York 1996 and 2006

David Sylvester, *Francis Bacon: The Human Body*, exh. cat., Hayward Gallery, London, 1998

Dennis Farr, *Francis Bacon: A Retrospective*, exh. cat., Yale Center for British Art, New Haven, 1999

Matthew Gale, *Francis Bacon: Working on Paper*, exh. cat., Tate Gallery, London, 1999 [Tate 1999]

David Sylvester, *Looking Back at Francis Bacon*, London 2000 [Sylvester 2000]

David Sylvester, *Francis Bacon in Dublin*, exh. cat. Hugh Lane Municipal Gallery of Modern Art, Dublin, 2000

Andre Brighton, *Francis Bacon*, London 2001

Hugh Davies, *Francis Bacon: The Papal Portraits of 1953*, exh. cat., Museum of Contemporary Art, San Diego, 2001

Barbara Dawson and Margarita Cappock, *Francis Bacon's Studio at the Hugh Lane*, exh. cat., Hugh Lane Municipal Gallery of Modern Art, Dublin, 2001

Van Gogh by Bacon, exh. cat. Fondation Vincent Van Gogh, Arles, 2002

Hugh M. Davies, *Francis Bacon: The Papal Portraits of 1953*, exh. cat., Museum of Contemporary Art, San Diego, 2002

Francis Bacon: Caged – Uncaged, Fundaçao de Serralves, Porto, 2003

Barbara Steffen (ed.), *Francis Bacon and the Tradition of Art*, exh. cat., Kunsthistorisches Museum, Vienna, 2003; Fondation Beyeler, Riehen/ Basel, 2004

Michael Peppiatt, *Lo sagrado y lo profano*, exh. cat., IVAM, Valencia; Musée Maillol, Paris, 2004

Francis Bacon: Portraits and Heads, exh. cat., National Galleries of Scotland, Edinburgh, 2005

Anne Baldassari, *Bacon Picasso: The Life of Images*, Paris 2005

Margarita Cappock, *Francis Bacon's Studio*, London 2005 [Cappock 2005]

Martin Harrison, *In Camera – Francis Bacon: Photography, Film and the Practice of Painting*, London 2005 [Harrison 2005]

Martin Hammer, *Bacon and Sutherland*, New Haven and London 2005 [Hammer 2005]

Michael Peppiatt, *Francis Bacon in the 1950s*, exh. cat., Sainsbury Centre for Visual Arts, University of East Anglia, Norwich, 2006; Milwaukee Art Museum, Wisconsin and Albright-Knox Art Gallery, Buffalo 2007 [Sainsbury Centre 2006]

Armin Zweite (ed.), *Francis Bacon; The Violence of the Real*, exh. cat., K20 Kunstsammlung Nordrhein-Westfalen, Düsseldorf, 2006

NOTES

An abbreviated title has been given for the major publications on Bacon. Please see Selected Reading for full details. ICA refers to the Institute of Contemporary Arts, London; MoMA to The Museum of Modern Art, New York; NMGW to the National Museum and Gallery of Wales, Cardiff; TGA to Tate Gallery Archive; UCL to University College Library, London.

ON THE MARGIN OF THE IMPOSSIBLE
Matthew Gale and Chris Stephens

1 T.S. Eliot, *The Family Reunion*, 1939, p.34.
2 Russell 1993, p.28.
3 Quoted in Roger Berthoud, *Graham Sutherland: A Biography*, London 1982, p.130, cited in Hammer 2005, p.30.
4 William Redgrave's journal, vol.8, p.66, 27 Sept. 1959, private collection.
5 Paul Brass, Bacon's doctor and lifelong friend, has recalled (in conversation) the artist saying everyone would forget him once he was dead.
6 Russell 1993, p.24. *Three Studies for Figures at the Base of a Crucifixion* (pp.146–7) and *Figure in a Landscape* (p.97) were shown in *Recent Paintings by Francis Bacon, Frances Hodgkins, Henry Moore, Matthew Smith, Graham Sutherland*, Lefevre Gallery, London, April 1945.
7 Lewis, 'Round the Galleries: Francis Bacon', *The Listener*, 17 Nov. 1949, republished in Walter Michel and C.J. Fox (eds.), *Wyndham Lewis on Art: Collected Writings 1913–1956*, London 1969, p.394.
8 The 'School of London' was a term coined by R.B. Kitaj in the touring exhibition *The Human Clay: An Exhibition Selected by R.B. Kitaj*, Arts Council of Great Britain, London 1976, and has generally come to be seen as including Bacon, Lucian Freud, Frank Auerbach, Leon Kossoff and Michael Andrews, as well as Kitaj himself.
9 Bowness (the Director of the Tate at the time), 'Preface', in Tate 1985, p.7.
10 Lyotard, *Discours/Figure*, Paris 1971; see also Gilles Deleuze, *Francis Bacon: The Logic of Sensation*, trans. Daniel W. Smith, London and New York 2003, p.2.
11 See Gary Tinterow's 'Bacon and his Critics', in this volume, pp.33–5.
12 MoMA acquired *Painting 1946* in 1948; the Tate Gallery acquired its first Bacon, *Figure in a Landscape* 1945, in 1950. Barr had published his famous chart in *Cubism and Abstract Art*, exh. cat., MoMA, New York, 1936.
13 This marginalisation continues, especially in American narratives, notably in Yve-Alain Bois, Benjamin

Buchloh, Hal Foster and Rosalind E. Krauss, *Art Since 1900: Modernism, Antimodernism, Postmodernism*, New York and London 2004; more surprising, perhaps, is Bacon's omission from the study of Georges Bataille's influence in Yve-Alain Bois and Rosalind E. Krauss, *Formless: A User's Guide*, New York 1997.
14 For example, Andrew Carnduff Ritchie (ed.), *The New Decade: 22 European Painters and Sculptors*, exh. cat., MoMA, New York, 1955, and Peter Selz, *New Images of Man*, exh. cat., The Metropolitan Museum of Art, New York, 1959.
15 See Bernard Ceysson, Michel Ragon et al., *L'Art en Europe: Les années décisives 1945–53*, exh. cat., Musée d'art moderne de Saint-Etienne, 1987.
16 Marcel Brion, Will Grohmann, Sam Hunter, Herbert Read et al., *Art Since 1945*, New York 1958.
17 For example, Stephen Polcari, *Abstract Expressionism and the Modern Experience*, Cambridge 1991, and, especially, Michael Leja, *Reframing Abstract Expressionism: Subjectivity and Painting in the 1940s*, New Haven and London 1993. The latter's theory of the 'modern man discourse' is cited by David Mellor in this volume, p.55.
18 Farson, London 1993; for Soho see, for example, Julian MacLaren Ross, *Memoirs of the Forties*, London 1965; Daniel Farson, *Soho in the Fifties*, London 1987; and Jonathan Fryer, *Soho in the Fifties and Sixties* (1998), London 2002.
19 Hunter, 'Francis Bacon: The Anatomy of Horror', *Magazine of Art*, New York, vol.95, no.1, Jan. 1952, pp.13–14; see also 'Animal' in this volume, pp.91–2.
20 *Horizon*, no.65, vol.11, May 1945; the 'flight to the continent' as noted by David Mellor, in *A Paradise Lost: The Neo-Romantic Imagination in Britain, 1935–55*, exh. cat., Barbican Art Gallery, London 1987, p.13.
21 The return trip is explored in his letter to Erica Brausen, 22 Feb. 1951, Hanover Gallery Papers, TGA 863. He kept a map of the Nile on his wall; see Cecil Beaton's photograph of Overstrand Mansions in Battersea, in Tate 1999, p.12. In 1960, he claimed to have visited Africa 'about 20 times' and to have travelled 'from one end to the other'; Robert Melville, answer to a questionnaire from James Thrall Soby, 21 Jan. 1960, Robert Melville Papers, TGA 948.
22 Bacon to Sutherland, fragmentary letter [1946?], Graham Sutherland Papers, NMGW, published in Hammer 2005, p.235.
23 Bacon to Sutherland, 30 Dec. [1946], Graham Sutherland Papers, NMGW,

published in Hammer 2005, pp.238–9; this may have been mischievous exaggeration.
24 Bacon to Brausen, 13 Dec. [1954], Hanover Gallery Papers, TGA 863; published in Sainsbury Centre 2006, p.146; financial necessity may have fuelled this impression.
25 Bacon to Daniel Farson, 6 Sept. [1956?], cited in Farson 1993, p.144.
26 Bacon to Brausen, 8 June 1958, Hanover Gallery Papers, TGA 863.6, in Sainsbury Centre 2006, p.150.
27 He was reported to have a retainer of £3,000 per annum from Marlborough.
28 Redgrave Journals, vol.8, pp.98, 119, 11 Dec. 1959 and 5 Jan. 1960.
29 See Rothenstein and Alley 1964; for the St Ives trip see also Ben Tufnell, *Francis Bacon in St Ives: Experiment and Transition 1957–62*, exh. cat., Tate St Ives, 2007.
30 Paul Tillich, 'A Prefatory Note', in *New Images of Man* 1959, p.10. For the relationship between the two painters see Hammer 2005.
31 Bacon, 'statement', in *Matthew Smith: Paintings from 1909 to 1952*, exh. cat., Tate Gallery, London, 1953, p.12.
32 Bacon, Oct. 1962, in Sylvester 1993, p.18.
33 'The End of the Streamlined Era', *The Times*, 2 Aug. 1955, republished in David Sylvester, *About Modern Art: Critical Essays 1948–2000*, London 1996, 2002 ed., pp.49–52.
34 See especially Dawn Ades, 'A Web of Images', in Tate 1985.
35 Bacon, 'from an interview with *Time*, 1952', extracted in *The New Decade* 1955, p.60.
36 Apart from the room in the apartment of Peter Pollock and Paul Danquah at 9 Overstrand Mansions, Prince of Wales Drive, Battersea, all of Bacon's studios were in South Kensington or Chelsea.
37 See Barbara Dawson and Margarita Cappock, *Francis Bacon's Studio at the Hugh Lane*, exh. cat., Hugh Lane Municipal Gallery of Modern Art, Dublin 2001; and Cappock 2005.
38 *Study after Velázquez 1950* (p.112), first returned at the exhibition *Francis Bacon: Important Paintings from the Estate*, Tony Shafrazi Gallery, New York 1998; see Sylvester 2000, p.44.
39 As well as the works on paper and related material acquired by the Tate in 1998 (catalogued in Tate 1999), and the material collected by his confidante at Marlborough, Valerie Beston, some of which is now held by the artist's estate (additional material being catalogued in the sale of her collection of the late Miss Valerie Beston: Artists from the London

School, Christie's, London, 8 and 10 Feb. 2006), other material has continued to emerge and attract controversy. The Barry Joule Archive of material from the studio of Francis Bacon (the subject of two exhibitions: *The Barry Joule Archive; Works on Paper attributed to Francis Bacon*, Irish Museum of Modern Art, Dublin, 2000, and *Bacon's Eye*, Barbican Art Gallery, London 2001) was donated to the Tate Archive in 2004; it has been made available for detailed investigation. Other caches of material have recently been dispersed at auction (Ewbank Fine Art Auctioneers, Woking, 24 April 2007).
40 Cappock 2005.
41 Harrison 2005, pp.30, 36.
42 See Rothenstein and Alley 1964, p.36; for the context of these works see 'Crucifixion' in this volume, pp.137–9.
43 Bacon, May 1966, in Sylvester 1993, p.30. Muybridge's key works, *Animal Locomotion* (Philadelphia 1887), *Animals in Motion* (London 1899) and *The Human Figure in Motion* (London 1901) were repeatedly reissued, and Bacon (supposedly introduced to them at the Victoria and Albert Museum Library by Denis Wirth-Miller) had multiple copies.
44 Wieland Schmied, *Francis Bacon: Commitment and Conflict*, Munich, Berlin, London and New York 2006, p.57
45 Bacon, Sept. 1974, in Sylvester 1993, p.114.
46 Ibid.
47 The list of painters manipulating photographs was already long, from Edgar Degas, Pierre Bonnard and Walter Sickert to Pablo Picasso, Richard Hamilton and Eduardo Paolozzi.
48 Roland Barthes, *Camera Lucida: Reflections on Photography*, trans. Richard Howard, New York 1981 and London 1982, p.115.
49 Bacon, April 1975, in Sylvester 1993, p.133.
50 In May 1966 (Sylvester 1993, p.32), Bacon cited K.C. Clark's *Positioning in Radiography* (1939), for which see also Harrison 2005, p.10. There are also morgue photographs and other shots of dead bodies in his archive that illustrate the prone solidity of the body.
51 Weegee, *Naked City*, New York 1945.
52 Russell 1993, p.55.
53 Davies, 'Bacon Material', unpublished typescript, spring 1973, private collection.
54 Bacon to Orwell, 13 Dec. 1954, Orwell Papers, UCL (punctuation added). Leo Longanesi, *Il Mondo cambia*, Milan 1949.
55 Bacon to Orwell, 13 Dec. 1954, UCL.
56 Melville, 'Francis Bacon', *Horizon*, vol.20, nos.120–1, Dec. 1949–Jan. 1950, pp.419–23.

57 See 'Animal' in this volume, pp.91–2.
58 Sylvester, 'Some Notes on the Paintings of Francis Bacon', exh. cat., Galerie Rive Droite, Paris, Feb. 1957; earlier texts included 'Francis Bacon', *Britain Today*, no.214, Feb. 1954, pp.23–6; 'Francis Bacon', in *Francis Bacon, Ben Nicholson, Lucian Freud*, British Pavilion, Venice Biennale, June 1954. Most unusually, Muybridge's albums of photographs were displayed within Bacon's 1962 retrospective at the Tate Gallery.
59 John Russell in Bryan Robertson, Russell and Lord Snowdon, *Private View: The Lively World of British Art*, London 1965, p.65.
60 As well as Sylvester 1993 and Archimbaud 1993, Bacon's published interviews (many of which are listed in Schmied 2006, p.176) include dialogues with *Time Magazine* (1952, extracted in *The New Decade* 1955, p.60); Daniel Farson (television interview, 27 Aug. 1958, published in Farson 1993, pp.105–7); Michael Peppiatt ('From a Conversation with Francis Bacon', *Cambridge Opinion*, Jan. 1964); Marguerite Duras ('Marguerite Duras s'entretient avec Bacon', *Arts, La Quinzaine littéraire*, 16 Nov. 1971); Peter Beard ('Remarks from an Interview with Peter Beard', in *Francis Bacon: Recent Paintings 1968-1974*, exh. cat., The Metropolitan Museum of Art, New York 1975); Michael Peppiatt ('Francis Bacon: Reality Conveyed by a Lie', *Art International*, autumn 1987); Jean Clair ('Pathos and Death: Interview with Francis Bacon with Jean Clair', in *Corps crucifiés*, exh. cat., Musée Picasso, Paris 1992); and Richard Cork ('Interview with Francis Bacon', in *Francis Bacon: Paintings 1981-1991*, exh. cat., Galería Marlborough, Madrid, and Marlborough Inc., New York, 1992).
61 The works on paper acquired by the Tate Gallery were discussed in Tate 1999.
62 Bacon to Leiris, 3 Apr. 1976, Bibliothèque Littéraire Jacques Doucet, published in *Francis Bacon: Triptychs*, exh. cat., Gagosian Gallery, London 2006, p.23.
63 Bacon claimed, in 1962, that *Painting 1946* 'came to me as an accident' (Bacon, Oct. 1962, in Sylvester 1993, p.11), but his emphasis on chance seems of that moment ('the way I work is totally, now, accidental', ibid. p.18). This had particular currency in the light of Abstract Expressionism, notably the idea of painting as an 'arena in which to act' emphasised in Harold Rosenberg, 'The American Action Painters', *Art News*, vol.51, no.8, Dec. 1952, republished in Rosenberg, *The Tradition of the New* (New York 1959), London 1962, p.25.

64 Bacon, Oct. 1962, in Sylvester 1993, pp.21–2.
65 List, 9 Jan. 1959, on front flyleaf of V.J. Staněk, *Introducing Monkeys*, London c.1957, TGA; transcribed in Tate 1999, p.77. For the source of *Study for Crouching Nude* see Martin Harrison, 'Bacon's Paintings' in this volume, p.49, as well as 'Zone', p.110.
66 This may reflect Bacon's interest in the spontaneity of photo-booth images, which the Surrealists had also used in the collective photographs that surround René Magritte's painting *je ne vois pas la [femme] cachée dans la forêt* in *La Révolution surréaliste*, no.12, 15 Dec. 1929, p.73.
67 Deleuze, *Francis Bacon: The Logic of Sensation* (1981), trans. Daniel W. Smith, London and New York 2003, pp.1–7.
68 Martin Harrison's research has shown how this evolved from manipulations of the source photographs; see Harrison, 'Francis Bacon: Extreme Points of Realism', in Armin Zweite (ed.), *Francis Bacon: The Violence of the Real*, exh. cat., K20 Kunstsammlung Nordrhein-Westfalen, Düsseldorf 2006, p.49.
69 See 'Memorial' in this volume, pp.201–5.
70 Hugh Davies recorded that this was a practice Bacon was not keen to acknowledge; Davies 1973, p.16.
71 Since his death a number of clearly abandoned canvases have emerged, as have numerous examples of canvases from which he had cut the central motif, leaving just a stretcher and the attached periphery; several friends have attested to this practice and to the fact that Bacon would ask others to enact it.
72 Bacon, Oct. 1962, in Sylvester 1993, p.18.
73 Davies 1973.
74 Sylvester 1971–3, in Sylvester 1993, p.96.
75 Bacon, Oct. 1962, in ibid. p.22.
76 Bacon, May 1966, in ibid. p.66.
77 Bacon, Oct. 1962, in ibid. p.28.
78 Bacon, May 1966, in ibid. p.56.
79 Bacon, Oct. 1962, in ibid. p.18.
80 Bacon, 'statement', in Tate 1953, p.12.
81 Bacon, Oct. 1962, in Sylvester 1993, p.12.
82 Bacon, May 1966, in ibid. p.43.
83 See in particular Rolf Læssøe, 'Francis Bacon and T.S. Eliot', *Hafnia Copenhagen Papers in the History of Art*, no.9, 1983, pp.116–17. Eliot's strategies of appropriation may also have provided a model for Bacon on a formal level, as he transformed and recontextualised quotations and references into cohesive, though not conventionally coherent, wholes.
84 Most quotations were given in Greek

in W.B. Stanford's *Aeschylus in his Style: A Study in Language and Personality*, Dublin 1942. Bacon's use of the phrase is discussed by Ades in Tate 1985, pp.19–20, and Peppiatt 1996, p.91; Hammer 2005, p.102, notes Sutherland owning the book and admiring the same phrase, as reported in Robert Melville, 'Graham Sutherland', *World Review*, Feb. 1952.
85 T.S. Eliot, *The Family Reunion*, London 1939.
86 Bacon, 1982–4, in Sylvester 1993, p.176.
87 Bacon, Oct. 1962, in Sylvester 1993, p.28.
88 Bacon, July 1973, in Sylvester 1993, p.80; and April/June 1975, ibid. p.133.
89 This conceit is first published by Bacon in his statement in *The New Decade* 1955, p.63, but is cited by Hunter 1952, p.13, indicating that Bacon used it at least as early as 1950.
90 Gilles Deleuze, 'Re-presentation of Masoch', in *Critique et Clinique*, Paris 1993, trans. as *Essays Critical and Clinical*, trans. Daniel W. Smith and Michael A. Greco, London and New York 1998, p.54.
91 Sylvester 1993, p.192. In fact, no dust has been found in that work, though it is especially evident in the 1950 *Fragment of a Crucifixion* (fig.59).
92 Eliot, 'The Burial of the Dead', in *The Waste Land* (1922), lines 27–30.

BACON AND HIS CRITICS
Gary Tinterow, assisted by Ian Alteveer

1 Peter Lennon, 'A Brush with Ebullient Despair', *The Times*, 15 Sept. 1983, p.8.
2 Bacon, Oct. 1962, in Sylvester 1993, p.20.
3 Russell, 'Art View: Time Vindicates Francis Bacon's Searing Vision', *The New York Times*, 9 June 1985, p.A31.
4 Ibid.
5 Bacon, 1971–3, in Sylvester 1993, p.83.
6 David Plante, 'Bacon's Instinct', *The New Yorker*, 1 Nov. 1993, p.96.
7 Bacon, filmed interview with Melvyn Bragg, *The South Bank Show*, London Weekend Television, 1985.
8 Ibid.
9 Quoted by Gopnik, 'The Art World: Optimist', *The New Yorker*, 26 Feb. 1990, p.125.
10 Plante 1993, p.93. Bacon ultimately admitted the obvious in his 1975 interview with Sylvester: 'I think in our previous discussions, when we've talked about the possibility of making appearance out of something which is not illustration, I've over-talked about it. Because, in spite of theoretically longing for the image to be made of irrational marks, inevitably, illustration has to come into it.' Sylvester 1993, p.126.

11 Bacon, in Bragg 1985.
12 Bacon, Oct. 1962, in Sylvester 1993. In his interviews with Sylvester, Bacon specifically denied any reference to the Eichmann trial: his cages or spaceframes were to him simply a means of focusing attention in his image.
13 Gopnik 1990, p.125.
14 Quoted by Hugh M. Davies in 'Bacon's Black Triptychs', *Art in America*, March–April 1975, p.64.
15 *Painting 1946* (p.101) was purchased by Barr from Erica Brausen for £240. See correspondence from MoMA to Brausen, Nov. 18, 1948, TGA 863.6.3. Soby's book was also published by MoMA: James Thrall Soby, *Contemporary Painters*, New York 1948. Soby, a collector, writer and interim Chairman of the Department of Painting and Sculpture at MoMA from 1947–57, was also the author of three early and prescient reviews of Bacon's work for the *Saturday Review*: 'Mr Francis Bacon', vol.36, 7 Nov. 1953, pp.46–7 (republished in Soby, *Modern Art and the New Past*, Norman, OK, 1957, pp.126–30); 'Reg Butler and Francis Bacon', vol.38, no.19, 7 May 1955, pp.60–2; and 'English Contemporary Art', vol.39, no.40, 6 Oct. 1956, pp.43–4.
16 The first appears in 'Contemporary Sculpture: Anthony Caro', *Arts Yearbook* 8, 1965; republished in *Clement Greenberg: The Collected Essays and Criticism*, vol. 4, Chicago 1993, pp.277–82. Greenberg calls up, in parentheses (p.207), the 'grand, sublime manner [that] has been a peculiarly English aspiration since the eighteenth century. Henry Moore and Francis Bacon are possessed by it in their separate ways just as much as Haydon, John Martin and even Turner were in theirs.'

The second mention is in an interview with Edward Lucie-Smith published in *Studio International* (Jan. 1968; republished Greenberg 1993). Greenberg finds Henry Moore a 'minor artist' and, in relation to Bacon, states: 'Their work has presence – a treacherous quality because it is so evanescent … it meets your expectation of what "big" modern art should look like. Tony Smith's sculpture does the same thing – and Smith's success is the fastest big success I've yet witnessed on the American art scene. Which is ominous. There are similar reasons for the speed of Bacon's success.' Later he continues: 'Some day, if I live long enough, I'll look back on Bacon's art as a precious curiosity of our period.'

The last mention is in a description of Greenberg's visit to Ireland from *Artforum* (April 1968; republished in

Greenberg 1993, pp.282–8), in which he describes an exhibition he saw at the Royal Dublin Society named *Rosc* ('poetry of vision' in Gaelic). *Rosc* contained two Bacon paintings from 1967, which, Greenberg describes, 'had the impact of "big" art, and on my first walk through the show they came forward in a way that put most things around them in the shade. But they somehow began to wilt when directly contemplated. The discrepancy between impact and substance in Bacon does not altogether compromise his art – at least not yet – but it does make him something less than the major artist *he* presents himself as being.'

17 Rosenberg, 'The Aesthetics of Mutilation', *The New Yorker*, 12 May 1975, pp.122–6.

18 Richard Shone quoted by François Jonquet, 'Francis Bacon à nouveau', *Art Press*, March 2007, p.65.

19 Plante 1993, p.97. 'There was a need in Bacon for what he called "real tragedy".'

20 Ibid. See also Nochlin, 'Francis Bacon: Centre Pompidou', *Artforum*, Oct. 1996, pp.109–10.

21 James King, *The Last Modern: A Life of Herbert Read*, London 1990, p.126; John Richardson, *The Sorcerer's Apprentice*, New York 1999, p.14. In the acknowledgements to the first edition of *Art Now: An Introduction to the Theory of Modern Painting and Sculpture*, London 1933, Read thanked Cooper for assembling the reproductions.

22 'Mr Francis Bacon', *The Times*, no.46680, 16 Feb. 1934, p.9. In this review of the show at Transition Gallery, Sunderland House, Curzon Street, the anonymous author adds: 'Does it, as a matter of cold fact, require a high degree of artistic talent to give the impression of a wound in pigment?' Later writers cited reviews like this as being so profoundly discouraging to Bacon that he barely exhibited again until the 1945 (see Arturo Bovi, 'Francis Bacon: Il sublime demoniaco come degradazione e caduta dell'umanità', *Capitolium*, vol. 50, no.1, Jan. 1975, pp.33–40.

23 'Bacon … est l'héritier de quelques aspects de l'expressionnisme – tel que l'écorché de Soutine – et de la période surréaliste de Picasso … C'est la faiblesse – sa vision le possède, il ne la possède pas – mais il est un des peintres actuels les plus dramatiques et les plus puissants' (my translation). Sylvester, 'Les problèmes du peintre', *L'Age nouveau*, no.31, 1948, pp.107–10. Sylvester mentions that Bacon seems to evoke Grünewald, 'who seems possessed by the germanic temperament of

epileptic delirium' ('dont la germanique humeur de délire épileptique semble le posséder'; my translation).

24 'Mr Francis Bacon', *The Times*, 22 Nov. 1949, p.7.

25 Robert Melville, 'Francis Bacon', *Horizon*, vol. 20, nos.120–1, Dec. 1949–Jan. 1950, p.423.

26 Lewis, 'Round The London Galleries', *The Listener*, 17 Nov. 1949, p.860.

27 Russell 1997, p.38.

28 Gowing, 'Francis Bacon', in *Francis Bacon: Paintings 1945–82*, exh. cat., National Museum of Modern Art, Tokyo 1983, p.21.

29 Sylvester, 'Curriculum Vitae', in *About Modern Art: Critical Essays 1948–2000*, London 1996, 2002 ed., p.16.

30 Andrew Brighton, *Francis Bacon*, London 2001, p.49.

31 Hunter, 'Francis Bacon: The Anatomy of Horror', *Magazine of Art*, Jan. 1952, pp.11–15.

32 Ibid.

33 Ofield, 'Cecil Beaton: Designs on Francis Bacon', *Visual Culture in Britain*, vol.7, no.1, 2006, p.25.

34 Cooper, 'Reflections on the Venice Biennale', *Burlington Magazine*, Oct. 1954, pp.316–22.

35 'Mr Francis Bacon's New Paintings', *The Times*, 13 Nov. 1953, p.10.

36 Sylvester 2002, pp.18–19.

37 'The Horrific Vision of Mr Francis Bacon', *The Times*, 24 May 1962, p.7.

38 Brookner, 'London', *Burlington Magazine*, July 1962, p.313.

39 Fried, 'Bacon's Achievement', *Arts Magazine*, Sept. 1962, pp.28–9.

40 Ibid.

41 Bacon, May 1966, in Sylvester 1993, p.58.

42 Fried compared Bacon to de Kooning, too, but with a different result: 'In de Kooning's canvases one feels that the figure is the desired, if only partially achieved, end (and there is in consequence a great sense of struggle that I for one find moving in its own right), while for Bacon the figure is patently what he begins with, a point of departure from which he goes nowhere at all'; Fried 1962, p.28.

43 Alloway, 'Introduction', *Francis Bacon*, exh. cat., Solomon R. Guggenheim Museum, New York 1963, pp.12–13.

44 O'Doherty, 'On the Strange Case of Frances [*sic*] Bacon', *Art Journal*, vol.24, no.3, spring 1965, pp.288–90. The *Art Journal* reprint (from *The New York Times*, 20 Oct. 1963) was published on the occasion that O'Doherty won the Frank Jewett Mather Award for art criticism from the American College Art Association.

45 Works by Bacon had been exhibited

and sold in Chicago and New York by Martha Jackson, Richard Feigen and Knoedler Gallery, but the 1968 Marlborough exhibition provoked Bacon's first trip to New York.

46 Battcock, 'Francis Bacon: First Major N.Y. Gallery Show', *Arts Magazine*, vol.43, no.2, Nov. 1968, pp.46–7.

47 R[aymond] C[ogniat], 'Francis Bacon prend sa place parmi les grands', *Le Figaro*, 8 Oct. 1971, p.30.

48 'C'est plus qu'une exposition réussie. Tout aura concouru à faire de cette rétrospective, en préparation depuis deux ans, un événement marqué du signe de l'exception: la puissance et l'originalité radicale d'un peintre que sa vision et ses procédés situent à contre-courant des orientations panurgiques les plus actuelles, le renouveau qu'il fait surgir d'une interrogation de l'humain et du quotidien et d'un métier classique qu'on aurait pu croire épuisés, la soudaineté de sa révélation longtemps différée en France, sa présentation irréprochable dans les galeries les plus récemment aménagées du Grand Palais' (my translation). Conil Lacoste, 'Francis Bacon: le paradoxe du tragique et du suave', *Le Monde*, 3 Nov. 1971, p.15.

49 Leiris, *Francis Bacon: Full Face and Profile*, trans. John Weightman, New York, 1983 (original French ed. *Francis Bacon: face et profil*, Paris 1983), p.14.

50 Ibid. pp.15–16.

51 Ibid. p.29.

52 Brett, 'Francis Bacon in Paris: Figures in a Room', *The Times*, 27 Oct. 1971, p.17.

53 Brogan, 'Francis Bacon Paintings Boost Britain: French Critics Acclaim a Great Artist whose Works Disturbed and Amazed Paris', *The Times*, no. 58372, 11 Jan. 1972, p.5.

54 Davis, 'Swatches of Bacon', *Newsweek*, 31 March 1975, p.68.

55 Davies, 'Bacon's "Black" Triptychs', *Art in America*, March–April 1975, pp.62–8.

56 Kuspit, 'Francis Bacon: The Authority of Flesh', *Artforum*, vol.13, no.10, summer 1975, pp.50–9. See also Jean-Paul Sartre, *Saint Genet: comédien et martyr*, first published in Paris 1952.

57 Richard Shone, 'David Sylvester (1924–2001), *Burlington Magazine*, Nov. 2001, p.695.

58 Smith, 'Art: Francis Bacon's Show Centers on 80s Triptychs', *The New York Times*, 22 May 1987, p.C19.

59 Ofield 2006, pp.24–5.

60 Ibid.

61 Deleuze, 'Francis Bacon: Logique de la sensation', fragment, *Artforum*, vol.22, Jan. 1984, pp.68–9. The book was first published in French in 1981.

62 On Bacon's proclivity to control the

release of information on his life and practice, see Martin Harrison, 'Francis Bacon: Lost and Found', *Apollo Magazine*, March 2005, p.97.

BACON'S PAINTINGS

Martin Harrison

1 Letter from Fischer to Soby, 3 Jan. 1960, courtesy Marlborough Fine Art, London, archive. I wish to thank Kate Austin, Gilbert Lloyd and Geoffrey Parton for kindly arranging access to the Soby correspondence.

2 J. Rothenstein, *Modern English Painters, Vol.3: Hennell to Hockney*, London 1984, p.155. The Daumier exhibition was held at the Tate Gallery in 1961.

3 Bacon, 1971/3, in Sylvester 1993, p.71.

4 Hugh M. Davies in conversation with the author, 14 Oct. 2006.

5 Sylvester 1993, p.182.

6 Bacon interviewed by Daniel Farson, Associated-Rediffusion Ltd TV, 27 Aug. 1958, quoted in Farson, *The Gilded Gutter Life of Francis Bacon*, London 1993, p.105.

7 Lebensztejn, 'Notes sur Bacon', *Francis Bacon*, exh. cat, Centre Pompidou, Paris 1996, p.43.

8 Sylvester 1993, p.37, for example, where Bacon calls his Popes 'very silly'. Strictly speaking this was not Bacon's final Pope, but the only addition to the 'series', *Study of Red Pope 1962, Second Version* 1971, was painted under the special circumstances of wishing to include the subject in Bacon's retrospective at the Grand Palais, Paris, 1971.

9 The oil sketch for *The Conjuror* 1775 retains the image of Angelica Kauffmann, naked and using an ear-trumpet, which prompted her to protest to the Royal Academy. Hone painted over the offending passage in the finished painting, but despite this it was removed from the Academy's walls. But Hone's real target in this reference to the pejorative connotations of copyism was Reynolds. *Art into Art* was the title of an exhibition organised by the *Burlington Magazine* at Sotheby's, London, in September 1971, which addressed the distinction between copyism and inspiration and the interconnections between the Antique and Renaissance and later art.

10 John Lessore, interviewed by the author, 21 Sept. 2007, recalled Bacon making this comment on the Le Nain while it was on loan to the National Gallery, London.

11 'Tearing the Human Image to Bits – Andrew Forge, Francis Bacon and Michael Levey Talk About Titian', *The Listener*, 6 March 1972, pp.334–5.

12 R. Læssøe, 'Francis Bacon's Crucifixions and Related Themes',

Hafnia, no.2, 1987, pp.7–38.

13 Sylvester 1993, p.23; Sylvester, 'Enter Bacon', *The New York Times,* magazine, 20 Oct. 1963, p.57.

14 Fischer to Soby, 9 May 1962; courtesy Marlborough Fine Art, London, archive.

15 Ibid. 19 July 1962.

16 Ibid. 2 Aug. 1962.

17 Bacon interviewed by Richard Francis, Tate Gallery 1983; sound tape, TGA.

18 J. Richardson, 'Tragedian: Francis Bacon', *New York Review of Books*, 25 March 1965, pp.6–7.

19 Sylvester 1993, p.65.

20 Matthew Gale kindly pointed out Bacon's quotation to me.

21 Sylvester 2000, p.114.

22 Sylvester 1993, p.30.

23 Ibid. p.18.

24 Ibid. p.58.

25 Holograph letter from Francis Bacon, private collection. The first letter quoted here is dated 12 March 1935; the second, though undated, was written earlier in the same year.

26 'Francis Bacon: Letters to Michel Leiris 1966–89', supplement to *Francis Bacon*, exh. cat, Gagosian Gallery, London, 2006, p.23. *Frêle Bruit* was the last of four parts to be published of Leiris's *La Règle du jeu* (1948–76). Long before Bacon, Reynolds had overturned Vasari's reproach of Tintoretto's 'crude' sketches that seemed to have been made by chance, and advised in his 12th Discourse: 'Accident, in the hands of an artist who knows how to take advantage of its hints, will often produce bold and capricious beauties of handling.' Bacon sometimes invoked Surrealist automatism when discussing the accident, and the currency of the aleatory in debates among the Independent Group in the 1950s may also be relevant in this context.

27 Archimbaud 1993, pp.80–4.

28 Tate 1999, p.77.

29 Sylvester 1993, p.37.

30 Richardson 1965.

FILM, FANTASY, HISTORY IN FRANCIS BACON

David Alan Mellor

The author would like to thank the generosity of both Martin Harrison and Barry Joule in making available research material.

1 Original typescript transcription of conversation between Bacon and Sylvester on ITV's *Aquarius*, 1975, Archive of Modern Conflict, London. In subsequent published versions (Sylvester 1993, p.141), this statement is extended.

2 Melville, 'Francis Bacon', *Horizon,* vol.20, nos.120–1, Dec. 1949–Jan. 1950, pp.419–23.

3 Bacon, transcribed conversation, with Barry Joule, summer 1988.

4 Martin Harrison confirmed in a conversation with the author, 8 Dec. 2007, that Bacon was a member of the London Film Society in the 1930s. In the late 1960s, Bacon attended screenings at the National Film Theatre, as a member of the British Film Institute.

5 Russell 1993, p.59. The three directors Russell cites were all inspirational figures for Bacon, and Russell may have been prompted by Bacon to cite them.

6 For example, Roger Manvell, *Film*, 1944; Sergei Eisenstein, *The Film Sense*, 1942; Nicole Vedrès, *Images du Cinéma Français*, Paris 1945. Bacon owned copies of all three (fig.36). The catholic nature of his cinematic interests is plain from books in the Francis Bacon Studio archive, Dublin City Gallery The Hugh Lane. These include Yon Barna, *Eisenstein*, 1973; and John Simon, *Ingmar Bergman Directs*, 1972. He also owned books that explored the para-cinematic, such as Gyorgy Kepes, *Vision in Motion*, 1947, and histories of cinema such as C.W. Ceram, *Archaeology of the Cinema*, London and New York 1965, which includes a photograph of 'the first film studio, the Black Maria, constructed by W.K.L. Dickson in 1894', that Bacon tore out and kept as a 'working document'.

7 Sylvester in conversation with the author, London, Feb. 1993. Alloway finally curated such an exhibition, *Violent America: The Movies, 1946–1964*, MoMA, New York, 1969, with a publication of the same name following in 1971.

8 Ibid. back cover.

9 Alexandrov, who co-wrote the screenplay for *October* with Eisenstein, was described by Ivor Montagu as 'that slim, strong, handsome, fair-haired and golden skinned athlete – an Adonis'; R. Bergan, *Sergei Eisenstein: A Life in Conflict*, New York 1999, p.72.

10 The figure is identified as Bacon himself in Hugh M. Davies and Sally Yard, *Francis Bacon*, London 1986, p.77.

11 'The Greatest War Photographer in the World', *Picture Post*, 3 Dec. 1938, p.13.

12 Bacon in conversation with the author, London, May 1987. Lerski's portrait has been dated to 1929–30 in Harrison 2005, p.24; cf. *Internationaler Ausstellung des Deutschen Werkbunds/Film und Foto*, Stuttgart 1929, p.67, cat. list 450–65. Lerski's address is given as Paulsbornstrasse 11, Berlin-Halensee.

13 *Köpfe des Alltags*, Berlin 1931.

14 Kenneth Macpherson, 'As Is', in D. Mellor (ed.), *Germany: The New Photography, 1927–33*, Arts Council of Great Britain, 1978, p.66.

15 Bacon in conversation with the author, London, May 1987.

16 Bacon, recorded conversation with Barry Joule, 1988. Bacon's identification of himself with the cine-cameraman murderer in *Peeping Tom* carries its own confessional and self-analytical shock.

17 Harrison 2005, pp.204–8.

18 Weltmann's performance is a kind of cinematic projection, an uncanny spectacle within a proscenium arch that reaches into the space of the spectators themselves.

19 Melville 1949–50.

20 Ibid. pp.420–1.

21 Michaux, 'Thinking about the Phenomena of Painting' (1946), in David Ball (ed.), *Darkness Moves: An Henri Michaux Anthology*, Berkeley 1994, pp.311–12.

22 Ludwig Goldscheider and Wilhelm Uhde, *Vincent Van Gogh*, London 1945, pl.69.

23 Russell 1993, p.51.

24 In conversation with Chris Stephens, March 2008.

25 The first reviews appeared around the middle of March, e.g. Isabel Quigly, 'Portrait of the Artist', *Spectator*, 15 March 1957, p.350; Basil Taylor, 'Bacon v. van Gogh', *Spectator*, 5 April 1957, p.443.

26 The phrase 'Poetic Realism' derives from André Bazin, 'Regards Neuf sur le Cinema', trans. J. Matthews, in *Marcel Carné: Le Jour se Lève*, London 1970, p.9. Poetic Realism shared the pessimistic world view of Albert Camus and T.S. Eliot, and related to other factors in Bacon's imagination. Bacon confirmed his admiration for Godard's work, particularly *A Bout de Souffle* (1960); recorded conversation with Barry Joule 1988.

27 Francis Bacon Studio archive, Dublin City Gallery The Hugh Lane, F1 A: 47.

28 Ibid. F105-25.

29 Bazin's discussion of superimposition and dissolve in *Le Jour se Lève* connects with Bacon's use of transparency: 'In general, superimposition is used to convey the imaginary quality of an event or character. It is often employed to represent ghosts'; Bazin 1970, p.5.

30 Harrison 2005, p.122.

31 Leja, *Reframing Abstract Expressionism: Subjectivity and Painting in the 1940s*, London and New Haven 1993, p.323.

32 Ibid.

33 Melville 1949, p.421.

34 Bacon was probably recollecting *Close Up*, vol.10, no.3, which featured these, and no.4, with an article by Upton Sinclair, 'Thunder over Mexico'.

35 Recorded conversation with Barry Joule, summer 1988.

36 Nesbet, *Savage Junctures: Sergei Eisenstein and the Shape of Thinking*, London and New York 2007, p.132.

37 Transcript of Bacon in conversation with Barry Joule, autumn 1988. The director Donald Cammell, who had known Bacon in the late 1950s when he was studying at the Royal College of Art, told David Del Valle, in the late 1980s, that he had shown his art director, John Clark, 'several examples of artists like Aubrey Beardsley and Francis Bacon. We deliberately wanted to reflect an artist's vision'; www.drkm.com/cammell1

38 These resemble John Deakin's photoportraits of Bacon's lover, the petty criminal George Dyer (fig.101). The film had links with actual dramatis personae of gangland London, and Bacon had similar associations with criminals. For an account of this refashioning of contemporary London crime as cinema, see C. McCabe, *Performance*, London 1998, pp.40–3. A more literal filmic conjunction of Bacon's scenography with the world of organised crime in London occurs in John Schlesinger's *Darling* (1965), when a villain-cum-painter, Ralphie Riggs, holds an exhibition of his bloodied paintings in a West End gallery.

39 Bazin 1970, pp.11–12. The 'sludge' and the dentures, along with one or two other fragments, that were recovered from Haigh's acid vats, during the police 'Hunt for the Vampire', as the *Daily Mirror* described it on 3 March 1949, resemble the inchoate human debris in Bacon's *Head I* and especially *Head II* (pp.102, 103), both of which he showed at the Hanover Gallery in November 1949.

40 Bacon indicated his interest in seeing the film again and his wish to meet its director, Michael Powell, in conversation with the author, May 1987.

41 See L. Marks, *Peeping Tom*, London 1998, pp.xxiv–xxvi.

42 In conversation with the author, June 1987.

43 Hans Sachs, 'Modern Witch Trials', in *Close Up*, vol.4, no.5, May 1929, reprinted in J. Donald (ed.), *Close Up 1927–33: Cinema and Modernism*, London 1998, pp.299–301.

44 See Cappock 2005, p.120, fig.209.

45 As in Bacon's anamorphosing, through pleating the paper, of a still from *Hiroshima Mon Amour* (1960); Dublin City Gallery the Hugh Lane RM98F1A:80.

46 Conversation with Barry Joule, June 1984.

47 Cappock 2005, p.186, note dated 'Jan. 4th 1954'.

48 The page is from Jack Bilbo, *Jack Bilbo: An Autobiography*, London 1948, pl.11.

49 The pavement in Bacon's depopulated *Street Scene…* has an unresolved passage of dark-grey smudges, possibly suggesting an erased pool of blood like that in *Blood on the Floor* 1986 and *Blood on Pavement* c.1988 (p.247). This area on the pavement is an abject zone, a mess, recalling the body horror evident in the photograph of political street killing, 'Archives of the Reich' in Franz Roh and Tischold, *foto-auge*, Stuttgart 1929, illus. 73, 'Wurtemburgisches Polizeipraisidium, Stuttgart: Mord im Freiden'.

50 Eisenstein helped Esther Shub recut *Dr Mabuse* for Soviet audiences just prior to his making *Strike*.

51 The sacrifice of animals and humans was a *locus* of imagery in Georges Bataille's Paris-based journal of the turn of the 1920s, *Documents*, with which Bacon was familiar. *Documents* also illustrated stills from Eisenstein; cf. Dawn Ades, 'Web of Images', in Tate 1985.

52 *Francis Bacon*, exh. cat., New Tretyakov Gallery, Moscow, 1988, p.5.

53 Deleuze, *Francis Bacon: The Logic of Sensation*, London 2003, p.23.

54 Bacon owned two similar publicity photographs of the comic French actor Michel Simon, with a monkey on his shoulder, as well as an older, distressed reproduction (information from Martin Harrison, to whom I am extremely grateful). Elsewhere Bacon's filmic animal iconography included *Study for Bullfight No.1* of 1969 (fig.13), in which the background eagle is probably taken from the logo of Republic Films. By evoking the corporate iconography of a film company, Bacon again incorporates emblems of the institution of film.

55 Daniel Farson, *The Gilded Gutter Life of Francis Bacon*, London 1993, p.126. Browning's film, which Bacon could have seen in London in the late 1930s, forecast a neo-romantic carnival world by using for narrative purpose the actual bodies of the deformed – like Bacon's appropriation of Eadweard Muybridge's photograph of a *Paralytic Child Walking on All Fours* 1961 (p.163).

56 Sylvester 1993, p.34. The italics in the quotation are mine: Bacon studies appear to have been unduly fixated on the moment of the wounding (by sabre rather than gunshot as generally stated) of the nurse at the foot of the Odessa Steps.

57 Reproduced Russell 1993, pp.148–9, pl.76.

58 S. Žižek, *Looking Awry*, Cambridge, MA, 1993, p.91.

59 Conversation with Barry Joule, June 1982.

60 Hugh Lane, RM98F1A:80. cf. Harrison 2005, pl.208, p.188.

61 Cf. M. Turim, *Flashbacks in Film: Memory and History*, New York 1989.

62 Ernst Junger 'Krieg und Lichtbild', *Das Antlitz des Weltkrieges*, Berlin 1930, p.26, republished as 'War and Photography', trans. Anthony Nassar, *New German Critique*, no.59, spring–summer 1993, pp.24–6.

63 Reproduced in *Francis Bacon: Paintings from the Estate 1980-1991*, Faggionato Fine Art, London 1999, p.27.

64 See François Dagognet, *Etienne-Jules Marey: A Passion for the Trace*, New York 1992, figs. 29–31, pp.92, 94–5.

65 Deleuze 2005, p.65.

66 Bacon, recorded conversation with Barry Joule, autumn 1991; *The Moving Image*, Museum of the Moving Image, London 1991.

67 For the seminal influence of *Intolerance* on Eisenstein, see Bergan 1999, p.86.

68 Nesbet 2007, p.75.

69 D.A. Cook, *A History of Narrative Film* (1981), London 1990, p.163.

70 Francis Bacon in conversation with the author, London, June 1987.

71 The photographer was probably Viktor Karlovitch Bulla, one of two sons of Karl Ostwald Bulla, the founder of commercial photography in Russia who had a studio in Nevsky Prospekt. It was possibly from there that the photograph was taken. Picture postcards of the shot were marketed from out of the Bulla studio.

72 Bacon, cited in Rothenstein and Alley 1964, p.17.

73 Russell 1993, p.58.

74 One is seen in Hunter's photograph (fig.88) and another is reproduced in Harrison 2005, fig.55, p.58.

75 Leyda, *Kino*, Princeton 1983, p.198.

76 M. Sperber, 'Eisenstein's *October*', *Jump Cut*, no.14, 1977, p.19.

77 The *Cagoulards* were members of a violent right-wing group in France in the 1930s.

78 Russell 1993, p.55. As discussed elsewhere in this volume, Bacon told Hugh Davies that Russell pushed him into continuing the idea and added, 'I don't think it is possible to achieve such an image, but one is obviously affected by the times one lives in'; Davies, in Rudi Chiappini (ed.), *Francis Bacon*, exh. cat., Museo d'Arte Moderna, Lugano, 1993, p.54.

79 Leiris in conversation with Barry Joule, May 1985. Peppiatt (1996, p.38) and Harrison (2005, p.170) have also both commented on Bacon's possible debt to *Napoléon*. Joule reports that much later Bacon was similarly enthused by the enhanced wrapping of the spectator's vision in the IMAX cinema and, in February 1990, visited one in Bradford.

80 For the association of the term 'paroxystic' with *Napoléon* by Gance and others see K. Brownlow, *Napoléon: Abel Gance's Classic Film*, London 1983, p.147; and N. King, *Abel Gance*, London 1984, p.72.

81 Jean Arroy quoted in Brownlow 1983, p.112. Cammell used a similar conceit – the compression of point of view and bullet – at the end of *Performance*.

82 F. Borel, 'Francis Bacon: The Face Flayed', in Milan Kundera and Borel, *Bacon Portraits and Self-Portraits*, London and New York 1996, p.190.

83 On the spectacle of paroxystic suffering and the iconography of the Crucifixion, Gance's film *La Fin du Monde* (1930) contains a Passion Play that emphasised a de-reified, reflexive account of the Crucifixion; in Gance's directions for the filming of the sequence, after close ups and realist accounts of the Crucifixion, 'The camera pulls back and we realise as the uprights of the set come into view to the left and right of the frame that we are watching a religious performance, a Passion Play'; cf. King 1984, p.110. Did Bacon know about this Gance film, which was filmed during the first part of 1930 and only shown at the beginning of 1931? Had he seen publicity about this sequence? We do know that in 1930 Bacon went to see the Passion Play at Oberammergau (Harrison 2005, p.24); the supposition might therefore be that Bacon was impressed by the modernising and alienation of the staging of the Passion in Gance's film, with its stress on lateral framing, while also encountering the visceral naturalism of the Oberammergau version. In relation to *Three Studies for Figures at the Base of a Crucifixion* 1944 (pp.146–7), Gance's screenplay looks for 'The radioactivity of suffering … His cry rips into the entrails of the future … Paroxysm'; cf. King 1984, pp.109–10.

COMPARATIVE STRANGERS
Simon Ofield

1 Simon Ofield, 'Wrestling with Francis Bacon', *Oxford Art Journal*, vol.24, no.1, 2001, pp.113–30.

2 For a comprehensive account of the emerging visibility of homosexuality in 1950s Britain see Patrick Higgins, *The Heterosexual Dictatorship: Male Sexuality in Post-War Britain*, London 1996. According to Higgins, 'The year 1954 was remarkable: in no year before or afterwards were so many trials for homosexual offences reported in the press'; p.214.

3 The Departmental Committee on Homosexual Offences and Prostitution (better known as the Wolfenden Committee, after its chairman John Wolfenden, who was Vice Chancellor of Reading University at the time) was announced in 1953, first met in 1954 and its report was finally published in 1957.

4 *Physique Pictorial*, vol.6, no.3, 1956.

5 For brief details of the work of John S. Barrington see Emmanuel Cooper, *Fully Exposed: The Male Nude in Photography*, London 1999.

6 *Physique Pictorial*, vol.7, no.2, 1957.

7 According to Patrick Higgins, 'In 1953 seventy-six men were arrested for acts of gross indecency in this area, most of them during the act of sex'; Higgins 1996, p.165.

8 The Hall-Carpenter Archive (HCA) is named after the authors Marguerite Radclyffe Hall and Edward Carpenter, and was founded in the early 1980s. There are three different archives, each on a separate site: 1) The Hall-Carpenter Archives main collection is located in the Archives Division of the London School of Economics Library (papers of campaign organisations, periodicals and printed ephemera); 2) The Lesbian and Gay Newsmedia Archive (LAGNA) is on Cat Hill campus, Middlesex University, Barnet, Hertfordshire (cuttings from national, local and foreign newspapers, badges and banners); 3) The HCA Oral History Project is a component of the National Sound Archive, British Library, Euston Road, London (oral history tapes and transcripts).

9 *Victim*, directed by Basil Dearden and starring Dirk Bogarde, Dennis Price and Sylvia Syms, was released in 1961.

10 *Keith Vaughan: Journals 1939–1977*, ed. Alan Ross, London 1989, p.99. This incident is recounted in Nigel Richardson, *Dog Days in Soho: One Man's Adventures in 1950s Soho*, London 2000.

11 Vaughan 1989, p.186.

12 Yorke, *Keith Vaughan, His Life and Work*, London 1990, pp.162–3.

13 Thompson, *Keith Vaughan Retrospective Exhibition*, exh. cat., Whitechapel Gallery, London, 1962, p.21.

14 Yorke 1990, p.166.

15 For an evocative fictional account of this particular form of masculinity and sexuality read Jake Arnott's *The Long Firm* (London 1999): 'The wardrobe was an essential part of the way that Harry operated. Being so well dressed was the

cutting edge of intimidation. A sort of decorative violence in itself'; p.14. 'But I loved the image of it all. Harry's masculinity. Being fancied by such a tough and dangerous man. The danger of it. It seemed so real compared to my privet-hedged experience of life. There was something sexy about it. Though the sex itself was really quite gentle. I know in some of the trial reports they made him out to be some sort of sadist but I don't think he was really into that. That was just business … Exciting to be amongst hard men and tough little boys'; p.62.
16 The classic account of the East End gangland rise and fall of Ronnie and Reggie Kray is John Pearson, *The Profession of Violence: The Rise and Fall of the Kray Twins*, London 1995.
17 Wildeblood, *A Way of Life*, London 1956, p.100.
18 Ibid. p.102.
19 Vaughan, *Journals and Drawings*, London 1966, p.171.
20 Hauser, *The Homosexual Society*, London 1962, p.75.

'REAL IMAGINATION IS TECHNICAL IMAGINATION'
Victoria Walsh

1 Francis Bacon, statement from interview published in *Time*, New York 1952, reproduced in Andrew Carnduff Ritchie (ed.), *The New Decade: 22 European Painters and Sculptors*, exh. cat., MoMA, New York 1955, p.60.
2 See Hugh M. Davies, *Francis Bacon: The Early and Middle Years, 1928–1958* (Ph.D. thesis, Princeton University 1975), New York and London 1978, p.172. In keeping with Bacon's sense of gaming and surrealist humour through jokes constructed by allusion, it is not inconceivable that, in his citations of Shakespeare, he was also self-referencing his adopted lineage. As 'Baconian Theory' contests, William Shakespeare was a pseudonym for Francis Bacon the philosopher.
3 Sylvester 1993, pp.6–7.
4 See Sally Yard, 'Francis Bacon', in Dennis Farr, *Francis Bacon: A Retrospective*, exh. cat., Yale Center for British Art, New Haven 1999, p.225.
5 Harrison, 'Francis Bacon: Lost and Found', *Apollo Magazine*, March 2005, p.97.
6 See Dawn Ades, 'Web of Images', in Tate 1985; David A. Mellor, 'Francis Bacon: Affinities, Contexts and the British Visual Tradition', in Achille Bonito Oliva (ed.), *Figurabile: Francis Bacon*, exh. cat., Museo Correr, Venice 1993; Hammer 2005.
7 See Anne Massey, *The Independent Group: Modernism and Mass Culture in Britain, 1945–1959*, London 1996.

8 Alloway, 'Pop Art Since 1949', *The Listener*, 27 Dec. 1962, pp.1085–7.
9 Sylvester 1993, p.199.
10 Bacon in Russell 1993, p.130.
11 See Harrison 2005, pp.11–13.
12 Amédée Ozenfant, *Foundations of Modern Art*, London 1931, pp.58–60.
13 See 'The 1930 Look in British Decoration', *The Studio*, Aug. 1930.
14 See László Moholy-Nagy, *Vision in Motion*, Chicago 1947, pp.12, 116–21, 206–8.
15 Bacon, 1952, in *The New Decade* 1955, p.60.
16 From correspondence between Michael Pearson and Henderson, 3 Dec. 1956 and 29 Jan. 1957, Henderson Archive, TGA. I am indebted to David Sylvester, who first alerted me to the 'close friendship' that began between Bacon and Henderson in the early 1950s and lasted until Henderson's death in 1985.
17 The nature of the friendship of Paolozzi and Bacon at this point is confirmed in a letter from Peter Rose Pulham to Isabel Rawsthorne on 3 March 1950, referring to 'several nights of drink and conversations with Francis and Eduardo'. The venue for such evenings may very well have been the Colony Club, which Henderson frequented, as did Bacon and many other artists at this time. Freda Paolozzi has also referred to this close relationship, and various other accounts are offered by Frank Whitford and Robin Spencer. Bacon and Paolozzi would also have crossed paths when they were both exhibiting at the Hanover Gallery in the early 1950s.
18 Hunter 1952, p.13.
19 ICA, *Fifty Years of the Future: A Chronicle of the Institute of Contemporary Arts 1947–1997*, London 1997, p.3.
20 Watson was renowned for his philanthropy for the arts, including the funding of the magazine *Horizon* edited by Cyril Connolly. He was also a financial supporter of Bacon, though on one occasion, according to Toni del Renzio, Bacon destroyed one of the paintings he had sold Watson, failing to return the money. See Del Renzio, interview by Dorothy Morland, TGA. Watson was found murdered in his bath in 1956.
21 It is not known which works were rejected by Read et al.
22 Herbert Read, 'Foreword', *Growth and Form*, exh. cat., ICA, London 1951.
23 Penrose, 'Foreword', *The Wonder and Horror of the Human Head*, exh. cat., ICA, London, 1953; press release for *Parallel of Life and Art*, 31 Aug. 1953.
24 Robertson, 'Parallel of Life and Art', *Art News and Review*, 19 Sept. 1953.

25 See Malraux, 'Museum Without Walls', *The Voices of Silence*, London 1956.
26 Ibid. p.68.
27 See Sylvester, 'Klee', *Modern Art*, 1951. As Anne Massey also notes: 'Not only did Klee's philosophy act as a liberating force for the Independent Group's formulation of a new and more dynamic aesthetic, but also the visual symbols he used entered into the paintings of the Group. Section 4 of Klee's *Pedagogical Sketchbook*, "Symbols of Form in Motion", had an important impact on Richard Hamilton's work at the time. The *Transition* series of four paintings features a key symbol from the work of Klee – the arrow … They [the arrows] deal with the problem of representing movement on a static, two-dimensional surface'; Massey 1996, pp.74–5.
28 Nigel Henderson, handwritten notes for Architectural Association talk, Henderson Estate, dated 1953.
29 Sylvester, 'Francis Bacon', *Britain Today*, Feb. 1954, republished in Sylvester, *About Modern Art: Critical Essays 1948–2000*, London 1996, 2002 ed., p.57.
30 Invited speakers to the symposium on 11 May 1954 included Stephen Spender, V. Sackville-West and Benedict Nicolson. See ICA Archive, TGA 955.1.12.
31 See Anne Massey, 'The Independent Group: Towards a Redefinition', *Burlington Magazine*, April 1987, pp.232–42.
32 According to the official chronicle of the ICA (*Fifty Years of the Future* 1997), Bacon took part in a discussion with Alloway, Anton Ehrenzweig, Victor Willing and Eric Newton at the time of his show.
33 See 'Francis Bacon, 19 January–19 February 1955', *Francis Bacon*, exh. cat., ICA, London 1955, TGA 955.1.12.63.
34 Alloway, 'Dr No's Bacon', *Art News and Review*, 9–23 April 1960, p.4.
35 See David Robbins (ed.), *The Independent Group: Postwar Britain and the Aesthetics of Plenty*, Cambridge, MA, and London 1990, p.139.
36 See John-Paul Stonard, 'Pop in the Age of Boom: Richard Hamilton's "Just what is it that makes today's homes so different, so appealing?"', *Burlington Magazine*, Sept. 2007, pp.607–20.
37 Interview with John McHale (Jr.), 2006, by Gary Comenas, at www.warhol-stars.org.articles
38 Ibid.
39 I owe this insight to a series of conversations with Peter Smithson, who also talked about the amount of time certain artists took to prepare their Christmas cards with hidden messages, only to find relationships had changed by the time Christmas came. The

more multilayered the meanings and references, the greater the challenge.
40 McHale 2006.
41 'The Importance of Collages', lecture written by Mesens, trans. Brenda Pool for presentation at the ICA, 21 Oct. 1954, ICA Archive, TGA 955.1.7.23.
42 Bacon in Davies 1978, p.67.
43 Bacon, interview with Michael Peppiatt from a conversation with Francis Bacon, *Cambridge Opinion*, 37, 1964, p.41.
44 Bacon in Russell 1993, p.21.
45 Bacon's van Gogh series of paintings further located him in contemporary practice and particularly in the debates around *Tachiste* painting which was also bound up with notions of Brutalist art put forward by Peter Reyner Banham in 'The New Brutalism', *Architectural Review*, Dec. 1955, pp.355–61. Marked by concerns with the 'image' and the aesthetic of 'all over', Banham identified artists including Giacometti, Paolozzi, Henderson and the Smithsons within this argument.
46 Francis Bacon, 'Introduction', *Matthew Smith: Paintings from 1909 to 1952*, exh. cat., Tate Gallery, London, 1953. Bacon had also spoken of this relationship, 'painting is the pattern of one's own nervous system being projected on a canvas'; Bacon, interview with *Time*, 21 Nov. 1949, p.44.
47 Sylvester, 'The Paintings of Francis Bacon', *The Listener*, 3 Jan. 1952. See also Sylvester 1993, pp.56–8.
48 Ozenfant 1931, p.305. 'I have deliberately tried to twist myself, but I have not gone far enough. My paintings are if you like, a record of this distortion. Photography has covered so much: in a painting that is even worth looking at the image must be twisted if it is to make a renewed assault upon the nervous system'; Bacon in Peppiatt 1964.
49 Bacon expanded on this in 1966, in Sylvester 1993, pp.56–8.
50 Cooper, *Gauguin*, exh. cat., Tate Gallery, London 1955.
51 Francis Bacon Papers, TGA 9810; Tate 1999, p.78.
52 See Robert Melville, 'The Evolution of the Double Head in the Art of Picasso', *Horizon*, Nov. 1942, pp.343–51.
53 Gombrich, 'Meditations on a Hobby Horse or The Roots of Artistic Form', reproduced in *Meditations on a Hobby Horse and Other Essays in the Theory of Art*, London 1963, pp.1–11.
54 Ibid. pp.10–11.
55 Bacon in Sylvester 1993, pp.11–12.
56 From a partial handlist of books in Bacon's possession retrieved from the Bacon archive and held at the Dublin City Gallery The Hugh Lane. Copies

of works by Proust were also found in Bacon's house and studio at 7 Reece Mews, and we know from photographic documentation of his studio by Perry Ogden (*7 Reece Mews: Francis Bacon's Studio*, London 2001) that Bacon also had a copy of Mario Praz's seminal account of the Romantic writers and artists, *The Romantic Agony*, which was originally published in 1933, although Bacon's copy looks more recent.

57 'Francis Bacon', in *The New Decade: 22 European Painters and Sculptors*, exh. cat., MoMA, New York 1955, p.63.

58 Proust quoted in Siegried Kracauer's article 'The Photographic Approach', *Magazine of Art*, March 1951, p.109.

59 Harrison, 'Francis Bacon: Lost and Found', *Apollo*, March 2005, p.97.

60 Peppiatt 1996, p.35.

61 Sylvester, 'Finding the Matisse in Bacon', *Tate Magazine*, winter 1996, p.46.

62 David A. Mellor, 'Francis Bacon: Affinities, Contexts and the British Visual Tradition' in Achille Bonito Oliva (ed.), *Figurabile: Francis Bacon*, exh. cat., Museo Correr, Venice, 1993.

ANIMAL

1 Hunter, in conversation with the author, Princeton, NJ, 24 Jan. 2008.

2 Hunter, 'Francis Bacon: The Anatomy of Horror', *Magazine of Art*, vol.45, no.1, Jan. 1952, p.12.

3 Hunter, in conversation with the author, 24 Jan. 2008.

4 Hunter 1952, p.12.

5 Melville, 'Francis Bacon', *Horizon*, vol.20, nos.120–1, Dec. 1949–Jan. 1950, pp.419–23.

6 Sylvester, 'Francis Bacon', *Britain Today*, no.214, Feb. 1954, pp.23–6; and 'Francis Bacon' in *Francis Bacon, Ben Nicholson, Lucian Freud*, British Pavilion, Venice Biennale, 1954.

7 Wirth-Miller in conversation with Matthew Gale, cited in Tate 1999, p.23 n.19.

8 Sylvester 2000, p.18. That the background of the composition appears to continue from that in *Figure Study I* 1946 (p.98) may suggest a later date.

9 Robert Buhler, who took the premises after Bacon, was responsible for later letting these works out into the market.

10 Bacon confirmed to Hugh Davies that they were microphones in *Figure in a Landscape*, Davies, 'Bacon Material', unpublished typescript, spring 1973, private collection, p.15.

11 The fragments of this destroyed canvas are at the Dublin City Gallery The Hugh Lane; see Cappock 2005, pp.224–7.

12 Bacon, letters to Duncan McDonald, Alex. Reid & Lefevre, 19 Oct. (1946) and

20 June (1947), Lefevre Gallery Papers, TGA.

13 Melville, typescript note on Bacon's Grand Palais exhibition, 1971, Melville papers, TGA 948; Hitler: Keystone Images.

14 *Oresteia*, trans. Philip Vellacott, Harmondsworth 1958, p.148.

15 Russell 1993, p.27.

16 Melville 1949–Jan. 1950, p.420.

17 Sutherland Papers, NMGW, in Hammer 2005, p.237. On 19 Oct. 1946, Bacon also wrote to McDonald, to say that he was 'working on three studies of Velasquez portrait of Innocent II [*sic*] I have almost finished one'. On 20 June 1947 he told McDonald that by September he would have 'a group of three large paintings … They want to be hung together in a series as they are a sort of Crucifixion'. On 23 Jan. 1948 he told McDonald, 'I have done a set of three paintings I would like to show. They are about the same size as the Contemporary Art Society one or a little smaller. I could get them to you by the end of April or beginning of May'; Lefevre Gallery Papers, TGA.

18 Bacon, May 1966, in Sylvester 1993, p.48.

19 Deleuze, *Francis Bacon: The Logic of Sensation* (1981), trans. Daniel W. Smith, London and New York 2003, p.60.

20 Bataille, 'La Bouche', *Documents*, vol.2, no.5, Paris 1930, pp.299–300; quoted in Dawn Ades, 'Web of Images', in Tate 1985, p.13.

ZONE

1 Deleuze, *Francis Bacon: The Logic of Sensation* (1981), trans. Daniel W. Smith, London and New York 2003, p.13.

2 Bacon in Russell 1993, p.92. The railings of race courses and around roulette tables in casinos have also been suggested by Martin Harrison as additional stimuli (Harrison 2005, pp.118–19).

3 Rawsthorne, 30 Dec. [1950], Rawsthorne Papers, TGA 8612.1.3.43.

4 See his interest in Baron von Schrenk Notzing's *Phenomena of Materialisation* (London 1920), discussed in Harrison 2005, pp.41, 204, 208. Aldous Huxley described El Greco's paintings as ectoplasmic at this moment in his 'Variations on El Greco', *Themes and Variations*, London 1950, p.182.

5 Untitled manuscript, c.1950–1, Robert Melville Papers, TGA 948.

6 For the rediscovery of *Study after Velázquez* see Sylvester 2000, pp.44–6.

7 Bacon, 'statement', in *Matthew Smith: Paintings from 1909 to 1952*, exh. cat., Tate Gallery, London, 1953, p.12.

8 Bacon remarked on how Velázquez 'had cooled Titian'; July or Oct. 1973,

from the previously edited-out 'Fragments of Talk', in Sylvester 2000, p.239.

9 See Dawn Ades, 'Web of Images', in Tate 1985, pp.12–13, who highlighted 'La Bouche', in *Documents*, vol.2, no.5, 1930; republished in Bataille, *Visions of Excess: Selected Writings, 1927–1939*, trans. and ed. Allan Stoekl, Minnesota and Manchester 1985, pp.59–60.

10 Frederick Rolfe ('Baron Corvo'), *Hadrian VII* (1904), London 1978, p.73. In the same year as *Hadrian VII* appeared, George Bernard Shaw masqueraded in the guise of Innocent X for a portrait; see David Mellor, 'Francis Bacon: Affinities, Contexts and the British Visual Tradition', in Achille Bonito Oliva (ed.), *Figurabile: Francis Bacon*, exh. cat., Museo Correr, Venice 1993, p.96.

11 See also *Dog* 1952 (Samuel & Ronnie Heyman, formerly MoMA, New York), *Sphinx I* (private collection) and *Sphinx II* (Yale University Art Gallery, New Haven), both 1953, reproduced in Rothenstein and Alley 1964, no.45 p.177, nos.67, 68 p.186.

12 Peter Selz, 'Francis Bacon', in *New Images of Man*, exh. cat., MoMA, New York 1959, p.29 in n.8, compared *Study of a Dog* to Luis Buñuel's film *The Young and the Damned* 1950, as *Los olvidados* was called in the USA.

13 Rothenstein and Alley 1964, p.58, indicated that the setting was taken from a postcard of formal flowerbeds in Monte Carlo and the dog from Muybridge's *Animal Locomotion*, Philadelphia 1887. Sylvester 2000, p.77, suggests the dog is chasing its tail. The step-down in the viewpoint is also evident in *Man with Dog* (p.130).

14 Rothenstein and Alley 1964, p.63.

15 However, there is no direct evidence for this image being known by Bacon.

16 Herbert Read, 'New Aspects of British Sculpture', in *Works by Sutherland, Wadsworth, Adams, Armitage, Butler, Chadwick, Clark, Meadows, Moore, Paolozzi, Turnbull*, exh. cat. British Pavilion, Venice Biennale, 1952; see also David Mellor, 'Existentialism and Post-War British Art', in Frances Morris, *Paris Post War: Art and Existentialism 1945–55*, exh. cat., Tate Gallery, London 1993, pp.54–5.

17 Bacon, Oct. 1962, in Sylvester 1993, p.24.

18 Already mentioned as a source in Bacon's letters to Graham Sutherland and Duncan McDonald, 19 Oct. (1946), NMGW in Hammer 2005, p.237; see also 'Animal', in this volume, p.94.

19 Bacon, Oct. 1962, in Sylvester 1993, p.26.

20 Discussed in ibid. pp.25–6.

21 Bacon, May 1966, in Sylvester 1993, p.37. Russell 1993, p.39, is one of those who reports that Bacon did not see the Velázquez while in Rome. He probably knew the copy attributed to Velázquez now in Apsley House, as Martin Harrison has noted ('Francis Bacon: Extreme Points of Realism', in Armin Zweite [ed.], *Francis Bacon: The Violence of the Real*, exh. cat., K20 Kunstsammlung Nordrhein-Westfalen, Düsseldorf, 2006, p.42), especially as it was exhibited at the Victoria and Albert Museum, across the road from his studio, in *Wellington Relics*, V&A, London, June–Aug. 1947, no.19.

22 Selz 1959, p.29.

23 Deleuze 2003, p.16.

24 Bacon, 'from an interview with *Time*, 1952', extracted in Andrew Carnduff Ritchie, *New Decade: 22 European Painters and Sculptors*, exh. cat., MoMA, New York 1955, p.60.

25 Bacon, May 1966, in Sylvester 1993, p.37; the list, dated '9 January 1959' is in V.J. Staněk, *Introducing Monkeys*, London c.1957, TGA, transcribed in Tate 1999, p.77.

26 *Crouching Boy*, c.1525, The Hermitage, St Petersburg; black-and-white photograph in Ludwig Goldscheider, *The Sculptures of Michelangelo: Complete Edition*, 2nd ed. London 1950, fig.117.

27 Bacon, Sept. 1974, in Sylvester 1993, p.114.

28 See Simon Ofield's essay in this volume, pp.64, 66.

29 Bachelard, *La Poétique de l'espace*, Paris 1958, trans. Maria Jolas as *The Poetics of Space*, New York 1964 and 1969, pp.211–12.

30 Deleuze 2003, p.21.

31 Bacon, Sept. 1974, in Sylvester 1993, p.116.

32 Bataille, in *Documents*, vol.2, no.5, 1930, republished as 'The Pineal Eye' in Bataille 1985, p.87.

APPREHENSION

1 For general accounts of the debates around abstraction and realism, see Margaret Garlake, *New Art New World: British Art in Postwar Society*, New Haven and London 1998; James Hyman, *The Battle for Realism*, New Haven and London 2001; and David Sylvester, 'Curriculum Vitae', in *About Modern Art: Critical Essays 1948–2000*, London 1996, 2002 ed., pp.11–34.

2 Bacon in *Matthew Smith: Paintings from 1909 to 1952*, exh. cat., Tate Gallery, London 1953, p.12.

3 See Frances Morris, *Paris Post-War: Art and Existentialism 1945–55*, exh. cat., Tate Gallery, London 1993, p.90.

4 Rothenstein and Alley 1964, p.86.

5 Bacon, letter to Sylvester, 15 Nov. 1954, David Sylvester Archive, TGA 200816.

6 Bacon, May 1966, in Sylvester 1993, p.48.

7 See Chris Waters, 'Disorders of the Mind, Disorders of the Body: Peter Wildeblood and the Making of the Modern Homosexual', Becky Conekin, Frank Mort and Chris Waters (eds.), *Moments of Modernity: Reconstructing Britain 1945–1964*, London and New York 1999, p.137.

8 Wildeblood, 'Wildeblood speaks of "My lonely moments"', *Daily Mirror*, 19 March 1954, quoted in Richard Hornsey, 'Francis Bacon and the Photobooth: Facing the Homosexual in Post-war Britain', in *Visual Culture in Britain*, vol.8, no.2, 2007, p.99.

9 Kristeva, *Powers of Horror: An Essay on Abjection*, New York 1982, p.3.

10 Bacon, April/June 1975, in Sylvester 1993, p.133.

11 Sheet (four pages) torn from *Picture Post*, with photographic illustrations on the life of Stalin, 14 March 1953, RM98F1A:70. Collection Francis Bacon Studio archive, Dublin City Gallery The Hugh Lane.

12 Bacon, letter to Sylvester, 15 Nov. 1954 (Ostia), David Sylvester Papers, TGA 200816.

13 Russell (1993, p.94) refers to Alley in relation to the Canadian Prime Minister; Sylvester 2000, p.70.

14 Russell 1993, p.94.

15 T.S. Eliot, 'Fragments of an Agon', in *Sweeney Agonistes: Fragments of an Aristophanic Melodrama*, London 1932, p.25.

16 Bacon, 1971/3, in Sylvester 1993, p.78.

CRUCIFIXION

1 Bacon in 1973, to Hugh M. Davies, in *Francis Bacon: The Early and Middle Years, 1928–1958* (Ph.D. thesis, Princeton University, 1975), New York and London 1978, pp.45–6.

2 Bacon, Oct. 1962, in Sylvester 1993, p.23. For differing discussions of the subject see Rolf Laessøc, 'Francis Bacon's Crucifixions and Related Themes', in *Hafnia: Copenhagen Papers in the History of Art*, no.11, 1987, pp.7–38; Paul Moorhouse, '"A Magnificent Armature": The Crucifixion in Francis Bacon's Work', *Art International*, no.8, autumn 1989; *Corps crucifiés*, exh. cat., Musée Picasso, Paris, 1992, and Anne Baldassari, *Bacon Picasso: The Life of Images*, Paris 2005, pp.134–70.

3 Bacon, May 1966, in Sylvester 1993, p.46.

4 See Ziva Amishai-Maissels, *Depiction and Interpretation: The Influence of the Holocaust on the Visual Arts*, Oxford, New York, Seoul and Tokyo 1993, pp.189–90, 225–6.

5 Bacon, May 1966, from the previously edited-out 'Fragments of Talk', in Sylvester 2000, p.231.

6 Martin Harrison has been kind enough to confirm the source (noted in Harrison 2005, p.24) as a postcard from Bacon to his former nanny Jessie Lightfoot, postmarked '28 April 1930'. The text reads: 'There is a big monastery near here. The play was lovely. We are going back to Munich tomorrow. It is very cold here. All my love. Frankie.'

7 Harrison 2005, p.24, cites evidence of visits to Germany other than the first stay in Berlin in 1927.

8 Dawn Ades, 'Web of Images', in Tate 1985, pp.18–19.

9 See Yve-Alain Bois, 'Abattoir', in Bois and Rosalind E. Krauss, *Formless: A User's Guide*, New York 1997, pp.43–51; and Neil Cox, 'Sacrifice', in *Undercover Surrealism: Georges Bataille and Documents*, exh. cat., Dawn Ades and Simon Baker (eds.), Hayward Gallery, London 2006, pp.101–14.

10 See Ades in Tate 1985, pp.18–19, and Margarita Cappock, 'The Motif of Meat and Flesh', in Barbara Steffen (ed.), *Francis Bacon and the Tradition of Art*, exh. cat., Kunsthistorisches Museum, Vienna, 2003, and Fondation Beyeler, Riehen, Basel, 2004, pp.311–16. Oddly, Bacon dismissed the Rembrandt as 'a lump of wax hanging there'; May 1966, in Sylvester 2000, p.241.

11 A lost Bacon, *Woman in the Sunlight*, was shown at the Mayor Gallery's opening exhibition in April 1933 (no.31). *Art Now* was published in October, when a *Composition*, usually taken to be *Crucifixion*, was shown in the *Art Now* exhibition (no.2). Read's book *Art Now* (London 1933) also included Roy De Maistre's *Composition* 1933 (fig.96), and the Australian painter may have been the contact between Bacon and the Gallery's Douglas Cooper (Peppiatt 1996, p.49).

12 Bacon, Oct. 1962, in Sylvester 1993, p.23. For Bacon's interest in Picasso see Davies 1978, pp.19, 26–7; David W. Boxer, 'The Early Work of Francis Bacon', unpublished Ph.D. thesis, John Hopkins University, Baltimore, Maryland, 1975, p.64, and Sylvester 2000, p.15. For a detailed reconstruction of the Picassos Bacon could have seen in Paris in 1927, see Baldassari 2005.

13 See Andrea del Verrocchio's sculpture of *Christ and Doubting Thomas* on Orsanmichele in Florence. Both the uplifted arms and the pose of Bacon's attendant loosely recall those of Picasso's *Three Dancers* 1925 (Tate), published in *Documents*, no.3, 1930.

14 Russell 1993, p.17. *Wound for a Crucifixion* was shown in Bacon's February 1934 exhibition at the Transition Gallery, and destroyed despite being reserved for Eric Allden (Peppiatt 1996, p.67). Martin Harrison has suggested (in correspondence) that Allden may be part of the 'We' in the postcard from Oberammergau noted above.

15 Mellor, 'Francis Bacon: Affinities, Contexts and the British Visual Tradition', in Achille Bonito Oliva (ed.), *Figurabile: Francis Bacon*, exh. cat., Museo Correr, Venice 1993, p.97.

16 Reproduced Cappock 2005, p.162 fig.294. This may be read as a central, yellow Christ between white thieves.

17 Sadler, who had bought the first *Crucifixion*, supplied Bacon with an x-ray to make his portrait: *The Crucifixion* seems to have been adapted to this requirement, with the skull incorporated as a sign for Golgotha.

18 For the relevance of Joseph de Maistre, see Andrew Brighton, *Francis Bacon*, London 2001, pp.22–8, for Roy De Maistre, see Heather Johnson, *Roy De Maistre: The English Years 1930–1968*, Roseville East, New South Wales, Australia 1995, pp.22–3.

19 For the treatment of religious subjects by De Maistre, Bacon and Sutherland, see Mellor 1993, pp.98–9.

20 Bacon, 1971–3, in Sylvester 1993, p.81.

21 *Picasso's Guernica with 67 Paintings, Sketches and Studies*, New Burlington Galleries, London, Oct. 1938.

22 'Crucifixion: Dessins de Picasso, d'après la *Crucifixion* de Grünewald', *Minotaure*, vol.1, no.1, June 1933, pp.31–2.

23 *Temptation Triptych* 1936–7, Staatsgalerie Moderner Kunst, Munich, shown at *Exhibition of 20th Century German Art*, New Burlington Galleries, London, July 1938.

24 It was first shown, with *Figure in a Landscape*, in *Recent Paintings by Francis Bacon, Frances Hodgkins, Henry Moore, Matthew Smith, Graham Sutherland*, Lefevre Gallery, London, April 1945. For an account of various interpretations, see Matthew Gale, 'Francis Bacon: *Three Studies for Figures at the Base of a Crucifixion*', full catalogue entry, 1998, www.tate.org.uk

25 For *Biomorphic Drawing*, see Cappock 2005, pp.160–1. *Abstraction and Abstraction from the Human Form* were published in *Referee*, 17 Jan. 1937 (reproduced in Rothenstein and Alley 1964, p.264), and recognised by Alley as preliminary to the central panel (ibid. p.35),

and also discussed in Davies 1978, pp.34–6.

26 Without specific evidence, Sylvester 2000, p.33, placed the interest in Baron von Schrenk Notzing's *Phenomena of Materialisation* (London 1920) in the 1930s, but the compelling identification of a photographic source for the left-hand panel of the 1944 triptych was made in Harrison 2005, pp.40–4.

27 See 'Animal', in this volume, pp.91–2.

28 Peppiatt 1996, p.83. Ebury Street, where De Maistre had had a studio, took a direct hit on 16 April 1941; see *Front Line 1940–41: The Official Story of the Civil Defence of Britain*, London 1942, p.33.

29 Ibid.

30 The 'F. BACON PETERSFIEL[D]' inscription on the reverse of the right panel is noted in Gale 1998, in which a consequent redating to 1942–4 is suggested, as Bacon claimed to be 'more often in London' by February 1943 (Bacon to Sutherland, 8 Feb. 1943, from Petersfield, NMGW, in Hammer 2005, p.234). While drawing on this evidence Martin Hammer (2005, pp.20–1) argued for the possibility of the board being reused.

31 Ronald Alley, *Graham Sutherland*, exh. cat., Tate Gallery, London, 1982, p.111; conversation with Vaughan, 18 April 1944, in Vaughan, *Journals 1939–1977*, ed. Alan Ross, London 1989, p.55. Prometheus is one of the subjects of Aeschylus' plays, an interest shared by Bacon and Sutherland.

32 Bacon to Sutherland, letter 'Dec. 30' (1946), from Hotel Ré, Monte Carlo, NMGW, in Hammer 2005, pp.238–9.

33 Rudolf Friedmann, 'Kierkegaard: The Analysis of the Psychological Personality', *Horizon*, vol.8, no.46, Oct. 1943, appeared just as Bacon was bringing his triptych to fruition. Friedmann analysed Kierkegaard's attack on established Christianity and deconstructed the philosopher's use of the Abraham and Isaac story ('I am thy murderer, and this is my desire') in Freudian terms, commenting: 'Perverted, degenerate love and death, murder and incestuous homosexuality merge as the mountain spring of the instinctive Eros gushes forth' (p.265).

34 See John Russell, *Francis Bacon*, London 1964, p.4. The shocked reviewer was 'Perspex' [Herbert Furst], 'Current Shows and Comments: On the Significance of a Word', *Apollo*, vol.41, no.231, May 1945, p.108.

35 See David Mellor, *A Paradise Lost: The Neo-Romantic Imagination in Britain, 1935–55*, exh. cat., Barbican Art Gallery, London, 1987, especially 'Graham

Sutherland: The Damned', pp.72–6.

36 Mortimer, 'At the Lefevre', *New Statesman and Nation*, vol.29, no.738, 14 April 1945, p.239.

37 Stefan Schimanski, 'Editorial: Towards a Personalist Psychology', *Transformation*, no.3, 1946, p.11.

38 Bacon, letter to Tate Gallery, 9 Jan. 1959, TGA, punctuation added. See also Michael Peppiatt's view that *Painting 1946* was that 'Crucifixion' (*Francis Bacon in the 1950s*, exh. cat., Sainsbury Centre for Visual Arts, University of East Anglia, Norwich, 2006, p.19).

39 See 'Animal', in this volume, p.92. See also Hammer 2005, esp. pp.14–37.

40 Bacon, letter to Tate Gallery, 9 Jan. 1959, TGA.

41 *Eumenides*, 55, in Aeschylus, *Oresteia*, trans. Robert Fagles, Harmondsworth 1977, p.233.

42 Bataille, in *Documents*, vol.2, no.8, 1930, republished as 'Sacrificial Mutilation and the Severed Ear of Vincent Van Gogh', in Bataille, *Visions of Excess: Selected Writings, 1927–1939*, trans. and ed. Allan Stoekl, Minnesota and Manchester 1985, p.69.

43 W.B. Stanford, *Aeschylus in his Style: A Study in Language and Personality*, Dublin 1942, encountered via Eric Hall or Sutherland (whose copy is noted by Hammer 2005, p.102). T.S. Eliot, *The Family Reunion*, London 1939, p.61 (produced at Westminster Theatre, March 1939); see Peppiatt 1996, p.89, and Harrison 2005, p.232.

44 Eliot 1939, p.95; see also 'Epic' in this volume, pp.213–18.

45 Bacon subsequently claimed never to have seen the painting, in conversation with Jean Clair', in *Corps Crucifiés*, exh. cat., Musée Picasso, Paris, 1992, p.135.

46 Previously shown in London at the ICA in Dec. 1948.

47 *Picasso*, exh. cat. Arts Council of Great Britain, Tate Gallery, London 1960, p.22.

48 Bacon, Oct. 1962, in Sylvester 1993, p.13. Sylvester identified it being made in February and March 1962 (Sylvester 2000, p.100), though the catalogue (*Francis Bacon*, Tate Gallery, London, 1962) stated 'April–May'.

49 The list dated 'Jan. 2nd 1962'; the phrase continues on the next line 'Rails as opposite', referring to the oil sketch on the facing page.

50 The connection of the sketch *Two Owls, No.1* (Tate) to *Three Studies for a Crucifixion* was suggested by Martin Harrison in 'Francis Bacon: Extreme Points of Realism' (in Armin Zweite [ed.], *Francis Bacon: The Violence of the Real*, exh. cat., K20 Kunstsammlung Nordrhein-Westfalen, Düsseldorf 2006,

p.46), in which he proposes a date of 'about 1960' for the sketch.

51 Sylvester 2000, p.107.

52 Bacon, Oct. 1962, in Sylvester 1993, p.13. Sylvester stressed this by reproducing the Cimabue upside down (ibid. p.14; Sylvester 2000, p.107).

53 An observation attributed to Ronald Alley in Robert Melville's manuscript notes on the painting, Melville Papers, TGA 948.

54 Laessøe 1987, pp.15–18; he cites Russell's observation of its 'left-to-right movement' (Russell 1993, p.128).

55 Penrose discreetly recounted the brothel story in the catalogue note (Tate 1960, p.22).

56 Sylvester 2000, p.111.

57 Ibid. p.114.

58 Bacon 1985, filmed interviewed by Richard Francis directed by Ian Morrison; cited by Martin Harrison in Kunstsammlung Nordrhein-Westfalen 2006, p.47. David Mellor has associated this figure with Sickert's Camden Town Murder paintings (in Mellor 1993, pp.100–1).

59 Michelangelo, *Victory* 1525–30, Palazzo Vecchio, Florence.

60 Bacon, May 1966, in Sylvester 1993, p.65. See Russell 1993, pp.128–9 for criticism of this work. Bacon list of works dated 'Jan. 2nd 1962' includes: 'Figure going through door as in Eichman photo.'

61 Bacon, May 1966, in Sylvester 1993, p.44.

62 Harrison 2005, pp.156–7, notes this and examples by Giotto and Guido Reni that Bacon could have seen during his stay in Rome in 1954.

CRISIS

1 Bacon to Robert Sainsbury, 1 June 1956, published in Michael Peppiatt, exh. cat., *Bacon in the 1950s*, Sainsbury Centre for Visual Arts, University of East Anglia, Norwich 2006, p.157.

2 Bacon moved to Battersea in the autumn of 1955, just as Lacy settled in Tangier; see Rothenstein and Alley 1964, p.99, and Tate 1999, pp.15–16. For the first trip to Tangier see Farson, *The Gilded Gutter Life of Francis Bacon*, London 1993, p.137. It is possible that the departure of Bacon, Danquah and Pollock was also related to the spy scandal around Guy Burgess and Donald Maclean. They had disappeared in 1951, but sensationally reappeared in Moscow in February 1956, confirming that they had been double agents for the KGB. Pollock had been Burgess's lover (see Miranda Carter, *Anthony Blunt: His Lives*, London 2001, p.402). The combination of Cold War spying and

homosexuality brought a wave of homophobia.

3 Hanover Gallery Records, TGA, and published in Sainsbury Centre 2006, pp.147–51.

4 Bacon to Robert Sainsbury, 14 July 1956, in ibid. p.157. His copy of *Images du Monde* (TGA 9810) dating from this visit (25 Aug. 1956), includes a report on the murder of journalists in Morocco; see Tate 1999, p.17 n.22.

5 Hanover Gallery Records, Sainsbury Centre 2006, pp.149–51.

6 Bacon to Sainsbury, 14 July 1956, published in ibid. p.157. Bacon noted a related subject in his list of 17 Dec. 1958 (inside back cover of V.J. Staněk, *Introducing Monkeys*, London c.1957, Tate; reproduced in Tate 1999, p.76): 'Camel Lying down in/ the middle of circle of/ sand Camel from/ Morco p.' The transcription of the final phrase (given as 'Mosco' in ibid. p.78) should be corrected to a condensation of Morocco.

7 *Untitled (Two Figures in the Grass)* is given this dating in Armin Zweite (ed.), *Francis Bacon: The Violence of the Real*, exh. cat., K20 Kunstsammlung Nordrhein-Westfalen, Düsseldorf 2006, p.111, but the vigorous handling might suggest a later date. For the reworking of *Crouching Nude* see 'Zone' in this volume, pp.118–19.

8 Galerie Rive Gauche, Paris, Feb. 1957; see the installation photograph in Sainsbury Centre 2006, p.169.

9 For Camus see *L'Etranger*, trans. as *The Outsider*, Harmondsworth 1942, and 'The Minotaur or the Stop in Oran', Paris 1939, in *The Myth of Sisyphus*, trans. Justin O'Brien (1955), London 1975; Paul Bowles, *The Sheltering Sky* (1949), London 1977. Bacon recommended it to Farson (Farson 1993, p.142).

10 Bacon to Sonia Orwell, 20 April 1957 (UCL), inquires about medicines on Jane Bowles's behalf.

11 Paul Bowles, *The Spider's House* (1955), London 1985, p.255.

12 For Bacon's reports of Yacoubi's imprisonment for seducing a minor, see the correspondence with Brausen in Hanover Gallery Records, Sainsbury Centre 2006, pp.149–51.

13 Bacon to Robert Sainsbury, from 9 Overstrand Mansions, Battersea, 1 June 1956, in ibid. p.157.

14 Wilhelm Uhde, *Van Gogh*, Oxford 1951.

15 Douglas Glass's 1957 photograph (fig.5) shows *The Painter on the Road to Tarascon* to the right of the rocking chair. A second photograph by Glass (reproduced in Harrison 2005, p.80 fig.73) shows the portrait below the chair.

16 Bruce Bernard, *Francis Bacon: Study for Portrait of Van Gogh*, Arts Council brochure, London 1994 (p.2). Rothenstein and Alley 1964, pp.110–11, identified the additions as *Study for a Portrait of Van Gogh V* and *Study for a Portrait of Van Gogh VI*.

17 See Glass's 1957 photograph, reproduced in Harrison 2005, p.82 fig.75.

18 Noted in John Golding, 'Lust for Death', *New Statesman and Nation*, vol.53, no.1360, 6 April 1957, p.438; two years later, Bacon denied any connection with the film, in a letter to the Tate Gallery, 9 Jan. 1959, TGA, cited in Mary Chamot, Dennis Farr and Martin Butlin, *Tate Gallery: The Modern British Paintings, Drawings and Sculptures*, vol.I, London 1964, p.23. The connection is explored by David Mellor in the present volume, pp.53–4.

19 Artaud, 'Van Gogh, the Man Suicided by Society', 1947, trans. in Susan Sontag (ed.), *Antonin Artaud, Selected Writings*, New York 1976.

20 Sartre, 'The Look', in *Being and Nothingness: An Essay on Phenomenological Ontology*, trans. Hazel E. Barnes, London 1957, p.254.

21 Russell 1993, p.51.

22 Alloway, 'Dr No's Bacon', *Art News and Review*, vol.12, no.6, April 1960, p.4.

23 Alloway, 'Francis Bacon', *Art International*, vol.4, nos.2–3, 1960, p.63.

24 Bacon interviewed by Farson, 27 Aug. 1958, in Farson 1993, p.103; he noted his admiration for Soutine in the same place (ibid. p.105).

25 *Lying Figure* 1958, Museum Bochum; and *Self-Portrait* 1958, Hirshhorn Museum and Sculpture Garden, Smithsonian Institution, Washington, D.C.

26 List, 11 Dec. 1958, on back flyleaf of Staněk c.1957, TGA; transcribed in Tate 1999, p.79.

27 List, 18 Aug. 1958, on front flyleaf of Staněk c.1957, The Francis Bacon Studio archive of Dublin City Gallery The Hugh Lane, RM98F; reproduced in Cappock 2005, pp.198–9, fig.341.

28 For Eisenstein see David Mellor's essay in this volume, pp.59–62.

29 The reference image is 'Infant paralysis, child walking on hands and feet', in Eadweard Muybridge, *Animal Locomotion*, 1887, pl.539.

30 See Ben Tufnell, *Bacon in St Ives: Experiment and Transition 1957–62*, exh. cat., Tate St Ives, 2007.

ARCHIVE

1 Melville, 'Francis Bacon', *Horizon*, vol.20, no.120–1, Dec. 1949–Jan. 1950, pp.419–23.

2 Hunter, 'Francis Bacon: The Anatomy

of Horror', *Magazine of Art*, vol.45, no. 1, Jan. 1952, p.12.

3 Bacon, May 1966, in Sylvester 1993, p.30.

4 John Edwards, Bacon's sole heir, donated the studio to Dublin City Gallery The Hugh Lane, in 1998. For several years a dedicated team painstakingly examined, documented and catalogued its contents before reconstructing the studio in Dublin, where it has been on public view since 2001.

5 Hunter 1952, p.12.

6 Bacon quoted in Archimbaud 1993, p.88.

7 See Cappock 2005.

8 Hunter 1952, p.13.

9 Bacon, 1971/3, in Sylvester 1993, p.68. Only ten paintings executed by Bacon between 1929–44 are listed in Rothenstein and Alley 1964.

10 John Russell described Bacon as having hoarded thousands of images and 'just as James Joyce was said to be able to put his hand on just the book or newspaper or magazine in which he could find the everyday phrase that he wanted to metamorphose, so Bacon knows every one of his strange family of images by name'. Russell 1993, p.66.

11 Bacon, Oct. 1962, in Sylvester 1993, p.17.

12 Four copies of *The Human Figure in Motion* and more than 100 additional pages torn from the same publication were discovered in Bacon's Reece Mews studio after his death; Cappock 2005, p.111.

13 Figures for these paintings have been taken from plates describing: 'Athlete Heaving 75-Pound Rock'; 'Man Performing a Standing Broad Jump'; 'Woman Walking Downstairs, Picking up Pitcher, and Turning' respectively.

14 Bacon, Sept. 1974, in Sylvester 1993, p.116.

15 Sylvester 2000, p.72.

16 Bacon, Sept. 1974, in Sylvester 1993, p.116.

17 Bacon, May 1966, in ibid. p.30.

18 Bacon, Sept. 1974, in ibid. p.114: there Bacon talked of Michelangelo and Muybridge being 'mixed up in my mind together'.

19 See Bacon, May 1966, in Sylvester 1993, p.30, and Cappock 1995, p.103.

20 Bacon, Sept. 1974, in Sylvester 1993, p.116.

21 Bacon, May 1966, in ibid. p.32.

22 Bacon, May 1966, in ibid. p.38.

23 Martin Harrison discusses the identification of three archives that counter Bacon's claims that he did not draw: the Tate collection of 'works on paper'; the contents of the Reece Mews studio catalogued by Dublin City Gallery The

Hugh Lane; and material presented to TGA by Barry Joule; Harrison 2005, p.69.

24 Indeed, one such reference, in the interview with Sylvester in May 1966 and broadcast on the BBC (18 Sept. 1966), was edited out of the final published form. Martin Harrison played this recording at the Francis Bacon Symposium, Trinity College, Dublin, 9 Nov. 2002.

25 Bacon, 1984–6, in Sylvester 1993, pp.144–5.

26 David Sylvester recalled that in interviews with the artist from 1962 onwards, he, Sylvester, refrained from mentioning a series of small pencil-sketches for paintings he had seen in the endpapers of Bacon's copy of a paperback edition of poems by T.S. Eliot; Sylvester, 'Bacon's Secret Vice', in Tate 1999, p.9. See also Matthew Gale's account in 'Working on Paper', ibid. pp.13–19. In 1973 Hugh Davies saw a drawing in a private collection and was told by David Hockney of two belonging to Stephen Spender, reproduced ibid. pp.40–1.

27 Bacon, 1979, in Sylvester 2000, p.232.

28 Tate 1999 and Harrison 2005, p.70.

29 See Tate 1999.

30 Bacon, Oct. 1962, in Sylvester 1993, p.21.

31 Tate 1999, p.26.

32 Bacon, Oct. 1962, in Sylvester 1993, pp.21–2.

33 Bacon, May 1966, in ibid. p.37.

34 Sylvester 2000, p.99.

35 Bacon, May 1966, in Sylvester 1993, p.41.

36 Sylvester 2000, p.69.

37 See 'Portrait' in this volume, pp.182–5.

38 Bacon, April–June 1975, in Sylvester 1993, p.129.

39 For further discussion on the photobooth and the presentation of Bacon's sexuality, see Richard Hornsey, 'Francis Bacon and the Photobooth: Facing the Homosexual in Post-war Britain', in *Visual Culture in Britain*, vol.8, no.2, 2007, pp.83–103.

40 Bacon, 1971/3, in Sylvester 1993, p.86.

41 Fig.136, taken by Bacon, shows how a seemingly casual snapshot was perhaps more consciously composed when viewed alongside the subsequent painting *Portrait of John Edwards* 1988 (p.244); the bookshelf translates quite literally into the rectangle of black behind Edwards's profile.

42 Harrison 2005, p.177.

43 Sylvester 2000, p.54.

44 Bacon, May 1966, in Sylvester 1993, p.57.

45 Harrison 2005, p.4.

46 Bacon, 1984–6, in Sylvester 1993, p.190.

47 Harrison 2005, pp.1–6.

48 Bacon, May 1966, in Sylvester 1993, p.59.

49 Ibid. p.63.

PORTRAIT

1 Moraes, *Henrietta*, London 1994, pp.71–3.

2 Harrison 2005, pp.163–8.

3 Melville, manuscript notes on paintings by Bacon, late 1960s, Robert Melville Papers, TGA 948.

4 Bacon, 1971–3, in Sylvester 1993, p.78.

5 Examples survive in the Francis Bacon Studio archive at Dublin City Gallery The Hugh Lane.

6 For example, the first 'colour supplement' magazine accompanied *The Sunday Times* on 4 Feb. 1962.

7 Bacon, May 1966, in Sylvester 1993, p.40.

8 Bacon, Oct. 1962, in Sylvester 1993, p.28.

9 See 'Memorial', pp.201–5.

10 Bacon, May 1966, in Sylvester 1993, p.47.

11 Although Bacon described the inspiration for this work as 'a paratrooper [I had] staying who was a magnificent specimen,' the facial features seem to identify the sitter as Dyer; quoted in Hugh M. Davies, 'Bacon Material', unpublished typescript, spring 1973, private collection.

12 Ibid. pp.11–12.

13 Ibid. p.29.

14 T.S. Eliot, *The Love Song of J. Alfred Prufrock*, 1917, lines 57–60.

MEMORIAL

1 Bacon, Dec. 1971 [?], in Sylvester 1993, p.76; Sylvester merged sessions, though indicating that this is the first.

2 Bacon, Dec. 1971, in ibid. pp.71–2.

3 'Postscript' in Russell, *Francis Bacon*, London 1979, p.151.

4 The discussion that established the lineage of works was Hugh M. Davies, 'Bacon's "Black" Triptychs', *Art in America*, vol.63, no.2, March–April 1975.

5 For the contrasting characters of Hall and Lacy, see Sylvester 2000, p.70.

6 See 'Portrait', in this volume, pp.182–5.

7 Bacon, May 1966, in Sylvester 1993, p.40. Bacon's 1960 portrait of Cecil Beaton, which he destroyed, seems to have been the last to have been painted from the sitter; see Richard Buckle (ed.), *Self-Portrait with Friends: The Selected Diaries of Cecil Beaton, 1926–1974*, London 1979, p.324.

8 Bacon, April 1975, in Sylvester 1993, pp.129–30.

9 See the drawings in the Tate Collection, in Tate 1999.

10 Sylvester later saw this figure as 'a human body paroxysmal in sex or

death', in Achille Bonito Oliva (ed.), *Figurabile: Francis Bacon*, exh. cat., Museo Correr, Venice 1993, p.68.

11 The rail is the alizarin/ green polarity that Bacon favoured; the solidity of the rail in the right-hand panel would suggest that the more tentative left panel was painted first.

12 An observation first made by Chris Stephens in conversation in front of the work. Deakin's photograph (Harrison 2005, p.182, fig.201) provided the source for the profile.

13 The over-laying of pink might suggest that this served to integrate a near-completed work into the triptych once the side panels were complete.

14 Peppiatt 1996, pp.249–50.

15 'Ash Wednesday', Section 3, lines 5–6, in T.S. Eliot, *The Waste Land and Other Poems* (1940), London 1972, pp.58–9. The reference is noted in Armin Zweite (ed.), *Francis Bacon; The Violence of the Real*, exh. cat., K20 Kunstsammlung Nordrhein-Westfalen, Düsseldorf 2006, p.199.

16 *The Waste Land* (1922), lines 411–14, in Eliot 1972, p.43. See the discussion of its reuse in relation to *Painting* 1978 in 'Epic' in this volume, pp.213–14.

17 This was the facsimile edition with Ezra Pound's annotations, published in 1971, according to Sylvester 2000, p.136.

18 See Anne Baldassari, *Bacon Picasso: The Life of Images*, Paris 2005.

19 Davies 1975; see also Davies and Sally Yard, *Francis Bacon*, New York 1986.

20 For example, Harrison 2005, p.184. Martin Harrison's recent findings indicate that the folds of these and other photographs in the studio were not by chance, but show Bacon 'transforming these single-plane images into three-dimensional objects' ('Francis Bacon: Extreme Points of Realism', in Kunstsammlung Nordrhein-Westfalen 2006, p.49).

21 Bacon, Dec. 1971, in Sylvester 1993, p.83.

22 Sylvester in Museo Correr 1993, p.68.

23 Muybridge, *The Human Figure in Motion*, London 1901, p.75.

24 Sylvester 2000, p.136.

25 Originally proposed in Davies 1975, p.63.

26 *Triptych, March 1974* was counted among the 'black triptychs' in Davies and Yard 1986, p.78; Sylvester identified *Triptych 1974–7* as containing Dyer, in Museo Correr 1993, p.68.

27 Peppiatt 1996, p.247.

28 'Francis Bacon: Remarks from an Interview with Peter Beard', in *Francis Bacon: Recent Paintings 1968–1974*, exh. cat., The Metropolitan Museum of Art, New York 1975, p.15.

EPIC

1 Bacon in Davies, 'Bacon Material', unpublished typescript, spring 1973, private collection.
2 Bacon in ibid. p.8.
3 Læssøe, 'Francis Bacon and T.S. Eliot', *Hafnia Copenhagen Papers in the History of Art*, no.9, 1983, pp.116–17.
4 T.S. Eliot, 'Fragment of an Agon', in *Sweeney Agonistes: Fragments of an Aristophanic Melodrama*, London 1932, p.25.
5 Raine, 'The Poet of Our Time', in R. Marsh and Tambimuttu (eds.), *T.S. Eliot*, London 1948, p.78.
6 Bacon, 1979, in Sylvester 1993, p.152.
7 Bacon, letter in French to Leiris, n.d. (between 11 Jan. and 27 March 1978), in Bibliothèque Littéraire Jacques Doucet, Paris, published in *Francis Bacon: Triptychs*, exh. cat., Gagosian Gallery, London 2006, p.26.
8 Eliot, *The Waste Land* (1922), lines 411–16.
9 Eliot, *Ash Wednesday*, section III, lines 5–6.
10 T.S. Eliot, 'Fragment of an Agon', in Eliot 1932, pp.30–1.
11 Bacon, May 1966, in Sylvester 1993, pp.64–5.
12 Eliot, *The Family Reunion*, London 1939, p.28.
13 Bacon, 1971/1973, in Sylvester 1993, p.76.
14 Davies 1973, p.22.
15 There is also a disputed work from c.1930 (private collection), which some have suggested is more likely to be a portrait of Bacon by Roy De Maistre, and an undisputed pastel from around that time has, in the past, been exhibited as a self-portrait (private collection).
16 Eliot 1939, p.62.
17 Dr Paul Brass, in conversation with the author, 4 July 2007.
18 See List, 11 Dec. 1958, Tate 1999, p.78.
19 Bacon, 1984–6, in Sylvester 1993, p.197.
20 Bacon, letter to Leiris, 3 April 1976, in *Francis Bacon: Triptychs* 2006, p.23.
21 *Oresteia*, trans. Philip Vellacott, Harmondsworth 1958, p.67.
22 Ibid. p.73.
23 Ibid. p.88.
24 Ibid. p.106.
25 Bacon, letter to Leiris, 20 Nov. 1981, in *Francis Bacon: Triptychs* 2006, p.30.
26 Lorca, *Selected Poems*, trans. J.L. Gili, Harmondsworth 1960, p.101.
27 Michael Peppiatt, 'Francis Bacon: Reality Conveyed by a Lie', *Art International*, autumn 1987, p.30.
28 'Rafaelillo at Nîmes October 9' (1939), republished in Leiris, *Brisées*, Paris 1966 and trans. Lydia Davis as *Brisées: Broken Branches*, San Francisco 1989, p.59.
29 See 'On the Margin of the Impossible' in this volume, pp.20–1.
30 Davies 1973.

LATE

1 Bacon, May 1966, in Sylvester 1993, pp.59–60.
2 F[ritz] Novotny, 'The Late Landscape Paintings', in William Rubin (ed.), *Cézanne: The Late Work*, exh. cat., MoMA, New York 1977, p.107. Lawrence Gowing, a friend of Bacon's, contributed to this publication, interestingly identifying Cézanne's 'Moses syndrome', an awareness of a goal with a diminishing time in which it might be completed; see Gowing, 'The Logic of Organized Sensations', ibid. p.63.
3 Peppiatt 1996, p.288.
4 'Francis Bacon: Remarks from an Interview with Peter Beard', ed. Henry Geldzahler, in *Francis Bacon: Recent Paintings 1968-1974*, exh. cat., The Metropolitan Museum of Art, New York 1975, p.15.
5 Bacon in Archimbaud 1993, p.153.
6 Linda Nochlin, 'Old-Age Style: Late Louise Bourgeois', in Frances Morris (ed.), *Louise Bourgeois*, exh. cat., Tate Modern, London 2007, pp.188–9; see also two discussions cited by Nochlin, Karen Painter and Thomas Crow (eds.), *Late Thoughts*, Los Angeles 2006, and Edward W. Said, *On Late Style: Music and Literature Against the Grain*, New York 2006.
7 David Sylvester, 'End Game', in *Late Picasso*, exh. cat., Centre Georges Pompidou, Paris, and Tate Gallery, London 1988, p.137.
8 See Margarita Cappock, 'Bacon and Ingres', *Francis Bacon and the Tradition of Art*, exh. cat., Kunsthistorisches Museum, Vienna 2003, p.247.
9 Sylvester 2000, p.162.
10 Ibid. p.162.
11 *Triptych* 1987 (pp.230–1) and *Triptych* 1991 (pp.250–1).
12 Archimbaud 1993, p.166.
13 Sylvester, 'Bacon's Course', in Achille Bonito Oliva (ed.), *Figurabile: Francis Bacon*, exh. cat., Museo Correr, Venice 1993, p.82.
14 'Crucifixion' in this volume, p.137.
15 Bacon in The Metropolitan Museum of Art 1975, p.15.
16 Margarita Cappock, '"The Chemist's Laboratory": Francis Bacon's Studio', in Kunsthistorisches Museum 2003, p.91.
17 Bacon in Michael Peppiatt, 'Provoking Accidents, Prompting Chance: An Interview with Francis Bacon', in *Art International*, no.8, autumn 1989, p.32.
18 Russell 1993, p.17, and cited in 'Crucifixion' in this volume, p.137.
19 Harrison, 'Francis Bacon: Triptych (1987)', unpublished paper, Dec. 2007.
20 Bacon in Sylvester 2000, p.175.
21 Bacon, 1979, in Sylvester 1993, p.161.
22 Ibid. p.162.
23 Peppiatt 1996, p.303.
24 Bacon, 1979, in Sylvester 1993, pp.162–4.
25 Bacon in Peppiatt 1989, p.32.
26 Bacon, 1971/3, in Sylvester 1993, p.81.
27 see www.jameshymanfineart.com/pages/archive/information
28 Lewison, 'Review: Francis Bacon. Venice', *The Burlington Magazine*, vol.135, no.1088, Nov. 1993, p.781.
29 Bacon in The Metropolitan Museum of Art 1975, p.16.
30 Bacon, May 1966, in Sylvester 1993, p.59.
31 Gilles Deleuze, 'Interpretations of the Body: A New Power of Laughter for the Living', in *Art International*, no.8, autumn 1989, p.34.
32 Harrison 2005, p.234.
33 Harrison 2007.
34 Bacon quoted in Armin Zweite (ed.), *Francis Bacon: The Violence of the Real*, London, p.194.
35 Bacon, 1971/3, in Sylvester 1993, p.82.

CHRONOLOGY

1 The original draft of the Chronology was compiled by Sophie Shaw, to whom the editors are very grateful.
2 Bacon, 1984–6, in Sylvester 1993, p.184.
3 Bacon in Archimbaud 1993, pp.84, 86.
4 Bacon, 1984–6, in Sylvester 1993, p.184.
5 Bacon in Archimbaud 1993, p.116.
6 Bacon, interview with Jean Clair, 3 Aug. 1991, in Gérard Régnier, *Corps Crucifiés*, exh. cat., Musée Picasso, Paris 1992, p.141.
7 Bacon, 1984–6, in Sylvester 1993, p.186.
8 Bacon, May 1966, in Sylvester 1993, pp.34–5.
9 Bacon quoted in Hugh M. Davies, 'Bacon Material', unpublished typescript, spring 1973, private collection.
10 Patrick White, *Flaws in the Glass: A Self-Portrait*, London 1981, p.62; quoted in Peppiatt 1996, p.50.
11 Anon., 'Mr Francis Bacon', *The Times*, 16 Feb. 1934.
12 Bacon in Archimbaud 1993, p.128.
13 Michael Wishart, *High Diver*, London 1978, p.61.
14 Raymond Mortimer, 'At the Lefevre', *New Statesman and Nation*, 14 April 1945, p.239.
15 Bacon to Sutherland, 19 Oct. [1946], Graham Sutherland Papers, NMGW, published in Hammer 2005, p.237.
16 Benedict Nicolson's diary, 13 Feb. 1947, cited in Hammer 2005, p.36.
17 Isabel Rawsthorne, letter to Peter Rose Pulham, 3 July [?1949], Rawsthorne Papers, TGA 8612.1.3.21.
18 Melville, 'Francis Bacon', *Horizon*, vol.20, nos.120–1, Dec.1949–Jan.1950, p.421.
19 Rawsthorne, letter to Pulham, 15 Dec. [c.1947–51], Rawsthorne Papers, TGA 9612.1.3.59.
20 Rawsthorne, letter to Pulham, 29 Aug. [?1949], Rawsthorne Papers, TGA 9612.1.3.28.
21 Belle Krasne, 'Visiting Team of British Artist Goes to Bat on a Sticky Wicket', *Art Digest*, vol. 25, no. 2, 15 October 1950, p. 7.
22 Bacon, letter to Erica Brausen, 22 Feb. 1951, Hanover Gallery Papers, TGA 863.6.
23 Albert Herbert, 'Francis Bacon at the Royal College of Art 1951–52', TGA 991.47.
24 Michael Middleton, 'Work in Progress', *Art News and Review*, vol.3, no.24, Dec. 1951, p.4.
25 Sam Hunter, 'Francis Bacon: The Anatomy of Horror', *Magazine of Art*, vol.45, no.1, Jan. 1952, p.14.
26 Rawsthorne, letter to Pulham, 30 Nov. [1952], Rawsthorne Papers, TGA 9612.1.3.93.
27 Bacon, interview, *Time*, 1952, extract in *The New Decade: 22 European Painters and Sculptors*, exh. cat., MoMA, New York 1955, p.63.
28 Andrew Forge recalling Bacon at the Slade, interview by Cathy Courtney for the National Life Story Collection of the British Library National Sound Archive, 25 May 1995, TGA TAV 1913b.
29 Bacon, 'Statement', in *Matthew Smith: Paintings from 1909 to 1952*, exh. cat., Tate Gallery, London 1953, p.12.
30 David Sylvester, 'Francis Bacon', in *The British Pavilion: Exhibition of Works by Nicholson, Bacon, Freud*, Venice XXVII Biennale, Venice 1954.
31 Max Clarac-Sérou, *Francis Bacon*, exh. cat., ICA, London 1955.
32 Bacon, in *The New Decade* 1955, p.63.
33 Bacon, interview with Jean Clair, 3 Aug. 1991, in *Corps Crucifiés*, Musée Picasso, Paris 1992, p.142.
34 Forge 1995.
35 John Golding, 'Lust for Death', in *New Statesman and Nation*, vol.53, no.1360, 6 April 1957, p.438.
36 Paul Bowles to Sonia Orwell (1957), UCL.
37 Questionnaire, sent 12 Dec. 1959, and the answers, which were generated by a discussion between Bacon, Melville and Marlborough's Harry Fischer, returned 21 Jan. 1960, Melville papers, TGA 948.
38 William Redgrave's journal, 11 Dec. 1959, private collection.
39 Bacon to Beaton, reported in Richard Buckle (ed.), *Self-Portrait with Friends:*

The Selected Diaries of Cecil Beaton, 1926–1974, London 1979, p.324.

40 Bacon, May 1966, in Sylvester 2000, p.246.

41 Melville, on the central panel of *Three Studies for a Crucifixion*, 1962, manuscript notes on Bacon paintings, late 1960s, Melville papers, TGA 948.

42 Bacon in Michael Peppiatt, 'From a Conversation with Francis Bacon', in *Cambridge Opinion*, no.37, 1963.

43 Lawrence Alloway, 'Introduction', *Francis Bacon*, exh. cat., Solomon R. Guggenheim Museum, New York 1963, p.13.

44 Bacon, 1979, in Sylvester 2000, p.246.

45 Hugh M. Davies, 'Bacon Material', unpublished typescript, spring 1973, p.4 (private collection).

46 Michel Leiris, 'What Francis Bacon's Paintings Say to Me', trans. Sonia Orwell, in *Francis Bacon: Recent Paintings*, exh. cat., Marlborough Fine Art, London 1967, p.23.

47 'Clement Greenberg; Interview Conducted by Edward Lucie-Smith', in *Studio International*, Jan. 1968; reprinted in John O'Brian (ed.), *Clement Greenberg: The Collected Essays and Criticism, vol.4, Modernism with a Vengeance, 1957–1969*, London 1993, p.278.

48 Bacon, 1971, in Sylvester 2000, p.246.

49 Bacon, 1973, in Sylvester 2000, p.240.

50 Harry Geldzahler, 'Introduction', in *Francis Bacon: Recent Paintings 1968–1974*, exh. cat., The Metropolitan Museum of Art, New York 1975, p.6.

51 Bacon to Michel Leiris, 16 Sept. 1981, modified version of trans. from Bacon's French in Bibliothèque Littéraire Jacques Doucet, Paris; published in 'Francis Bacon: Letters to Michel Leiris 1966–1989', in *Francis Bacon: Triptychs*, exh. cat., Gagosian Gallery, London 2006, p.29.

52 Bacon to Michel Leiris, 20 Nov. 1981, ibid. p.31.

53 Michel Leiris, *Francis Bacon, face et profil*, Paris, Munich and Milan 1983, trans. John Weightman as *Francis Bacon: Full Face and in Profile*, Oxford 1983, p.44.

54 Dawn Ades, in Tate 1985, p.14.

55 Bacon in *Francis Bacon*, exh. cat., New Tretyakov Gallery, Moscow 1988, p.5.

56 Bacon in Michael Peppiatt, 'An Interview with Francis Bacon: Provoking Accidents, Prompting Chance', *Art International*, Paris, autumn 1989, pp.28–33.

57 Bacon in Archimbaud 1993, p.12.

58 Bacon to Louis le Brocquy, 20 Mar. 1992, The Francis Bacon Studio archive of Dublin City Gallery The Hugh Lane Gallery, published in Cappock 2005, p.154.

LIST OF WORKS

Dimensions are given in centimetres, height before width

PAINTINGS

Crucifixion
1933, oil on canvas, 60.5 × 47
Murderme, London
p.145

Three Studies for Figures at the Base of a Crucifixion
c.1944, oil on board
Triptych, each panel 94 × 73.7
Tate. Presented by Eric Hall 1953
p.146–7

Figure in a Landscape
1945, oil on canvas, 144.8 × 128.3
Tate. Purchased 1950
p.97

Figure Study I
1945–6, oil on canvas, 123 × 105.5
Scottish National Gallery of Modern Art, Edinburgh. Accepted by H.M. Government in lieu of inheritance tax on the Estate of Gabrielle Keiller and allocated to the Scottish National Gallery of Modern Art in 1998
p.98

Figure Study II
1945–6, oil on canvas, 145 × 129
Huddersfield Art Gallery
p.99

Painting
1946, oil and pastel on linen, 197.8 × 132.1
The Museum of Modern Art, New York
(New York only)
p.101

Head I
1947–8, oil and tempera on board, 100.3 × 74.9
Lent by the Metropolitan Museum of Art, Bequest of Richard S. Zeisler, 2007.
p.102

Head II
1949, oil on canvas, 80 × 63.3
Ulster Museum, Belfast. Gift of the Contemporary Art Society London
p.103

Head VI
1949, oil on canvas, 93.2 × 76.5
Arts Council Collection, Southbank Centre, London
p.104

Study from the Human Body
1949, oil on canvas, 147 × 134.2
National Gallery of Victoria, Melbourne, Australia. Purchased 1953
p.105

Study after Velázquez
1950, oil on canvas, 197.8 × 137.4
Private collection to The Steven and Alexandra Cohen Collection
p.112

Pope I – Study after Pope Innocent X by Velázquez
1951, oil on canvas, 197.8 × 137.4
Aberdeen Art Gallery & Museums Collections
p.114

Study for Nude
1951, oil on canvas, 198 × 137
Collection of Samuel and Ronnie Heyman
(London and New York)
p.115

Study of a Dog
1952, oil on canvas, 198.1 × 137.2
Tate. Presented by Eric Hall 1952
p.113

Study for Crouching Nude
1952, oil on canvas, 198 × 137.2
The Detroit Institute of Arts. Gift of Dr Wilhelm R. Valentiner
p.118

Study of a Figure in a Landscape
1952, oil on canvas, 198.1 × 137.2
The Phillips Collection, Washington D.C.
(New York only)
p.117

Untitled (Two Figures in the Grass)
c.1952, oil on canvas, 147.3 × 132.2
The Estate of Francis Bacon, London, courtesy Faggionato Fine Arts, London and Tony Shafrazi Gallery, New York
p.158

Study of a Nude
1952–3, oil on canvas, 59.7 × 49.5
Robert and Lisa Sainsbury Collection, University of East Anglia, Norwich
p.125

Man with Dog
1953, oil on canvas, 152 × 117
Albright-Knox Art Gallery Buffalo. Gift of Seymour H. Knox, Jr., 1955
p.130

Study after Velázquez's Portrait of Pope Innocent X
1953, oil on canvas, 153 × 118
Purchased with funds from the Coffin Fine Arts Trust; Nathan Emory Coffin Collection of the Des Moines Art Center
p.119

Study for a Portrait
1953, oil on canvas, 152.2 × 118
Hamburger Kunsthalle
p.126

Study for a Portrait
1953, oil on canvas, 198 × 137
Hess Art Collection, Berne
p.131

Study for Portrait I
1953, oil on canvas, 152.1 × 118.1
Denise and Andrew Saul
(New York only)
p.128

Study of a Baboon
1953, oil on canvas, 198.3 × 137.3
The Museum of Modern Art, New York. James Thrall Soby Bequest, 1979
p.127

Study for Figure II
1953–4, oil on canvas, 198 × 137
The Collection of Mr. and Mrs. J. Tomilson Hill, New York
(London and New York)
p.129

Man in Blue IV
1954, oil on canvas, 198 × 137
Museum Moderner Kunst Stiftung Ludwig, Vienna, on loan from the Austrian Ludwig Collection
p.133

Man in Blue V
1954, oil on canvas, 198 × 137
Kunstsammlung Nordrhein-Westfalen, Düsseldorf
p.132

Two Figures in the Grass
1954, oil on canvas, 152 × 117
Private collection
(London only)
p.134

Chimpanzee
1955, oil on canvas, 152.5 × 117
Staatsgalerie Stuttgart
p.135

Study for Portrait II (after the Life Mask of William Blake)
1955, oil on canvas, 61 × 50.8
Tate. Purchased 1979
p.157

Figure in a Mountain Landscape
1956, oil on canvas, 152 × 119
Kunsthaus, Zurich
p.160

Figures in a Landscape
1956–7, oil on canvas, 150 × 107.5
Birmingham Museums & Art Gallery. Presented by the Contemporary Art Society, 1959
p.159

Study for Portrait of Van Gogh VI
1957, oil on canvas, 198.1 × 142.2
Arts Council Collection, Southbank Centre, London
p.161

Study for the Nurse from the Battleship Potemkin
1957, oil on canvas, 198 × 142
Städel Museum, Frankfurt am Main
p.162

Paralytic Child Walking on All Fours (from Muybridge)
1961, oil on canvas, 198 × 142
Collection Gemeentemuseum Den Haag, The Hague, Netherlands
p.163

Three Studies for a Crucifixion
1962, oil on canvas
Triptych, each panel 198.2 × 144.8
Solomon R. Guggenheim Museum, New York
p.148–9

Landscape near Malabata, Tangier
1963, oil on canvas, 198 × 145
Private collection, London
p.187

Three Studies for a Portrait of George Dyer
1963, oil on canvas
Triptych, each panel 35.3 × 35.5
Private Collection
p.186

Three Figures in a Room
1964, oil on canvas
Triptych, each panel 198 × 147.5
Centre Pompidou, Paris. Musée national d'art moderne / Centre de création industrielle
p.188–9

Crucifixion
1965, oil on canvas
Triptych, each panel 198 × 147.5
Bayerische Staatsgemäldesammlungen,
Pinakothek der Moderne, Munich
(London and Madrid)
p.150–1

Study from Portrait of Pope
Innocent X
1965, oil on canvas, 198 × 147.5
Private collection
(London and Madrid)
p.190

Portrait of George Dyer Riding
a Bicycle
1966, oil on canvas, 198 × 147.5
Fondation Beyeler, Riehen/Basel
p.195

Portrait of Isabel Rawsthorne
1966, oil on canvas, 81.3 × 68.6
Tate. Purchased 1966
p.191

Henrietta Moraes
1966, oil on canvas, 146 × 152
Private collection
p.192

Triptych – Inspired by
T.S. Eliot's Poem
'Sweeney Agonistes'
1967, oil on canvas
Triptych, each panel 198 × 147.5
Hirshhorn Museum and Sculpture
Garden, Smithsonian Institution,
Washington D.C. Gift of the Joseph H.
Hirshhorn Foundation, 1972
p.220–1

Study for Head of George Dyer
1967, oil on canvas, 35.8 × 30.4
Private collection
p.194

Portrait of Isabel Rawsthorne
Standing in a Street in Soho
1967, oil on canvas, 198 × 147.5
Staatliche Museen zu Berlin,
Nationalgalerie
p.193

Study of George Dyer in
a Mirror
1968, oil on canvas, 198 × 147.5
Museo Thyssen-Bornemisza, Madrid
p.197

Two Studies for a Portrait
of George Dyer
1968, oil on canvas, 198 × 147.5
Sara Hildén Foundation/Sara Hildén Art
Museum, Tampere, Finland
p.196

Lying Figure
1969, oil on canvas, 198 × 147.5
Fondation Beyeler, Riehen/Basel
p.199

Three Studies for Portraits
including Self-Portrait
1969, oil on canvas
Triptych, each panel 35.5 × 30.5
Private collection
p.198

Triptych – In Memory
of George Dyer
1971, oil on canvas
Triptych, each panel 198 × 147.5
Fondation Beyeler, Riehen/Basel
p.206–7

Triptych – August 1972
1972, oil on canvas
Triptych, each panel 198 × 147.5
Tate. Purchased 1980
p.208–9

Triptych May – June 1973
1973, oil on canvas
Triptych, each panel 198 × 147.5
Private collection, Switzerland
(London only)
p.210–11

Self-Portrait with a Watch
1973, oil on canvas, 198 × 147.5
Private collection
p.222

Portrait of Michel Leiris
1976, oil on canvas, 34 x 29
Centre Pompidou, Paris. Musée national
d'art moderne / Centre de création
industrielle. Gift of Louise and Michel
Leiris 1984
(New York only)
p.239

Triptych
1976, oil and pastel on canvas
Triptych, each panel 198 × 147.5
Private collection
(London only)
p.224–5

Self-Portrait
1973, oil on canvas, 198 × 147.5
Private collection courtesy of
Richard Nagy Ltd., London
(New York only)
p.223

Painting
1978, oil on canvas, 198 × 147.5
Private collection, London
(London only)
p.227

Three Studies for a
Self-Portrait
1979–80, oil on canvas
Triptych, each panel 37.5 × 31.8
The Metropolitan Museum of Art, New
York. The Jacques and Natasha Gelman
Collection, 1998
p.238

Triptych – Inspired by the
Oresteia of Aeschylus
1981, oil on canvas
Triptych, each panel 198 × 147.5
Astrup Fearnley Collection, Oslo,
Norway
p.228–9

Study from the Human Body
1981, oil on canvas, 198 × 147.5
Private collection
p.242

A Piece of Waste Land
1982, oil on canvas, 198 × 147.5
Private collection
(New York only)
p.219

Triptych
1983, oil and pastel on canvas
Triptych, each panel 198 × 147.5
Colección Juan Abelló
(Madrid only)
p.240–1

Figure in Movement
1985, oil on canvas, 198 × 147.5
Lent to Tate from a private collection
2000
p.243

Triptych
1987, oil on canvas
Triptych, each panel 198 × 147.5
The Estate of Francis Bacon, London,
courtesy Faggionato Fine Arts, London
p.230–1

Blood on Pavement
c.1988, oil on canvas, 198 × 147.5
Private collection
p.247

Portrait of John Edwards
1988, oil on canvas, 198 × 147.5
The Estate of Francis Bacon, London,
courtesy Faggionato Fine Arts, London
and Tony Shafrazi Gallery New York
p.244

Jet of Water
1988, oil on canvas, 198 × 147.5
The Collection of Mr. and Mrs. J.
Tomilson Hill, New York
(London and New York)
p.245

Second Version of Triptych
1944
1988, oil and acrylic on canvas
Triptych, each panel 198 × 147.5
Tate. Presented by the artist 1991
p.248–9

Triptych
1991, oil on linen
Triptych, each panel 198.1 × 147.6
The Museum of Modern Art, New York.
William A.M. Burden Fund and Nelson
A. Rockerfeller Bequest Fund (both by
exchange), 2003
p.250–1

ARCHIVE

The following works are exhibited in London. The selection varies in Madrid and New York.

Dimensions are given in centimetres, height before width.

Entries are followed by the lender's accession numbers:
HL = Dublin City Gallery The Hugh Lane
EFB = Estate of Francis Bacon, London, courtesy Faggionato Fine Arts, London and Tony Shafrazi Gallery, New York
TGA = Tate Gallery Archive

A MATRIX OF IMAGES

Sam Hunter, three photographs of material from Francis Bacon's studio (exhibition prints), c.1950s

Sam Hunter, photomontage, c.1950s

Leaf showing images of severed and shattered limbs from *The true aspects of the Algerian Revolution*, produced by French Ministry of Algeria, late 1957, 23.8 × 16 [HL 12:26]

Images du Monde (10) 27 Aug.–2 Sept. 1955, 7 × 35 [TGA 9810/6]

Leaf from unidentified French magazine showing dead bodies in a damaged interior, 1970s–1980s, c.30.2 × 23.2

Leaf from unidentified French magazine showing scene of a massacre, probably in Zaire, date unknown, c.30.2 × 23 [HL 23.6]

Overpainted and mounted leaf with still of screaming nurse from Sergei Eisenstein's *Battleship Potemkin*, date unknown, 16 × 17 [HL 15.11]

Mounted leaf with still from Alain Resnais's *Hiroshima mon Amour* (1959), date unknown, 32.4 × 24.8 [HL 12.13]

Three mounted cuttings on board: one showing a painting of two lovers, one Eadweard Muybridge's wrestlers, Bacon's *Painting* (1946), paper fragments with a needle, date unknown, c.29.3 × 40.1 [HL IA:40]

Illustration of Viktor Bulla's photograph of Nevsky Prospekt demonstrators being fired on in Petrograd, 17 July 1917 [TGA 200816]

Leaf with illustrations concerned with the spine, from K. C. Clark's *Positioning in Radiography* (c.1939), 29.1 × 22.7 [HL 114.46]

Overpainted reproduction of Bacon's *Study for Crouching Nude* (1952), 1964 [HL 1:18]

Overpainted reproduction of Bacon's *Figures in a Landscape* (1956), date unknown [HL 22:47]

THE PHYSICAL BODY

Plate 69 from Eadweard Muybridge, *The Human Figure in Motion* (1955 ed.), 19.7 × 27.3 [HL 16.54]

Plate 60* from Eadweard Muybridge, *The Human Figure in Motion* (1955 ed.), 20 × 27.3 [HL 1.34]

Mounted and overpainted plate *4 from Eadweard Muybridge, *The Human Figure in Motion* (1955 ed.), 21 × 33 [HL 8:19]

Page 183 from Eadweard Muybridge, *The Human Figure in Motion* (1955 ed.) inscribed by Bacon, 'Make shadow into separate unit', date unknown, 31 × 23.5 [HL 1:59]

Overpainted plate 124 from Eadweard Muybridge, *The Human Figure in Motion* (1955 ed.), 27 × 19.6 [HL 105:147]

Leaf from unidentified book with reproduction of a study by Michelangelo for an *ignudo* for the Sistine Chapel Ceiling 1508–12, date unknown, 31.7 × 23.3 [HL 108:42]

Unknown photographer, contact sheets of wrestlers, c.1975, gelatin silver print, 40 × 50.5, courtesy Michael Hoppen Gallery, London, UK

Overpainted magazine page showing 'Jack Dempsey', 27.5 × 20.8 [TGA 9810/8]

Overpainted magazine page showing 'Carpentier Bogeyman to British Heavyweights: Joe Beckett v Georges Carpentier', 27.5 × 20.8 [TGA 9810/8]

Mounted photograph of boxers, cut from a book, date unknown, 28.5 × 21.5 [EFB Studio item 25]

Magazine page showing Spanish bull fighter, Llego la Cornada, date unknown, 31.8 × 23 [EFB Studio item 4]

Photograph of bullfighter Manuel Granero killed in the Madrid ring, date unknown, 14.5 × 21.6 [EFB Studio item 26]

Mounted leaf from unidentified book with colour illustration of three cricketers, '2nd test India V Calcutta', date unknown, 30.4 × 38.8 [HL IA:70]

Nigel Henderson, *Stressed Photograph of Bathers*, gelatin silver print, 1950, 12.7 × 89 [EFB Studio item 40]

Two naked photographs of wounded men, date unknown, c.6 × 10 [HL IA: 138D, IA:138F]

LISTS AND DRAWINGS

V.J. Staněk, *Introducing Monkeys* (London c.1957), with handwritten lists of works, 11, 13, 17 Dec. 1958 , 28.4 × 21.2 [TGA 9810/5]

V.J. Staněk, *Introducing Monkeys*, trans. G. Theiner (London c.1957), with handwritten lists of works, Aug.–Sept. 1958, 28.4 × 21.2 [HL FIA:151]

Loose leaf of handwritten notes entitled 'The Series of Nudes', 10 Dec.1957, 28.4 × 21.2 [TGA 981015]

Sketch and handwritten list of works on leaf from Eadweard Muybridge, *The Human Figure in Motion* (1955 ed.) 2 Jan 1962, 27.9 × 41.6 , Peter and Nejma Beard

Loose leaf of handwritten notes, date unknown, 22.8 × 17.7 [HL 107:9]

Two leaves with handwritten lists of works, date unknown, each 18 x 11 [TGA 200816]

FRANCIS BACON WORKS ON PAPER

All works on paper are Tate. Purchased with assistance from the National Lottery through the Heritage Lottery Fund, The Art Fund and a group of anonymous donors in memory of Mario Tazzoli 1998

Figure in a Landscape
c.1952, oil on paper, 33.9 × 26.3

Figure with Foot in Hand
c.1957–61, ballpoint pen and oil on paper, 27 × 34

Blue Crawling Figure, No.2
c.1957–61, oil on paper, 34 × 27

Figure with Left Arm Raised, No.1
c.1957–61, oil on paper, 34 × 27

Turning Figure
c.1959–62, pencil and oil on paper, 33.9 × 26.3

Bending Figure, No.2
c.1957–61, ballpoint pen and oil on paper, 34 × 27

Two Owls, No.2
c.1957–61, oil on paper, 34 × 27

Figure in Grey Interior
c.1957–61, pencil and oil on paper, 34 × 27

Figure Lying, No. 1
c.1957–61, oil on paper, 34 × 27

Figure with Left Arm Raised, No. 2
c.1957–61, oil on paper, 34 × 27

Falling Figure
c.1957–61, pencil and oil on paper, 34 × 27

Figure Bending Forwards
c.1957–61, oil on paper, 34 × 27

Figure Lying, No. 2
c.1957–61, oil on paper, 34 × 27

Figure Crawling
c.1957–61, oil on paper, 34 × 27

Pink Crawling Figure
c.1957–61, ballpoint pen and oil on paper, 34 × 27

Blue Crawling Figure, No. 1
c.1957–61, oil on paper, 34 × 27

Composition
c.1957–61, oil on paper, 34 × 27

Reclining Figure, No. 1
c.1961, ballpoint pen and oil on paper, 23.8 × 15.6

Reclining Figure, No. 2
c.1961, ballpoint pen and oil on paper, 22.2 × 15

THE MEDIATED IMAGE

All images below are gelatin silver prints:

Francis Bacon
John Edwards seated in an interior late 1970s, 25.4 × 30.4 [HL RM98BC23]

Francis Bacon
John Edwards by washbasin in 7 Reece Mews with Francis Bacon reflected in mirror, 30.2 × 23.6 [EFB Studio item 32]

Photobooth strip of Bacon
1960s, 20 × 4 [HL 112:37]

Three photobooth strips of Bacon, Dyer and David Plante mounted on book cover
1966–7, 25.9 × 22 [EFB Studio item 34]

Photobooth strip of Bacon
1970s–1980s, 19.8 x 4 [HL 16:248]

Mounted photobooth strip of Bacon
Date unknown, 21.5 × 5.7 [HL 11:12]

Photographer unknown
Portrait of Francis Bacon
c.1972, 23.7 × 17.8 [EFB Studio item 2]

All images below are taken by John Deakin :

Portrait of Peter Lacy
c.1959, 19.5 × 25 [EFB Studio item 14]

Portrait of Peter Lacy
c.1959, 25.5 × 20.7 [EFB Image 3T]

Portrait of Henrietta Moraes
c.1960s, 29.5 × 25 [EFB Image 19T]

Henrietta Moraes lying on a bed
c.1963, 24 × 30 [EFB Image 22T]

Henrietta Moraes on a bed, photographic contact sheet fragment
c.1963, 25.2 × 7.2 [HLIA:107]

Henrietta Moraes on a bed
c.1963, 20.7 × 24.9 [HL 17:124]

George Dyer, cut-out photograph
photograph c.1964, date of cut-out unknown, c.22.7 × 15.2 [HL 130:82]

George Dyer seated in Bacon's studio
c.1964, 30.3 × 30.2 [HL IA:161]

George Dyer
c.1964, 30.2 × 30.4 [HL 149:81]

George Dyer and Francis Bacon in Soho
c.1960, 30 × 24 cm [EFB Studio item 36]

Portrait of George Dyer
c.1960s [EFB Image 5T]

George Dyer standing in Bacon's studio
c.1965 [EFB Studio item 28]

George Dyer standing in Bacon's Studio (leaning)
c.1965, 30.3 × 30.5

Lucian Freud on a bed
c.1964, 29.7 × 30.3 [EFB Image 20T]

Lucian Freud on a bed
c.1964, 29.8 × 30.3 [EFB Image 13T]

Lucian Freud on a bed
c.1964, 30 × 29.3 [EFB Image 14T]

Lucian Freud on a bed
c.1964, 29.8 × 29.2 [EFB Image 07T]

Isabel Rawsthorne in Dean St, Soho
c.1965, 30.3 × 30.5 [EFB Image 09T]

Isabel Rawsthorne in Dean St, Soho
c.1965, 30.5 × 30.3 [EFB Image 26T]

Isabel Rawsthorne in Dean St, Soho
c.1965 [EFB Image 04T]

Isabel Rawsthorne in Dean St, Soho
c.1965, 30.5 × 30.3 [EFB Image 24T]

Muriel Belcher
c.1965 [EFB Image 23T]

Muriel Belcher
c.1965 [EFB Image 06T]

LIST OF LENDERS

PUBLIC COLLECTIONS

Aberdeen Art Gallery & Museums Collections
Staatliche Museen zu Berlin, Nationalgalerie
Birmingham Museums & Art Gallery
Ulster Museum, Belfast
Collection Albright-Knox Art Gallery Buffalo, New York
Collection Gemeentemuseum Den Haag, The Hague, Netherlands
Des Moines Art Centre
The Detroit Institute of Arts
Dublin City Gallery, The Hugh Lane Archive
Kunstsammlung Nordrhein-Westfalen, Düsseldorf
Scottish National Gallery of Modern Art, Edinburgh
Städel Museum, Frankfurt am Main
Museum für Moderne Kunst, Frankfurt
Hamburger Kunsthalle
Huddersfield Art Gallery
Pinacothek der Moderne, Munich
Astrup Fearnley Collection, Oslo, Norway
Centre Georges Pompidou, Paris Musée national d'art moderne /
 Centre de création industrielle
Arts Council Collection, Southbank Centre, London
Tate, London
Museo Thyssen-Bornemisza, Madrid
National Gallery of Victoria, Melbourne
The Metropolitan Museum of Art, New York
The Museum of Modern Art, New York.
Solomon R. Guggenheim Museum, New York
Robert and Lisa Sainsbury Collection, University of East Anglia, Norwich
Fondation Beyeler, Riehen/Basel
Staatsgalerie Stuttgart
Sara Hildén Foundation/Sara Hildén Art Museum, Tampere
Hirshhorn Museum and Sculpture Garden,
 Smithsonian Institution, Washington, D.C.
The Phillips Collection, Washington, D.C.
Museum Moderner Kunst Stiftung Ludwig Wien,
 on loan from the Austrian Ludwig Collection
Kunsthaus, Zürich

PRIVATE COLLECTIONS / GALLERIES

Colección Juan Abelló
Private collection to The Steven and Alexandra Cohen Collection
Collection of Samuel and Ronnie Heyman
Estate of Francis Bacon, London, courtesy of Faggionato Fine Arts, London
 and Tony Shafrazi Gallery, New York
Peter and Nejma Beard
Hess Art Collection, Berne
Collection of Mr. and Mrs. J. Tomilson Hill
Michael Hoppen Gallery, London
Murderme, London
Private collection, London
Private collection, Switzerland

and other private lenders who wish to remain anonymous

INDEX

Page numbers in *italic* type refer to plates.

Abstract Expressionism 14, 24, 30,
34, 37, 121, 154, 182
abstraction 34, 85, 86, 121, 182
Ades, Dawn 74, 137
Adonis magazine 67, 70
Adorno, Theodor W. 46
Aeschylus 22, 26
Oresteia 26, 49, 92, 140, 214,
216, 218, 228–9, 234
Africa 16, 111, 153–4
Alexandrov, Grisha 50
Allden, Eric 48
Alley, Ronald 107, 122
Alloway, Lawrence 34–5, 50, 74,
76, 80, 81, 82, 154
Alphen, Ernst van 39
animal in man, concept of 91–5, 137
Art Brut 36
Artaud, Antonin 154

Bachelard, Gaston 111
Bacon, Francis *frontispiece*; figs.1, 5, 52, 71,
105, 121
 asthma 45, 139
 atheism 14, 22, 26, 28, 137, 139, 213
 attraction to danger and risk 37
 death 30
 death of mother 201
 destruction of works by 17, 24, 49, 91, 153,
 165
 drive and self-criticism 17
 expulsion from family home 45
 guilt 216, 233
 masochism 27, 57
 optimism 27, 28
 quoted 28, 76, 85
 relationship with father 45, 51, 60, 143,
 201
 source materials 48–9, 88, 165–8; *see also*
 film; literature; photography
 and tragedy 30
Barr, Alfred H. 14, 30, 49, 94
Barrington, John S. 66
Bataille, Georges 95, 107, 111, 121, 137, 140
Battock, Gregory 35
Baudelaire, Charles 87, 88
Baxandall, Michael 40
Beard, Peter 205
Beardsley, Aubrey 33
Beaton, Cecil 17, 19
Beckett, Samuel 45, 80
Beckmann, Max
 Temptation Triptych 139
Beethoven, Ludwig van 233
Belcher, Muriel 167, 181, 233; fig.103
Bell, Clive 47
Benjamin, Andrew 39
Berger, John 32, 121
Bernard, Bruce 16
Bernard, Jeffrey 16
Bernard, Oliver 16
Beston, Valerie 213
Bilbo, Jack 56, 91
Blake, William 14, 43, 157
 life-mask 52, 167
Blood on Pavement (1988) 234, 247
Bloomsbury Group 47–8
Bonnard, Pierre 47
Borel, France 62
Bowles, Paul
 The Sheltering Sky 153
 The Spider's House 153
Bowness, Alan 14
Brancusi, Constantin 14
Braque, Georges 121
Brausen, Erica 16, 35, 53, 94, 153
Breton, André 36
Brett, Guy 36
Brighton, Andrew 32
Brogan, Patrick 36
Brookner, Anita 34
Brown, Cecily 31
Browning, Tod

Freaks 57
Bulla, Viktor 60–1; fig.42
bullfight series 25, 218, 234; figs.13–14
Buñuel, Luis
 L'Age d'or 50, 56
 Un Chien andalou (with Dalí) 21, 50, 56, 91,
 185; fig.9
Burgess, Guy 122
Burra, Edward 48
Burri, Alberto 85
Burroughs, William 181
Butler, Reg 14, 110

Calder, Alexander 36
Cammell, Donald
 Performance (with Roeg) 56
Camus, Albert 34, 55
 L'Etranger 153
Capa, Robert 51; fig.32
Capello, José 237
Cappock, Margarita 19, 165
Carné, Marcel 54
 Le Jour se Lève 54–5; fig.36
Carpenter, Edward 71
Cartier-Bresson, Henri 168
Cézanne, Paul 47, 233
 Bathers 110
Chadwick, Lynn 14
Chamberlain, Joseph 76, 92
chance, Bacon's use of 24–5, 48–9, 234
Chimpanzee (1955) 124, 135
Christian imagery 28, 137–43
Cimabue 22
 Crucifixion 45, 143
cinema *see* film as source material
Clair, René 55
Clark, K.C.
 Positioning in Radiography 166, 218; fig.94
Clark, Kenneth 14
Clarke, Arundell 48
Cocteau, Jean 20
Coldstream, William 48
collage 76, 80, 81, 82, 84–5
Colony Room 16, 78, 181; fig.55
Colour Field painting 34, 122, 182
Conrad, Joseph
 Heart of Darkness 49, 216
Constable, John 43
Cook, David 59
Cooper, Douglas 31, 86
critical responses to Bacon's work 28–39
 American critics 28, 30, 34, 35, 36–7, 38
Crucifixion (1933) 31, 47, 91, 137, 139, 143, 145;
 fig.16
The Crucifixion (1933) 19, 137, 139; fig.74
Crucifixion (1965) 45, 137, 143, 150–1, 165, 181,
213, 214; fig.29
crucifixion series 137–43, 181
Cubism 36

Dalí, Salvador
 Un Chien andalou (with Buñuel) 21, 50, 56,
 91, 185; fig.9
Daumier, Honoré Victorin 40–1
 Don Quixote and Sancho Panza 40; fig.22
 Jean-Auguste Chevandier de Valdrôme 40;
 fig.23
David, Jacques-Louis
 The Death of Marat 202
Davies, Douglas 24, 37
Davies, Hugh M. 37, 185, 202, 213, 218
de Kooning, Willem 30
 Women 154
De Maistre, Roy 48, 139
Deakin, John 16, 48
 photograph of Bacon fig.52
 photographs for Bacon 167, 168, 181, 182,
 201, 202; figs.101–4
dealers 16, 35, 94, 153
death in Bacon's work 124, 201–5, 233–7
Degas, Edgar 23, 47, 48, 86
 After the Bath 182
Delacroix, Eugène 88
Deleuze, Gilles 27, 39, 46, 57, 59, 95, 107, 110
*Diptych: Study of the Human Body – From a
Drawing by Ingres* (1982–4) 233; fig.116
Discobolos 214

Donne, John 27
drawings 22, 166–7
Dubuffet, Jean 14, 36, 121
 Corps de dame series 17
 The Tree of Fluids 17; fig.4
Duchamp, Marcel 45, 82, 86
Dürer, Albrecht
 Melancholia 216
Durgnat, Raymond 56
Dyer, George 23, 43, 48, 72, 73, 166, 167–8,
182, 214; figs.51, 101, 105
 death 30, 36–7, 185, 201, 202, 205,
 214, 216, 233
 portraits by Bacon 180, 181, 182, 185, 186,
 194–7, 200, 205–5, 206–11; fig.110

Edwards, John 19, 37, 39, 72, 168, 214, 233
Egypt 16
Eichmann, Adolf 21, 28
Eisenstein, Sergei 50, 54, 55–6, 59–62
 Battleship Potemkin 21, 42, 56, 57, 59–60,
 74, 76, 91, 95, 110, 156, 162, 165; figs.80, 84
 October 59, 60–1; figs.41, 43
 Que Viva Mexico 55–6
 Strike 57, 59
El Greco
 Crucifixion 41
 View of Toledo 40, 41
Elephant Fording a River (1952) 40
Elgin Marbles 20
Eliot, T.S. 22, 26, 27, 45, 88, 213–14
 'Ash Wednesday' 202, 214
 The Family Reunion 140, 214, 216
 Four Quartets 213
 The Lovesong of J. Alfred Prufrock 185, 214
 Sweeny Agonistes 124, 213, 214, 216, 220–1
 The Waste Land 22, 26, 91, 202, 213, 214
Eumenides 140, 214, 216, 218, 234
exhibitions 31
 1934 Transition Gallery 31
 1936 *International Surrealist Exhibition* 78
 1945 Lefevre Gallery 91
 1949 Hanover Gallery 31
 1950 *London – Paris: New Trends in Painting
 and Sculpture* 74
 1953 Durlacher Gallery 35
 1953 *Parallel of Life and Art* 78, 81; fig.56
 1953 *Wonder and Horror of
 the Human Head* 78
 1954 Venice Biennale 80, 87, 153
 1955 retrospective, ICA 50, 80–2; fig.58
 1955 *The New Decade* 33
 1956 *This is Tomorrow* 82; figs.60–1
 1957 Hanover Gallery 154
 1957 Paris 21, 153
 1959 *New Images of Man* 33, 154
 1959 São Paulo Biennial 156
 1962 retrospective, Tate Gallery 22, 30,
 33, 35, 156, 181; fig.18
 1963 Guggenheim Museum, New York
 33, 34–5
 1968 New York 35
 1969 Picasso, Tate Gallery 140
 1971 retrospective, Grand Palais
 30, 36, 201; fig.19
 1975 Metropolitan Museum of Art
 36–7; fig.20
 1985 *The Artist's Eye*, National gallery 42
 1989 Hirshhorn Museum fig.21
 1993 Venice 237
Existentialism 17, 30, 33–4, 35, 140

Farson, Daniel 39, 153, 154
 Francis Bacon fig.1
 The Gilded Gutter Life of Francis Bacon 16
Faure, Elie 62
Fautrier, Jean 14, 121
 Head of a Hostage, No.14 121; fig.69
 Otages 17, 121; fig.69
Feaver, William 69
figuration 34, 85, 121
Figure Getting Out of a Car (1943) 92; fig.63
Figure in a Landscape (1945) 17, 19, 27, 60, 61,
91, 92, 93, 97
Figure in a Landscape (c.1952) 111
Figure with Left Arm Raised, No.1 (1957–61) 167;
fig.100

Figure in a Mountain Landscape (1956) 40, 152,
153–4, 160
Figure in Movement (1985) 233, 243
Figure Study I (1945–6) 92, 98
Figure Study II (1945–6) 92, 94, 99
Figures in a Garden (1936) 47, 49, 91, 92; fig.31
Figures in a Landscape (1956–7) 153, 159
film as source material 21, 22, 50–63, 154,
156, 165
Fischer, Harry 40, 45
Fox, James 56
Fragment of a Crucifixion (1950) 82, 140; fig.59
France 16, 19, 36, 47, 153
Frêle Bruit 49, 216
French House 16
Freud, Lucian 14, 16, 28, 77, 91
 portraits by Bacon 167, 181, 182, 213;
 figs.107, 110
Freud, Sigmund 34, 49, 107
Fried, Michael 30, 34, 38
Friedrich, Caspar David 122
Frost, Terry 122
Fry, Roger 47
Fuseli, Henry 43

Gabin, Jean 54–5, 56; fig.36
Gale, Matthew 166, 167, 234
gambling 16, 24, 48, 69, 139, 153
Gance, Abel
 Napoléon 50, 56, 59, 62; fig.44
Garland, Madge 47–8
Gascoyne, David 48
Gauguin, Paul 47, 86
 Arearea 47; fig.30
 Yellow Christ 139
Geldzahler, Henry 36
Genet, Jean 35, 37; fig.3
Giacometti, Alberto 14, 17, 28, 45, 110
 Jean Genet 17; fig.3
Gideon, Siegfried 76
Glass, Douglas
 Francis Bacon in his Studio 19; fig.5
Godard, Jean-Luc 54
Goebbels, Joseph 91, 92, 94
Gombrich, Ernst 80, 86–7
Göring, Hermann 91
Gower, David 233
Gowing, Lawrence 32
Goya, Francisco de 33
Greenberg, Clement 14, 30, 34, 121
Greene, Graham 56
Griffith, D.W.
 Intolerance 50, 59, 60
Group Two 82, 85
Grünwald, Matthias 22, 40
 Isenheim Altarpiece 139, 216; fig.75
 Mocking of Christ 91

Haigh, John George 56
Hall, Eric 19, 48, 92, 139, 201
Hamilton, Richard 76, 78, 81, 82, 86
 Collage of the Senses 82; fig.60
 *Just what is it that makes today's homes so
 different, so appealing?* 82, 84; fig.61
Hampstead Heath 71
Hanover Gallery 31, 35, 53, 94, 153, 154
Hardy, M.
 Francis Bacon's Reece Mews living room 19;
 fig.6
Harrison, Martin 19, 52, 55, 74, 76, 88, 139,
166, 168, 234, 237
Hauser, Richard 73
Head I (1947–8) 31, 94, 102; fig.17
Head II (1949) 17, 31, 90, 94, 103
Head VI (1949) 17, 18, 44, 77, 94, 95, 104, 107,
110, 165
Henderson, Nigel 76, 77–8, 81, 82, 84
 Colony Room 78; fig.55
 Eduardo Paolozzi 77; fig.54
 photograph of bathers 77; fig.53
Henley-on-Thames 16, 122, 153
Henrietta Moraes (1966) 43, 182, 192
Heron, Patrick 121
Hess, Thomas 30
Hirst, Damien 31
Hitler, Adolf 91, 92, 137

Hockney, David 28, 69
Holroyd, Geoffrey 82
homosexuality 16, 27, 28, 35, 45, 48, 64–75,
84, 122, 153, 214
 Bacon's attitude towards 216
 Homosexual Law Reform Society 69
 Man in Blue series 122
 muscle and physique magazines 66–7,
 69, 70–2; figs.45, 47
 Wolfenden Report 64, 66, 69, 71, 72, 73, 84
Hone, Nathaniel 43–4
Horizon magazine 91
Hume, Gary 31
Hunter, Sam 32–3, 37, 77, 91, 165
 *Montages of material from Bacon's studio,
 c.1950* 16, 87, 91, 92, 165; figs.2, 88–9
Huxley, Aldous 47
Huysman, Joris-Karl 87

Ibsen, Henrik 233
Impressionism 36, 47
Independent Group 74, 76, 81, 82, 84–5
Ingres, Jean-Auguste-Dominique 233
 Le Bain turc 233; fig.115
 Oedipus and the Sphinx 233
Institute of Contemporary Art (ICA) 74, 76,
78, 80–2; fig.56
interior designer, Bacon as 47, 48, 76
Interior of a Room (1934) 47
interpretations of Bacon's work 44–6
Ireland 60, 137, 218

Jet of Water (1988) 234, 245
Johns, Jasper 36
Junger, Ernst 59

kino-glas 51
Kitchen Sink group 121–2
Klee, Paul 80, 153
 Pedagogical Sketchbook 85
Klein-Rogge, Rudolf 50
Koestler, Arthur 59
Kristeva, Julia 58, 122
Kuspit, Donald 37

Lacoste, Michel Conil 36
Lacy, Peter 16, 122, 124, 153, 156, 166, 181;
fig.72
 death 181, 201
Læssøe, Rolf 45, 213
Landscape (1978) 234
Landscape and Car (1944) 92
Landscape near Malabata, Tangier (1963) 181,
187
landscapes 181, 234
Lang, Fritz 50, 54
 Dr Mabuse series 50, 52, 56–7
 Metropolis 51
Lanyon, Peter 122
Lartigue, Jacques Henri
 The Grand Prix of the A.C.F. June 26 1912 46;
 fig.28
Le Nain, Mathieu
 A Quarrel 44
Lebensztejn, Jean-Claude 43
Leiris, Michel 22, 30, 36, 45, 49, 62, 213, 218
 portrait by Bacon 239
Leja, Michael 55
Leni, Paul
 Wachsfigurenkabinett 51
Leonardo da Vinci 86
Lerski, Helmar
 photograph of Bacon 51; fig.121
Lewis, Wyndham 14, 31
Lewison, Jeremy 237
Leyda, Jay 61
Lightfoot, Jessie 16
Limehouse flat 185
literature as source material 22, 26, 49, 87–8,
213–18, 234
 occultist literature 52
Longanesi, Leo
 Il Mondo Cambia 21; fig.8
Lorca, Federico García 26, 59, 60, 234
 Lament for Ignacio Sánchez Mejías 218
Lotar, Eli 137
 Aux Abattoirs de la Villette fig.73

Lying Figure (1958) 156
Lying Figure (1969) 199
Lying Figure with Hypodermic Syringe (1963) 45, 181, 199
Lyotard, Jean-François 46

McHale, John 76, 80, 81, 82, 84
Maclean, Donald 122
Macpherson, Kenneth 51
Maistre, Joseph de 139
Male Classics magazine 67, 69
Mallarmé, Stephane 45
Malraux, André 79–80, 82
Man in Blue series 18, 70, 121–4, 156
Man in Blue I (1954) 70, 121; fig.4
Man in Blue IV (1954) 18, 70, 121, 133
Man in Blue V (1954) 18, 70, 121, 132
Man in a Cap (1943) 92; fig.62
Man Carrying a Child (1956) 154
Man with Dog (1953) 44, 120, 122, 130
Man Standing (1941–2) 92; fig.64
Manet, Edouard 47
MANifique magazine 66
Marey, Etienne-Jules 59, 167
Marlborough Fine Art 16, 35, 40
Marsh, Mae 52
Masaccio
 Expulsion from the Garden of Eden 110
 Virgin and Child with Angels 47
Masson, André 36, 137
Matisse, Henri 40, 43, 153, 182
 Bathers with a Turtle 43
 Odalisque with a Tambourine 43
Mellor, David 137
Melville, Robert 21, 31, 40, 52, 55, 80, 82, 86, 91, 92, 94, 107, 165, 181
Merleau-Ponty, Maurice 86
Mesens, E.L.T. 78, 85
Michaux, Henri 53, 121
Michelangelo Buonarroti 14, 20, 35, 40, 143
 Brutus 202
 Crouching Boy or The Adolescent (attributed) 110; fig.65
 drawings 166; fig.93
 Victory 143
Minnelli, Vincente 54
 Lust for Life 53–4, 154; fig.35
Minton, John 54, 69
mirrors and reflections in Bacon's work 185
Mock, Jean-Yves 53
modernism 38, 48, 121, 139
Moholy-Nagy, László 76–7, 80, 82
Monet, Claude 40, 47
Monte Carlo 16, 21, 94, 153
Moore, Henry 28, 139
Moraes, Henrietta 48, 167; fig.102
 portraits by Bacon 181–2, 192
Moreau, Gustave 87
Morland, Dorothy 80
Morocco 153
Mortimer, Raymond 48, 139
muscle and physique magazines 66–7, 69, 70–2; figs.45, 47
Mussolini, Benito 143
Muybridge, Eadweard 19–20, 21, 33, 43, 45, 76, 91, 110, 122, 156, 165–7
 Animals in Motion 107, 110; fig.67
 Athlete Heaving 75 Pound Rock 19; fig.7
 Human Figure in Motion 10, 48, 165–7, 214; figs.85–6, 90–1, 99
 wrestlers 124, 166, 202, 214, 237; fig.91

Nash, Paul 48
Nazis 21, 28, 33, 45, 60, 91–3, 139, 143, 214
 Lichtdom: Party Rally, Nuremberg 110; fig.66
neo-romanticism 54, 87
Nesbet, Anne 56, 59
Neue Sachlichkeit 51
Newman, Barnett 122
Nichol, Tom 66; fig.47
Nietzsche, Friedrich 22
Nochlin, Linda 30, 233

Oberammergau Passion Play 137
occultist photography and literature 52, 139; fig.76

O'Doherty, Brian 35
Oedipus and the Sphinx after Ingres (1983) 233, 234; fig.117
Ofield, Simon 39, 84
Olante, David 39
Orwell, Sonia 21, 58, 91, 233
Ostia 16, 153
Ozenfant, Amédée 47, 76, 82, 85

Painting (1946) 30, 41, 45, 49, 60, 87, 91, 92, 94, 101, 107, 140; fig.95
Painting (1978) 23, 212, 213, 227
Painting (1980) 59
painting formats 22
painting method 17, 22–6, 44, 53, 166–7, 234
 airbrushing 234
 backgrounds 23
 chance, Bacon's use of 24–5, 48–9, 234
 changes and revisions 23–4; figs.11–12
 spray paints 234
 unprimed canvas 33, 47, 69
Paolozzi, Eduardo 14, 76, 77, 78, 80, 81, 82, 84, 110; fig.54
 Windtunnel Test 81; fig.57
Paralytic Child Walking on All Fours (from Muybridge) (1961) 156, 163, 165
Paris 16, 19, 36, 47
Penrose, Roland 78, 80, 140
Peppiatt, Michael 39, 85, 88, 205, 233, 234
Petersfield 139
photographic material, Bacon's use of 19–22, 27, 31, 32–3, 42, 45, 48, 55, 58, 76, 80, 85, 88, 91, 97, 110, 156, 165–8, 234, 237; figs.2, 7, 28, 37, 84–105
 morgue photographs 181
 muscle and physique magazines 66–7, 69, 70–2; figs.45, 47
 occultist photography 52, 139; fig.76
 portraits painted from 181, 182, 201
 see also film; Muybridge, Eadweard
Physique Pictorial magazine 64, 66, 71, 72; fig.45
Picasso, Pablo 22, 31, 36, 40, 43, 45, 47, 86, 92, 182, 202, 233
 Bather 137; fig.16
 Charnel House 94
 Crucifixion 140; fig.78
 Les Demoiselles d'Avignon 140, 143, 182; fig.79
 Guernica 139
 Las Meniñas 40
 variations on the Isenheim Altarpiece 139
A Piece of Waste Land (1982) 219
Piero della Francesca
 St Sigismund and Sigismondo Pandolfo Malatesta 47
Plante, David 28, 30; fig.105
Poetic Realism 54
Polan, Dana 39
Pollock, Jackson 55, 85, 121
Ponge, Francis 121
Pop art 34, 54, 74, 76, 82, 84, 85, 182
Pope I – Study after Pope Innocent X by Velázquez (1951) 18, 110, 114
Portrait of George Dyer Riding a Bicycle (1966) 185, 195, 201
Portrait of Isabel Rawsthorne (1966) 182, 191
Portrait of Isabel Rawsthorne Standing in a Street in Soho (1967) 193
Portrait of John Edwards (1988) 168, 214, 218, 233, 244
Portrait of a Man Walking Down Steps (1972) fig.118
Portrait of Michel Leiris (1976) 239
portraits 167–8, 181–5
Post-Impressionism 36, 47
post-painterly abstraction 182
Pound, Ezra 26
Poussin, Nicolas 22
 Massacre of the Innocents 95
Powell, Michael
 Peeping Tom 51, 56
Proust, Marcel 87–8

Ragon, Michel 121
Rawsthorne, Isabel 16, 107, 110, 167; figs.55, 104

portraits by Bacon 181, 182, 191, 193
Read, Herbert 78, 81, 110
 Art Now 31, 91, 137; fig.16
Reclining Woman (1961) 23–4
Reece Mews 16, 19, 64, 91, 185; figs.6, 45, 83, 87, 101
Rembrandt van Rijn 14, 21, 22, 26, 40, 43, 44, 49, 86–7, 92, 137, 166, 233
Renzio, Toni del 82
Resnais, Alain
 Hiroshima Mon Amour 58–9, 182; fig.40
Reynolds, Joshua 44
Ribera, Jusepe de 44
Ribot, Théodule-Augustin 44
Richardson, John 45, 49
Richier, Germaine 14, 110
Rimbaud, Arthur 35
Ritchie, Andrew Carnduff 33
Riva, Emmanuelle 58; fig.40
Robertson, Bryan 78
Rodin, Auguste 14, 167
 Thinker 91
Roeg, Nicolas
 Performance (with Cammell) 56
Rolfe, Frederick 107
Romanticism 87
Rome 16
Rosenberg, Harold 30, 37
Rothenstein, John 40–1, 49
Rothko, Mark 122
Rubens, Peter Paul 40
Russell, John 14, 20, 21–2, 28, 30, 32, 33–4, 50, 94
Sackville-West, Vita 47
Sade, Marquis de 35
Sadler, Michael 19, 31, 139
Sainsbury, Robert 153
St Ives 16, 156
Sartre, Jean-Paul 34, 36, 37, 55, 154
School of London 14
Schrenk Notzing, Baron von
 Phenomena of Materialisation 139; fig.76
Scott Studios 66, 70; fig.47
Seated Figure (1974) 216; fig.113
Second Version of Triptych 1944 (1988) 143, 216, 232, 233–4, 248–9
Self-Portrait (1970) fig.10
Self-Portrait (1973) 216, 223
Self-Portrait with a Watch (1973) 216, 222
self-portraits 156, 168, 214, 216; fig.110
Selz, Peter 33
Senna, Ayrton 237
Seurat, Georges 33, 40, 41, 43, 86
sexuality in Bacon's work 27, 35, 124, 153, 202, 214; *see also* homosexuality
Shakespeare, William 26
Sickert, Walter 48, 82
Simon, Michel 57; fig.39
Simon, Matthew 17, 43, 85, 107, 121
Smith, Roberta 38
Smithson, Peter and Alison 78, 80, 82
Soby, James Thrall 30, 40
Soho 16, 67, 71–2
Soutine, Chaïme 31, 40, 43, 92, 137, 154
space, pictorial 107, 110–11, 121
Spencer, Stanley 14
Spender, Stephen 80
Sperber, Murray 61
Stalin, Joseph 124
Stanek, V.J.
 Introducing Monkeys 167; fig.97
Stanford, W.B. 26, 140
Stark, Peter 168, 216
Stirling, William 42
Street Scene with Car in the Distance (1988) 56–7
studios 16, 18–19, 67, 69, 165; fig.18
 Battersea 19; fig.5
 Cromwell Place 16, 91, 92, 139, 153
 re-creation in Hugh Lane Gallery, Dublin 19, 39, 91
 Reece Mews 16, 64, 91; figs.45, 83, 101
Study after Velázquez (1950) 18, 77, 107, 110, 112
Study after Velázquez (1951) 82

Study after Velázquez (1954) 82
Study after Velázquez's Portrait of Pope Innocent X (1953) 18, 77, 110, 119
Study of a Baboon (1953) 124, 127
Study for a Bullfight No.2 (1969) 25; fig.13
Study for a Bullfight No.2 (1969; 2nd version) 25; fig.14
Study for Crouching Nude (1952) 22, 43, 49, 106, 110–11, 118, 153, 166, 167
Study of a Dog (1952) 107, 111, 113
Study for a Figure II (1953–4) 129
Study of a Figure in a Landscape (1952) 111, 117
Study from the Human Body (1949) 95, 105, 107, 168
Study from the Human Body (1981) 233, 242
Study of the Human Body (1982) 233
Study from Portrait of Pope Innocent X (1965) 43, 190
Study of George Dyer in a Mirror (1968) 43, 72, 185, 197; fig.51
Study for Head of George Dyer (1967) 194
Study for Man with Microphones (1946) 30, 92; fig.126
Study for Nude (1951) 110, 115, 165
Study of a Nude (1952–3) 122, 125, 165
Study for the Nurse from the Battleship Potemkin (1957) 156, 162, 165
Study for a Portrait (1953; Hamburger Kunsthalle) 82, 124, 126
Study for a Portrait (1953; Hess Art Collection) 124, 131
Study for a Portrait (1966) 40; fig.24
Study for a Portrait I (1953) 121, 128
Study for a Portrait II (after the Life Mask of William Blake) (1955) 52, 157, 167
Study for Portrait of Van Gogh III (1957) 53–4, 85; fig.33
Study for Portrait of Van Gogh VI (1957) 85, 154, 161
Study for Three Heads (1962) fig.106
Surrealism 30, 31, 36, 48, 78, 80, 81, 84, 86
Sutherland, Graham 14, 16, 17, 48, 69, 94, 139
 The Crucifixion 139, 140; fig.77
 portrait of Winston Churchill 124
Swinburne, Algernon 88
Sylvester, David 17, 19, 21, 24, 26, 30, 31, 32, 33, 50, 80, 85, 88, 91, 92, 144, 165, 205, 234
 interviews with Bacon 22, 26–7, 43, 50, 74, 87, 110, 122, 124, 201
 portrait by Bacon 166, 181
Synthetism 86

Tachism 24, 85, 121
Tangier 16, 153–4, 181, 187
Tàpies, Antoni 36
Ternante-Lemaire, Amédée 44
Thomas, Dylan 16
Thompson, David 69
Three Figures in a Room (1964) 182, 188–9
Three Portraits – Posthumous Portrait of George Dyer, Self-Portrait, Portrait of Lucian Freud (1973) 205; fig.110
Three Studies for a Crucifixion (1962) 33, 44–5, 48, 94, 136, 137, 148–9, 156, 181, 213
Three Studies for Figures at the Base of a Crucifixion (1944) 17, 56, 91, 95, 107, 137, 139–43, 146–7, 213, 233; fig.15
Three Studies for Figures on a Bed (1972) 205; fig.109
Three Studies of the Human Head (1953) 82, 92, 124; fig.70
Three Studies of Isabel Rawsthorne (1967) 182
Three Studies of Lucien Freud (1969) 182, 213; fig.107
Three Studies of the Male Back (1970) 43, 185; fig.108
Three Studies for a Portrait of George Dyer (1963) 186
Three Studies for Portraits including Self-Portrait (1969) 198
Three Studies for a Self-Portrait (1979–80) 238
Tissé, Edouard 55
Titian 26, 40, 233
 The Death of Actaeon 44; fig.26
Todd, Dorothy 47–8
Toulouse-Lautrec, Henri de 47, 49
Triptych (1970) 57

Study after Velázquez (1954) 82
Triptych (1974–7) 24, 205; figs.11–12
Triptych (1976) 76, 216, 224–5
Triptych (1983) 240–1
Triptych (1987; Estate of Francis Bacon) 166, 230–1, 234, 237
Triptych (1987; Private Collection) 218; fig.114
Triptych (1991) 166, 237, 250–1
Triptych – August 1972 (1972) 23, 24, 36–7, 166, 168, 185, 202, 208–9
Triptych, March 1974 (1974) 43, 59, 205, 214; fig.111
Triptych, May–June 1973 (1973) 202, 210–11, 214, 216
Triptych – In Memory of George Dyer (1971) 200, 201–2, 206–7
Triptych – Inspired by the Oresteia of Aeschylus (1981) 216, 228–9, 234
Triptych – Inspired by T.S. Eliot's 'Sweeny Agonistes' (1967) 23, 202, 213, 216, 220–1
Triptych – Studies from the Human Body (1970) 50–1, 214; fig.112
triptychs 22, 62, 213, 234
Trotsky, Leon 218
The True Aspects of the Algerian Revolution 45; fig.131
Turnbull, William 110
Turner, J.M.W. 44
Two Figures (1953) 64, 70, 124, 165–6; fig.46
Two Figures in the Grass (1954) 64, 111, 134, 166
Two Figures Lying on a Bed with Attendants (1968) 214
Two Studies for a Portrait of George Dyer (1968) 180, 182, 185, 196

Untitled (Marching Figures) (1950) 76
Untitled (Two Figures in the Grass) (1952) 153, 158

Valentino, Rudolph 52
Van Gogh in a Landscape (1957) 54, 85, 154; fig.81
van Gogh series 153–4, 156
van Gogh, Vincent 22, 41, 47, 85, 182
 The Painter on the Road to Tarascon 54, 154; figs.34, 82
 Portrait of Eugène Boch 154
Vaughan, Keith 69–71, 73, 139
 Highgate Ponds 71; fig.50
 Second Assembly of Figures 70; fig.49
Velázquez, Diego 14, 22, 25–6, 32, 44, 64, 91, 182
 Las Meniñas 43
 Philip IV of Spain in Brown and Silver 44; fig.27
 Portrait of Pope Innocent X 18, 21, 40, 42, 44, 74, 85, 91, 94–5, 107, 110, 154, 165; fig.68
 The Toilet of Venus 42–3
Victim 67
violence in Bacon's work 60, 91–5, 137, 139, 140, 216
Voelcker, John 82

Walker, Kenneth 73
Walsh, Johnny 70–2, 73
Watson, Peter 78, 91
Webster, John
 Duchess of Malfi 49
 The White Devil 49
Weegee
 Naked City 20
Whistler, James Abbott McNeill 88
Wildeblood, Peter 72–3, 84, 122
Williams, Dennis 69
Wilson, Colin 80
Wilson, Woodrow 218
Wirth-Miller, Denis 91
Wolfenden Report 64, 66, 69, 71, 72, 73, 84
Woolf, Virginia 47, 48
World War II 28, 71, 91–2, 94, 137, 139–40, 143
Wound for a Crucifixion (1934) 137, 234

Yacoubi, Ahmed 153
Yeats, W.B. 26, 88
Yorke, Malcolm 69, 70

Zurbarán, Francisco 40, 41
 Saint Francis in Meditation 41–2; fig.25

SUPPORTING TATE

Tate relies on a large number of supporters – individuals, foundations, companies and public sector sources – to enable it to deliver its programme of activities, both on and off its gallery sites. This support is essential in order for Tate to acquire works of art for the Collection, run education, outreach and exhibition programmes, care for the Collection in storage and enable art to be displayed, both digitally and physically, inside and outside Tate. Your donation will make a real difference and enable others to enjoy Tate and its Collection both now and in the future. There are a variety of ways in which you can help support Tate and also benefit as a UK or US taxpayer. Please contact us at:

Development Office
Tate
Millbank
London SW1P 4RG
Tel: 020 7887 8945
Fax: 020 7887 8098

American Patrons of Tate
1285 6th Avenue
(35th floor)
New York, NY 10019, USA
Tel: 001 212 713 8497
Fax: 001 212 713 8655

Donations
Donations, of whatever size, are gratefully received, either to support particular areas of interest, or to contribute to general activity costs.

Gifts of Shares
We can accept gifts of quoted share and securities. All gifts of shares to Tate are exempt from capital gains tax, and higher rate taxpayers enjoy additional tax efficiencies. For further information please contact the Development Office.

Gift Aid
Through Gift Aid you can increase the value of your donation to Tate as we are able to reclaim the tax on your gift. Gift Aid applies to gifts of any size, whether regular or a one-off gift. Higher rate taxpayers are also able to claim additional personal tax relief. Contact us for further information and to make a Gift Aid Declaration.

Legacies
A legacy to Tate may take the form of a residual share of an estate, a specific cash sum or item of property such as a work of art. Legacies to Tate are free of inheritance tax, and help to secure a strong future for the Collection and galleries.

Offers in lieu of tax
Inheritance Tax can be satisfied by transferring to the Government a work of art of outstanding importance. In this case the amount of tax is reduced, and it can be made a condition of the offer that the work of art is allocated to Tate. Please contact us for details.

Membership Programmes
Tate Members enjoy unlimited free admission throughout the year to all exhibitions at Tate, as well as a number of other benefits such as exclusive use of our Members' Rooms and a free annual subscription to Tate Etc. Whilst enjoying the exclusive privileges of membership, you are also helping secure Tate's position at the very heart of British and modern art. Your support actively contributes to new purchases of important art, ensuring that the Tate's Collection continues to be relevant and comprehensive, as well as funding projects in London, Liverpool and St Ives that increase access and understanding for everyone.

Tate Patrons
Tate Patrons share a strong enthusiasm for art and are committed to giving significant financial support to Tate on an annual basis. The Patrons support the acquisition of works across Tate's broad collecting remit, as well as other areas of Tate activity such as conservation, education and research. The scheme provides a forum for Patrons to share their interest in art and to exchange knowledge and information in an enjoyable environment. United States taxpayers who wish to receive full tax exempt status from the IRS under Section 501 (c) (3) are able to

support the Patrons through the American Patrons of Tate. For more information on the scheme please contact the Patrons office.

Corporate Membership
Corporate Membership at Tate Modern, Tate Liverpool and Tate Britain offers companies opportunities for corporate entertaining and the chance for a wide variety of employee benefits. These include special private views, special access to paying exhibitions, out-of-hours visits and tours, invitations to VIP events and talks at members' offices.

Corporate Investment
Tate has developed a range of imaginative partnerships with the corporate sector, ranging from international interpretation and exhibition programmes to local outreach and staff development programmes. We are particularly known for high-profile business to business marketing initiatives and employee benefit packages. Please contact the Corporate Fundraising team for further details.

Charity Details
The Tate Gallery is an exempt charity; the Museums & Galleries Act 1992 added the Tate Gallery to the list of exempt charities defined in the 1960 Charities Act. Tate Members is a registered charity (number 313021). Tate Foundation is a registered charity (number 1085314).

American Patrons of Tate
American Patrons of Tate is an independent charity based in New York that supports the work of Tate in the United Kingdom. It receives full tax exempt status from the IRS under section 501(c)(3) allowing United States taxpayers to receive tax deductions on gifts towards annual membership programmes, exhibitions, scholarship and capital projects. For more information contact the American Patrons of Tate office.